THE COMPLETE GUIDE TO
NIGHT & LOW-LIGHT
PHOTOGRAPHY

THE COMPLETE GUIDE TO
NIGHT & LOW-LIGHT
PHOTOGRAPHY

LEE FROST

David & Charles

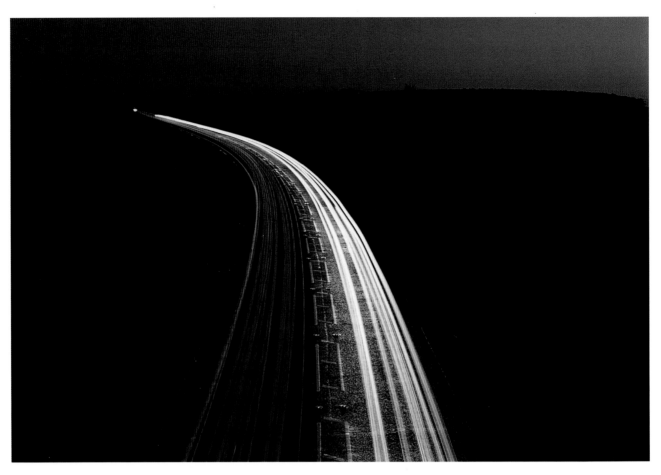

A DAVID & CHARLES BOOK
Copyright © David & Charles Limited 1999, 2001

David & Charles is an F+W Publications Inc. company
4700 East Galbraith Road, Cincinnati, OH 45236

First published in the UK in 1999
First published in paperback 2001
Reprinted 2002, 2003, 2004, 2005 (Twice), 2006, 2007

Text and images copyright © Lee Frost 1999, 2001

Lee Frost has asserted his right to be identified as author of this
work in accordance with the Copyright, Designs and Patents Act, 1988.

All photographs by the author, except: Simon Stafford; pages 136, 137,
142, 190 and Steve Bavister; pages 188, 191

A catalogue record for this book is available from the British Library.

ISBN-13: 978-0-7153-1274-2
ISBN-10: 0-7153-1274-X

Designed by Gary Day-Ellison
Printed in China by SNP Leefung
for David & Charles
Brunel House Newton Abbot Devon

Visit our website at www.davidandcharles.co.uk

David & Charles books are available from all good bookshops; alternatively
you can contact our Orderline on 0870 9908222 or write to us at FREEPOST
EX2 110, D&C Direct, Newton Abbot, TQ12 4ZZ (no stamp required UK only);
US customers call 800-289-0963 and Canadian customers call 800-840-5220.

CONTENTS

INTRODUCTION

The earliest piece of photographic advice I ever received came from the owner of the shop where I bought my first camera. 'Leave it set to 1/125second at f/5.6 and you should be OK,' I was told; so armed with this nugget of priceless information, a brand new SLR and a pocketful of film, I promptly headed off into the big wide world and took lots of badly exposed pictures.

What my friendly teacher failed to point out is that such a simple approach to photography only works if you are taking pictures in bright sunshine on a clear summer's day, which tends to be when the majority of people reach for a camera. But I soon discovered that such conditions are far from exciting, and immediately began searching for more challenging photo opportunities. That search inevitably led me into the colourful world of night and low-light photography, and marked the beginning of a love affair that endures to this day – perhaps with more passion than ever before.

What makes night and low-light photography so interesting is the challenge it presents. Working in extreme conditions tests your skills and equipment to the very limit, but the pictures that result always repay this effort a thousand times over. It is also an area of photography that encompasses all manner of subjects, from landscapes, architecture and still-life to portraiture, action and nature, while the vast range of techniques that can be applied to these subjects offers endless creative potential.

The aim of this book is to show you the types of picture that can be taken in night and low-light situations, and to explain in an easy-to-understand way how you can produce similar results yourself – no matter what your level of interest or experience.

The first chapter deals with equipment, telling you not only which cameras, lenses, flashguns and filters are best for night and low-light photography, but also how to keep your camera steady so that you produce pin-sharp pictures every time, and how to choose the right film to suit different low-light situations.

Next, exposure and metering is explored in depth, teaching you how to take perfectly exposed pictures no matter how tricky the lighting, along with the quality of light and the factors that affect it.

Finally, this information is applied to a wide range of low-light subjects and techniques, from photographing towns and cities to capturing people indoors; from shooting the sky at night to 'painting' with light.

The photographs – there are over 250 of them – are intended both to inspire and to inform; and when combined with the advice contained within the text they will, I hope, provide all creative image-makers with many hours of enjoyment, and will also help you to become a better and more skilful photographer.

EQUIPMENT

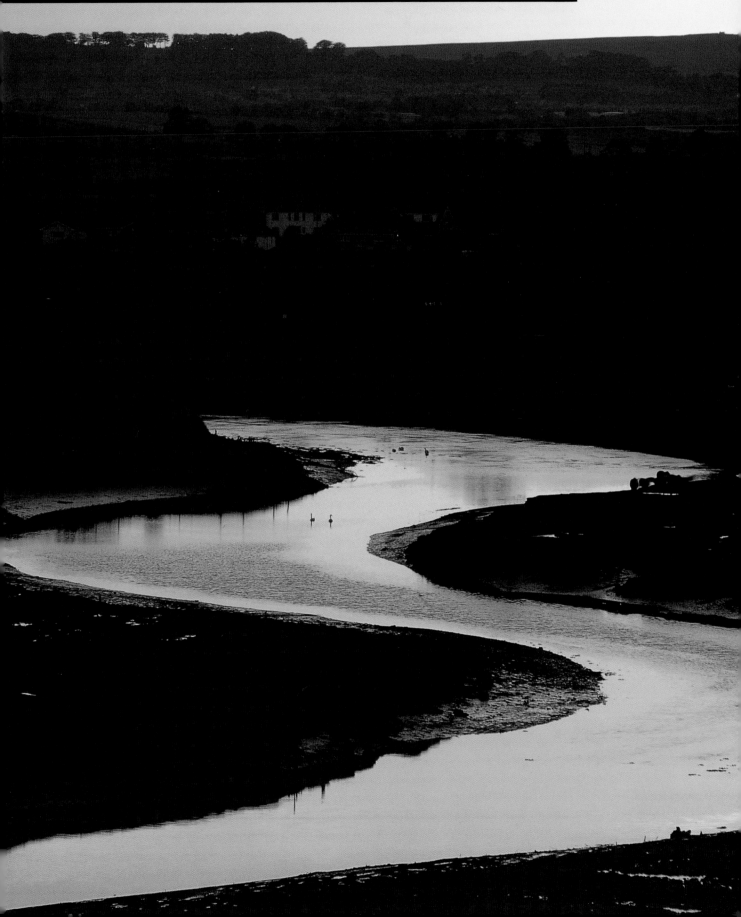

CAMERAS

Cameras and cars have a lot in common. Most of us like the idea of racing around in a Porsche or a Ferrari, but if you strip away the glamour and power, they are no more capable of getting you from A to B than the banger you picked up from your local used car lot for a fraction of the cost – they just do it a little quicker and with rather more style.

Similarly, while many photographers dream of owning the latest all-singing, all-dancing SLR, you don't actually need one to take successful pictures: a top-of-the-range Nikon or Canon swinging from your shoulder may look impressive, but if you're a skilled photographer you will be able to produce breathtaking work with any camera, no matter how simple. That's because a camera is essentially just a lightproof box that holds a roll of film so that you can expose it to light and record photographic images, and while all the fancy features, modes and functions that modern cameras offer undoubtedly make the picture-taking process quicker and easier, none of them can actually make you a better photographer – only imagination and creativity can do that.

You might think that night and low-light photography is an exception to the rule because it involves taking pictures in demanding conditions, often using rather specialised or complicated techniques. But nothing could be further from the truth, and as you read through this book you will realise just how little you really need to produce successful photographs time after time. It will also become apparent that in most situations it's your own skill and experience that makes the difference, rather than how sophisticated your camera is.

USEFUL FEATURES

An unfortunate fact of life is that when thinking about buying a new camera, many photographers are enticed by certain models for all the wrong reasons. The way it looks, how many pictures-per-second it can take and the number of gimmicks on offer tend to be top of the list – yet none of these is particularly important when it comes to actually using the thing, and the features that should be considered tend to be ignored because they don't have the same 'wow' factor.

It's the glamorous car scenario again – amazing acceleration and sleek styling are all well and good, but on a day-to-day basis it is

Whichever type of camera you use for low-light photography, the most important factor is that it gives you the control to produce high-quality images of the scenes and subjects you encounter. Fortunately, as your experience grows you will become less and less reliant on your camera, so the number of features it has and how sophisticated it is will be irrelevant. This graphic picture of a neon sign outside a seaside aquarium was taken with an Olympus OM1, a simple, all-manual 35mm SLR that lacks many of the features discussed in this chapter, but is as capable as any other of coming up with the goods when placed in proficient hands.

practical considerations like being able to fit your groceries in the boot or having enough room in the back for your kids that are more important – and if they aren't there, the novelty will soon wear off.

The features you need in a camera obviously depend on the subject you're photographing, but for night and low-light photography the following should be at the top of your list.

EXPOSURE MODES

When you take a photograph, there are two variables at your disposal which allow you to control precisely how much light reaches the film so as to ensure that a correctly exposed image is recorded: the aperture and the shutter speed. We'll look at these things more closely in Metering and Exposure on page 78, but the way in which the aperture and shutter speed are set, and the amount of control you have over them, are governed by the exposure mode to which your camera is set.

With simple or traditional cameras the choice will be limited to perhaps just one or two modes, but modern 35mm SLRs often boast many different exposure modes, some offering the user greater control than others, but all essentially doing the same job. Here's a rundown of the most common modes and how they work.

Program mode

This is a fully automatic mode where the camera sets both the aperture and shutter speed automatically. The choice is made at random, without taking into account the subject or lighting, so it won't always be suitable – thus the camera may set a wide aperture when you want a small one, for example, or a slow shutter speed when in fact you need a fast one.

Many cameras today get round this by offering a program shift facility, which allows you to alter the aperture and shutter speed combination to suit each situation. However program mode tends to be used for snapshots or by complete beginners, and for night and low-light photography, where you usually need a greater degree of control over the camera's setting, it's too automated.

The main exception to this is if you're using a dedicated flashgun. In these situations, the easiest way to ensure correctly exposed flash shots is by setting your camera to program mode so that everything is done automatically – all you have to do is compose the shot, focus and fire away. This is ideal if you're using flash to photograph special events, parties, festivals and so on, as it allows you to concentrate on capturing interesting moments rather than fiddling around with buttons and dials.

Program bias

Taking the idea of program mode a few steps further, these modes – found in a growing number of SLRs and compact cameras – are again fully automatic, but the aperture and shutter speed, along with other functions such as flash and autofocusing mode, are biased to suit particular subjects. When set to action mode, for example, the camera will set a wider aperture and a fast shutter speed to freeze action, whereas in landscape mode a small aperture will be chosen to give plenty of depth-of-field, along with a slower shutter speed.

For night and low-light photography these modes are pretty useless. Again, the only exception is night mode, or slow-sync mode, which many compact cameras have, plus some 35mm SLRs with an integral flash. In this mode the camera automatically sets a slow shutter speed and a burst of flash, so you can take well exposed flash shots in low light – the slow shutter speed helps to record the available light, while the flash illuminates subjects that are

Although fully automatic exposure modes such as program and program bias take much of the control out of your hands, they're ideal for grab shots like this, where you have to act quickly and instinctively if an opportunity isn't to be missed.

at close quarters, such as a person standing in front of a floodlit building at night.

The combination of flash and a slow shutter speed – commonly known as slow-sync flash – is also ideal for taking creative shots of moving subjects. We'll look more closely at these techniques later in the book.

The main thing you need to check with compact cameras is what the slowest available shutter speed is: if it's only 1/2 or 1 second, then you're going to be pretty limited in low light because much longer exposures are usually required, and night mode becomes incapable of living up to its name.

Shutter priority

This is a semi-automatic mode where you decide which shutter speed to set and the camera automatically selects a suitable lens aperture to give correct exposure. Consequently, it tends to be favoured in situations where you need to control subject movement by setting a specific shutter speed – be this a fast shutter speed to freeze fast-moving action, or a slow shutter speed to record subject movement.

For night and low-light photography this mode has its uses – you could set an exposure of 30 seconds when photographing traffic trails, for example, and let the camera decide which aperture to select. Generally, however, it's more useful if you have control over which aperture is set, and the camera is left to sort out the required shutter speed.

Aperture priority

Which is where this mode comes in. Of all the automatic and semi-automatic exposure modes available, aperture priority is by far the most versatile, not only for general use but for night and low-light photography as well. As you've probably guessed by now, with your camera set to aperture priority mode, *you* decide which lens aperture (f/number) to select, and the camera automatically sets the shutter speed/exposure time to give correct exposure. This makes aperture priority handy in low-light situations, for a number of reasons.

Firstly, because *you* decide which lens aperture to set, you have full control over depth-of-field. If you need lots of it to ensure a

scene is recorded in sharp focus from front to back (see picture below), you just set the lens to a small aperture such as f/16 or f/22, while if you want to reduce depth-of-field so that only a limited area in a scene comes out sharply focused you can set the lens to a wide aperture such as f/4 or f/2.8.

As you do this, the camera automatically adjusts the shutter speed to correspond with the aperture you've selected, so if you move from a wide aperture to a small aperture, the camera will select a slower shutter speed, and vice versa. In practice this is highly convenient, because if you need to use the slowest shutter speed possible, all you have to do is set your lens to its smallest aperture – an approach you will encounter many times throughout this book.

Secondly, setting your camera to aperture priority allows you to make full use of its long-exposure capability. All cameras have a specified shutter speed range, which could be as small as 1-1/1000 second, or as big as 30-1/4000 second, sometimes more. In exposure modes such as shutter priority and manual (see below), you can set your camera to any shutter speed within its range. However, in aperture priority mode, where the shutter speed is controlled by the camera, you may find that the range is extended far beyond its lower limit – you may think the longest exposure you can work at automatically is 30 seconds, for example, but find that in aperture priority mode the camera continues exposing for a minute or more – some keep going for 4 or 5 minutes. In low-light situations this can obviously be a great benefit, allowing you effectively to extend the long-exposure range of your camera.

Thirdly, aperture priority is an ideal mode to use with electronic flash for techniques such as slow-sync or fill-in. That's because it's the lens aperture which governs correct flash exposure, not the shutter speed, so being able to control the aperture your lens is set to becomes vitally important.

Aperture priority is a handy exposure mode to use for night and low-light photography as it gives you control over depth-of-field by allowing you to select the lens aperture. In this case, the lens was stopped right down to f/22 so the whole scene was recorded from the statue in the immediate foreground.

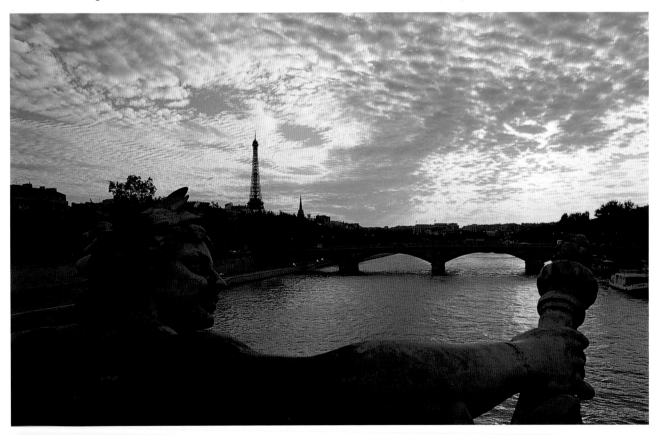

Metered manual

The simplest and most traditional exposure mode of all is manual, where *you* set both the aperture and the shutter speed. An indicator in the viewfinder tells you when the combination you have chosen will give correct exposure. On older or very basic cameras this tends to be a needle with a plus (+) symbol above it and a minus (–) symbol beneath, and correct exposure is achieved when the needle is between the two. On more modern cameras, the indicator tends to consist of either flashing LEDs or an LCD scale.

Although slower to use than all the other exposure modes, manual is the most versatile because it gives you ultimate control. Once the aperture and shutter speed are set, neither will change unless you change them, so the exposure remains the same even if light levels fluctuate or you alter the camera's position. This is particularly useful

If you are using a handheld lightmeter to determine correct exposure, as the photographer did here, manual mode is the one to use as you can then set the required exposure on your camera.

for some low-light subjects, such as traffic trails or fairground rides, where the bright lights moving in the scene could fool automatic exposure modes and give a false meter reading.

In manual mode you can also set an exposure so as to achieve a certain effect, rather than to give 'correct' exposure, whereas in automatic modes such as aperture priority or shutter priority the camera always tries to give correct exposure because that is what it's designed to do. Lastly, if you use a handheld meter rather than your camera's integral metering system – which can be a real advantage/benefit in many low-light situations – you will need to set your camera to manual mode so that the required aperture and shutter speed can be set.

In summary, of all the exposure modes described here, you can see that the two most useful for night and low-light photography are aperture priority and manual. With just these two modes at your disposal, you can tackle any subject or technique with ease.

METERING PATTERNS

In the same way that different exposure modes vary the degree of control you have over the aperture and shutter speed your camera sets, metering patterns control the way in which light levels are measured to determine correct exposure.

There are three main metering patterns now on offer: centre-

weighted average, which is still very common; multi-zone metering, a more intelligent system found in modern SLRs; and spot metering, which is a more specialist option that allows you to take a meter reading from a very specific part of a scene.

All these patterns will be discussed in detail, in Metering and Exposure on page 80. For the benefit of camera choice, however, it's worth saying at this point that you could manage quite happily with either centre-weighted or multi-zone, but having a spot-metering option would be very useful and well worth paying extra for, as you will discover later.

SHUTTER SPEED RANGE

By its very nature, night and low-light photography involves working with lengthy exposures, so when looking at the shutter speed range a camera offers, it's the slower end that counts rather than the top. It's unlikely that you'll ever take a low-light shot in available light at a shutter speed faster than 1/30 or 1/15 second, and more commonly you'll be using exposures of 1 second or more.

Traditional or older SLRs tend to be rather limited in this respect, with the slowest specified shutter speed being only 1 or 2 seconds. However, modern models offer a much greater shutter speed range, often down to 30 seconds or more.

If you're looking to buy a new camera, check this out before making a decision and go for one that offers the longest long exposure capability you can find – the longer it is, the more useful the camera will prove to be.

Modern multi-pattern metering systems make it easier to obtain correct exposure in low-light situations like this, where the tonal range of the scene is fairly average, but be aware of their limitations (see page 80).

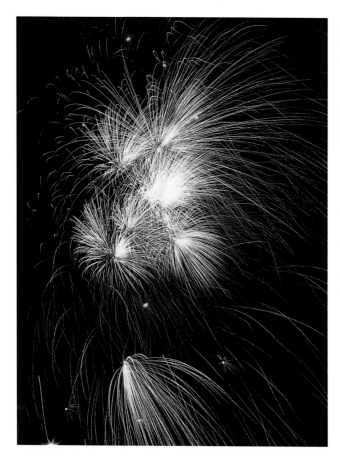

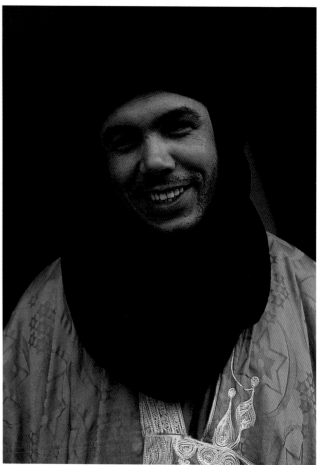

CABLE RELEASE SOCKET

This innocent little feature can easily be overlooked when you're choosing a camera, but for low-light photography its importance cannot be overstated.

When you're using long exposures, a cable release allows you to trigger the camera's shutter release without actually having to touch it. This is useful because no matter how steady you think your hand is, the very act of pressing a finger down on the camera's shutter release button when the camera is on a tripod can be enough to cause vibrations which lead to unsharp pictures.

Check that the camera you have or are thinking of buying has a cable release socket. For decades this feature was provided as standard, but for some reason, certain manufacturers of autofocus 35mm SLRs decided it wasn't necessary and omitted it altogether from some models.

If you are unlucky enough to own one of these cameras, don't worry because attachments are now available from all good camera stores which allow you to use a cable release on cameras that don't actually have the facility for one built in.

EXPOSURE COMPENSATION FACILITY

If you set your camera to manual exposure mode, you have full control over the exposure set. This makes it very quick and easy to override the integral metering system so that you can increase or reduce the exposure to prevent tricky lighting causing exposure error, or to achieve certain creative effects.

When using automatic or semi-automatic exposure modes, however, this isn't so easy. In shutter priority mode, for example,

ABOVE **A bulb (B) facility is essential for low-light subjects such as firework displays and traffic trails, as it allows you to lock your camera's shutter open for as long as you need to. Don't even consider buying a camera without one.**

RIGHT **Your camera's exposure compensation facility is there to help you avoid exposure error in tricky light, so make the most of it. For this portrait of a Tuareg tribesman in Morocco, the metered exposure was reduced by I stop so as to prevent the dark background causing overexposure of the subject's face.**

BULB (B) FACILITY

Another feature all self-respecting low-light photographer's must have is a bulb or 'B' setting, which allows you to hold the camera's shutter open for as long as you need to – seconds or hours.

The vast majority, if not all SLRs – medium- and large-format cameras – have a B setting. A growing number of 35mm compacts are also offering this feature, thus making them far more capable in low-light situations.

The beauty of the B setting is that it opens a whole new world of long-exposure photography. For subjects such as aerial firework displays and traffic trails, it's essential. The same applies to creative techniques such as painting with light or open flash, which we'll explore later on, and for photographing the sky at night, where exposures of 3 or 4 hours are usually required to capture star trails.

If your camera's slow shutter speed capability is limited, the B setting also comes into play in less extreme situations and means that even the simplest cameras can be used for successful night and low light photography

A wide film speed range will allow you to make full use of all film types, from slow to ultra-fast. For this dramatic landscape, captured in the Derbyshire Peak District, ISO400 mono infrared film was used in conjunction with a deep red filter to record a strong IR effect.

every time you adjust the shutter speed, the camera automatically adjusts the aperture setting to maintain 'correct' exposure. Similarly, in aperture priority mode, the camera automatically adjusts the shutter speed if you alter the lens aperture for the very same reason.

To overcome this, the vast majority of cameras that offer such exposure modes also feature an exposure compensation facility. This allows you to override the metering system and bias the exposure to suit a particular situation, or to bracket exposures – take a series of shots of the same subject or scene at different exposures to ensure that at least one is acceptable.

The extent to which you can do this depends on your camera. Traditional SLRs that use dials on the top plate tend to be limited to ± 2 stops of compensation in 1/3 or 1/2 stop increments, while modern electronic cameras offer a much greater range, often as wide as ± 5 stops in 1/3 stop increments; the amount set is displayed on the top plate LCD and sometimes also in the camera's viewfinder.

The way that the exposure is adjusted when you use this facility depends on the exposure mode set. In aperture priority mode, it's the shutter speed that is increased or reduced so the aperture remains constant, whereas in shutter priority mode the aperture setting is adjusted so the shutter speed doesn't change. If you switch to manual exposure mode instead, *you* decide which to adjust: the aperture, shutter speed, or both if so desired. This approach is more limiting with traditional cameras, because you can only adjust the shutter speed in full-stop increments and the aperture in 1/2 stops. Modern electronic SLRs are more versatile, because the shutter speed is adjusted using dials or buttons and can often be adjusted in 1/2 or even 1/3 stops for precise control.

Ultimately, any exposure compensation facility is better than none, but the smaller the adjustment steps available, the more useful it will be.

FILM SPEED RANGE

A wide film speed range is invaluable for both night and low-light photography, as it allows you to take advantage of the full range of films available, from slow to ultra fast.

Traditional manual focus SLRs tend to offer the smallest range, usually from ISO25 or 50 to ISO1000 or 1600, but modern models may go up to ISO6400. It's not essential that your camera can be set to such a high ISO, because 99 per cent of the time you'll probably be using film no faster than ISO1600. However, using ultra-fast films is essential for certain low-light subjects as we'll discover later, so the higher it goes the better. Films are available at ISO3200, and uprating them beyond this to ISO6400 or more is possible (see page 37), so a range from ISO25–6400 would be ideal.

DX-coding is also a common feature on 35mm SLRs and compacts these days. This is a system which sets film speed automatically using a series of pins inside the camera's film chamber: these read a chequered pattern of silver and black squares on the film cassette to find out what the recommended film speed is.

From a convenience point of view, DX-coding is very useful, as it gives you one less thing to think about and prevents you from accidentally setting the wrong film speed, which would result in all the pictures on a roll of film being under- or overexposed. Unfortunately, it does have its limitations if you want to uprate film (see page 37), because unless your camera has a DX-override facility, you will need special DX-recoding labels in order to alter the speed of a roll of film.

VIEWFINDER

Cameras with bright, clear viewfinders are ideal for night and low-light photography, for no other reason than that they make it easier to compose and focus your shots when light levels are poor. Modern SLRs are pretty good in this respect, especially autofocus models which don't require focusing aids such as fresnal screens or split image devices to help the user achieve sharp focus, since both reduce viewfinder brightness.

If your camera's viewfinder is pretty dull, you may be able to improve it by fitting a different focusing screen. Pro-spec cameras usually have this facility as standard, but many others can have different screens fitted by the manufacturer. Clear grid screens are ideal, but they lack focusing aids.

FOCUSING SYSTEM

Over the last ten years, autofocus technology has come on in leaps and bounds, and today's 35mm SLRs are sophisticated, capable machines. Many photographers still balk at the idea of autofocusing, seeing it as something that beginners use. However, for low-light photography it does have its uses.

For a start, modern AF systems are extremely sensitive and highly accurate, so they can focus on objects when light levels are so low you can hardly see them with the naked eye. This is thanks mainly to the use of infrared focusing aids, which shine on the subject you want to photograph and help the lens to focus – to the point that accurate focusing is possible in near or total darkness.

The same applies to many dedicated flash units designed for use with autofocus SLRs. They do exactly the same thing, not only to aid focusing but also to measure flash-to-subject distance to achieve correct exposure when you're taking flash shots in low light.

This facility is not something you're likely to need every day, but it's always handy to know it is there, and that you can use it to take successful photographs as and when required.

Does this technology make good old manual focusing obsolete? Well, to answer that question, take a look at the photographs in this book. Not a single one was taken with the help of autofocusing, so while it can be a great ally, don't feel that you must rush out and buy a new camera if the one you currently have is only manual focus. I certainly didn't, and I have been taking low-light photographs for more years than I care to remember.

BATTERY DEPENDENCY

The more sophisticated that cameras become, the more dependent on batteries they are and the more quickly those batteries will drain – especially if you use an autofocus SLR with integral motordrive or regularly work at long exposures – something that's unavoidable in low light. If this happens when you're on location taking pictures it will put an end to your activities, so it's always a good idea to carry at least one spare set. Outdoors at night, when temperatures can be very low, batteries also drain more quickly than normal, so it's a good idea to keep those spares in a pocket close to your body, so they remain warm.

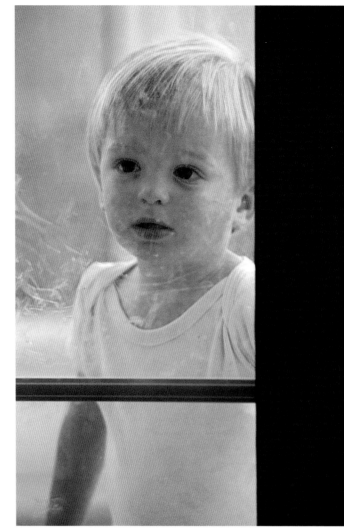

Modern autofocusing systems are better than ever, though you may find that some systems hunt around in low light, or when trying to take pictures through glass. For this shot, I switched to manual focus as the lens insisted on focusing on the dirty window, instead of my son looking through it.

An even better idea, however, is to use a camera that has some level of mechanical back-up. Some traditional manual-focus SLRs have a fully mechanical shutter that doesn't need batteries in order to operate, while some medium-format cameras and all large-format cameras use leaf shutters which are built into the lens rather than the camera body and are usually mechanical. More commonly, many cameras with a battery-dependent shutter have a mechanical B setting, so if all else fails you can at least use that to continue shooting – which you'll be doing anyway in many low-light situations.

The worst contenders are modern autofocus electronic SLRs, which only allow you to access features using buttons and thumb-wheels. The minute the batteries fail, the whole camera shuts down and there ain't a thing you can do about it short of putting in a fresh set of batteries – which is pretty tricky if you're on the top of a hill at 2am trying to photograph star trails!

To avoid problems, find out if your camera has any mechanical back up, and if not, never leave home without spare batteries.

The less battery dependent a camera is, the more reliable it will be, especially when using long exposures outdoors in cold weather – the very conditions that make batteries lose power at a surprising rate.

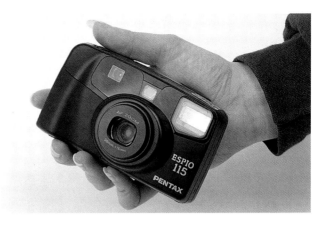

35mm compact cameras are becoming increasingly sophisticated, with many models now boasting a shutter speed range down to several seconds, and a bulb facility for longer exposures. This makes them highly capable for night and low-light pictures (see left). The Pentax Espio 115M shown above has a programmed shutter speed range down to 5 minutes, which is longer than most 35mm SLRs.

MULTIPLE EXPOSURE FACILITY

This feature is usually a button on the camera body which, when depressed, disengages the sprockets in the film advance mechanism so that the shutter can be re-cocked without the film moving, thus allowing you to expose the same frame two or more times.

Though by no means essential, and certainly not important enough to sway your decision between any one camera or another, it can come in handy for some low-light techniques, such as adding the moon to a night scene (see page 152–157), creating special effects, or capturing the same subject several times on a single frame of film.

These techniques can all be practised using different methods, as we will discover later, but there's no denying that a multiple exposure facility makes them far easier.

CAMERA TYPES

Now we've established the features you need to be looking for in a camera that's ideal for night and low-light photography, the next step is to consider what type of camera that might be.

35MM COMPACTS

Traditionally seen as cameras for 'snapshooters' who just want to point and shoot, 35mm compact cameras are becoming more and more sophisticated, so they shouldn't be discounted out of hand – you might be surprised at just how versatile they can be.

The main benefit that compacts offer is their size and simplicity. Being small and relatively light compared to other camera types, they're ideal for slipping into a pocket, so you need never miss the chance to grab a great shot, while their ease of use makes it possible to take pictures quickly, with the minimum of fuss.

These two factors make compacts ideal for parties, for special occasions, and events such as carnivals and processions where you don't want to carry a heavy bag of cameras and lenses, but equally don't want to miss out on any photo opportunities that might arise.

The integral flash unit found in just about all compacts may not be very powerful – subjects must be no more than a couple of metres away to avoid underexposure – but it will enable you to take pictures indoors where light levels are low, or outdoors at night, especially of people having fun.

Modern compacts also offer other features that allow you to be more adventurous. Many models, particularly the more advanced zoom compacts, tend to have a wide film speed range – usually up to ISO1000 or ISO1600. This means you can load fast film and take pictures in low light without the aid of flash.

SLRs are often forbidden at pop concerts, for example, but few people will bother if they see you touting a compact because of the snapshooter reputation they have. However, if it's loaded with fast film and you can get close enough to the stage, it's possible to take high-quality pictures. The same applies in bars, clubs and other low-light environments, where an SLR would get you noticed but the small size of compacts makes them relatively discreet, allowing you to grab candid shots.

Another handy feature offered by many compacts is the night or slow-sync mode mentioned earlier, where a slow shutter speed and a burst of flash are combined so that you can record low-lit backgrounds as well as flash-lit subjects close to the camera.

The main drawback with compacts is the high level of automation, which gives you little or no control over the exposure. It's very rare to find a compact that gives any indication of the aperture and shutter speed set, so usually you just have to cross your fingers and hope for the best. Features like exposure compensation and different exposure modes are also thin on the ground.

35MM SLRS

Of the main types of camera discussed in this chapter, the 35mm SLR (single lens reflex) is by far the best choice for night and low-light photography – and most other areas of photography too.

Offering the perfect compromise between cost, quality, ease of use, and portability, it's the ideal solution to most picture-taking situations, which is why the vast majority of enthusiast photographers make it their first choice every time.

The latest breed of 35mm SLRs are at the cutting edge of photographic technology, offering the most sophisticated metering systems, the very best focusing and the biggest choice of features. There are literally dozens of different models available offering all the essential features outlined earlier and often many more besides, and no matter how big or small your budget, there will be several SLRs that suit you down to the ground.

The range of films available in 35mm is also greater than for any other format, covering speeds from ISO25 to ISO3200 in colour, black and white, print or slide, while the back-up system of lenses, flashguns and accessories from both independent and marque manufacturers is vast. In other words, you really are spoilt for choice, and no matter which badge you choose, be it Canon, Nikon, Pentax, Minolta or any of the others, you won't be left wanting for anything.

If you are in the market for a new 35mm SLR, think carefully before parting with your cash. Check the reviews in photographic magazines, try out a variety of different models at your local photographic store, and take a close look at the features on offer. There are no bad SLRs available these days, but some models at the lower end of the price range won't necessarily offer everything you need for night and low-light photography, or have the build quality to withstand regular use in extreme conditions.

All things considered, a secondhand manual focus model with aperture priority and manual exposure modes, an exposure compensation facility, a decent film speed range and a cable release socket will serve you just as well as the latest all-singing, all-dancing electronic SLRs costing four or five times more that come packed with many features you'll never use.

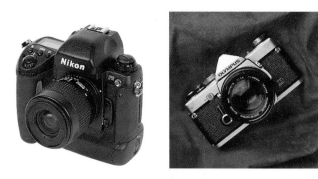

Whether you opt for a traditional, manual SLR like the Olympus OM1 (right), or a sophisticated model like the Nikon F5 (left), will be down to personal preference and the size of your bank balance, but remember that any camera can produce stunning photographs in the hands of a creative and skilled user.

That's not to say you shouldn't tap into the latest technology – much depends on the amount of money you have to spend and whether you are a techno-freak rather than a techno-phobe. I definitely fall into the latter category and have never seen it as a disadvantage, but at the end of the day the choice is yours. The key is not to let your heart rule your head, or to blow all your budget on a camera and then be left with no money for lenses or accessories – at the end of the day, they are more use to you than a camera brimming over with unnecessary features for which you've paid an enormously high price.

For many years I used an Olympus system for 35mm work, based around OM1, OM2n and OM4-Ti cameras: all simple, robust, manual focus SLRs. Today my choice is the Nikon F90x, an autofocus camera that offers all the latest technology and a superb performance. That said, only a fraction of the features available are ever used, and focusing is almost always done manually – even though the F90x has one of the best AF systems around.

MEDIUM-FORMAT CAMERAS

After using 35mm SLRs for a few years, many photographers are tempted by the lure of medium-format camera systems. They cost much more to buy and use, offer less sophistication, fewer features and fewer lenses, but the superior image quality they provide due to the larger film size usually makes up for this.

Medium-format cameras also instil a more considered approach to picture-taking due to their increased size and weight, which makes it virtually essential to use a tripod all the time, plus the increased cost-per-shot which makes users think twice before taking a photograph. In comparison, 35mm film is relatively inexpensive and 35mm SLRs are much easier to handhold, so there's a tendency to fire away without considering for a moment if the end result will be worth the effort and expense.

There's no denying that both these factors can lead to better pictures, but other than that, medium-format cameras don't necessarily offer any benefits over 35mm SLRs when it comes to night and low-light photography. Certainly, in low-light situations where a quick response is required and pictures must be taken handheld, their increased size and weight can be a real drawback, and they only come into their own when mounted on a sturdy tripod.

Levels of sophistication are also much lower on many medium-format cameras as compared to modern 35mm SLRs. One or two

All things considered, the 35mm SLR is the ideal tool for night and low-light photography, providing all the features you need in one compact package, as well as an enormous back-up system of lenses, flashguns and accessories that will allow you to take top-quality pictures in the most demanding situations.

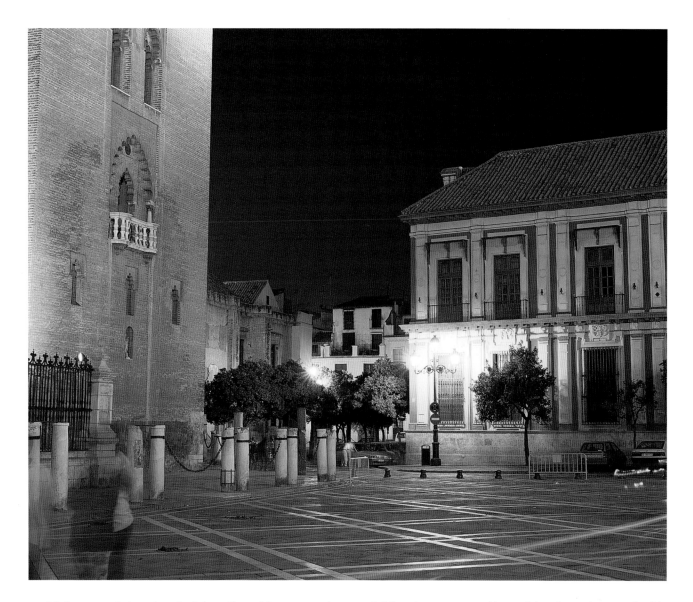

models have recently been launched that offer multi-zone metering and autofocusing, but by and large medium-format cameras come without integral metering unless you spend extra on an optional metering prism – because that's how the majority of medium-format users prefer it. Consequently, you're usually limited to manual exposure mode only, a smaller shutter speed range, and exposure readings have to be taken with a handheld meter. If you're used to the speed and convenience of 35mm SLRs, all this can come as something of a shock. However, you'll soon get used to it, and if you like the idea of a bigger film format and improved image quality, you won't mind overcoming those initial teething troubles.

Another consideration is which medium format to go for, because there are several, all using the same film. The smallest is 6x4.5cm, which gives 15 shots on 120 film. This is a safe choice because the image size is three times bigger than 35mm, but the cameras and lenses aren't much bigger so they're easier to handle. Next comes 6x6cm, a square format that gives 12 shots on 120 film. There's no middle ground here – you'll either love it or hate it. If you're used to the rectangular 3:2 proportions of 35mm, switching to a square picture format can be difficult to get used to; but photographers who do use it wouldn't swap it for anything else.

Moving up we get to 6x7cm, not quite as rectangular as 35mm

or 6x4.5cm, but not square either and therefore easier to work with. For many photographers, 6x7cm is the ideal medium format – you get 10 shots on a roll of 120 film, and the image size is almost five times bigger than 35mm, so quality is superb. Beyond 6x7cm the choice of cameras is limited to just a few models with an image size of 6x8cm or 6x9cm, the latter offering the same 2:3 image proportions as 35mm.

Ultimately, it's all down to how much money you have to spend and what your motives are. The only benefit that medium-format cameras offer over 35mm for night and low-light work is superior image quality; nothing more, nothing less.

ABOVE & RIGHT **Medium-format cameras offer improved image quality over 35mm (see above), but both the equipment and materials are more expensive so weigh up the pros and cons carefully before upgrading. I use a Pentax 67 camera system almost exclusively now, because the greater image size makes my work more saleable, but I enjoy switching back to 35mm whenever possible.**

LARGE-FORMAT CAMERAS

The grand old cameras of yesteryear are still going strong among committed photographers, despite the fact that they're slow to use and require the user to disappear beneath a darkcloth in order to compose and focus an image on the huge focusing screen.

The main benefit of stepping up to large format is one of image quality. A 5x4in sheet of film is 14 times bigger than a 35mm film frame, so if you enlarge both images to the same size, the larger format is obviously going to exhibit superior sharpness and clarity.

There are other advantages. The shutter is in the lens rather than the camera body, so it's easy to produce double or multiple exposures with a large-format camera: you just re-cock the shutter and leave the same sheet of film in the camera. And if you want to produce complicated multiple exposures, guide marks can be drawn on to the focusing screen using either a Chinagraph pencil or non-permanent marker so you don't accidentally overlap features.

The position of the lens in relation to the film plane can also be altered using what's known as 'camera movements'. You can move the lens up (rising-front), down (drop-front) and tilt the lens panel up, down, or side-to-side. This facility enables you to increase or reduce depth-of-field without changing the lens aperture, but more useful is the fact that you can control perspective. By using rising-front, so the lens is raised, for example, you can combat converging verticals. This is a common problem when photographing buildings from close range with a wide-angle lens, because you normally have to tilt the camera back to include the top of the building, and doing so causes the vertical sides of that building to lean inwards. With a large-format camera you keep the camera back perfectly square to the building, then simply raise the lens to get the top of it in the shot, without the sides converging.

This latter feature can be particularly useful if you specialise in photographing buildings at night, but there's a price to pay for it. Material and equipment costs are high for a start. The cameras are also very basic, lacking integral metering – or much else for that matter. You don't actually need anything more than this in order to take successful low-light photographs, but unless you really do want the improved image quality, or have the facility to use camera movements, there isn't much point in changing formats.

ADVANCED PHOTO SYSTEM (APS)

In the last few years a completely new film format, known as APS, has been launched to rival 35mm, and is increasing in popularity at a rate of knots.

The main aim of APS is to make picture-taking easier than ever before, so at present it's aimed mainly at the snapshot end of the market rather than at serious enthusiasts. That's set to change, however, because as well as the dozens of APS compact cameras available with prices and features to suit all needs, there's also a small selection of APS SLRs on the market that accept interchangeable lenses.

The APS film format is smaller than 35mm – images measure

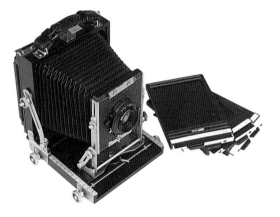

ABOVE **This is my 5x4in field camera, a lightweight Woodman model that folds down for easy carrying. Film is loaded into the darkslides shown, each carrying two sheets.**

RIGHT **Large-format cameras offer ultimate image quality as well as other benefits such as movements, but you have to be really dedicated to cart one around if the large image size isn't vitally important, and the slow operation makes them unsuitable for many low-light subject landscapes and architecture being notable exceptions.**

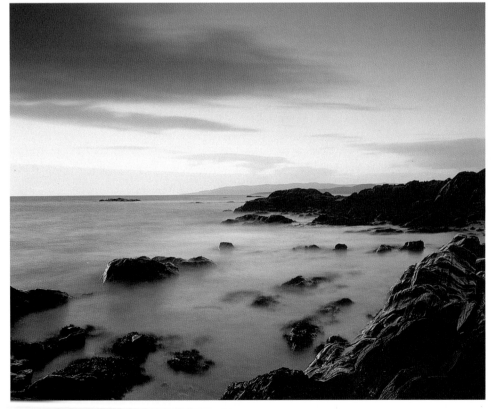

just 17x24mm compared to 35mm's 24x36mm. This means that image quality isn't quite as high, but APS cameras are generally smaller – some compacts are now available that are no bigger than a cigarette packet, making them incredibly portable.

More significantly, APS film offers the user a choice of three different picture sizes which can be selected mid-roll: Classic, from which you get a standard 6x4in enprint; HDTV, from which you get a 7x4in print; and Panoramic, from which a 10x4in print is produced. The vast majority of APS cameras also have a facility which allows you to add information to each shot, including the time and date, as well as a wide selection of messages or greetings such as Happy Birthday, Congratulations, I Love You and so on.

Further benefits include easy loading – the film is inside a cartridge rather than a cassette – plus magnetic strips along the edges of the film which store information about the use of things like electronic flash when you take a picture, to help the processing lab ensure that the best-quality prints are produced. Also, when your film is processed, as well as getting a set of prints you also receive an Index Print which contains a thumbnail image from each negative to make filing and retrieving images much easier, and to aid the ordering of reprints. Convenience is definitely the order of the day.

Unfortunately, this convenience comes at a price. Although the cameras are getting better all the time, 35mm still has the edge over APS and always will do from a quality point of view, simply because the film format is bigger. The choice of film is also far greater for 35mm at the moment, though this is likely to change in the future as demand increases.

If you're interested in buying a compact camera, it's definitely worth checking out APS alongside 35mm, as you'll get a similar range of features for the same money, as well as the added benefits/gimmicks (delete as you see fit) that APS has to offer. When it comes to SLRs, though, 35mm is streets ahead, and it will be a long time before APS SLRs pose any kind of threat in the market for the serious enthusiast or the professional.

DIGITAL CAMERAS

Even more revolutionary, and quite scary if your interest in photography is firmly rooted in silver-based materials, is the advent of digital camera technology. This has actually been around for some years on a professional level, but digital cameras are now available for a similar price to a top-of-the-range compact camera, and as technology improves, prices seem to be falling.

The obvious benefit of a digital camera is that it allows you to take photographs without film. These are stored in the camera's internal memory, or more commonly on removable memory cards so that you can replace a full card with an empty one and continue shooting. Once you're back home, the images are then downloaded on to a computer for storage and printing out on an inkjet printer. With suitable software you can also manipulate the images in any way you see fit, removing distracting elements, combining more than one image and so on.

Unfortunately, like anything new, digital cameras still have a long way to go before serious photographers are encouraged away from film-based picture-taking. Technology is good, with cameras offering mega-pixel resolution now available at affordable prices, but they need to get a lot better yet to rival the quality you can produce from a sharp, well-exposed negative or transparency. There's also the additional outlay on a computer and inkjet printer if you don't already have one, and the total price for a digital imaging system

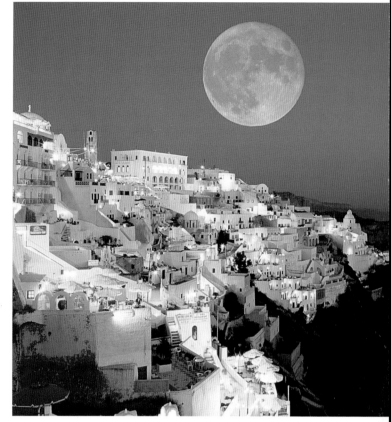

ABOVE & BELOW **Digital cameras like the Olympus Camedia C-1400L offer mega-pixel resolution and produce high-quality images, but you don't have to buy a digital camera to experiment with digital imaging techniques. This image started life as two separate colour transparencies – the night scene and the moon – which were scanned into a computer, then combined and re-sized using Adobe Photoshop software.**

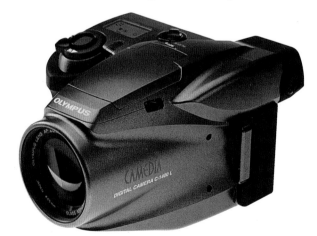

capable of average results can quickly exceed that of a top-quality 35mm SLR with a couple of zoom lenses.

Given the rate at which digital camera technology has advanced over the last two or three years, this will no doubt change. But for now at least, if you're excited by the creative possibilities digital imaging offers, a better bet is to have high-resolution scans made from existing photographs so that you can manipulate them on your computer. That's what the vast majority of photographers are doing, as it gives them the best of both worlds.

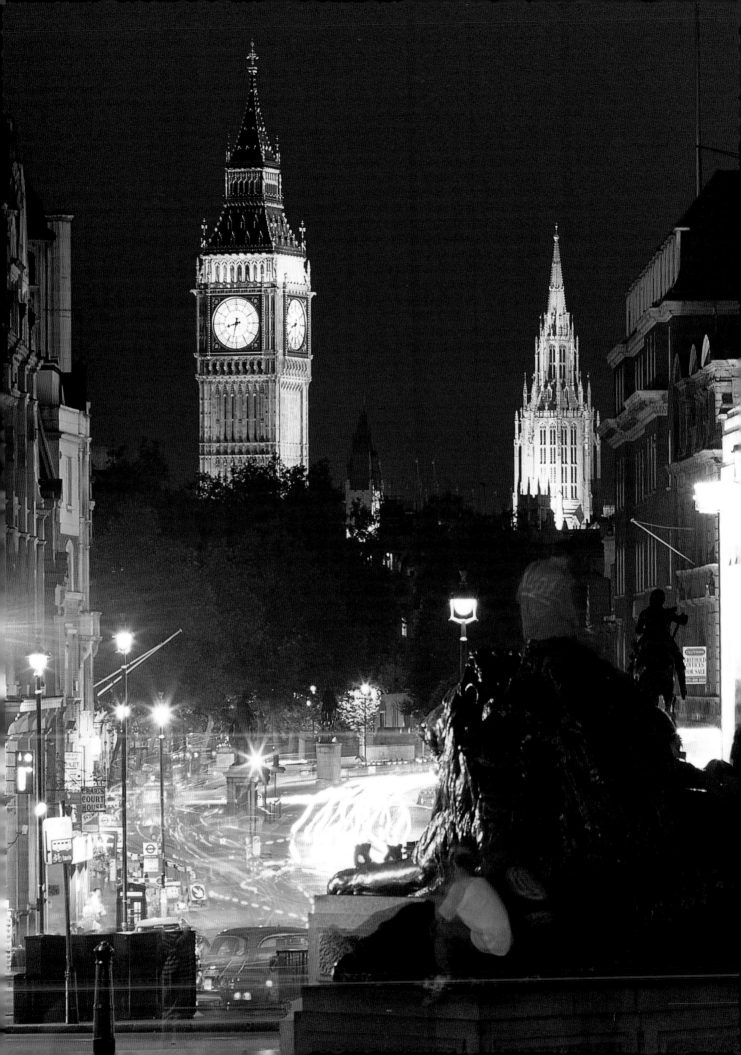

LENSES

The lenses you use for night and low-light photography will depend very much on the subject you're photographing or the effect you're trying to achieve, but suffice to say there are no specialist requirements. Chances are that the range of lenses you already have will be more than adequate – the vast majority of pictures in this book were taken with focal lengths of 28–200mm, and only in exceptional cases was anything longer or wider needed.

These lenses were also a mixture of prime and zoom, camera-maker's own and independent, which illustrates, if nothing else, that in capable hands any make or type of lens can be used to produce great low-light photographs.

PRIME OR ZOOM?

The debate about whether prime (fixed focal length) lenses are any better than zooms has raged for years, and will no doubt continue to do so. In reality, however, optical technology has reached such levels today that you can rarely see an obvious difference in quality between the two, unless you compare a bargain-basement zoom lens with a top-notch camera-maker's own prime lens and even then the difference is unlikely to be staggering unless you blow up the pictures taken with both to huge sizes.

So, the decision to use one or the other should be based on your own needs and preferences, and the budget at your disposal, rather than the opinions of a bunch of stubborn photographers who refuse to move with the times. Certainly, in the last five years many professional photographers have made the switch to zoom lenses after many years of working exclusively with prime lenses, and few have anything to complain about, myself included – I use both 80–200mm and 18–35mm zooms for low-light photography.

If you look at things from the point of view of convenience, then zoom lenses have a lot to commend them. By investing in just two separate lenses, such as a 28–80mm and an 80–200mm, you will have a focal length range broad enough to cover the vast majority of night and low-light situations. This combination would replace five popular prime lenses – 28mm, 50mm, 85mm, 135mm and 200mm – but cost far less and be lighter and more compact to carry.

And let's not forget the compositional benefits of zoom lenses, which allow you to make tiny adjustments to focal length so that you can crop out unwanted detail or empty space and take tightly framed pictures. Zooms also allow you to produce eye-catching special effect shots of things like neon signs and illuminations, something you won't be able to do with a prime lens (see below).

The downside of zooms is that they're usually bigger and much heavier than individual prime lenses, particularly at the wider end of the focal length range. A 28mm wide-angle is generally smaller and lighter than a 28–80mm zoom, for example, so it will be easier to handhold at slow shutter speeds without your pictures suffering from camera shake.

Prime lenses also tend to be faster than zooms. The average maximum aperture for a 28mm wide-angle lens is f/2.8, whereas it's going to be f/3.5–4.5 for a 28–80mm zoom, unless you pay more for a faster zoom. But, as explained earlier, this will only be a problem if you need to take pictures handheld in low light, with the lens at its maximum aperture to give the fastest possible shutter speed, and in most low-light situations a tripod will be required anyway. Also the difference in viewfinder brightness a faster lens gives is unlikely to be a huge benefit for low-light photography, unless you're taking pictures in the dimmest conditions.

At the end of the day, it's a case of you pays your money and you makes your choice, but given the quality of modern lenses, prime or zoom, you are unlikely to be disappointed – no matter which route you take.

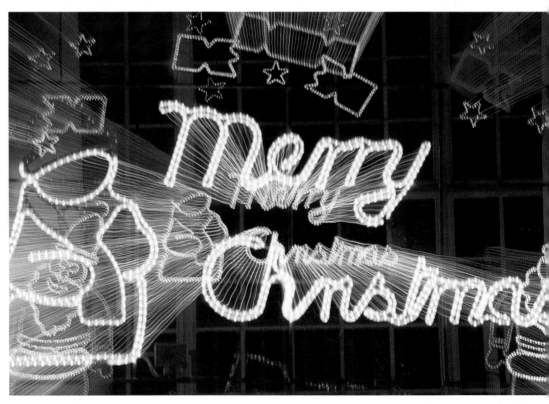

LEFT **Choosing the best lens for the job is a decision that you will have to make every time you encounter an interesting low-light scene. For this shot of London's Big Ben, a 135mm short telephoto lens was used to produce a compressed perspective so that the main elements were all pulled together in a tight, frame-filling composition.**

RIGHT **An obvious benefit of zooms over prime lenses is that they can be used to create interesting 'zoomed' effects by adjusting focal length during exposure. An 80–200mm telezoom was used for this shot of a festive illuminated sign, with an exposure of 10 seconds at f/11.**

LENS SPEED – IS IT IMPORTANT?

Lenses are often referred to not only in terms of their focal length, but also in terms of their speed. Thus you may come across the phrases 'fast' telephoto or 'slow' zoom. What this refers to is the maximum aperture of the lens in relation to its focal length – if it's wide, then the lens is said to be 'fast' because it has greater light-gathering power than a lens of the same focal length with a smaller maximum aperture; on the other hand, a 'slow' lens has a smaller-than-average maximum aperture for its focal length.

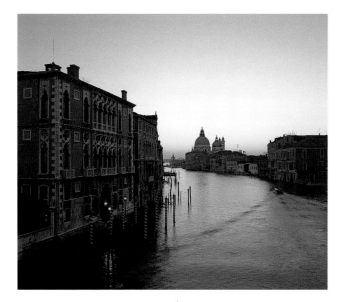

To give you a few examples: a 50mm standard lens normally has a maximum aperture of f/1.8 or f/2, so an f/1.4 or f/1.2 model is considered to be a fast standard lens. A 300mm telephoto normally has a maximum aperture of f/4 or f/4.5, so one with a maximum aperture of f/2.8 is a fast 300mm. An 80–200mm f/2.8 zoom, a 200mm f/2, a 400mm f/4 and a 600mm f/5.6 also fall into the same category. A 500mm f/8 lens, on the other hand, would be considered slow, as would a 300mm f/5.6, or an 80–200mm f/4–5.6 zoom.

In the case of a zoom lens, the main benefit a fast lens offers over a slow one with the same focal length or focal length range is that you get a brighter viewfinder image, which aids composition and focusing in low light, but more importantly, it allows you to use faster shutter speeds or smaller apertures. If you were using an 80–200mm f/2.8 zoom alongside an 80–200mm f/4–5.6 zoom, both set to 200mm, for example, and the f/2.8 lens would allow you to set a shutter speed of 1/500 second, the f/4–5.6 model would be limited to 1/125 second with the same speed film in the same light. Alternatively, with the f/2.8 lens set to f/16, the f/4-5.6 model would be limited to an aperture 2 stops wider – f/8 in this example – if both were used at the same shutter speed.

It's the ability to use faster shutter speeds which really make fast lenses attractive – which is why professional sports photographers use them – the difference between 1/500 second and 1/125 second can be huge if you're trying to freeze a fast-moving subject and your lens is already set to its widest aperture.

The drawback is that you pay a premium price for fast lenses, so you have to weigh up the benefits they offer for low-light photography against the cost. At the time of going to print a Nikon 50mm f/1.8 standard lens costs £130, against £480 for the f/1.4 version and £600 for the f/1.2, which basically equates to £350 for an extra stop or £470 for an extra 2 stops. As focal length increases, so the

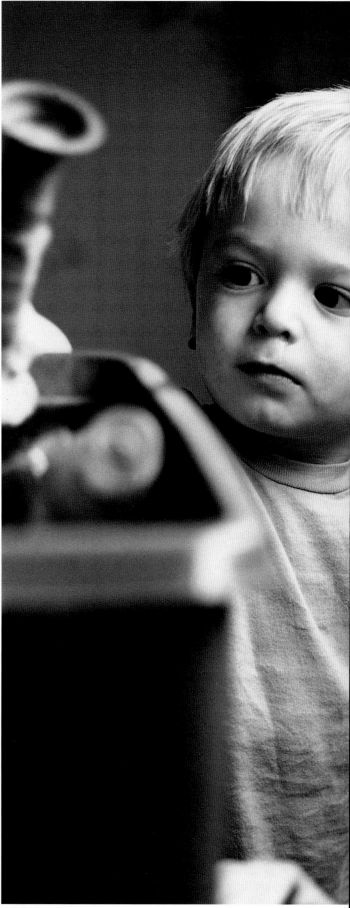

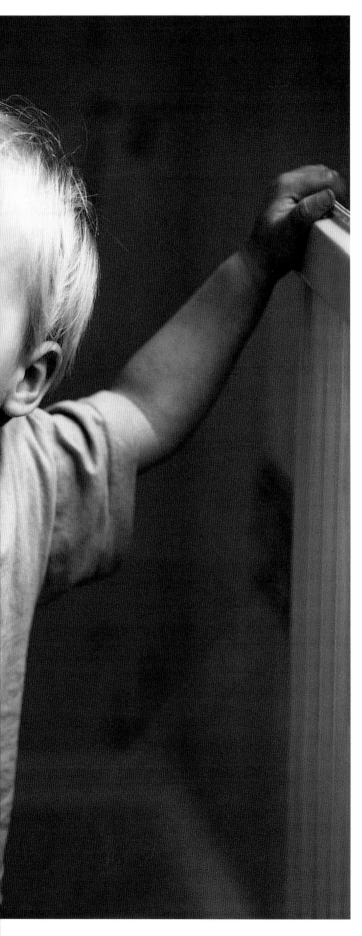

prices become even higher. A Nikon AF 300mm f/4 telephoto currently retails at £1,260, while the Nikon AF 300mm f/2.8 would set you back £4,500. That's £3,240 for an extra stop. Similarly, a Nikon AF 80–200mm f/4.5–5.6 zoom costs £180, while the 80–200mm f/2.8 costs £900: a difference of £720 for an extra stop at the lower end of the focal length range and 2 stops at the upper end.

If your idea of low-light photography is to walk around taking pictures handheld with your lens set to its widest aperture, then fast lenses will be a real boon, allowing you to work at faster shutter speeds or to use slow-speed film. However, if you are more likely to mount your camera on a tripod and be working at moderate to small apertures, then having a faster lens will offer you nothing other than a brighter viewfinder image, which is handy but not worth the kind of additional outlay mentioned above.

Remember, also, that using faster film will have exactly the same effect on shutter speed choice as using a faster lens. If you use a 300mm f/4 telephoto lens with ISO100 film in your camera, you will be able to use the same shutter speed at maximum aperture (f/4) as you would with a 300mm f/2.8 lens at maximum aperture and ISO50 film. The main difference is that it costs next to nothing to buy film that's a stop faster compared to buying a lens that's a stop faster – you would have to use literally hundreds of rolls of faster film for the costs to level out.

OK, by using faster film you are sacrificing image quality. But the difference between ISO50 and ISO100, or ISO100 and ISO200 will be marginal, and certainly not worth worrying about. The only fast lens I use for low-light photography is an 80–200mm f/2.8 zoom, but all my other lenses have a moderate maximum aperture, including a 28mm f/2.8, a 50mm f/1.8 and a 300mm f/4.

FAR LEFT **Most night and low-light pictures are taken using small lens apertures to maximise depth-of-field, so the need for 'fast' lenses with a wide maximum aperture becomes less important. This scene along the Grand Canal in Venice was taken using a 55mm wide-angle lens on a Pentax 67 camera, with an exposure of 15 seconds at f/16.**

LEFT **Fast lenses are invaluable if you need to take handheld pictures in low light, but wish to keep film speed as low as possible. For this grab shot of my son, an 80–200mm f/2.8 zoom was used wide open at f/2.8 so that a shutter speed of 1/60 second could be used with ISO400 film. A typical zoom lens covering this focal length range has a maximum aperture which is 2 stops slower, so in the same situation, ISO1600 film would have been required to maintain the same shutter speed.**

RIGHT **Its small size, low weight and wide maximum aperture makes the 50mm standard lens ideal for taking handheld pictures in poor light, both indoors and out. This architectural detail was photographed just before sunset with a 50mm f/1.8 lens at maximum aperture, giving a shutter speed of 1/30 second on ISO100 film.**

WHICH FOCAL LENGTH?

For most night and low-light situations, a range of lenses covering focal lengths of 28–200mm will be more than adequate, and it's only specialist applications such as photographing the moon or shooting cramped interiors where something longer or wider comes in handy.

Wide-angle lenses are likely to prove the most useful of all, not only because they allow you to include more in a picture, but also because they exaggerate perspective, allowing you to produce dynamic compositions. Wides also give extensive depth-of-field, so you can record everything in sharp focus – the wider the lens is, the more depth-of-field you get for any given aperture. Many of the pictures in this book were taken with a 28mm wide-angle on 35mm, or its equivalent in larger formats (see panel) as I find the angle of view so versatile. I use it for street scenes, floodlit buildings, traffic trails, low-light landscapes, building interiors, illuminations and any other subject where a broad view is required. To maximise depth-of-field, set the lens to its smallest aperture – usually f/22. This will allow you to capture everything in sharp focus, from less than 1m (3ft) to infinity if you use the hyperfocal focusing technique (see Focusing in low light on page 26).

Telephoto lenses are a better choice if you want to isolate small details in a scene, such as a distant building that's floodlit, the setting sun or a neon sign – the longer the focal length, the greater the magnification. Teles are also invaluable for candids and portraits in low light, or in still-life studies and interior details. Obviously, they are bigger and heavier than wide-angle lenses, so the need to use a tripod in low light is increased considerably if you want to avoid camera shake, or to load up with faster film. Depth-of-field is also reduced, so less of the scene will be recorded in sharp focus. Stopping right down to minimum aperture – often f/32 with telephoto lenses – will help to overcome this. Alternatively, shoot at a wide aperture such as f/4 or f/5.6, so that only your main subject is recorded in sharp focus and the background is blurred. Then you can also use a faster shutter speed.

Finally, telephoto lenses compress perspective, so the elements in a scene appear closer together than they are in reality. This characteristic is ideal for shots of busy streets at night, rows of houses, electricity pylons at sunset and so on, as it makes the elements in a scene seem crowded together and so produce powerful pictures.

LENS FOCAL LENGTH/FORMAT COMPARISON

This table shows how lens focal length in different camera formats compares to 35mm lenses.

	LENS TYPE				
Format	Ultra-wide	Wide-angle	Standard	Short tele	Long tele
35mm	20mm	28mm	50mm	100mm	300mm
6x4.5cm	35mm	50mm	75mm	150mm	500mm
6x6cm	40mm	50mm	80mm	150mm	500mm
6x7cm	45mm	55mm	90mm	180mm	600mm
5x4inch	60mm	90mm	150mm	300mm	800mm

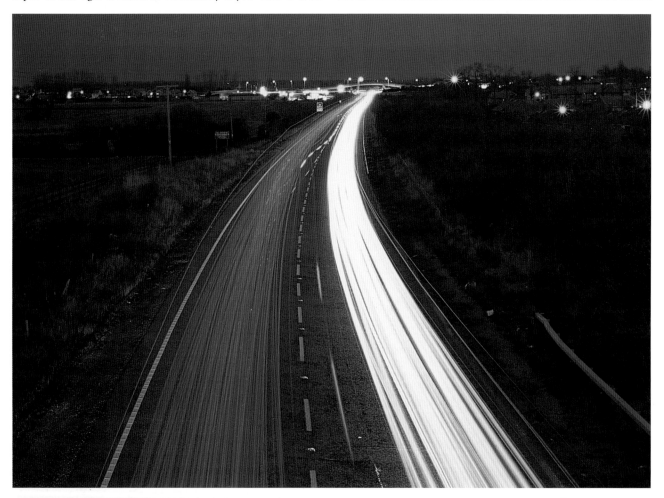

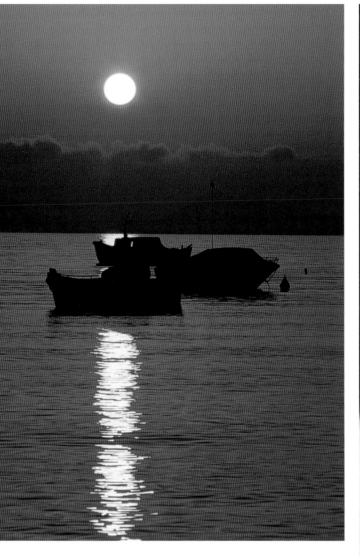

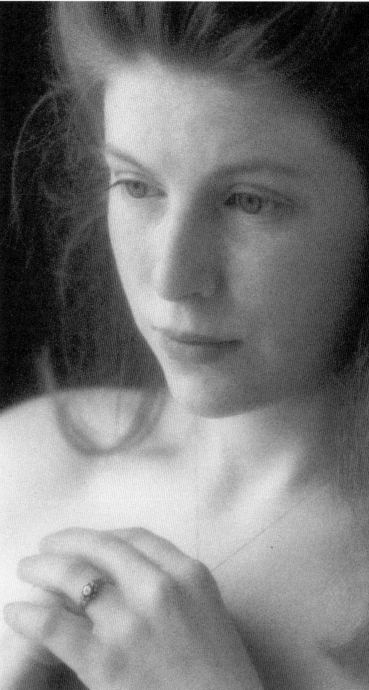

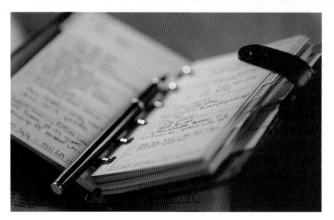

ABOVE **Telephoto lenses and telezoom lenses come into their own when you want to isolate a small part of a scene, or increase the size of the sun's orb when shooting the sunrise or sunset. Here a 200mm lens was used to capture the boats in silhouette, with the sun rising majestically into the sky behind them.**

ABOVE RIGHT **A short telephoto lens with a focal length of 85–135mm is perfect for portraiture, because it compresses perspective slightly and so flatters facial features. For this romantic window-lit portrait, an 85mm f/2 lens was used.**

LEFT **Wide-angle lenses are ideal for photographing night scenes out-doors, allowing you to include large areas in the frame and produce dynamic compositions by 'stretching' perspective. This traffic trail shot was taken with a 28mm lens, my favourite focal length, and using an exposure of 2 minutes at f/22.**

RIGHT **Creative use of depth-of-field can make a big difference to the impact of an image. For this still-life of an open FiloFax, photographed in the light of a tungsten reading lamp, I used a 105mm f/2.8 lens at f/2.8, so depth-of-field was minimised. Doing so has added a sense of intrigue to the picture by throwing the names and addresses out of focus so that you can't read them.**

TELECONVERTERS

Long telephoto lenses are ideal for shots of the moon, or the rising and setting sun, because the longer the focal length is, the bigger the moon or the sun's orb will be. Unfortunately, they are also expensive compared to more moderate focal lengths, so unless you need one for other subjects and are likely to use it on a regular basis, the high cost becomes really prohibitive.

Fortunately there is a solution and that is to use a teleconverter. This handy accessory fits between the camera body and the lens, and multiplies the focal length of that lens. The most popular type is a 2x teleconverter, which doubles focal length – turning a 200mm lens into a 400mm, or a 75–300mm zoom into a 150–600mm. You can also buy 1.4x teleconverters, which increase focal length by 40 per cent. In both cases, the minimum focusing distance of the lens remains unchanged.

The main drawback with teleconverters is that they lose light – 2 stops for a 2x and 1 stop for a 1.4x – which means you have to use slower shutter speeds or faster film. They also reduce image quality slightly, especially budget-priced models. However, if you are using your camera on a tripod, as you almost certainly will be for telephoto shots in low light, this light loss needn't limit you in any way. The loss of image quality can also be minimised by choosing a high-quality teleconverter, using it on fixed focal length lenses rather than zooms and working at an aperture of f/8 or f/11, which tends to give the sharpest results.

FOCUSING IN LOW LIGHT

Making sure your lens is sharply focused when taking pictures in low light can be tricky if you are using a manual focus camera, especially if it has a rather dim viewfinder.

To help overcome this, give your eyes the chance to adapt when you peer through the viewfinder: if you wait a few seconds, you should notice that the viewfinder image becomes brighter as your pupils dilate to take in more light. With close-range subjects you could always shine a torch and focus on the area it illuminates. For more distant subjects, look for something a similar distance away that's brighter or in better light and use it as a focusing guide.

With wide-angle lenses, the need to focus accurately is less important because you have greater depth-of-field to play with. In fact, it's possible to focus without even looking through the viewfinder by using a technique known as hyperfocal focusing.

To do this, focus your lens on infinity and check the depth-of-field scale on the barrel to see what the nearest point of sharp focus will be at the aperture you're using. This is the hyperfocal distance. Next, focus the lens on the hyperfocal distance, and depth-of-field will extend from half the hyperfocal distance to infinity.

Autofocus cameras and lenses cope better with low light. The latest systems are very sensitive and can focus accurately in the dimmest situations, where an exposure of 2 minutes or more at f/11 would be required on ISO100 film. Some also use an infrared beam to aid focusing in almost total darkness.

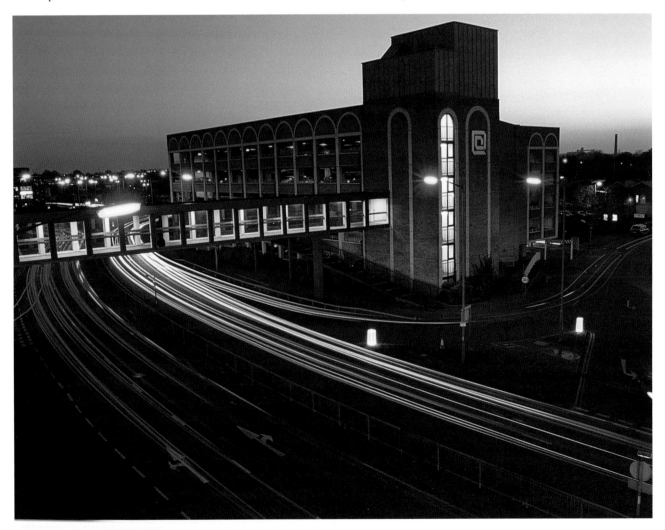

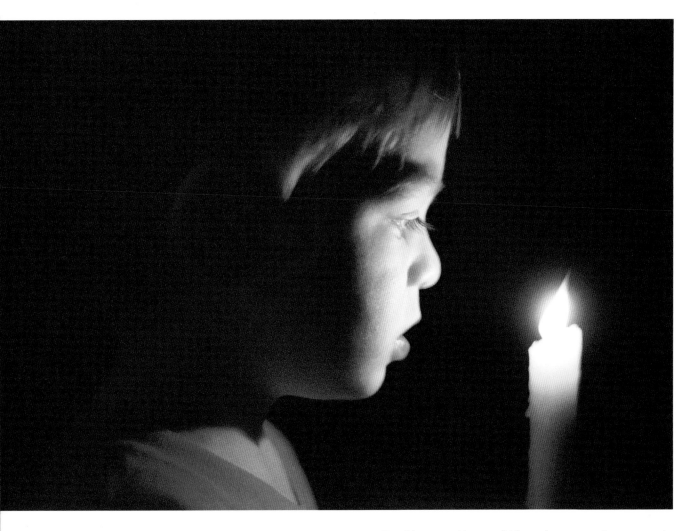

ABOVE **Modern autofocus systems in 35mm SLRs are incredibly sensitive, and can focus quickly and accurately in the lowest of light – even that provided by a single candle.**

LEFT **When using a wide-angle lens to photograph night and low-light scenes, accurate focusing is not important at apertures of f/11 or smaller because depth-of-field will be so great. Often, you will also find that the lens needs to be focused on infinity if everything in the scene is more than a few metres away, as it was for this picture, taken from the roof of a multi-storey carpark.**

RIGHT **Keeping your lenses and filters clean will reduce the risk of flare, and minimise its effects if you find you can't avoid it – which may well be the case when shooting directly into the sun, as here.**

CARING FOR YOUR LENSES

The bright lights that often appear in low-light and night scenes can cause flare, which reduces image contrast, washes out colours and often creates ghostly light patches on your pictures.

Using a lens hood to shield the front element of your lens from stray light will certainly help to reduce the risk of flare, but it's also vitally important that you keep your lenses, and any filters which you use on them, as clean as possible. Dust and greasy fingerprints or smears can increase the likelihood of flare, as can scratches on your lenses and filters.

For this reason, it's a good idea to keep protective caps on the front of your lenses when they're not in use, and an even better one to place a clear skylight of ultraviolet filter on each lens so that the front element is protected from damage – it's far safer to clean a dirty filter than a dirty lens, and far cheaper to replace a scratched filter than a scratched lens.

If you need to clean your lenses, you should do so very carefully. Use a blast of canned air or an anti-static brush to remove the dust and dirt particles, before wiping away any smears with a micro-fibre cloth – this sort won't scratch the delicate multi-coating on the front element of the lens.

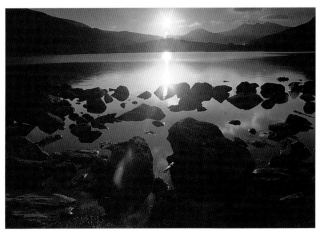

FILMS

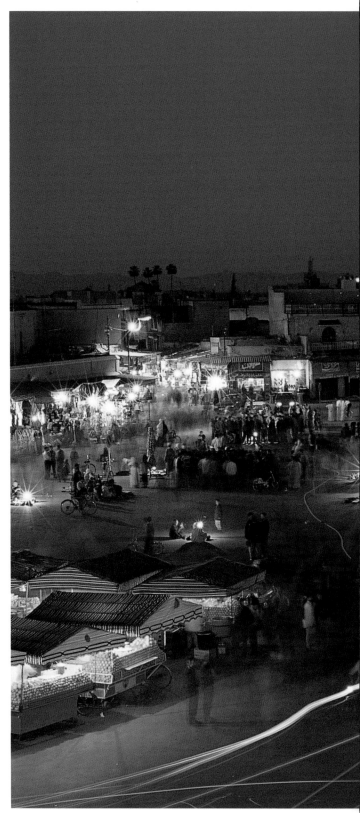

The type of film you decide to use for night and low-light photography depends mainly on the subject that you are photographing and the effect you are trying to achieve. Fortunately there are now so many films available in different brands and speeds, in colour or black and white, and for prints or slides, that photographers have never had it so good, and no matter what your needs might be, you can guarantee there will be at least one film that will satisfy them.

Film technology has also advanced incredibly over the last decade, especially at the higher end of the ISO range, so whichever film you use, you can guarantee top-quality results. This is particularly good news for night and low-light photography, where pictures are often taken in extreme conditions and film is pushed to the very limit of its capabilities.

FILM SPEED

The main mistake that photographers tend to make when selecting film for low-light work is to assume that they must use fast film (film with a high ISO rating) because it's more sensitive to light and allows shorter exposures to be used. However, while this approach may be necessary in some situations, it should by no means be taken as standard practice, because by doing so you will compromise the quality of your pictures when there is no need to do so.

The reason for this is because film 'speed' is directly related to image quality. Generally, 'slow' films with a low ISO rating (100 or less) need to be exposed for longer because they are less sensitive to light, but in return they give you pictures with finer grain, a higher degree of sharpness, better contrast and stronger colours. In other words, the slower the film is, the better the quality tends to be.

As film speed increases and the ISO rating gets higher, exposures become shorter because the film is more sensitive to light. Unfortunately, nothing comes without a price in photography, and in being more sensitive, fast film delivers pictures which exhibit coarser grain, a drop in sharpness and the ability to resolve fine detail, poorer shadow density and weaker colours.

The key to choosing film, and not only for night and low-light photography but for any subject or situation, is therefore to keep it as slow as you possibly can, so that image quality is optimised but the film's insensitivity to light doesn't cause further problems.

SLOW FILM (ISO100 OR LESS)

The slowest films available, from ISO25, produce the sharpest, most vibrant images of all, so whenever possible you should stick to this film speed range.

The main drawback with using slow film in low-light situations is that it requires long exposures to record an image – often many seconds or minutes rather than fractions of a second. But if your subject is static, such as a building or a landscape scene, and your camera is mounted on a sturdy tripod to keep it perfectly still so that the risk of camera shake is eliminated, long exposures needn't be a problem – in which case you might as well take advantage of the benefits that slow film offers.

Long exposures can also be an ally in some situations as they allow you to record movement in night or low-light scenes, such as when photographing traffic trails, aerial firework displays or the sky at night – subjects that are covered in detail later in the book. There is a wide range of slow-speed films available from all the major film manufacturers. The majority have an ISO rating of 100 as this tends to be the most popular choice among photographers, but ISO25, ISO50 and ISO64 films are also available.

The film or films you choose depend on personal preference.

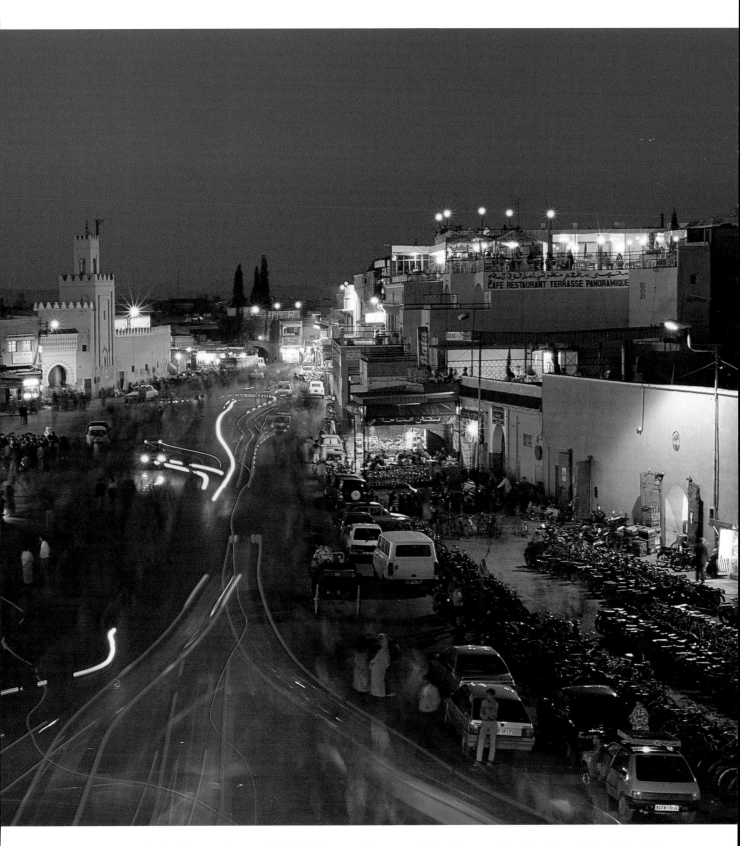

Most of the pictures in this book were taken on ISO50 Fujichrome Velvia colour slide film, which is renowned for its superb sharpness, near-invisible grain and amazingly rich colour rendition, but slow films from Kodak, Agfa and Konica, as well as other films in the Fuji range, are well worth trying out.

If you want ultimate image quality when photographing night and low-light scenes, nothing beats slow-speed film. I use ISO50 Fujichrome Velvia slide film whenever possible. It is, quite simply, superb, as you can see from this shot of the Djemma el Fna in Marrakech, Morocco which I captured from the roof of my hotel using a Nikon F90X and 28mm lens.

MEDIUM-SPEED FILM (ISO200–400)

Films in this category tend to offer neither one thing nor the other for night and low-light photography in the available light. The extra speed offered over slower films isn't enough to make a huge difference to exposures, so a tripod will still be required in order to prevent camera shake, and if your subject is moving it will still come out blurred.

One advantage they do offer, however, is in making your electronic flashgun more effective, so that you can capture subjects that are further away from the camera or use a smaller lens aperture to give greater depth-of-field. If you use ISO400 film instead of ISO100, for example, the flash-to-subject distance will double, or you can set your lens aperture to an f/number 2 stops smaller (f/16 instead of f/8, say) for the same flash-to-subject distance.

This factor is well worth considering if you want to take pictures with flash in low-light situations such as at barbecues or parties outdoors at night – especially if you intend using your camera's integral flash unit, which tends to be relatively low-powered.

Where light levels aren't too low, the extra speed can also come in handy – to provide a faster shutter speed when shooting windowlight portraits, for example, and prevent slight subject movement taking the edge off the sharpness of your pictures.

Medium-speed films don't offer quite the same quality as slow

Medium-speed film is ideal for taking handheld pictures indoors, where flash would ruin the ambience of the available light. This amusing candid was captured at a wedding reception using a 75–300mm zoom lens at its maximum focal length, with a shutter speed of just 1/30 second. I kept the camera steady by resting my elbows on a tabletop.

films, but these days the difference is comparatively small and not worth worrying about.

FAST FILM (ISO400–800)

This category of film comes into its own in situations where light levels are too low for slow film but high enough for you not to need the fastest film available in order to take a decent photograph. They won't allow you to handhold the camera while shooting moonlit landscapes, but what they can do is make it easier to capture the atmosphere of available light in situations where a tripod can't be used or would get in the way.

If you're shooting fast-moving sport on a dull day for example, ISO400 film will provide shutter speeds that are high enough to

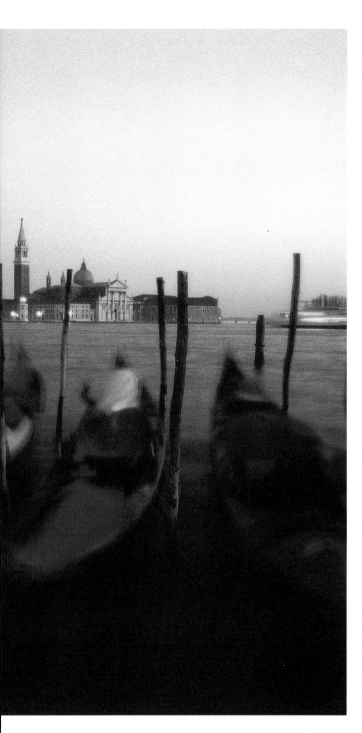

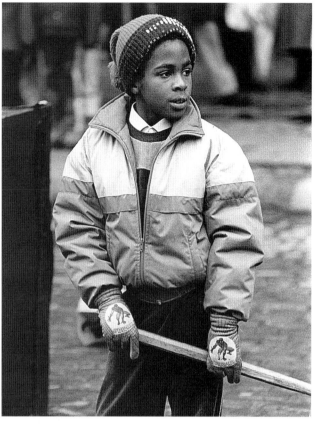

ABOVE **Fast film around ISO400 is ideal for general use if you enjoy shooting candids or reportage-style pictures of people, allowing hand-held pictures to be taken in poor light without fear of camera shake. Ilford HP5 was used for this shot, taken in London's Covent Garden.**

LEFT **Fast film shows a marked increase in grain size compared to slower brands, but in some situations it's a small price to pay for the benefits on offer. For this shot taken in Venice, ISO400 film enabled the photographer to use a shutter speed fast enough to minimise blur in the gondolas in the foreground, despite the low light levels. Slower film would have given improved image quality, but necessitated an exposure so long that the gondolas would have blurred beyond recognition.**

freeze the action. You can also use it to take handheld portraits in failing daylight or windowlight, or to photograph the poorly lit interiors of old buildings such as cathedrals where tripods sometimes aren't allowed and flash would ruin the atmosphere of the lighting.

Press photographers and photojournalists often use ISO400 or ISO800 film these days as standard. That's because it's fast enough to cope with all manner of lighting situations, so they can use the same film for most subjects, but image quality is very high considering the speed – the graininess, sharpness and colour rendition of modern ISO400 films is as good as you could have expected from an ISO100 film not that many years ago.

If you enjoy carrying a compact camera at all times so that you can grab pictures as and when situations occur, films in this range are

ideal. Fast film in the ISO400–800 range also responds better to artificial lighting than slower film does, with colour casts often being less obvious (see page 74 for more information on artificial lighting).

ULTRA FAST-FILM (ISO1000 OR MORE)
Photographers who enjoy taking pictures at night or in low light tend to move from one extreme of the film speed range to the other, missing out everything in between. This is mainly because both offer distinct advantages and differences over the other which can be put to good use.

The main benefit of ultra-fast film is that its high sensitivity to light means much shorter exposures or smaller lens apertures can be used. For example, ISO1600 film is 5 stops faster than ISO50 film. So, if your camera's light meter suggested an exposure of 1 second at f/4 with ISO50 film, ISO1600 would allow you to use a shutter speed of 1/30 second. This is because each time you double the film speed the exposure can be halved, so it would be 1 second at ISO50,

1/2 second at ISO100, 1/4 second at ISO200, 1/8 second at ISO400, 1/15 second at ISO800 and 1/30 second at ISO1600.

Alternatively, you could stick to the 1 second exposure and set your lens to an aperture of f/22 to give much greater depth-of-field. Again, this is because every time you double the film speed, you can use an aperture that's 1 stop smaller – in this case, f/4 at ISO50, f/5.6 at ISO100, f/8 at ISO200, f/11 at ISO400, f/16 at ISO800 and f/22 at ISO1600.

More often than not, it's the ability to use faster shutter speeds that makes ultra-fast film so attractive for low-light photography, as it allows you either to take pictures handheld without any risk of camera shake, or to freeze subject movement.

With ISO1600 film in your camera you could take handheld shots in candlelight, outdoors at night under street lighting, or shoot candids in places such as pubs and clubs. Sports photographers often use ISO1600 film when covering indoor events such as basketball and table tennis, or for pictures of football matches under flood-lighting at night. It's also ideal for taking photographs of rock concerts or at theatres, where light levels are low and your subjects are lit by stage lighting.

The downside of ultra-fast film, as mentioned earlier, is that you have to sacrifice image quality for speed. The higher the ISO rating of a film is, the coarser its grain structure tends to be; from ISO1000 up, this is often fondly referred to as 'golf ball' grain by photographers because it seems so big, especially if you make large prints from the negatives or slides. Colour rendition also tends to be more subdued and shadow density drops, so that deep shadows tend to record as a

murky grey rather than true black – although if you're shooting in black and white you can remedy this latter problem at the printing stage.

But rather than see these things as obstacles, use them to your advantage. Coarse grain adds a gritty, textural feel to photographs that can work well on landscapes, windowlit portraits or still-lifes, classic figure studies and many other subjects photographed in low light. The muted rendition of ultra-fast colour films can be really evocative, too, when combined with coarse grain, allowing you to produce painterly images that ooze atmosphere – try some ISO1600 colour film for portraits or landscapes, fitting soft focus and warm-up filters to your lens to enhance the mood.

As for the poor shadow density of ultra-fast film, there isn't much you can do about it when working in colour, other than avoiding harsh, contrasty light and scenes that contain a lot of dense shadow. With black and white film, you can overcome it by printing on a harder grade of paper to boost contrast and ensure that blacks record as true blacks.

The choice of ultra-fast film is smaller than for slower speeds, but

The coarse grain and muted colours of ultra-fast film can create wonderful pictorial effects when partnered with the right subject or scene, so don't reserve it merely for times when you need extra speed. For this shot of the Patio De Los Mirtos in Spain's Alhambra Palace, Agfachrome RS1000 film (sadly no longer available) was used with a soft focus filter to create a simple yet evocative image.

the films that are available are all capable of excellent results. Kodak T-Max 3200 and Ilford Delta 3200 are the fastest black and white films available, along with Fuji Neopan 1600 which is a stop slower. For colour photography, films to try include Fujichrome Provia 1600, Kodak Ektachrome P800/1600 for colour slides and Fujicolor Super G Plus 1600 or Kodak Royal Gold 1000 for colour prints.

The key to success with ultra-fast film is to use it in situations where nothing else will do, or for the effects it can generate, rather than as a substitute for having to carry a tripod around. For general night scenes slow film can't be beaten, but for moody low-light shots or in situations where only the fastest film will allow you to take a photograph, hike your camera's ISO setting as high as it will go.

FILM TYPES

Although speed is the main thing to consider when deciding which films to use for night and low-light photography, there are also a few other factors worth bearing in mind that will help you achieve the best possible results.

BRAND DIFFERENCES

Each manufacturer tends to produce films with certain characteristics that make their products different from the rest, and while these differences aren't of great importance for night and low-light photography, they're certainly worth considering. For example, I use Fuji films exclusively for colour photography because the whole range, regardless of speed, is renowned for its vibrant rendition of colours. Fujichrome Velvia, the slowest film in the Fuji clan at ISO50, is best known for this, but Fuji Provia, Sensia and Astia for colour slides, and

You're unlikely to need ultra-fast film very often to cope with low light levels, but when you do it can be an absolute Godsend. This portrait was taken in the dim light of a workshop using Kodak T-Max 3200 at ISO3200, handheld on 1/30 second at f/5.6. In the same situation, at the same lens aperture, ISO50 film would have required an exposure of 2 seconds. Try handholding that!

Fujicolor Superior, NPS and NPH for colour negatives, are equally capable. As night scenes tend to be colourful due to the predominance of artificial lighting, these films are ideally suited.

That's not to rubbish the films from other manufacturers, of course. Kodak produce a superb range of colour films these days, for both slides and negatives, and although they still have a reputation for neutral, faithful colour rendition – particularly Kodachrome 25 and 64, still a favourite of many after 30 years – the range now covers all tastes. Agfa, too, continues to upgrade its film range as the boundaries of technology are constantly pushed back, and the current line-up is highly capable.

Experimentation is always the name of the game. You may be completely happy with the film or films you're currently using, but it's always a good idea to test new films as they are launched, just in case something comes along that can offer you a bit more than your existing choice.

Brand differences are less marked with black and white film, the main ones being tonality, contrast and grain size, though these only become obvious in the hands of a skilled printer. Basically you will get top-quality results from any brand.

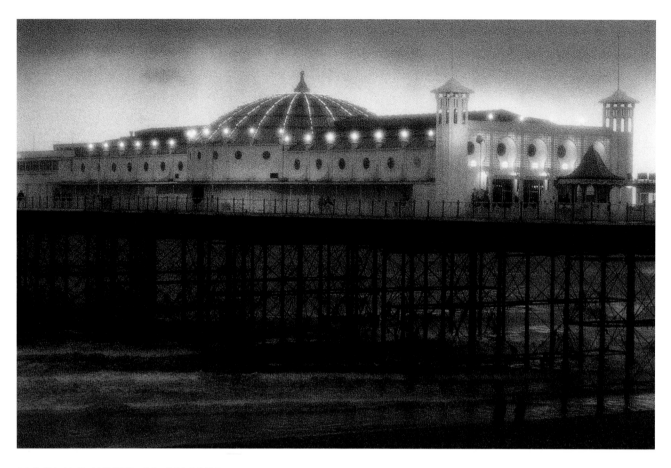

BLACK AND WHITE OR COLOUR?

Whether you use colour or black and white film for your low-light pictures depends mainly on the subject you are photographing. You only have to look at the pictures in this book to see that, outdoors at least, the appeal of many low-light subjects comes from the wonderful colours they offer. Think of a floodlit castle against the velvety blue twilight sky, or the vibrant reds, yellows and greens of a spinning fairground ride: such subjects scream out to be captured on colour film, and to use anything else would be an injustice.

That said, black and white film does have a place in the low-light photographer's repertoire. If nothing else, it overcomes the problems of colour casts created by mixed light sources. When shooting colour images, you can balance the cast created by one source using filters or specialist film (see page 44), but if there's more than one source – tungsten and daylight, perhaps, or sodium vapour and fluorescent – there isn't a great deal you can do.

Loading your camera with black and white film is a simple solution, because by removing colour from the equation altogether you don't have to worry about it. This isn't such a sensible move if those colours are integral to the success of the photograph, but where colour is less important it's a move worth taking. People photography is an ideal example. Artificial lighting can make skin tones go all manner of strange colours and ruin an otherwise appealing shot, so if you're taking people pictures indoors, where the location is lit artificially, black and white film comes into its own.

If you're working with ultra-fast films (ISO1000+), black and white is also much easier to use and control than colour. It handles uprating and push-processing better (see page 37), so you can squeeze every last bit of speed from it and different developers can be used to control image contrast so that the negatives you end up

with contain the maximum amount of details, particularly in the highlights and shadows, and are easier to print. The negatives can also be manipulated at the printing stage to control contrast – burning in highlights or dodging shadow areas to reveal detail and produce a balanced image.

Favourite black and white films include Ilford FP4 Plus, Ilford Delta 100 and Agfapan 100 for general use. For medium speed, Ilford HP5 Plus, Ilford Delta 400, Agfapan 400, Kodak T-Max 400 and Tri-X 400 are popular choices, while for ultra-fast film your choice is limited to three options – Kodak T-Max 3200, Ilford Delta 3200 or Fuji Neopan 1600.

Finally, two rather special black and white films deserve mention – Kodak T-400CN and Ilford XP2-Super. Both are chromogenic black and white films, which means they are designed to be processed in C-41 colour chemistry like normal colour negative film. Both produce superb results with fine grain and a high degree of sharpness, and can be rated anywhere between ISO50 and ISO800 for standard use, though Kodak T400 CN can be uprated to ISO1600 or even ISO3200 then push-processed – providing you can find a lab that offers push-processing of C-41 compatible films (see below).

If you like the idea of taking black and white photographs, without having to process and print your own films, these are well worth considering. The only drawback with chromogenic black and white film is that lab-produced enprints come out with a colour cast – usually sepia, blue or green – as they're printed on colour paper. To avoid this, ask for the prints to be made on black and white paper.

Technical considerations aside, black and white pictures offer aesthetic qualities that colour can't match: a lack of colour for a start, which many photographers see as a benefit as it allows them to produce images that are a step away from reality and concentrate on

the texture and form in a scene or subject. This is particularly so with classic subjects such as still-life, portraiture and nude figure studies shot in low light. Photojournalists prefer black and white for similar reasons – the starkness makes it much easier to deliver a powerful message by focusing attention on what the photograph is really about.

So, while many night and low-light subjects lend themselves naturally to colour film, don't be afraid to experiment with black and white – it can have a potency unmatched by anything else when used on the right subject.

COLOUR NEGATIVE OR COLOUR SLIDE?

The debate about whether colour slide (reversal) film is better than colour negative film has raged for years, and will no doubt continue to do so. But when it comes to low-light photography, both can offer the user certain advantages.

From a sharpness point of view, slide film still has the edge because the final image is first generation. Negatives, on the other hand, have to be printed to produce the final image, so a loss of image quality is bound to occur during this process, and the film is thicker, so causing a further drop in sharpness. Other problems can also be created at the printing stage, such as the accidental addition of colour casts, or hairs and dust spots on the negative which spoil the photograph.

Colour slide film also responds well to uprating and to push-processing, and more processing labs offer this service. Unfortunately, colour negative film, with the exception of a few professional brands such as Kodak Ektapress PJ400, 800 and 1600, is already pretty much at the limit of its speed capability, so pushing tends to produce disappointing results (see page 37 for more information).

ABOVE & LEFT **Black and white or colour, which do you prefer? These pictures of Brighton's Palace Pier show exactly the same scene, taken in low light on ultra-fast film, about two years apart, yet they exhibit completely different moods – the colour image has a dreamy, painterly quality, while the toned black and white picture has a darker, more dramatic feel. Ultimately, it's up to you which medium you decide to work with, but if you're in any way unsure, you could always use both, then pick your favourite later.**

Negative film partly makes up for this by being far more tolerant of exposure error – especially overexposure – because adjustments can be made at the printing stage. As many night and low-light subjects are tricky to meter for, as we'll discuss in Metering and Exposure on page 78, this can provide a welcome safety net. Colour slide film doesn't offer this benefit – it must be exposed with great accuracy to avoid highlights burning out or shadows blocking up. Secondly, negative film tends to handle artificial lighting better than slide film, again because you can instruct the printer to filter out a colour cast while enlarging the negative.

And let's not forget the convenience of colour negative film. Because prints are made from the negatives, you can look at your photographs very easily, and pass them around family and friends. With slides, a projector and screen must be set up if you want to look at them properly, a job that's both fiddly and time-consuming when all you want to do is show off your photographic skills or look through some shots.

Ultimately, the choice is yours. From a quality point of view, colour slide film can't be beaten, but if convenience is more important then you'll no doubt prefer colour negative film.

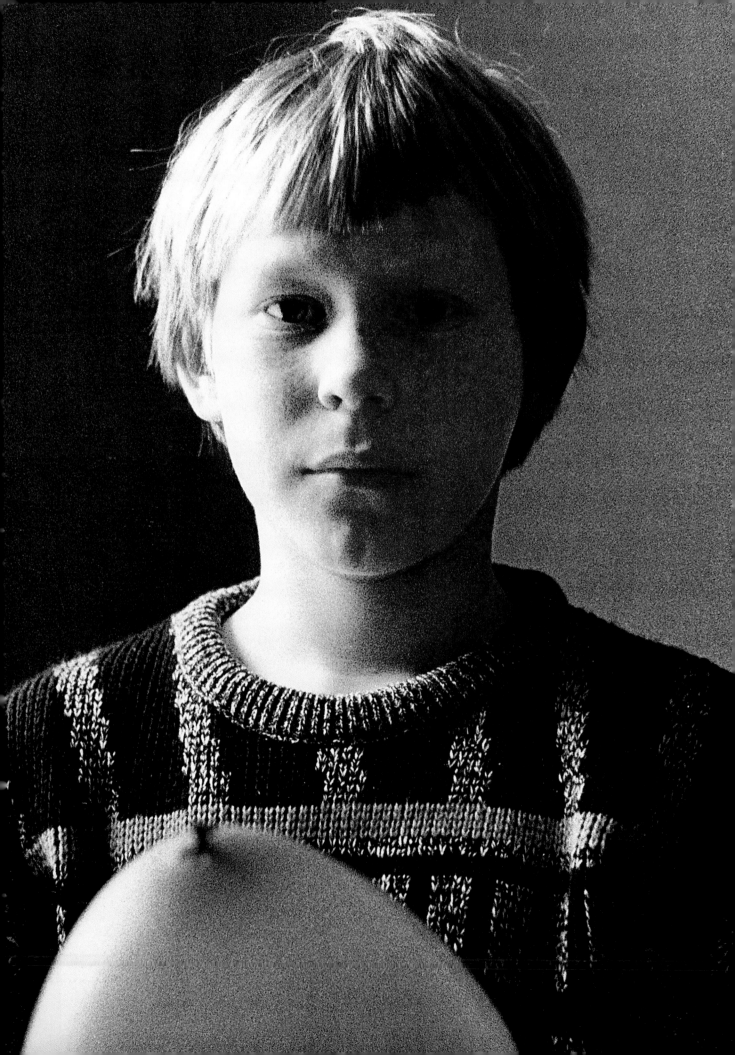

UPRATING FILM

Should you find yourself in a situation where the film you're using just isn't fast enough, and you don't have any faster film with you, all need not be lost, because there's a handy technique known as 'uprating' that can be used to allow your picture-taking to continue. Sports photographers and photojournalists often uprate film when they find themselves working in low light and needing faster shutter speeds, but it's something you can try for any low-light subject that suits fast film.

The basic idea behind uprating is that you rate the film you're using at a higher ISO so that it requires less exposure. By doing so you're effectively underexposing the film, so the processing time must be modified accordingly – this is known as 'push-processing', or 'pushing'.

There are certain films available today that have been designed specifically for pushing, so you can use them at different ISO ratings. Fujichrome Provia 1600 colour slide film, for example, is essentially an ISO400 film that's intended for rating at either ISO800, ISO1600 or ISO3200, though as its name implies it tends to be used mainly at ISO1600. A more recent addition to the Fuji colour slide film line-up is MS 100/1000, which can be rated anywhere between ISO100 and ISO1000, depending on how much speed you need. Kodak Ektapress Multispeed is a colour negative film that can be used in the same way. But any film can be uprated and push-processed, so you needn't buy one of these films. And the results they produce aren't necessarily any better, either.

When a film is uprated, the normal practice is to double or quadruple the recommended speed. So, for example, ISO100 film could be rated at ISO200 or ISO400, ISO400 film could be rated at ISO800 or ISO1600 and so on. Each time the ISO rating is doubled the film must be push-processed by an extra stop, so ISO100 film rated at ISO200 must be pushed 1 stop, while ISO1000 film rated at ISO4000 must be pushed 2 stops.

Most processing labs that handle colour slide (E6) film offer a 1- or 2-stop push-processing service, often at no extra cost. The same applies with black and white film. If you want to have colour negative film pushed, however, you will have to find a professional lab that offers the service as very few, if any, high street mini-labs are able to do it.

The consequences of uprating and pushing film are that you get an increase in grain size, increase in contrast, and in some cases the appearance of base fog, which makes the image look rather washed out. Colours also come out harsher if you're shooting colour film.

Under normal circumstances, film is only pushed 1 or 2 stops to minimise these side effects. However, coarse grain and increased contrast don't have to be a problem, and when turned to your advantage can be exactly the opposite, so why not experiment with more extreme levels of pushing and see what happens? You could rate ISO1600 film at ISO12500, or rate ISO3200 film at ISO25000 and then push-process it by 3 stops.

This is easy with black and white film, because you can process the films yourself and deal with any related problems such as high contrast at the printing stage.

Some black and white developers, such as Ilford Microphen, Kodak X-Tol and Paterson Acuspeed, are designed for use with film that has had a speed increase, but you could experiment with any developer. As a rule-of-thumb, increase the development time by 30 per cent for each stop you uprate, so if the recommended development time at normal ISO rating is eight minutes at 20°C, increase it to 10.5 minutes for a 1-stop push, 13.5 minutes for a 2-stop push and 18 minutes for a 3-stop push.

For more accurate timing, refer to the data below, which shows the processing times of various popular fast or ultra-fast black and white films when uprated and push-processed up to 3 stops. Continuous agitation for the first 30 seconds, then for 5 seconds every 30 seconds is suggested.

FILM	ORIGINAL ISO	NEW ISO	DEVELOPER	DEVELOPMENT TIME AT 20°C (MINUTES)
Fuji Neopan 400	400	1600	Kodak T-Max (1:4)	10
Fuji Neopan 400	400	3200	Ilford Microphen (stock)	16
Fuji Neopan 1600	1600	3200	Kodak T-Max (1:4)	10
Fuji Neopan 1600	1600	3200	Ilford Microphen (stock)	5.75
Fuji Neopan 1600	1600	6400	Kodak X-Tol (stock)	7.25
Kodak Tri-X 400	400	1600	Kodak X-Tol (1:1)	11.75
Kodak Tri-X 400	400	3200	Kodak X-Tol (1:1)	13.5
Kodak T-Max 400	400	1600	Kodak X-Tol (stock)	8.5
Kodak T-Max 400	400	3200	Kodak X-Tol (stock)	10
Kodak T-Max P3200	3200	6400	Kodak X-Tol (stock)	12.5
Kodak T-Max P3200	3200	12500	Kodak X-Tol (stock)	15.25
Kodak T-Max P3200	3200	25000	Kodak X-Tol (stock)	18.5
Ilford HP5 Plus	400	800	Kodak T-Max (1:4)	8
Ilford HP5 Plus	400	1600	Kodak T-Max (1:4)	9.5
Ilford HP5 Plus	400	3200	Kodak T-Max (1:4)	11.5
Ilford Delta 400	400	800	Ilford Microphen (stock)	9
Ilford Delta 400	400	1600	Kodak T-Max (1:4)	14
Ilford Delta 400	400	3200	Kodak X-Tol (stock)	12
Ilford Delta 3200	3200	6400	Kodak T-Max (1:4)	11
Ilford Delta 3200	3200	12500	Ilford Microphen (stock)	16.5
Ilford Delta 3200	3200	25000	Ilford Microphen (stock)	22
Agfapan 400	400	1600	Kodak X-Tol (stock)	12.25
Agfapan 400	400	3200	Kodak X-Tol (stock)	14.5

LEFT **Black and white film is ideal for uprating and push-processing, as you can use dodging and burning techniques in the darkroom to control contrast, whereas with colour slide film that versatility is taken away. For this windowlit portrait, ISO400 film was uprated to ISO1600, then push-processed by 2 stops. Doing so has increased grain size, but it adds a pleasant texture to the image.**

RIGHT **Uprating film is a handy back-up technique to use when all else fails. In this case, I found myself without a tripod while waiting for a train, so in order to capture the misty view along the tracks I uprated ISO400 film to ISO1600 and handheld the camera fitted with a 300mm lens.**

Extreme uprating and pushing of colour film is less predictable as you may encounter other problems such as colour shifts, base fog and muddy green shadows, but until you try you won't know. Few labs will push film more than 2 stops under normal circumstances, but if you have a good relationship with a professional lab they will push 3, perhaps 4 stops if you ask – providing you are willing to accept responsibility for the outcome. This service may cost more, and as film manufacturers don't publish data for such extreme pushing it will be down to guesswork, but you could always try it first with a test film so you know what to expect the next time. The test shots shown here will also give you some idea of how film responds to extreme pushing.

If your camera uses DX-coding to set film speed automatically and there's no override facility, you won't physically be able to change the recommended ISO rating to a higher one. One way around this problem is to buy a set of DX re-coding labels which you stick over the chequered DX-coding pattern on the film cassette, so that the camera is fooled into setting a different ISO. Another is to use your camera's exposure compensation facility to underexpose the film, which is just the same as uprating the film speed. If you want to uprate by 1 stop, set the exposure compensation to -1 for the entire roll of film; to uprate by 2 stops set the exposure compensation to -2, and so on.

Once you have finished shooting a roll of uprated film, remove it from the camera and mark the new speed on the cassette, so that you don't forget it has been uprated. You must also inform the lab that the film requires pushing by however many stops, otherwise they will process it as normal and all the images will be underexposed.

Uprating and pushing film is by no means a panacea, but when you need to squeeze a little extra speed from a roll of film, or you want to use the side effects of push-processing for pictorial reasons, it's a technique well worth using. From a purely financial point of view it can also save you money. The cost of a roll of film tends to go on a rising scale according to its ISO rating, so instead of buying a roll of ISO1600 film, you could instead buy ISO400 film, which costs about 30 per cent less, and uprate it to ISO1600. Providing you don't then have to pay a surcharge for the push-processing this can represent quite a saving if you shoot a lot of fast film – and the quality of the results will be indistinguishable.

RIGHT **This comparison set of pictures shows the effects of uprating and push-processing black and white film. The film used was Ilford Delta 3200, already an ultra-fast film at ISO3200, but one which can also be uprated quite easily to greater speeds when lighting conditions dictate it. Pushed 1 stop to ISO6400 there's hardly any difference in quality, and although the films rated at ISO12500 and ISO25000 show a rise in contrast and grain size and a drop in shadow density, the quality is still remarkable considering the speed, and the negatives printed easily on grade II paper. This film is well worth trying if you really do need to work at ISO25000!**

BELOW **Uprating ultra-fast colour film may allow you to take pictures in the poorest of light, but don't expect miracles. For this twilight picture, Agfachrome 1000RS was uprated to ISO4000 and push-processed 2 stops. The result is an image with weak colours and muddy shadows – not the end of the world, but not wonderful either. You just have to decide if any picture is better than no picture at all.**

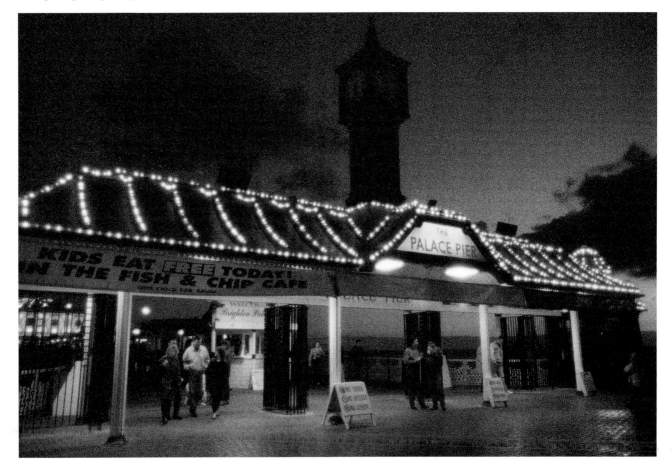

Ilford Delta 3200 at ISO3200.

Ilford Delta 3200 at ISO6400.

Ilford Delta 3200 at ISO12500.

Ilford Delta 3200 at ISO25000.

SPECIALIST FILMS

Although normal daylight-balanced film is perfectly adequate for the vast majority of night and low-light subjects, there are a couple of specialist films worth trying, for both technical and creative reasons.

TUNGSTEN-BALANCED FILM

The most useful is tungsten-balanced film, which is designed to give natural colour rendition if you take pictures in tungsten lighting, or in lighting with a low colour temperature such as candlelight.

Normal daylight-balanced film can be used, but the pictures you take will come out with a strong yellow/orange cast because tungsten lighting has a low colour temperature (see page 74). Tungsten-balanced film has an in-built 'filter' to overcome this so everything appears normal. There are two tungsten-balanced colour negative films available – Kodak Ektacolor Pro Gold 100T and Fujicolor 160 NPL – while for colour slides there is Kodak Ektachrome 64T, 160T or 320T and Fujichrome 64T.

You can also produce some interesting effects by using tungsten-

The two comparison pictures below show the effect of using tungsten-balanced film. Both were taken in identical conditions, using a standard tungsten desk lamp bounced off a white reflector to provide illumination.

Taken on daylight-balanced film. **Taken on tungsten-balanced film.**

Used outdoors, unfiltered, tungsten-balanced film will cool down artificial lighting by adding a cold blue cast to any areas lit by daylight. You can see what a difference it can make by comparing this shot to the one below of the same scene that has been captured on normal daylight-balanced film.

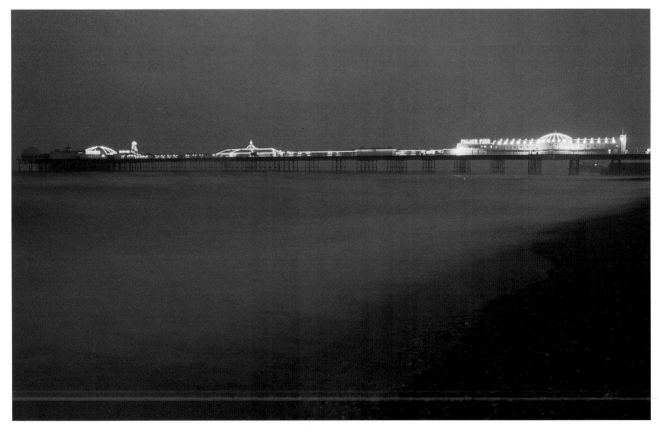

balanced film outdoors for daylight shots. If you do this, your pictures will take on a deep blue colour cast which can look really effective on low-light landscapes or coastal shots. It's also worth experimenting with tungsten-balanced film on scenes that contain mixed lighting.

Although it takes a while to master the intricacies of infrared film, the effects it can create make the effort well worthwhile. For this shot of Dunster Castle in Somerset, Kodak 2481 film was used, and the negative was printed on grade IV paper to enhance the eerie feel of the location.

INFRARED FILM

Although it offers no real technical advantage for general low-light photography, the creative effects you can achieve with infrared film makes it well worth trying.

Black and white infrared is particularly versatile, and of the three brands available – Kodak 2481 High Speed Mono Infrared, Konica 750 and Ilford SFX – the Kodak version is the most suitable for low-light work. This is for two reasons: firstly, with a recommended speed rating of ISO400 it's the fastest (Konica 750 is a much slower ISO50 and Ilford SFX ISO200); secondly, it gives the strongest infrared effect.

To get the best results from infrared film you must load and unload it in complete darkness to avoid fogging. This is especially important with Kodak mono infrared film because of it's high sensitivity, though the other two can be handled in subdued light.

A filter must also be used on your lens to emphasise the infrared effect. Visually opaque infrared filters give the best results as they filter out all traces of visible light, but they're fiddly to use and most photographers compromise by using a deep red filter, which you can see through to compose your pictures and meter through to take an exposure reading. Any deep red filter will do the job.

Getting the exposure right with infrared film can be tricky, so it's a good idea to bracket exposures – take one shot at the metered exposure, a second with your camera's exposure compensation facility set to -1 stop and a third at +1 stop. Of these three negatives,

you should be able to make a decent print from one. The ISO ratings mentioned for the three films assume you will be taking TTL meter readings through a deep red filter fitted to your lens.

The main characteristics of mono infrared film are shown at their best in sunny weather, when blue sky goes black and foliage records as a ghostly white tone. Out of doors in low light or in bad weather this effect won't be as strong, but infrared film is still ideal for adding an eerie feel to landscapes or shots of old buildings – ruined castles or abandoned cottages covered in creepers and surrounded by overgrowth look positively spooky.

Infrared film can also be used indoors to photograph people in places such as nightclubs, discos or bars that are dimly lit. To try the technique for yourself you'll need an electronic flash to provide the lighting, and instead of placing a deep red filter over your lens, you fit it over the flash. By doing this, the pulse of light from your flashgun will be reduced to the point where it's hardly visible to the naked eye – and if you use a visually opaque infrared filter it won't be visible at all. As a result, it is possible to photograph people from close range, with a wide-angle lens, without them even realising it.

If you're using a dedicated flashgun, the light loss caused by the filter should be taken into account automatically by your camera.

With manual flashguns, set the aperture on your lens to an f/number 3 stops wider than the scale on the flashgun says you should be using, to compensate for the filter's 3-stop light reduction.

FILTERS

Like any aspect of photography, night and low-light subjects can often benefit from the use of filters, either for technical reasons to prevent different types of lighting causing colour casts, or creatively to add interesting effects.

The number of filters you are likely to use on a regular basis can actually be counted on the fingers of one hand, but in many situations they will prove invaluable and are well worth investing in if you don't already have them.

FILTER SYSTEMS

Before looking at specific filters and the jobs they do, first a few words about filter systems.

There are basically two types to consider here: round screw-in filters, or square and rectangular filters that fit into a multi-slot holder. Round filters are convenient in that you simply screw them on to the front of your lens. Their main drawback, however, is that they're made to fit a specific thread size, be it 49mm, 52mm, 67mm or whatever, so if you have lenses with a different thread size, which is highly likely, you will need to do one of two things.

One option is to buy the same range of filters in all relevant thread sizes so that they will fit your full lens system – a potentially

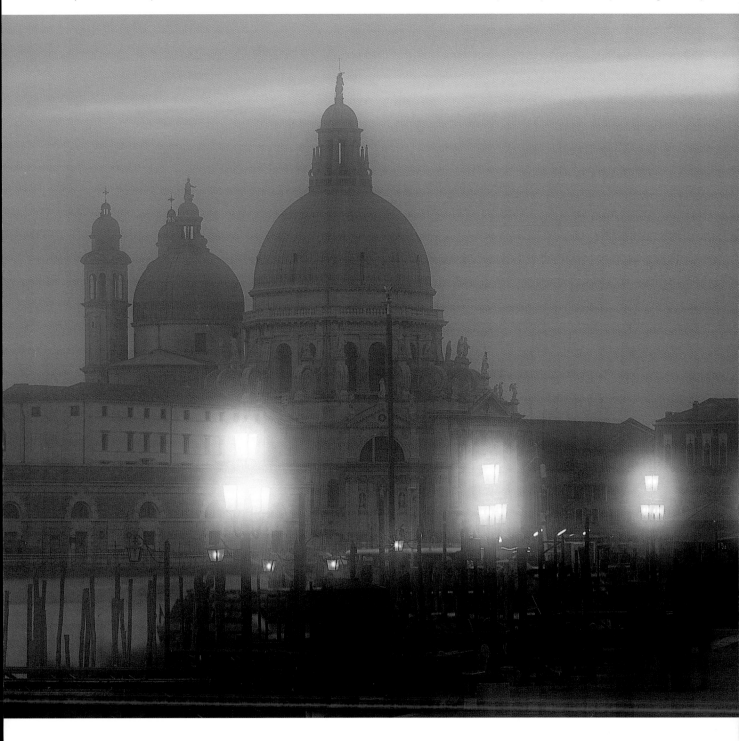

expensive move if you have four or five different threads. The sheer number of filters you will need to carry also becomes prohibitive. The other option is to buy one set of filters in the biggest thread size you need, or are likely to need, then invest in stepping rings which will adapt these filters to smaller thread sizes so that they can be used on your other lenses.

Buying bigger filters and then adapting them to smaller thread sizes is more practical than adapting smaller filters for use on lenses with bigger thread sizes, because if you do this there's a strong chance of vignetting, or cut-off. This problem is caused when an object, be it a filter or lens hood, encroaches on a lens's field-of-view and darkens the corners of the pictures. Cut-off isn't so common with telephoto lenses, because their field-of-view is limited, but wide-angle lenses are prone to it.

If you have a 28mm lens with a 52mm filter thread and you fit a filter with a 49mm diameter on it using a stepping-down ring, for example, it will almost certainly cause vignetting. And the wider the lens is, the greater the risk.

Unfortunately, because most cameras only show 85–90 per cent of the picture area in the viewfinder, you won't always know vignetting has been caused until your pictures are returned from the processing lab. Cut-off is also exaggerated at small lens apertures such as f/16 or f/22, but when you peer through the viewfinder of an SLR camera you are looking through the lens at its widest aperture setting, so again, the problem may not be apparent.

Another drawback with screw-in filters is that if you want to use two or three together, the combined depth of the mounts – perhaps 3–4mm per filter – may extend too far and creep into the field-of-view, causing cut-off yet again. The only way around this is to buy oversized filters that are considerably bigger than the lens's thread size, but doing this can be expensive as prices rise with thread size, and life just starts to get difficult.

Taking these factors into account, screw-in filters are ideal if you only want to use them individually, and your lenses have the same or very similar thread sizes, but beyond that they become inconvenient and a holder-based filter system is a better bet. The immediate advantage of buying a slot-in system is that you can use the same filters on lenses with widely different thread sizes simply by investing in a set of inexpensive adaptor rings – which means you only need ever buy one set of filters. You can also use as many filters together as the holder has slots – usually three – without having to worry about vignetting. Saying that, vignetting can't be ruled out altogether, because if the filter holder is too small it will encroach on the lens's field-of-view just like a screw-in filter would.

Again, the key to avoiding this is to buy a big rather than a small system. It will prove more expensive at the outset, as the holders, adaptors and filters cost more, but in the long term you will benefit because you should never need to upgrade the system.

The main sizes available are the Cokin 'A' type, which use 67mm filters, and the Cokin 'P' type which use 84mm filters. Beyond that you get into professional filter systems which are usually 100mm

wide. Cokin has also just launched a new system, called X-Pro, of 130mm filters.

The smallest systems are adequate for 35mm SLR users on lenses as wide as 28mm, but if you go wider than that vignetting will result. The next size up, based around 84mm filters, will solve this problem and work with 35mm lenses as wide as 20mm, but again, beyond that you will need a bigger system to avoid vignetting. Users of medium-format camera systems are also advised to use at least an 84mm system, but preferably something bigger.

When choosing a filter system, you should look not only at your current needs, but at your future needs too. Your widest lens may only be 28mm now, for instance, but who's to say you won't buy a wider lens such as a 24mm or 20mm in the future? Equally, while you are happy at the moment using a 35mm SLR system, in a year or two you may decide to upgrade to medium format.

With this in mind, you are advised to play it safe and buy the biggest system you can afford or are likely to need. Professional brands such as Hitech and Lee are excellent, if rather pricey, but the Cokin X-Pro series, which will be well established by the time you read this book, is well within the budget of most serious enthusiasts, and at 130mm wide will suit any lens or camera format with which you are likely to use filters.

Modular square filter systems like the Hitech brand shown above and below are far more versatile than traditional screw-in filters, allowing you to use several filters together and fit the same filters to all your lenses.

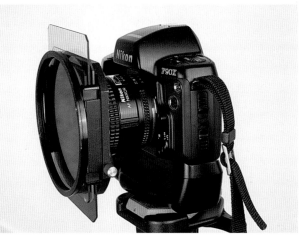

LEFT **When used with care and imagination, filters can be a great ally to the night and low-light photographer for both creative and technical applications. For this atmospheric dusk shot of Santa Maria Della Salute church in Venice, two filters were combined – a warm-up to enhance the natural light and a soft focus to give the image a dreamy feel.**

FILTER TYPES

With your mind now clear about which type of filter system to buy, all that remains is to look at which filters you actually need, how to use them, and what they do.

TECHNICAL FILTERS
Colour-balancing filters

Night and low-light photography usually involves photographing scenes or subjects that are lit by artificial light sources, a mixture of artificial and natural daylight, or natural daylight at the beginning or end of the day. In all cases, this means subjecting your film to conditions it wasn't designed to deal with, and the usual outcome is that your pictures take on a strange colour cast – sometimes welcome, at other times not. This will be discussed in greater detail in Understanding Light on pages 58–77, but the usual solution is to get rid of those colour casts using colour-balancing filters.

There are three main types of filter in this category: these are colour correction, colour conversion and colour compensation.

Colour correction

These filters come in two colours: the light orange 81-series, more commonly referred to as 'warm-ups', and the light blue 82-series of 'cool' filters. In each case, different strengths are available: 81, 81A, 81B, 81C, 81D and 81EF for warm-ups and 82, 82A, 82B and 82C for cool filters, with the strength of the filter increasing as you move down the range alphabetically. These filters are designed to correct subtle colour casts – the 81-series to balance slight blue casts and the 82-series to cool down light that's too warm.

Warm-up filters are ideal for balancing the cool blue cast you often get when taking pictures in really dull, cloudy weather out-doors, or to make skin tones more attractive when shooting colour portraits in windowlight on a dull day. They can also be used in the opposite way to which they were intended – to enhance sunrise or sunset shots by making the light even warmer than it is naturally, for instance. I carry almost a full range of warm-up filters with me – 81B, 81C, 81D and 81EF – and use them on a regular basis for all these reasons, though it's often creatively rather than technically.

Less useful are the 82-series cool filters. You would rarely want to make warm daylight cooler, and when the light is too warm, it usually requires a much stronger filter to solve the problem (see below). Creatively, they can be used to enhance cool light – especially if you use an 82B or 82C – but a stronger blue filter tends to do this job more effectively.

Colour conversion

Again there are two colours – the blue 80-series and the orange 85-series – but this time they are much stronger and able to balance more obvious colour casts. Both come in different strengths: blue 80A, 80B, 80C and 80D; orange 85, 85A, 85B and 85C. This time, however, just to confuse matters, the density is reversed, with 80A and 85 being the strongest in their respective ranges and the density reducing as you move down the scale alphabetically – so an 80D is the weakest in the blue series and 85C the weakest in the orange.

The blue 80-series filters are the most popular for low-light photography as they are designed to balance the yellow/orange casts created by tungsten lighting on daylight-balanced film. If you take pictures under domestic room lighting a blue 80A filter should be used, and for tungsten photoflood studio lights which aren't quite as warm, you would be as well to choose a blue 80B. The 80A can also be used to cool down the extreme warmth of candlelight should you wish to do so (see page 184).

These filters also have creative applications. An 80A or 80B will add a strong blue cast to pictures taken outdoors in daylight, for example, which can work well on low-light landscapes, pictures taken in misty or foggy weather, or low-light scenes covered in snow.

For this scene, captured in North Africa just moments before sunset, an 81C warm-up filter was used to enhance the naturally warm light bathing the sandstone mountains.

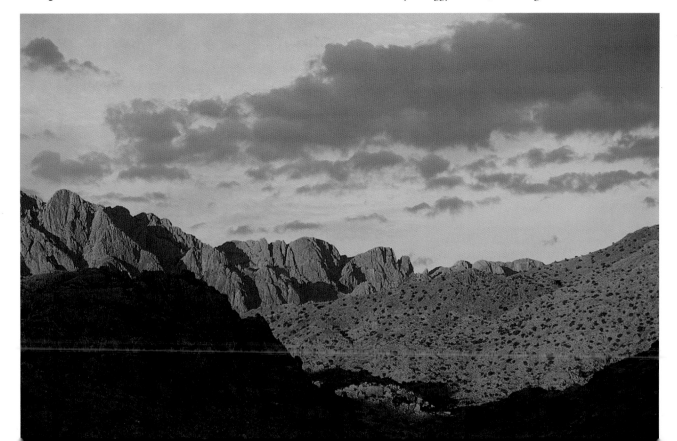

The 85-series orange filters are less useful for night and low-light photography because it's unlikely you will find yourself in a situation where the light is so blue that you need a strong amber filter in order to balance it – and if you do, such as when you are photographing a moonlit landscape covered in snow or a twilight scene in dull, cloudy weather, the cold cast will enhance rather than ruin the atmosphere of the shot.

The only real technical application this series of filters has is if you happen to have a roll of tungsten-balanced film in your camera and want to take some pictures outdoors or with electronic flash. In that case, an 85 or 85A filter will balance the blue cast that you get by exposing tungsten-balanced film to daylight or flash, but more often than not the blue cast can itself work well.

Creatively, any of the 85-series filters can be used to add a warm glow to pictures taken in natural daylight or using flash, though you should avoid overdoing this as the effect can look odd. At sunrise or sunset an 85B or 85C can be used, but you'll get a more natural warming of the light by sticking to the 81-series warm-up filters that we discussed earlier.

Colour compensation (CC)

This final type of colour-balancing filter comes in a range of colours and strengths, so you can make precise adjustments to any casts that may be present in the light due to the type of light source being used if you're indoors, and the time of day and prevailing weather conditions outdoors. Even the way light reflects from a coloured surface such as painted walls in a building can affect the colour of the light and produce an unwanted cast.

To make the best use of CC filters, ideally you need a colour temperature meter which will indicate any colour deficiencies in the light and recommend which filter, or combination of filters, will cancel them. Consequently, you need a wide selection of these filters in different densities to make the necessary adjustments.

Are they worth bothering with? For subjects such as architectural and interior photography, food photography, and specialist still-life work where precise colour balance is required, yes they are, but for night and low-light photography they are generally unnecessary because slight colour casts will rarely ruin a shot, and usually do exactly the opposite.

For those of you who are interested, the range includes yellow, magenta, cyan, red, green and blue, in densities from 0.025 to 0.5. Kodak Wratten gels are the best-known brand of CC filters, but professional filter manufacturers such as Hitech also produce them.

Neutral density (ND) filters

The aim of neutral density filters is to reduce the amount of light passing through the lens so that an exposure increase is required, without affecting the colour balance of the subject or scene. Given that night and low-light photography involves taking pictures in situations where light is already in short supply, you would be forgiven for thinking that these filters are the last thing you need. However, the definition of low-light is far-reaching, and with some subjects you may find that even when light levels are relatively low, you could actually do with them being even lower so as to make a particular effect possible.

Rivers and waterfalls are perhaps the most common example. To achieve the attractive effect of moving water recording as a blurred mist, an exposure longer than 1 second in duration is required – anything from 4 to 30 seconds, depending on how fast the

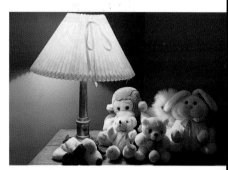

RIGHT **The blue 80A colour conversion filter is invaluable for balancing the warm colour cast produced on pictures taken in domestic tungsten lighting with daylight-balanced film. You can clearly see the effect it has on this still-life comparison.**

Unfiltered.

BELOW **Colour conversion filters are ideal for adding a strong colour cast to pictures taken in low light. For this shot of Derwentwater in the English Lake District, captured before sunrise, I used a blue 80B filter to give the image an atmospheric cold cast and to heighten the mood of the scene.**

With blue 80A filter.

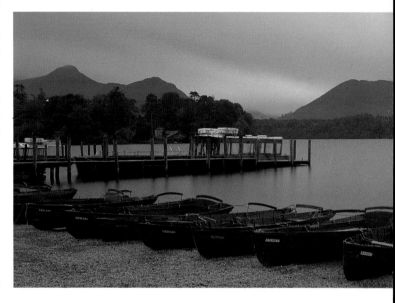

water is flowing. However, even if you are in dense woodland where little daylight is getting through, using slow-speed film and the smallest aperture your lens can offer, you may still find that the longest exposure you can use is only 1/2 or 1 second.

Neutral density filters come to the rescue here, allowing you to set a longer exposure and get the effect you desire. A wide range of different densities is available, though the most useful are those requiring an exposure increase of 1 (0.3), 2 (0.6), 3 (0.9) or even 4 stops (1.2), the figures in brackets indicating the density of the filter.

If you need an even greater exposure increase than your strongest ND has to offer, two filters can be combined. For this reason, it's a good idea to buy a couple of ND filters – perhaps 0.3 and 0.6 density, so that you have the option of 1, 2 and 3 stops of exposure increase. You should only combine filters when absolutely necessary, though, as the more optical accessories you place on your lens, the more that image quality will be reduced.

take a meter reading from the landscape by tilting your camera down to exclude the sky from the viewfinder, then a second reading from the sky by tilting the camera up. This will tell you the difference in brightness between the landscape and the sky, and armed with that information you can choose the right density of grad.

When using ND graduates you should slide the filter into its holder while looking through the camera's viewfinder and stop when it is correctly aligned. Pressing the depth-of-field preview button on the camera or lens so it stops down to the aperture set can help with alignment, as it darkens the viewfinder image and lets you see more

Neutral density (grey) graduates

Neutral density graduates perform the same job as neutral density filters, but instead of affecting the whole image, they work only on the sky. This is often necessary when taking scenic photographs because the sky is much brighter than the landscape, so if you set an exposure that's correct for the landscape, the sky will be overexposed.

In low-light situations this problem is a common one, because if you are shooting landscapes before sunrise or after sunset, the only light hitting the landscape comes from the sky, rather than the sun, so it is bound to be darker than the sky – just as a window is always going to be brighter than a wall opposite that's illuminated solely by light from that window. To redress this difference in brightness, neutral density graduate filters are used to darken down the sky so that it requires the same exposure as the rest of the scene. That way, the photograph you take will capture the scene as it appeared to the naked eye.

As with ND filters, ND graduates come in different densities so that you can darken the sky by a precise amount. A 0.3ND grad will darken the sky by 1 stop, a 0.6ND by 2 stops, a 0.9 by 3 stops and a 1.2 by 4 stops. In most situations a 0.6ND graduate will be adequate, but when the sky is very bright a 0.9 or 1.2 density grad will be required. A good example of this is if you are capturing a scene on film just after sunset, when the sun itself has disappeared but the sky is very bright. If you want to capture features against the sky in silhouette, then no graduate is required, but if you wish to record detail in the landscape without the sky being so overexposed it comes out white, a strong graduate such as a 1.2 density will be required.

With experience you will know which ND graduate is required just by looking at the scene. But if in doubt, all you need to do is

clearly the effect the grad is having on the sky. Alternatively, if the sky is occupying the top third or half of the viewfinder, position the grad in its holder so that the dark part of the filter covers the top third or half of the lens's front element. This may seem rather Heath Robinson, but it works.

Finally, a word about exposure. The purpose of neutral density filters is that they force an exposure increase. With neutral density graduates, however, you don't need to adjust the exposure because the primary aim of using one is to darken the sky, and increasing the exposure will merely compensate for this and overexpose the landscape. Instead, what you should do is take a meter reading for the landscape without the filter in place, set the required aperture and shutter speed with your camera in manual exposure mode, then position the filter and take the shot – without doing anything to the exposure at all.

Don't use neutral density grads with your camera set to an automatic exposure mode such as aperture priority or program, because as soon as you fit it over the lens, the exposure will automatically change to compensate for the sudden loss of light through the top part of the lens, and overexposure may result.

CREATIVE FILTERS

As well as using filters for technical reasons, there are several that are worth experimenting with on night and low-light subjects to produce interesting creative effects. The key to success here is moderation. Avoid using any of the filters too often, as the effects they produce will quickly become boring and predictable. Neither

Here's a classic low-light situation where a neutral density graduate filter was required to balance the brightness between the dawn sky and dark landscape, so that both recorded as the eye saw them. A spot reading was taken from the foreground to determine correct exposure, then a 0.9 ND grad was fitted to the lens to darken the sky by 3 stops.

should you try to rescue a dull shot by sticking a crazy filter over your lens – it will still be a dull shot, just with a crazy effect added.

Sunset filter

The design of this filter is similar to a graduate in that the top half is darker than the bottom, the main difference being that the whole filter also has a strong orange colour to mimic the golden glow of a sunset. If you use this filter on evenings when the natural colours of the sunset are already intense then the effect will look odd; however if the sunset is a weak affair, it can work wonders.

Remember, too, that the light at sunset is much warmer than you actually think, because your eyes adjust automatically. Pictures taken at sunset without filters therefore tend to look warmer than you remembered, and it's only in rare situations that a filter is required.

Soft focus filters

Soft focus filters come in many different forms and can create anything from a barely noticeable effect to a really strong one, depending on the type you buy. It's also easy to make your own by smearing a tiny amount of petroleum jelly (Vaseline) on a clear filter, or by using the frosted half of an anti-newton glass slide mount – the latter produces beautiful results.

The main purpose of soft focus filters is to diffuse the image and to introduce a romantic, dreamy quality which adds atmosphere. Consequently, they can be used on a wide range of low-light subjects, from landscapes and night scenes to portraits, still-life and nude studies. They also suit all types and speeds of film and lighting conditions, though the effect can be particularly evocative when combined with the coarse grain and pastel colours of ultra-fast film and warm light.

These filters work by bleeding the highlights into the shadows, so the effect is most obvious on backlit scenes or subjects against dark backgrounds. You needn't limit yourself to these situations alone, however, as they can work wonders in all kinds of conditions, and are without doubt the most versatile of all creative filters.

To vary the strength of diffusion, set your lens to different apertures – the wider the aperture (the smaller the f/number), the stronger the effect, so an aperture of f/2.8 or f/4 will show a stronger effect than f/16 of f/22.

Starburst filters

When placed over your lens, this filter will turn bright points of light, or intense highlights, into twinkling stars with anything from two to sixteen points, depending on the filter that you buy. When used on the right subject, the results can look really effective. For example, try it on Christmas illuminations, Christmas trees, the setting sun, a candle flame, urban night scenes and so on.

For the best results, use the filter on scenes where the lights or highlights are quite small – a Christmas tree covered in tiny lights being a good example – because it makes the stars themselves quite subtle. Use it when you are photographing the setting sun, or any other large, single point of light, however, and the effect can be very garish, with a huge star streaking across the image. Another option is to rotate the filter in its mount while making an exposure, so that you get circles of light rather than stars.

Starburst filters are just pieces of glass or optical plastic with lines etched in them – the more lines criss-crossing, the more points the stars have. So instead of buying one, you could make your own by etching lines on to a piece of clear plastic or an old skylight filter.

Diffraction filters

These work on the same lines as the starburst, but instead of stars, bright points of light are turned into colourful streaks or haloes that contain all the colours of the spectrum – different diffractors give different results.

The effect works well on night scenes that contain bright lights or illuminations, but in this case, the fewer lights the better, otherwise you won't be able to see the scene for the filter effect. Smaller points of light also create smaller haloes or streaks. Again, try rotating the filter during exposure to obtain a different effect.

This pair of pictures below shows how a sunset filter can be used to enhance the warmth of photographs taken at sunset. The effect is very obvious, but without the unfiltered shot as comparison you wouldn't really know that a filter had been used.

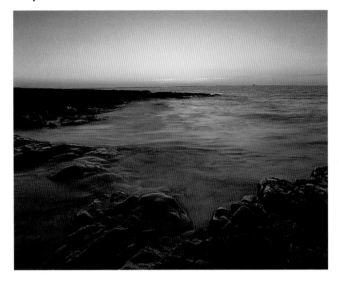

Unfiltered.

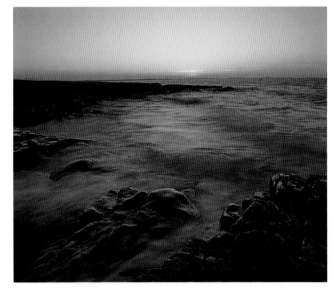

With sunset filter.

RIGHT **Soft focus filters are ideal for all manner of low-light subjects – for this windowlit portrait, a weak filter was used to add a gentle level of diffusion that flatters the subject's skin tones beautifully.**

Multiple image filters

These filters work by producing a number of repeated images of whatever you point your camera at. The most common have a hole in the middle through which your main subject is seen, and then a series of prisms around it which create the multiple image effect – anything from three to 25, depending on the filter you buy. Linear versions are also available, where half the filter is empty and the other half contains a series of prisms side by side to repeat your subject across one half of the picture.

For the best results, these filters should be used on a standard or short telephoto lens – 80-100mm – and at apertures no smaller than f/8, so that the border between each image blurs nicely rather than being sharply defined. Keep your compositions simple and frame a single, bold subject such as a neon sign, a face or a candle flame.

Coloured graduates

Coloured graduates do the same job as neutral density graduates, except that they also add colour to the sky instead of leaving it natural. A wide range of colours is available too, from tobacco, pink and blue to green, mauve and red.

They should be used in exactly the same way as their neutral cousins, although you need to exercise a greater degree of caution, otherwise the effect can look over the top. Subtle colours such as pink and blue are ideal for livening up dull skies, while the warmer colours can be used to make the sky at sunrise or sunset look more attractive, but things like tobacco and mauve have become something of a standing joke.

The main problem with coloured grads is that if you use them to brighten up dull skies, the rest of the scene can easily end up looking worse that it did before. Some photographers overcome this by using a second coloured grad upside-down, to colour the foreground. It might sound bizarre, but the effect can look incredibly good on the right type of scene.

USING FILTERS TOGETHER

As well as using filters individually, many can also be added together to give interesting results. For example two or more technical filters can be combined, such as a grey graduate and a warm-up, a technical filter and a creative one such as a warm-up and a soft focus, or two creative filters such as a soft focus and a starburst. It all depends

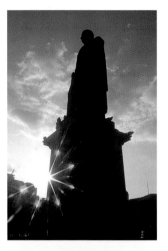

RIGHT **This picture, taken in London's Trafalgar Square, shows the effect a diffraction filter has, turning the sun – which was partially obscured by the statue – into a colourful star.**

BELOW **Starburst filters work well on night scenes outdoors, turning every point of light into a twinkling star. For this picture of Christmas illuminations in a town centre, an eight-point starburst was used.**

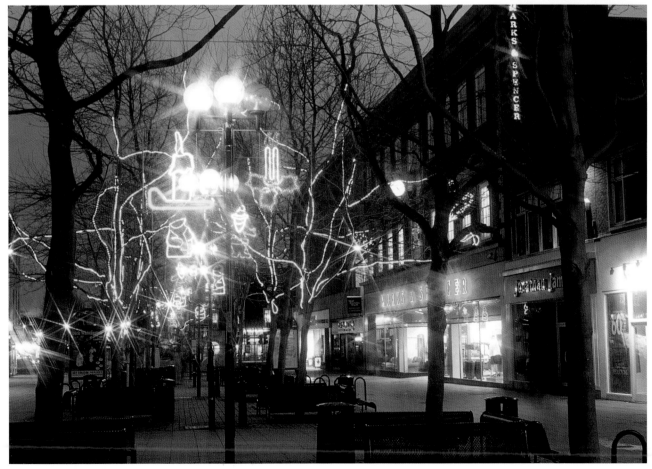

on what type of subject you are photographing and the effect you are trying to achieve in your picture.

The key is to think about which filters you combine, otherwise the effect can look ridiculous. You must also remember that the more filters you use together, the more the image quality will be degraded, so keep numbers to a minimum, and keep your filters clean so that the risk of flare is reduced.

FILTER FACTORS

Most filters cause a light reduction when placed over your lens, so the exposure must be increased accordingly to compensate. If you are using a camera with integral metering, and a meter reading is taken with the filter in place, this light loss will be taken into account automatically, so you don't have to change anything. However, if you use a handheld meter to take a reading, or you take a meter reading with your camera before fitting the filter, you will need to make the necessary increase to the exposure so as to prevent your pictures coming out too dark.

The amount of exposure increase varies depending on the filter. Some require no adjustment, but most do. Below is a listing of all the filters discussed in this chapter, and the degree of exposure increase they require.

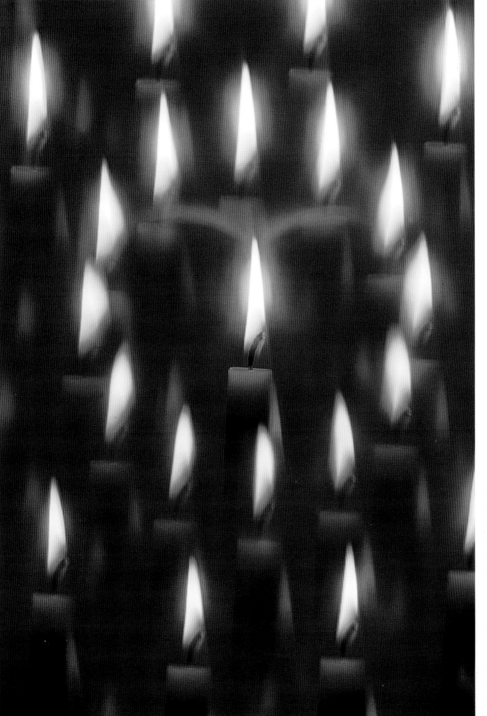

FILTER TYPE	EXPOSURE INCREASE (IN STOPS)
COLOUR CORRECTION	
81	$\frac{1}{3}$
81A	$\frac{1}{3}$
81B	$\frac{1}{3}$
81C	$\frac{1}{3}$
81D	$\frac{2}{3}$
81EF	$\frac{2}{3}$
82	$\frac{1}{3}$
82A	$\frac{1}{3}$
82B	$\frac{2}{3}$
82C	$\frac{2}{3}$
COLOUR CONVERSION	
80A	2
80B	$1\frac{1}{3}$
80C	1
80D	$\frac{1}{3}$
85	$\frac{2}{3}$
85B	$\frac{2}{3}$
85C	$\frac{1}{3}$
CREATIVE FILTERS	
Soft focus	0
Diffractor	0
Starburst	0
Coloured graduates	0
Sunset (normal)	$1\frac{1}{2}$
Sunset (strong)	$2\frac{1}{2}$
ND (grey) grads	0
ND 0.3	1
ND 0.45	$1\frac{1}{2}$
ND 0.6	2
ND 0.9	3
ND 1.2	4

A multiple image 25 was used here, to turn a shot of a single candle flame into an eye-catching, creative image. The flame in the centre of the frame was the real thing – the rest are repeated images of it.

FLASHGUNS

The electronic flashgun is a much underrated piece of equipment. For many photographers it's regarded merely as a last resort – something that provides extra light in situations where available light levels are insufficient – which is why it tends to be used mainly for snapshots at parties and special events, but little else. However, in creative hands, even the simplest flashgun can produce breathtaking results and be used as the basis of many specialist low-light techniques both indoors and out.

These techniques, which include slow-sync flash, multiple flash and painting with light, will be covered in detail later in the book. But before turning to them, you first need to learn a little more about the humble flashgun and how it works, so that you can put that knowledge to good use.

FLASHGUN TYPES

The main way in which flashguns differ is in their mode of operation, as this will determine how much – or how little – control you have over what they are doing. The three main types to consider, in order of simplicity, are manual, automatic and dedicated.

MANUAL FLASHGUNS

This is the most basic flashgun type or mode of all. The gun always delivers a fixed amount of light, firing either at full power on simpler models, or at a predetermined output if the gun has a variable power facility – and a chart or scale is usually provided to tell you which lens aperture to select to give correct exposure at a given film speed and flash-to-subject distance. Therefore, the only control you have is:

• To vary the speed of film you use – by using faster film you can set a smaller lens aperture, and by using slower film you can set a wider aperture at any given flash-to-subject distance.

Once you understand how your flashgun works, it can be used to create a wide range of special effects in low-light situations. This action-packed picture shows slow-sync flash, which involves combining a burst of flash to freeze a moving subject with a slow shutter speed to record blur.

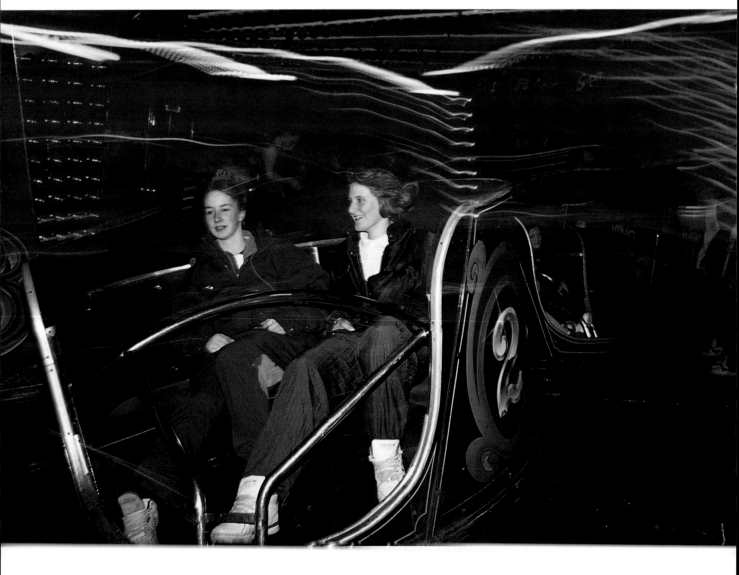

• To move the flashgun physically – closer to your subject if you want or need to use a smaller lens aperture; further away if you want or need to use a wider lens aperture.

• To reduce the amount of light coming from the flashgun by covering up the flash tube so that the light is diffused. A white handkerchief over the tube will roughly halve the light output, allowing you to set a wider aperture or work from closer range. Some modern flashguns also have a variable power output in manual mode, or a variable guide number (same difference), so you can select full power, 1/2 power, 1/4 power and so on.

That said, because each burst of flash delivers a consistent amount of light, manual flashguns, or flashguns set to manual mode, can be the most versatile for low-light flash photography – especially in situations where you need to use multiple flash bursts, want to use the gun off-camera and fire it with the test button, or need to be able to choose precisely when during a long exposure the flashgun is fired.

AUTOMATIC FLASHGUNS

At the next level come automatic flashguns, or flashguns with an automatic mode.

This system works by providing the user with a selection of 'auto aperture settings'. All you do is set the gun to one of its auto apertures, set your camera lens to the same aperture, and correct exposure will be provided automatically within a given flash-to-subject distance range. This is made possible by a sensor on the flashgun which measures the amount of light reflected back from your subject and automatically quenches the flash when sufficient light has been delivered.

The versatility of this type of flashgun depends mainly on the number of auto aperture settings it offers. If there are only one or two, then you're going to be fairly limited, but sophisticated, powerful guns may offer five, six, even seven auto settings, from f/2.8 to f/22, making them far more useful.

Automatic guns are particularly good for flash techniques such as fill-in and slow-sync, because you can easily 'fool' them into delivering less light by varying the flash and lens settings.

DEDICATED FLASHGUNS

At the cutting edge of flash technology you'll find dedicated guns, which are designed to be used with a particular make and model of camera. Dedicated guns made by the major camera manufacturers, such as Nikon, Canon and Minolta, can only be used with their respective range of 35mm SLRs, but independent manufacturers such as Metz produce dedicated flashguns that can be used with a wide range of different SLRs by fitting special dedicated adaptors that contain the correct array of electrical contacts.

Dedicated flashguns work by linking up directly to a camera's metering system, so that perfectly exposed pictures can be taken quickly and easily. Levels of dedication vary, but the norm today is for you to be able to fit the flashgun to your camera's hotshoe, set your camera to program mode and fire away. The camera automatically sets the correct flash sync speed and lens aperture, and the flash delivers just enough light to give correct exposure. Many dedicated flashguns even have an infrared beam which helps autofocus lenses to focus in total darkness.

The level of control you have depends entirely on the camera/flash combination. With some models you can't override a

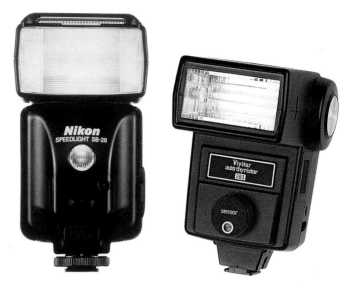

Modern dedicated flashguns such as the Nikon SB28 shown offer all the features and modes that you will ever need to produce stunning flash pictures in all situations. That said, if your budget is limited, an auto/manual flashgun such as the Vivitar 283 can be just as versatile for many low-light subjects and techniques, and was used for many of the flash pictures that appear in this book.

single thing, while with others there is flash exposure compensation so that you can control the flash exposure and bias it towards a particular effect; variable power output so that you can vary the effect the flash has – setting it to 1/2 or 1/4 power for fill-in, as an example – and so on. Dedicated control can also be obtained in any automatic or semi-automatic exposure mode, be it program, aperture priority or shutter priority.

When you need to take flash pictures quickly and without much thought, dedicated flashguns are undoubtedly worth considering. They're also ideal for combining a burst of flash with a long exposure when you want to photograph, for example, a person standing in front of a floodlit building. But for specialist flash techniques such as multiple flash and open flash, they can be just too clever for their own good, simply because they take much-needed control out of the photographer's hands. And unless you buy a model that offers things like variable power output and auto' fill-in, you will soon find it very limiting for low-light photography.

THE IDEAL FLASHGUN....

Taking all these factors into account, a picture of the ideal flashgun is beginning to emerge, though much will depend on your budget.

If money is no option and your main priority is buying a flashgun that will suit all picture-taking situations, not just low light, then a dedicated gun with automatic and manual modes as well can't be beaten as it will give you complete control. The latest models offer an incredible range of features, many of which can be used in dedicated, automatic and manual modes, and will help you take perfectly exposed pictures no matter how demanding the conditions.

If your budget is limited, look at automatic models that have a manual mode as well. I use a Vivitar 283, which is an auto/manual gun with a very affordable price tag. This model has changed little in 20 years, but it continues to be a favourite because it's so reliable. There are also many other comparable models available.

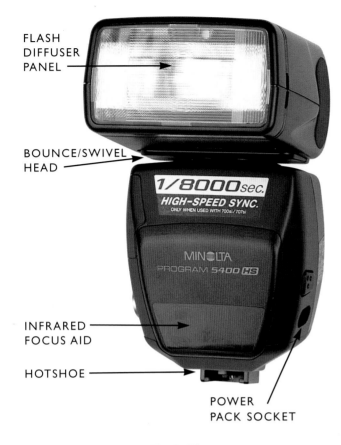

FLASH
DIFFUSER
PANEL

BOUNCE/SWIVEL
HEAD

1/8000sec.
HIGH-SPEED SYNC.
ONLY WHEN USED WITH 700si/707si

MINOLTA
PROGRAM 5400 HS

INFRARED
FOCUS AID

HOTSHOE

POWER
PACK SOCKET

FLASHGUN FEATURES

This section looks at the main features found on modern electronic flashguns. Generally, the more features and modes a flashgun has, the more versatile it will be, though as with most things in life, you don't miss something if you have never been used to it, and an all-manual gun with a basic specification is just as capable as an all-singing, all-dancing model; the main difference is that you have to work a little harder and think about what you're doing, but that is no bad thing.

POWER BUTTON

This button turns the flash on and off. When you first turn it to 'On' there will be a delay of a few seconds while the flash charges up.

FLASH READY LIGHT

Found on most flashguns, this feature tells you when the flash has charged up and is ready for use. On compact and 35mm SLR cameras with integral flash unit, the ready light indicator is usually in the viewfinder, so you know when the flash has charged without taking the camera from your eye. The same applies with most dedicated flashguns when fitted to the appropriate SLR.

EXPOSURE CONFIRMATION

If this light comes on, or changes colour, when the flash fires, it indicates that correct exposure is achieved. An indicator usually lights up in the camera's viewfinder when using a dedicated flashgun, as it does on cameras that have an integral flash unit, so you know if correct exposure has been achieved when a picture is taken.

The confirmation light on the flashgun itself is used in conjunction with a test button (see below), and is a good way of checking that your subject isn't out of range when using an automatic flashgun set to a particular auto aperture setting.

TEST BUTTON

By pressing this button you can trigger the flash manually. It's used mainly in conjunction with the exposure confirmation as a means of checking that the flash will give correct exposure before you actually take a picture. For night and low-light photography it also allows you to fire the flash whenever you like while the gun is off the camera, to combine a burst of flash with a long exposure, or to use multiple flash bursts to build up light levels or create special effects (see page 176).

POWER OUTPUT

A flashgun's power is expressed as a guide number (GN) in metres for ISO100 film; the bigger the number the greater the power. Small, low-powered models and built-in flashguns have a GN around 10 or 12, but a high-powered model will have a GN of 45, 50 or more.

More power means you can use smaller lens apertures and can photograph subjects that are further away from the camera. As flash-to-subject distance increases, the area covered by the flash also expands, allowing you to photograph bigger subjects in a single burst. For this reason, it pays to buy the most powerful flashgun you can afford – a GN from 36 up will be ideal in most low-light situations, and for general use.

BOUNCE/SWIVEL HEAD

This feature allows you to adjust the position of the flash so that it can be bounced off a convenient surface such as a wall, ceiling or reflector to produce more attractive illumination and soften shadows. Bouncing is a handy technique to use when photographing people indoors or when using a flashgun to light a dark interior, because the light from a direct flashgun is very harsh and unflattering. A bounce head isn't essential, however, because you can achieve the same ends by taking the flashgun off the camera's hotshoe and pointing it towards a convenient surface.

Bouncing is easier to do with automatic and dedicated flashguns because any light loss incurred is accounted for automatically to ensure correct exposure. With manual guns, you need to open up the lens aperture by 1 or 2 stops.

SYNC SOCKET

If you want to use a flashgun off the camera, but still connect the two together so that the flash fires when you trip the camera's shutter release, the flashgun must have a socket into which you can plug a flash sync lead. Most flashguns have this facility, but some do not. If your flashgun doesn't, you will need to buy an off-camera shoe adaptor which slips on to the gun's base and provides a socket for a sync lead. Equally, not all cameras have a polarity connection (PC) socket which allows you to plug a flash sync lead into the body. If yours doesn't, you will also need a co-axial adaptor which slips on to the camera's hotshoe and provides a PC socket.

ZOOM HEAD

This handy feature allows you to adjust the angle-of-coverage of the flash to suit lenses with different focal lengths. The range usually covers lenses from 24mm or 28mm to 85mm or so, and when used with longer focal lengths effectively increases the guide number of the flashgun by narrowing down the angle-of-coverage so that the flash travels further.

Although not essential, it's a handy feature to have if you use on-camera flash a lot to photograph people.

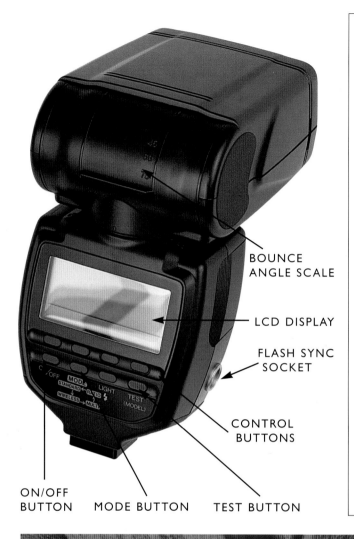

BOUNCE
ANGLE SCALE

LCD DISPLAY

FLASH SYNC
SOCKET

CONTROL
BUTTONS

ON/OFF
BUTTON MODE BUTTON TEST BUTTON

HAMMERHEAD OR HOTSHOE?

The two main flashgun designs to consider are hammerhead and hotshoe, both of which could offer any of the three modes discussed earlier (manual, automatic and dedicated), depending on the model you buy. Neither offers any great advantage over the other from a user point of view.

Hammerhead flashguns, by the nature of their design, are bigger and heavier, but the way they fit on the side of the camera rather than above it can improve handling, with the flashgun providing an ideal grip and the weight not making the camera feel top heavy.

Hammerhead guns traditionally also tend to be more powerful than hotshoe models, so if you're looking for a model with lots of ooomph, chances are it will be this type that attracts your attention.

Electronic flash is ideal for close-up photography indoors or outdoors in poor weather. In either case, low-light levels mean exposure times are usually very long. The need to work at small lens apertures such as f/16 or f/22 to maintain sufficient depth-of-field also adds to the problem. By using flash as your main source of illumination it will not only allow you to set a small aperture, but also use a relatively fast shutter speed – dependent on your camera's flash synchronisation speed – while the brief pulse of light from the flashgun will freeze any subject or camera movement.

VARIABLE POWER OUTPUT

Being able to control the power output of your flashgun means you have full control over its effect on a picture. When using fill-in flash, for example, variable power allows you to alter the flash-to-ambient (existing) light ratio according to what you want – you can have the flash and ambient light equal, or at a ratio of 1:2, 1:4 and so on. The same applies with slow-sync flash where a flash-to-ambient ratio of 1:2 normally gives the best results.

These ratios can be achieved using an automatic flashgun, by 'fooling' it into giving less light, but life is made much easier if you can simply press a button and dial in the power output you require. Flashguns with this facility usually give you a choice of anything from full to 1/16, 1/32, even 1/64 power.

RED-EYE REDUCTION

The most common problem encountered when taking flash pictures of people, particularly in low-light situations with the flashgun on your camera's hotshoe, is red-eye. This is caused by light from the flashgun bouncing back off the retina in your subject's eyes, causing them to glow bright red.

Some flashguns have a red-eye reduction mode which is designed to eliminate the problem. This is achieved by either firing a series of weak pre-flashes or shining a light in your subject's eyes before the main flash fires – the aim being to reduce the size of the pupils. Whether or not they work depends on the flashgun being used, and the situation you are using it in. Low light increases the risk of red-eye because our pupils dilate considerably so we can see, and a red-eye reduction feature may not reduce their size sufficiently If this proves to be the case, refer to pages 165–166 for other ways of eliminating the problem.

The brief pulse of light from a portable flashgun is fast enough to freeze the fastest movement. Here the moto-cross rider was travelling at 65kmph, possibly more, but that posed no problems for my Vivitar 283 gun.

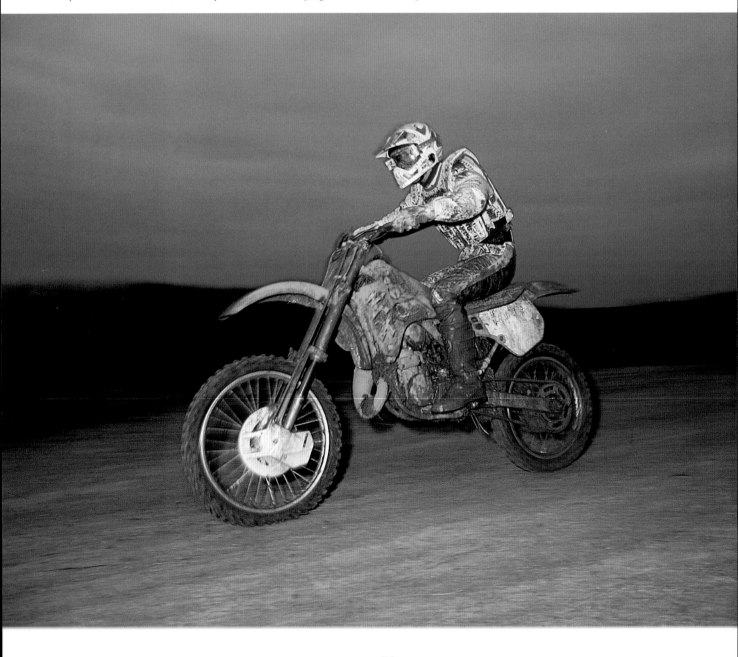

STROBE MODE

Although found on only a few of the more highly specified portable flashguns, a strobe mode will fire the flash many times per second. This allows you to create amazing multiple flash effects in low light by capturing a moving subject – such as a person swinging a golf club or jumping through the air, or a hammer falling towards a nail – several times on the same frame of film.

In some cases, it is possible actually to program the flash to fire a certain number of times over a specified period of time, thus giving you complete control.

MOTORDRIVE MODE

Some modern flashguns can be programmed to fire at the same rate as a motordrive, allowing you to take flash-lit pictures at three, four and five frames per second. This is ideal for capturing rapid action sequences with flash in low light, though unless you do a lot of reportage or paparazzi-style low-light photography it's unnecessary.

RECYCLING TIME

This is the time it takes for a flash to charge after being fired. Modern automatic and dedicated flashguns use thyristor circuitry, which stores unused power from the last flash to reduce the length of time it takes to recharge the gun for the next flash. Because auto and dedicated guns quench the flash when enough light has been

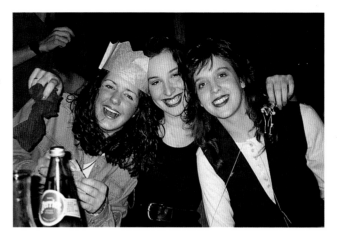

Red-eye is a common problem when using flash in low-light situations, so do everything you can to avoid it.

delivered they are also economical with power, whereas manual guns fire on full power all the time and take longer to recharge. With fresh batteries, recharging time is kept to a minimum. Some of the bigger guns also use Nicad packs instead of batteries to provide more power and shorter recycling times.

FLASH SYNC SPEED

The vast majority of 35mm SLRs and medium-format cameras have a maximum shutter speed at which electronic flash can be used, known as the flash sync speed. This varies from camera to camera – for example, my Pentax 67 has a flash sync speed of just 1/30 second, whereas on some modern 35mm SLRs it's as fast as 1/250 second.

This limit is set because of the way the camera's focal plane shutter works. When you press the shutter release to take a picture, the shutter's first 'curtain' opens to allow light through to the film; then to close the shutter again, a second 'curtain' follows it. Imagine a curtain being opened to let light in through a window, then a second curtain being drawn over it again soon after. Obviously, the faster the shutter speed you're using, the sooner this second curtain begins its travel across the shutter gate to end the exposure.

The flash sync speed is the fastest shutter speed at which the whole shutter gate is open when the flash fires. You can also use slower shutter speeds than the flash sync speed, but if you use a faster shutter speed with flash, part of the picture will be blacked out because when the flash fires, the shutter's second curtain has already begun its travel across the shutter gate.

There are a few exceptions to this with 35mm SLRs. If you use the Olympus OM4-Ti with the Olympus T280 flashgun, for example, flash synchronisation can be achieved at all shutter speeds. The same applies with the Minolta 5400HS flashgun used on the Minolta Dynax 600si or 700si cameras. Camera systems that use a leaf shutter in the lens rather than a focal plane shutter in the camera body can also give flash sync at all shutter speeds. This category includes all large-format and many medium-format cameras.

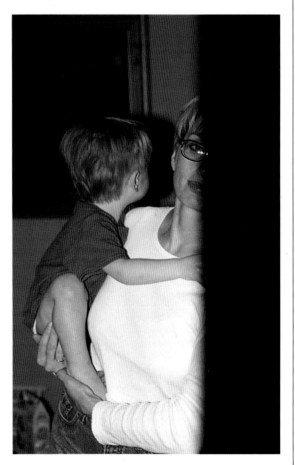

This is what happens if you take a flash picture at the wrong sync speed – part of the image is blacked out.

USEFUL ACCESSORIES
SYNC LEAD

If you want to use an electronic flashgun off the camera's hotshoe, it must be connected to the camera to provide synchronisation when the shutter release is tripped to take a picture.

The easiest way to do this is with a sync lead, which simply links the camera and flash together via their sync sockets. If you have a dedicated camera, buy a dedicated sync lead so that full control between the camera and flash is maintained. It's also a good idea to

buy a long rather than a short lead, so that you can use the flash quite a distance from the camera – for closer range, excess lead can be gathered up and secured with a piece of sticky tape.

There are one or two 35mm SLR and dedicated flashgun combinations that provide wireless remote flash control, so you can use the gun off-camera and trigger it using a controller on the hotshoe rather than a sync lead. One example is the Minolta 5400HS flashgun with the Minolta Dynax 600si or 700si camera and remote wireless flash controller module.

SLAVE UNIT

If you want to use more than one flashgun to take a picture in low light, you need to ensure that they all fire at the same time when the camera's shutter release is pressed.

One way of doing this is to buy a multiple sync adaptor into which two, three or four flashguns can all be plugged using a sync lead on each. However, a much more convenient method is to fit one flashgun to your camera's hotshoe, or connect it to the camera with a single sync lead, then fit a slave unit to each of the remaining flashguns that are being used.

A slave unit is basically an electronic 'eye' which fits to the foot of a flashgun or plugs into its sync socket and automatically fires the flash when it picks up light from the flashgun that is connected

Techniques such as painting with light, where a flashgun is fired many times to illuminate part of a low-light scene, rely on a fast recycling time, so a separate power pack is well worth considering (see page 59). For this landscape shot, the flash had to be fired 15 times to illuminate the rocks in the foreground.

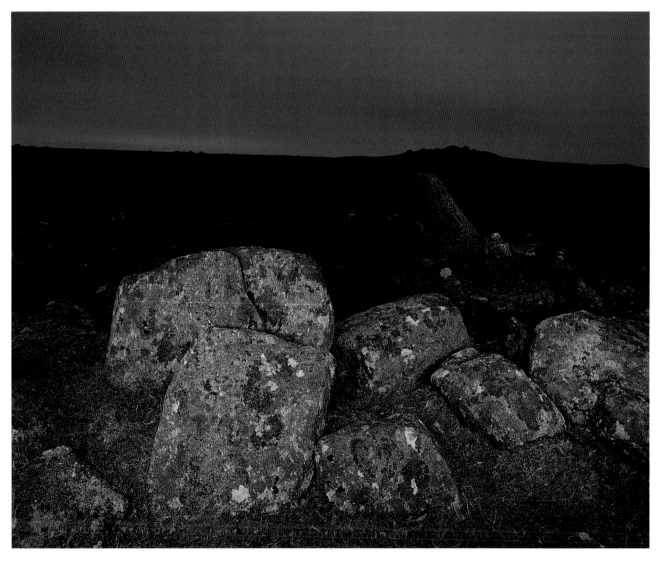

to your camera. So you can synchronise as many extra flashguns as you like.

The simplest slave units have an operating range of about 30m, but more sensitive models are available that will trigger the flashgun they're fitted to at a range of 900m or more from the camera. This means you could set up a flashgun to light a distant feature in a night or low-light scene and trigger it from the camera's position by placing a second gun on the hotshoe.

SLAVE FLASHGUN

As an alternative to slave units, you could buy a flashgun that already has a slave unit built in. A range of models is available, with prices and power outputs to suit all budgets and needs, though the most popular slave guns tend to be inexpensive, low-powered models that are used to supplement a main hotshoe-mounted flashgun.

They're ideal for taking flashlit pictures of building interiors, as you can position several flashguns to illuminate certain areas.

POWER PACK

If you use flash a lot for low-light photography, especially multiple flash techniques that require several bursts in quick succession, it's worth investing in an independent power pack for your flashgun.

The best-known brand available is Quantum, and there's a range of different battery packs to fit just about any make and model of flashgun. The most powerful pack, the Quantum Turbo, will recharge your flashgun six times faster than normal AA alkaline batteries. That can make a huge difference when you're using a flashgun for painting with light techniques (see page 176), as it reduces the delay between each flash and makes life much easier.

FLASHMETER

If you find yourself using more than one flashgun on a regular basis, it might be worth investing in a flashmeter, which you can use to measure precisely the output of each gun and determine correct exposure. Many hand-held lightmeters can be used for flash as well as ambient light, but there are also several flash-only meters available at very reasonable cost.

FLASH DIFFUSER

The light from a hotshoe-mounted flash is very harsh and unflattering, creating bright highlights and deep shadows. If you regularly take pictures in this way, particularly of people, you should therefore consider fitting an attachment to the gun that will diffuse the light and produce a more flattering, attractive form of illumination.

There are many different flash diffusers available, from simple translucent plastic covers that clip over the tube, to mini softboxes which soften and spread the light (see top right). All do a similar job, some better than others it has to be said, but anything is better than a bare flash.

One thing all these diffusers have in common is that they cause a light loss. If you are using a dedicated or automatic gun, and in the latter case the sensor isn't obscured, this will be taken into account so you don't have to adjust the exposure. With manual flashguns, however, you need to set a wider lens aperture than normal to prevent underexposure – this may be anything from 1 to 3 stops, depending on the type of diffuser being used. Take a few test shots to determine this.

With a long sync lead, you can take the flashgun off the camera and vary its position in relation to your subject to produce different lighting effects. For this amusing portrait, the flash was placed under the subject's chin to create eerie lighting on her face.

USING YOUR FLASHGUN

For advice on how to use your flashgun for specific techniques, refer to the pages listed below:

Slow-sync flash – pages 144, 145
Painting with flash – pages 176–179
Multiple flash – page 140
Bounced flash – page 174
Avoiding red-eye – pages 165–166

USEFUL ACCESSORIES

With your photographic bag or case packed full with cameras, lenses, filters, film and a flashgun, you're almost ready to head off for a low-light photography adventure. But before doing this, there are a few accessories and gadgets worth filling those last remaining spaces with, that could make your life a whole lot easier.

CABLE RELEASE

If you are working with your camera mounted on a tripod – as you will be in probably 95 per cent of low-light situations due to the need for long exposure – the shutter release should be triggered with a cable release rather than your finger. By doing this the risk of camera shake will be eliminated, because you can fire the shutter without touching the camera, whereas if you use your finger there's a high probability of the camera moving at the moment of exposure, resulting in unsharp pictures.

The likelihood of this happening is also increased a hundred times when you're using the camera's B setting, and the shutter release has to remain depressed for the duration of the exposure. Trying to do this with your finger without moving the camera is like trying to keep a hand-grenade squeezed together after removing the pin so that it doesn't explode – the longer you do it for, the harder it gets.

There are two main types of cable release available. If your camera has a threaded hole in the shutter release button you will need a traditional 'plunger' type release, while modern SLRs tend to have a socket somewhere on the body into which an electronic release is plugged.

With the latter, as well as basic electronic releases that allow you to trip the camera's shutter and lock it open on the B setting, some camera manufacturers also produce more sophisticated releases which can be programmed to lock the shutter open for a specific length of time – up to 10 hours in the case of the Nikon MC20 release – via an LCD and control buttons. They're obviously more expensive, but invaluable for some aspects of low-light photography that require very long exposures, such as capturing star trails.

With either type, choose a release that's 40–50cm long so that it can be used without you hovering over the camera, and make sure it has a lock facility so that once the shutter is triggered when using the camera's B setting, you can lock the release and let it go, instead of having to keep your finger on the plunger or button for the duration of the exposure – this can be very tiresome when using exposures of a minute or more.

NOTEPAD AND PEN

TORCH

SPIRIT LEVEL

LENS HOOD

SPIRIT LEVEL

Judging whether or not your camera is perfectly square when taking pictures in low light can be tricky, usually because there is no obvious reference point in the scene which you can rely on.

To overcome this, use a spirit level. Many tripods have one built into the head, but if yours doesn't, you can buy a small hotshoe-mounted spirit level which slips onto the camera's accessory shoe on top of the pentaprism and provides an instant check for levelness.

NOTEPAD AND PEN

If you are trying a low-light technique for the first time, or taking pictures in situations you have never encountered before, it's always a good idea to make notes of things like meter readings, exposures used, flash setting and so on. That way, if the pictures don't come out the way you expected – perhaps they're all underexposed or half of them are overexposed – you can refer to your notes and try to figure out exactly what went wrong.

SPARE BATTERIES

There's nothing worse than the batteries in your camera or flashgun dying on you just as you are in the middle of taking a great photograph. To prevent this, always carry at least one spare set of batteries so that you can swap them over if necessary.

Batteries tend to drain faster in low temperatures, so a cold night outdoors increases the risk of this happening. If you are taking pictures in cold conditions, keep the spare batteries in a pocket close to your body so that they remain warm.

LENS HOODS

If you are photographing night scenes that contain bright lights, particularly at close range, there's a high risk of flare being created. This is usually caused by light glancing across the front of your lens or bouncing around inside the camera, and either leads to patches or streaks of light appearing on your pictures, or creates an overall haze which reduces contrast and makes colours look washed out.

If the lights causing the flare are visible through the viewfinder, there may be little you can do to avoid flare. However, if it is being caused by lights that are just out of shot, you may be able to prevent it by fitting a hood on your lens.

Many telephoto and zoom lenses come with a hood attached or supplied, but for wide-angle and standard lenses you will need to buy one. Collapsible rubber hoods are ideal as they cost little and take up minimal bag space. The main thing to remember is you buy the right hood for the right lens. A hood for a 50mm lens used on a 28mm or 24mm wide-angle will cause vignetting (cut-off), where the corners of the pictures come out dark because the lens can see the edges of the hood. Similarly, a wide-angle hood used on a telephoto lens may not provide sufficient protection.

Keeping your lenses and filters free from dust and greasy fingermarks will also reduce the risk of flare.

CABLE RELEASE

SPARE BATTERIES

PIECE OF CARD

TORCH

As well as being invaluable for painting with light techniques (see pages 178–179), it's also worth carrying a small torch so that you can see what you're doing when taking pictures outdoors at night. There's nothing worse than trying to find some small accessory at the bottom of your gadget bag in darkness, or wanting to check camera settings and not being able to see them.

A pocket-sized torch will overcome both these problems, and help you find your way back to the car if you are shooting landscapes at night in the middle of nowhere.

PIECE OF CARD

For some low-light techniques involving the use of your camera's B setting, it may be necessary to interrupt the exposure if a lull in the action occurs – while waiting for more traffic to appear if you are capturing traffic trails, or while more fireworks are launched if you are photographing an aerial firework display, for example.

The easiest way to do this is by carrying a piece of card – it needn't be any bigger than 20x25cm – so that you can hold it in front of the lens to prevent light reaching the film while the shutter is open, then remove it when you want to resume the exposure.

CAMERA SUPPORTS

By its very nature, night and low-light photography usually involves working at relatively long exposures compared with most other subjects. Instead of using shutter speeds measured in hundredths or thousandths of a second, exposure times often run into many seconds, even minutes. Consequently, if you want to produce pin-sharp pictures and have full control over your choice of film speed and lens aperture, your camera will need to be supported in some way to prevent it moving while an exposure is being made.

This is no great revelation, and many photographers do it as a matter of course, it's just that with low-light photography it becomes essential rather than optional.

RIGHT **High-quality tripods like this Manfrotto model are ideal for night and low-light photography, and should provide years of trouble-free service as well as shake-free pictures.**

BELOW **A sturdy, solid tripod is the most useful accessory you can buy for night and low-light photography, allowing you to produce pin-sharp pictures no matter how low the light is and no matter how long the exposure is. So test various models before making a decision, buy the very best you can afford, and most important of all – use it.**

TRIPOD

Of all the camera supports available, nothing beats a solid, sturdy tripod. With your camera fixed to one of these, exposure times become irrelevant: seconds, minutes, hours – it doesn't matter how long you need to keep your camera's shutter open, because if it's perfectly still you will still get a pin-sharp image.

The biggest mistake photographers tend to make when buying a tripod is choosing a model that tries too hard to compromise between weight and stability. Lightweight tripods may be convenient to carry around, but they can be surprisingly unstable, especially in windy weather or when using telephoto or zoom lenses, and I have seen literally hundreds of pictures taken by enthusiasts with flimsy tripods that would have been sharper if they had actually handheld the camera. Equally, there's little point in going to the other extreme and buying a tripod that's so big and heavy you just can't be bothered to take it with you. Some kind of middle ground must be found, then, between a tripod that's strong enough to keep your camera and longest lens rock steady, but is compact and light enough to carry around everywhere.

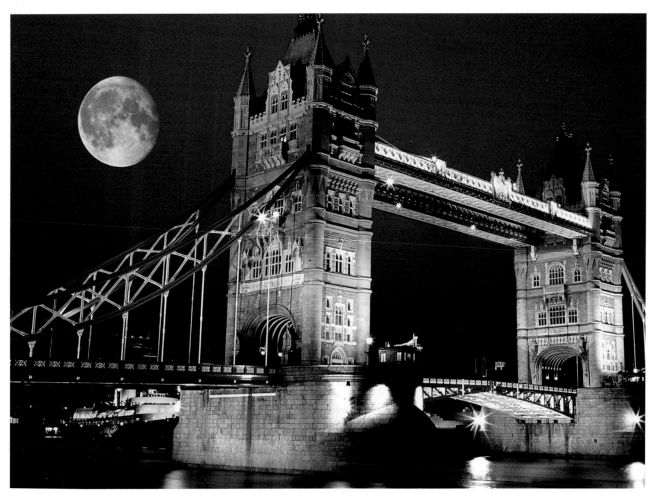

The first step in achieving this is to stick with reputable brand names, especially those that tend to be chosen by professional photographers, such as Manfrotto, Gitzo, Benbo and Slik. You may pay more for the privilege, but what you end up with will be a tripod that should last a lifetime and be reliable in all situations.

It is better to spend double what you expected on a solid, well-made tripod, than half as much on a flimsy model that needs replacing after a few months.

You can also stack the odds of making a successful purchase in your favour by considering a few important factors.

• The tripod legs should have strong locks on them (see left) so that the leg sections are totally solid when extended.

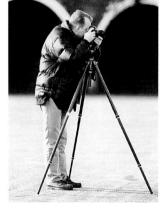

• The tripod should be able to extend to eye level (see right) without needing to use the centre column, which is one of the weakest parts of the tripod.

• Centre-bracing for the legs increases stability but at the same time can be restrictive, because on uneven ground it is important to be able to adjust each leg independently.

• Check the head for wobbles which could lead to camera shake. Big, heavy tripod heads are a much better bet than smaller, lightweight ones because they provide a more stable platform for the camera.

• Many photographers prefer heavy-duty ball-and-socket heads (see left) to traditional pan-and-tilt heads because they have fewer areas of weakness and are therefore more stable.

• Some manufacturers, including Gitzo and Velbon, produce carbon-fibre tripods which are considerably lighter than their alloy counterparts but match them for stability. They also cost at least double the price, but if weight is an issue then they are well worth considering.

USING YOUR TRIPOD

Once you have found a tripod that suits your needs, and budget, the battle is almost won. However, you won't get the best performance from your tripod if you don't use it properly, so here are a few top tips:

• Always make sure the tripod is perfectly upright – a leaning tripod is an unstable tripod.

• Erect the tripod on solid ground. Spongy surfaces are unsuitable as they can easily lead to vibrations. Pushing the tripod legs down to solid ground can overcome this if you're working in undergrowth which creates a tangled barrier.

• Always extend the fattest leg section first as this is the strongest, and make sure that all the leg locks are secure, otherwise the tripod could start to tilt.

• If you are using long lenses that have their own tripod socket, use it and fix the lens to the tripod head rather than the camera body (see right). This will spread the weight of the camera and lens more evenly to reduce the risk of shake, and take the strain off the camera's lens mounting, which could be damaged by the weight of the lens. If you use long lenses that don't have their own tripod sockets, accessories are available which you can fit to the tripod and which help to support the lens.

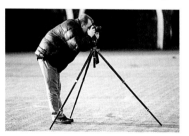

• Never extend the tripod's centre column unless you need to. Achieve the desired height by extending the legs first.

• Don't extend the tripod higher than you need to, and don't splay the legs too wide to reduce height as this can lead to instability.

• In windy weather, increase the stability of your tripod by hanging your gadget bag from the centre column to lower its centre of gravity (see left). Alternatively, carry a mesh or canvas bag that you can hang from the tripod, and fill it with stones to do the same job.

• Always trip the camera's shutter with a cable release when it is tripod mounted. This prevents you having to touch the camera and risk causing vibrations which lead to unsharp pictures.

• Give your tripod a regular service to ensure everything is working properly. Fixings can wear loose and cause wobbles so they should be checked and tightened periodically, while controls on the head should be lubricated so that they work smoothly and freely.

• Get into the habit of using a tripod at all times so that it becomes a natural part of the picture-taking process rather than a hassle – your pictures will improve dramatically.

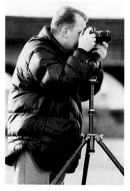

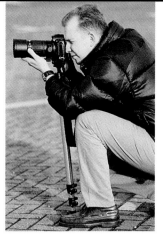

ALTERNATIVE SUPPORTS
COMPACT TRIPOD

As a back-up to your main tripod, a smaller model is well worth considering for use in those situations where the size and bulk of anything bigger would be inconvenient.

Photographers are not normally allowed to use tripods in most stately homes, certain cathedrals and public buildings, for example, because they are thought to be cumbersome and could annoy other visitors, but a pocket tripod is far more likely to be accepted, and you could set it up on any available platform such as a wall, banister or tabletop. Outdoors, a pocket tripod could also be set up on a convenient wall or post, or even the roof or the bonnet of your car.

Compact tripods obviously don't offer the convenience of a full-sized model, but if you use them properly it's surprising how effective they can be, so you can take pictures in low-light situations where handholding is out of the question.

MONOPOD

Sport and action photographers favour monopods, because they provide lots of support for long telephoto lenses, but considerably more freedom of movement than a tripod. However, this one-legged accessory can also be invaluable for low-light photography, especially in situations where you don't need the kind of support a tripod can offer or are unable to carry one, but light levels are too low to handhold the camera. These include taking pictures inside buildings or outdoors at dawn or dusk, photographing indoor sporting events, or concerts and plays. On the one hand, a monopod will allow you to use long lenses at shutter speeds slower than you could get away with if you were handholding – the rule-of-thumb when handholding is to use a shutter speed that at least matches the focal length of the lens. On the other, it can provide enough stability for you to take pictures with short-focal length lenses at exposures up to 1/8, 1/4 even 1/2 second.

This can be invaluable for landscape photography in bad weather or low light, freeing you from the need to carry a heavy tripod but providing sufficient support for you still to set small lens apertures, to give extensive depth-of-field without worrying about slow shutter speeds causing camera shake. A monopod is also ideal for capturing street life, allowing you to move around much more quickly than you could with your camera on a tripod.

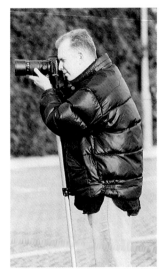

To help you get the best performance from a monopod, here are just a few tips on how to use one:

• If you are standing up, extend the monopod so that the camera is at eye-level without you having to lean forward. Do not over-extend the monopod so that you have to strain to see through the camera's viewfinder.

• Always extend the monopod starting with the fattest leg sections as they are the strongest.

• For extra stability, especially with long lenses try crouching down so that one knee is resting on the ground, then lower the monopod to your lower eye level.

• Whether you are standing up or crouching down, pull the monopod close to your body and hold the camera with your legs slightly apart rather than close together. This is the most stable stance.

• You can increase the stability of a monopod by making use of things like posts and pillars. Pull the monopod in towards the side of the post, and with long lenses wrap your left arm around the post so that the camera is pulled in tight. You can then support the front end of the lens with your left hand cupped beneath it.

CHEST OR SHOULDER POD

These devices rely on your own body stability, but like a monopod they can be highly effective, allowing you to use much slower shutter speeds than would be possible if you were simply hand-holding the camera.

Chest pods work by securing the camera at eye level and have supports or a brace which rest on your chest, so that by pulling the camera towards you it becomes much more stable. Shoulder pods, on the other hand, work rather like the stock of a rifle – the camera is secured in place, then the pod is pulled into your shoulder and the camera is held in the normal way. They are particularly useful for long lens photography.

CLAMPS

A range of different photographic clamps is available, from basic vice-like designs to contraptions with adjustable arms. All serve the same purpose, in that they allow you to set up your camera literally anywhere – on the branch of a tree, secured to a partially opened car window, tabletop or ledge, and so on.

Clamps are ideal in low-light situations where a tripod would take up too much space or simply wouldn't fit, and can also be used for wildlife photography outdoors at night, allowing you to set up your camera close to a favourite perch or roost, for example, so the camera can be fired remotely from a distance.

Equally, these clamps can be used to position flashguns as well as cameras. Furthermore, if you want to illuminate parts of a building interior by setting up flashguns out of sight of the camera, they are particularly versatile.

SUCKER PODS

This handy accessory has a rubber sucker plate on the base and a small ball-and-socket head on to which your camera can be attached. The base can then be suckered on to any flush, smooth surface such as a tabletop or window, so that the camera can be set up in awkward spots.

A more novel use which some photographers take advantage of is to clamp the sucker on the bonnet of their car so that the camera is pointing back towards the windscreen, then take long exposure photographs while driving along a road at night, or through a tunnel, so that the lights record as colourful streaks passing over the car and reflecting in its shiny bonnet. The shutter can be tripped while driving using a long cable release trailed along the side of the car and through the driver's window.

Naturally, there is a certain risk attached to this technique – if the camera falls off the car while you are driving at speed it is almost cer-

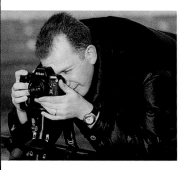

tain to be damaged beyond repair – but the pictures that result can be amazing, so it's well worth trying. You could also attach a flashgun to the camera so that it lights up the car when you trip the shutter. If you are worried about the sucker pod coming lose and falling off the car, try securing it with tape as a safety measure.

HANDHOLDING YOUR CAMERA

Although there's no substitute for a sturdy tripod if you want to be sure of keeping your camera completely steady, in some low-light situations the use of one may be neither convenient nor possible, and the only option is to take the picture handheld.

The rule-of-thumb when handholding is to use a shutter speed that at least matches the focal length of the lens: 1/30 second with a 28mm or 35mm lens, 1/60 second with a 50mm, 1/250 second with a 200mm, 1/500 second and with a 500mm and so on. This is not only because longer focal length lenses are generally more difficult to hold steady due to their increased size and weight, but also because the longer the focal length, the more that camera shake is emphasised.

Saying that, providing you hold the camera properly, with practice it is possible to take pin-sharp pictures at much slower shutter speeds than these – down to 1/15 second or 1/8 second with short focal-length lenses such as wide-angles and standards.

• The first step is to make sure the camera is held firmly in your

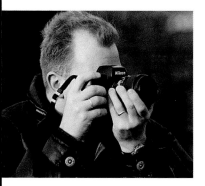

hands. The easiest way to do this is by gripping the right side of the camera body with your right hand, so that the right index finger falls naturally on the shutter release button. Meanwhile, the left hand should be cupped under the lens so that you can support it and, in the case of manual focus cameras, focus at the same time. If you

MAKESHIFT SUPPORTS

If you don't have a purpose-made support at your disposal, it's usually possible to find something else that can be pressed into service whether you're indoors or out. Walls, gates, posts, fence, the frame of an open car window, the back of a chair, your car bonnet and many other things are ideal, so if you're in a situation where you need more support than your hands can provide, have a quick look around and something is bound to turn up.

To increase the stability of a makeshift support you should ideally place something on it that will cushion your camera or lens. Many photographers carry a purpose-made or home-made 'beanbag' for this very task, which is usually just a fabric bag filled with dried peas or polystyrene balls. Alternatively, use a rolled-up sweater or jacket to cushion the lens.

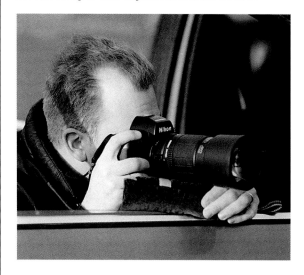

Here the photographer is using a small beanbag to support his telephoto lens on the frame of an open car window.

are using a long lens, the left hand should support it at the middle or towards the front end, depending on which you find most comfortable. Avoid cupping the lens at the rear, as the weight towards the front will put a strain on your wrist and increase the risk of camera shake.

• Next, adopt a stable stance. Do this first by tucking your elbows into your sides so that your arms form the two sides of a triangle and your chest the base. Next, stand with your back straight and your legs slightly apart – so that your feet are as far apart as your shoulders. Do not lean backwards or forwards, as this will reduce stability and increase the risk of camera shake. If your camera has a shoulder strap, it can help if

you wrap this around your left or right wrist so that it pulls the camera into your hands.

The best time actually to take a photograph when handholding is just after breathing out, so your body is relaxed, and you should do this by gently squeezing the shutter release button rather than stabbing at it with your index finger.

If you find that this technique still doesn't solve the problem, there are various other methods you can use:

• Look for a convenient post, pillar or tree trunk and jam the camera against it. This can provide an extremely stable support, and with short focal-length lenses will allow you to shoot at shutter speeds down to 1/4 or even 1/2 second.

• With long telephoto or zoom lenses, try crouching down so that your right knee is resting on the ground and your left knee is upright. You can then rest your left elbow on your left knee.

• Lying flat out with both elbows resting on the ground to support the camera and lens can also work well, though the low viewpoint this gives you may not be suitable.

BELOW **If you practise, handheld pictures can be taken at surprisingly slow shutter speeds without a hint of camera shake – in this case, 1/15 second was used to photograph a shopping centre.**

LIGHT & EXPOSURE

UNDERSTANDING LIGHT

Think of any night or low-light subject, and the one thing more than any other that determines the success of a picture is the quality of light. From the warm glow of a flickering candle flame or traffic trails on a busy road, to a floodlit building against the dusk sky or colourful illuminations strung along a seaside pier, night and low-light photography is concerned more with harnessing and exploiting unusual lighting situations that any other. An understanding of the different types of light you are likely to encounter, both natural and artificial, and the factors that influence the quality of light, is therefore important if you are to make the most of each situation.

NATURAL DAYLIGHT

Daylight is an ever-changing force. From the moment the sun rises every morning to the time it sets every evening, the colour, harshness and intensity of the light it generates is forever changing. And although low-light photography only involves working in extremes of daylight, it's surprising just how different that light can be from one minute, one hour, one day or one month to the next.

PRE-DAWN

Before the sun rises, any light hitting a scene is reflected from the sky, which acts like a huge diffuser. This means that the light is soft and the shadows are weak. It also has a steely blue quality, as the colour of the sky – blue on clear days, grey in cloudy weather – influences the colour of the light, and this can be very atmospheric.

Pre-dawn is an ideal time to shoot low-light landscapes. Scenes containing water can be particularly enchanting, especially in calm weather when the surface is mirror-like, and so can wintry scenes covered in snow, mist or thick frost.

City streets have a completely different mood before sun-up, too. The roads are empty of both traffic and people, and an eerie stillness pervades. Street lighting also looks effective in the cold, blue light, adding welcome splashes of warmth.

To emphasise the coolness in the light, use a weak blue filter such as an 82B or 82C, or for a stronger colour cast use an 80-series blue filter. Unfiltered tungsten-balanced film can also be used well at this time of day as it will add its own blue colour cast.

The pre-dawn period begins at different times of day depending on the season. In high summer, first light may occur as early as 2–3am, whereas in winter, 6–6.30am is the time to be outdoors. Above the Arctic Circle, this pre-dawn period of twilight persists all day, because the sun never rises.

Extremes of daylight can produce breathtaking conditions for scenic photography, as this view of Tarbert Harbour in Scotland shows. Taken an hour or so after sunset during midsummer, it captures the beauty and atmosphere of the location perfectly, and illustrates just how important the quality of light is to the success of a photograph.

ABOVE **The cold blue light of pre-dawn has a quality not found at any other time of day, so it's well worth venturing outdoors before sun-up. This scene appears bluer than it did to the naked eye because film is more sensitive to changes in the colour temperature of light.**

BELOW **There are few sights more beautiful than a misty landscape washed with the delicate warmth of light from the rising sun. Spring and autumn are ideal times to take pictures like this, which I captured in southern France.**

SUNRISE

As the sun rises, the quality of light changes dramatically in a very short space of time. Once the sun breaks over the horizon in clear weather, golden rays of light rake across the landscape, adding a warm glow, while long shadows reveal texture. The shadows are also blue because they're lit mainly by skylight, which is still cool, and this contrasts beautifully with the sunlight.

Occasionally, when there is broken cloud in the sky and the rising sun illuminates it from beneath, the light can be magnificent, but in temperate regions it's usually a more subdued affair, and on cloudy days you may only have a minute or two to capture light breaking over the horizon before the sun rises and is obscured by cloud. On cold, misty mornings, the sun may also appear much bigger than normal because its light rays are scattered by the atmosphere. This scattering reduces the sun's intensity, too, so you can look at it without squinting, and photograph it without your pictures suffering from flare.

Sunrise is again an ideal time to shoot low-light landscapes, buildings bathed in the first light of the day, sunlight burning through mist in woodland. The warm glow of first light can also be used for outdoor portraiture.

THE GOLDEN HOUR

Once the sun has risen, light levels climb quickly and low-light photography is no longer possible – outdoors at least – until later in the day. The best time to begin work again is about an hour

ABOVE **Daylight is usually at its warmest during the last hour before sunset, adding a golden glow to anything it strikes and making the most mundane scene appear magical. This photograph of the ancient border town of Berwick-upon-Tweed was enhanced using an 81C warm-up filter to make the light even more sumptuous.**

before sunset, during a period fondly known as the 'golden hour'.

This name is given, as you might have guessed, because the light is warm – the closer to the horizon the sun is, the warmer the light gets. This assumes clear weather, of course; in cloudy conditions the colour and quality of the light will show little change at all.

Sunlight tends to be warmer at the end of the day because the atmosphere is denser, and in urban or industrial areas clogged with pollution, so the light is scattered, much of its blue wavelengths are absorbed, and the redder wavelengths are left to perform their magic.

Everything the light strikes takes on a beautiful golden glow, whether it's a person's face, a building or a mountain, and it's hard not to take successful pictures at this time of the day. The colour temperature of the light is also much lower than it is around midday, so your pictures will come out even warmer than you expected (see page 74).

Shadows are also long again, and rake across the landscape, revealing texture in the flattest of scenes. Those cast by trees, people and lamp posts seem to stretch for miles, creating a variety of fascinating patterns and lines, while the low sun accentuates gentle ripples on sandy beaches and the rough texture of surfaces such as stone walls or tree bark.

SUNSET

Although sunrise and sunset are pretty much the same thing in reverse, you can often tell one from the other when looking at photographs. This is mainly because the warmth of the light is often far greater at sunset than at sunrise due to the effects of atmospheric haze scattering the light, and the fact that the sun sets on a warm earth whereas it rises over a cold one.

The beauty of a setting sun is hard to beat, though its impact is influenced by prevailing weather conditions, and in many parts of the world – especially temperate regions – no two sunsets are the same and it can be impossible to predict what it is going to be like from one day to the next. Visiting a location specifically to photograph

the sunset can therefore be disappointing, but this disappointment is more than made up for by the occasions when everything falls perfectly into place.

What makes sunset appealing for photographers is its versatility. You can use the sun's fiery orb and golden sky as a backdrop to silhouettes one minute, then turn your back and capture the golden glow of its light on buildings, people and scenery the next. Often the sun itself is too intense to include in your pictures, but in urban areas, where pollution clogs the atmosphere, this is less common and you can often capture it sinking towards the horizon. The light also looks much warmer on photographs than it did to the naked eye because its colour temperature is very low.

BELOW **Few photographers can resist a good sunset, and when you look at pictures like this it's easy to see why. You need to act quickly to capture it on film, however, because in a matter of minutes it's all over.**

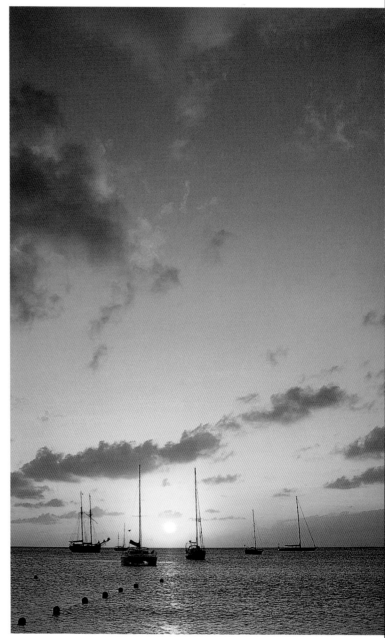

TWILIGHT AND BEYOND

Once sunset is over, light levels begin to drop and the most active period of the day for low-light photography begins.

As during pre-dawn, the light after sunset is reflected solely from the sky, but it tends to be more photogenic because the sky itself often contains a myriad of colours, starting off as a warm glow and gradually fading to pastel shades of blue, pink and purple. This is an ideal time for low-light landscapes or coastal views, and again, scenes containing water are worth pursuing as the colours in the sky are reflected to incredible effect. Light levels are also low enough to necessitate the use of long exposures – 10 seconds or more with slow-speed film – so you can record the movement of people, traffic, water or trees swaying in the breeze.

The first 30 minutes or so after sunset are the best in this respect, but there's more to come, because as the twilight colours in the sky begin to fade back to blue, a period known as 'afterlight' begins.

This is the perfect time to photograph scenes containing artificial lighting, be it floodlighting on buildings, traffic moving along busy roads, or urban street scenes containing everything from neon signs and street lamps to illuminated shop and office windows. That's because the natural and artificial light levels are very similar, so both require the same amount of exposure. If you begin shooting too soon, the artificial lighting won't be obvious enough because ambient light levels are too high, but if you leave it for too long, there won't be enough ambient light around so shadow areas and the sky come out black when you expose for the brighter artificial lighting.

This afterlight period occurs at different times depending on the season. During summer it begins 30–40 minutes after sunset and may continue for upwards of an hour, but during winter it lasts no longer than 20–30 minutes. You can therefore take more pictures and visit more locations in an evening during the summer than you can during the winter, but in winter you don't have to wait so long for afterlight to arrive – at the time of writing, in later November, the sun sets at around 4pm, then afterlight begins at 4.30pm – and by 4.50pm it's all over.

Once light levels fade to a point where the sky appears black to the naked eye, you should stop photographing urban scenes as the difference between ambient and artificial lighting is too great and contrast too high. The main exception is if you are excluding the sky from your pictures and concentrating on details, such as shop windows, people captured in the glow of a street lamp, or neon signs.

That doesn't mean you have to stop shooting altogether, though, because it's still possible to take successful landscape pictures by night. The sky may look black and the scenery monochromatic, but that's simply because our eyes aren't sensitive enough to cope with the low light levels. There is still colour there, however, and if you expose photographic film for long enough, it will record it.

Landscapes pictures taken in such extreme conditions have a surreal quality because they show us something we've never seen before. The light is soft and shadows weak, and the long exposures – of 30 minutes or more – that you will need to use also record movement in everything from clouds drifting across the sky to water flowing and trees swaying.

This approach is rather hit and miss, so don't expect brilliant results straightaway. Some handheld lightmeters can measure light levels so low that an exposure of 30 minutes or more is required, but reciprocity failure must be accounted for (see page 88), and if you are shooting in colour, expect strange casts to appear.

If it is full moon, light levels will be much higher, relatively speaking, and the eerie glow that it casts can be very effective, especially on scenes containing water. Exposures of several minutes will still be required, however, and the moon should be excluded from your pictures as it will be overexposed and its movement will record. During summer, this period of darkness is relatively short, so it's quite possible to continue shooting through the night until first light occurs at 2–3am.

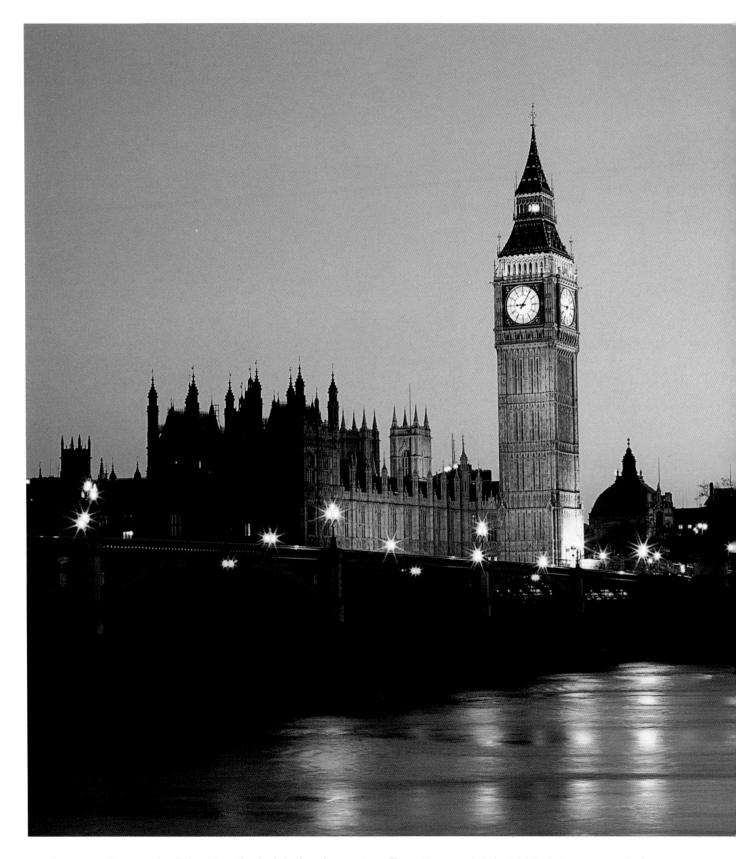

LEFT **Once the sun has set and twilight arrives, the sky fades from fiery hues to a calmer, cooler blue, creating a wonderful colour contrast with the orange glow on the horizon. This Scottish scene was captured at around 10pm in mid-August, using an exposure of 2 minutes at f/22 to blur the motion of the sea.**

ABOVE **The optimum period for 'night' photography usually begins 30–40 minutes after sunset, when daylight levels are low enough to make colourful manmade illumination stand out, but there's still colour in the sky to provide an attractive backdrop. This is more commonly known as 'cross-over' lighting.**

LEFT & RIGHT **These two photographs show the extremes of colour temperature you are likely to encounter when taking night and low-light pictures. The winter landscape scene has a cold, blue cast because cloudy weather conditions increased the colour temperature of the light way beyond the 'average' for which daylight-balanced film is designed. Similarly, the light at sunset has a very low colour temperature – around 2000K – so it creates a golden cast. Both pictures work well in their own way, so don't be too eager to get rid of colour casts until you know what effect they are likely to have.**

THE COLOUR TEMPERATURE OF LIGHT

Variations in the colour of light are referred to as colour temperature, and quantified using a unit known as Kelvins (K) – the warmer (redder) the light is, the lower its colour temperature; the colder (bluer) the light is, the higher its colour temperature.

Normal daylight-balanced film is intended to give natural results in light which has a colour temperature of 5500K. This is typically found around noon or early afternoon in clear, sunny weather and is known as 'average noon daylight'. Electronic flash also has a colour temperature of 5500K.

There is a certain degree of flexibility built into this – if you take photos during early morning or late afternoon, you won't suddenly encounter problems. But once you get into the extreme situations that night and low-light photographers thrive on, your film won't necessarily perform in the way you expect it to.

The main outcome is that colour casts will probably appear on your pictures – casts that you didn't see with the naked eye because it adjusts automatically to make everything look more or less normal, but which photographic film records because it doesn't have that same ability to adjust.

The colour of daylight changes constantly depending on the time of day, the season and the prevailing weather conditions. Similarly, different types of artificial lighting, whether it is tungsten, fluorescent or sodium vapour, each have their own colour which photographic film will pick up.

In some situations, the colour cast created can actually improve a photograph. At sunset, for example, daylight is much warmer than it is at midday, so your pictures will usually come out with a stronger orange or reddy glow than you expected, but it is unlikely you would want to reduce that warmth because by and large it looks attractive – a fully corrected sunset would look decidedly strange. Similarly, if you take a picture at dusk in cloudy weather, it may well come out with quite a strong blue cast because the colour temperature of the light is much higher than earlier in the day. The colour casts created by artificial light source, may not be so welcome, however, so you will need to take steps to get rid of them.

The easiest way to do this is by using filters to balance the colour cast, as explained in Filters on pages 44–45. Pictures taken on daylight film in tungsten light come out with a strong yellow/orange cast, for example, but by using a blue 80A filter you can balance that cast to give a more natural colour rendition. Similarly, the cool cast that you get out of doors in cloudy weather can be balanced with an 81-series warm-up filter such as an 81B or 81C.

The table on page 75 shows the colour temperature of light in a variety of low-light situations, along with the filter you need to use to bring the colour temperature back to around 5500K, either by warming it up or cooling it down.

The thing to remember is that these filters are recommended to give total correction, so in the case of lighting with a low colour temperature, such as tungsten bulbs, all traces of warmth will be removed. As our eyes don't adjust fully to extremes of colour temperature, fully correcting the light photographically would therefore produce rather strange results, so you are advised, if using filters at all, to use one that's a grade or two weaker; where two filters are recommended, ignore the weaker of the two (the second filter mentioned) to retain some degree of warmth.

Where light sources are mixed, as will be the case when you are photographing urban scenes that contain artificial light sources used to illuminate buildings and streets, there isn't much you can do to correct the colour casts they create, because by using a filter to balance one cast, you will introduce its own colour in areas lit by daylight or other sources of illumination. Fortunately, much of the appeal of scenes like this comes from the fact that they contain many different light sources which all produce their own colour, so you probably wouldn't want to filter them out, even if you could.

LIGHTING	COLOUR TEMPERATURE	FILTER REQUIRED	TEMPERATURE SHIFT
Early morning/late afternoon sun	4300K	Blue 80D	+1200K
Orange sun close to horizon	3500K	Blue 80B	+2100K
Golden sunset	2500K	Blue 80C+80D	+3000K
Candlelight or firelight	2000K	Blue 80A+80B	+3400K
Domestic tungsten bulb	2900K	Blue 80B+82C	+2600K
Tungsten floodlighting	3000K	Blue 80A+82A	+2500K
Tungsten halogen lamp	3200K	Blue 80A	+2300K
Photoflood studio light	3400K	Blue 80B	+2100K
Overcast sky	6000K	Amber 81D	-500K
Cloudy sky	0000V	Orange 85	-2100K

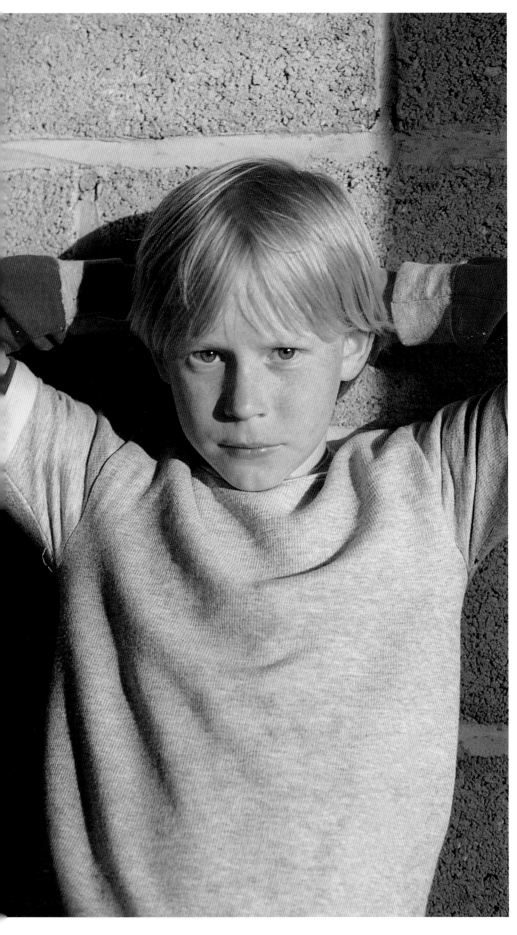

Unfiltered.

With blue 80A filter.

ABOVE **This pair of pictures shows how filters can be used to eliminate or calm down the colour cast produced by domestic tungsten lighting on daylight-balanced film. The unfiltered image shows an obvious orange colour cast, while the filtered version is much closer to how it appeared to the naked eye.**

FLUORESCENT LIGHTING

If you take photographs in fluorescent lighting your pictures will come out with a colour cast – usually green on daylight film. This is because the lamps have a discontinuous spectrum caused by the fluorescers in the tube glowing at different wavelengths.

To get rid of the green cast you have three options. The simplest is to buy a CC30 magenta gel, which will partly but not totally balance any type of fluorescent lighting to give a more natural result. Instead, you could buy a proprietary correction filter – an FL-D for use with daylight-balanced film or an FL-B for use with tungsten-balanced film. One manufacturer (Hitech) even produces an FL-F filter which has been specially designed for use with Fuji film.

Mixed light sources can add extra colour and interest to low-light scenes. In this shot of Bath Abbey, the green cast on the abbey itself is caused by either fluorescent or mercury vapour lighting, while the yellow cast on the buildings to each side is because of tungsten lamps and sodium vapour spotlights.

These filters will only give partial correction, however, and if you want to do it properly you must find out which type of tube is in use, then choose the right filter. The chart on the next page details both. These names are for filters in the Hitech range – other manufacturers may call them something different, so check.

FILM TYPE	DAYLIGHT-BALANCED FILM	TUNGSTEN-BALANCED FILM
Fluorescent lamp	Filter	Filter
Daylight	FL1	FL8
White	FL2	FL9
Warm white	FL3	FL10
Warm white deluxe	FL4	FL11
Cool white	FL5	FL12
Cool white deluxe	FL6	FL13
Unknown tubes	FL7	FL14

DISCHARGE LIGHTING

Although the colour cast produced by incandescent lighting such as tungsten is easy to balance using filters with daylight film (or by using tungsten-balanced film), other forms of artificial illumination are not. Discharge lamps are more troublesome because they work by using electricity to vaporise a metal such as mercury or sodium, so the light produced covers only a narrow band of the spectrum and misses out other wavelengths – sodium vapour burns almost entirely as yellow wavelengths. Consequently, it's impossible to correct them with any degree of accuracy, because by taking out one colour you simply add another, or make the colour cast worse.

The main types of vapour discharge lamps used nowadays are sodium, mercury and multi-vapour. Sodium vapour, common in street lighting and for floodlighting on buildings, comes out yellow, while mercury vapour lamps used in warehouses and industrial plants tend to go blue-green on daylight-balanced film. Multi-vapour tends to be used in places where TV cameras are at work, such as sports stadiums, so it's well balanced and doesn't give a noticeable colour cast.

These colour casts aren't such a problem outdoors, where light sources are mixed in most urban scenes at night, because the colour casts only cover small areas and can add interest to the shot – such as the yellow glow from sodium vapour lamps used for street lighting. Life isn't so convenient indoors, however.

Switching to black and white film is one way out. Using colour negative film is also worth trying, as you've then got the option to try to balance any colour casts at the printing stage, but generally your best bet is to accept things for what they are, unless you are shooting on a small scale and can use flash to provide the main source of light, so that it overpowers the vapour lighting.

USING COLOUR TEMPERATURE CREATIVELY

Once you understand the theory of colour temperature it's possible to experiment with different combinations of film, filter and lighting to create interesting effects, especially where there are mixed light sources.

If you take a picture outdoors at dusk of a house or shop that's lit by tungsten lamps inside, for example, and place a blue 80A filter over your lens, it will add a strong blue cast to the parts of the scene that are lit by daylight, but cool down the warmth of the interior lighting so that it looks natural. This contrast between the warm interior and cold exterior can be incredibly effective. The same effect is possible by using tungsten-balanced film.

Alternatively, use a weaker blue filter such as an 80B or 80C, so that it adds a cool cast to the exterior of the building but doesn't balance the warmth of the interior lighting completely, and then the warm/cold contrast will be even stronger. This effect works particularly well on snowy winter scenes, as the blue cast gives the impression of it being very cold outside while the warmth of the interior lighting creates a welcoming glow from the windows.

Tungsten lighting and electronic flash or windowlight can be mixed to give similar results. If you use a tungsten lamp as illumination for a portrait, for example, and flash or daylight to light the background, by placing a blue 80A filter on your lens or by using tungsten-balanced film, your subject, lit by tungsten, will come out normal while the background, lit by flash or daylight, will be blue. This would look highly effective on a portrait of a person working at their desk under the glow of a desk lamp, while nearby there's a window admitting daylight.

Or why not use the colour shift capabilities of filters in the same way? Blue 80A and orange 85 filters are of equal density and opposing colour, so they effectively cancel each other out. Therefore, if you place one over your camera lens and the other over a flashgun, the areas lit by flash will look normal, because the two filters have counterbalanced each other, while the background takes on the colour of the filter on the camera lens.

The green cast caused by fluorescent lighting is rarely welcome, especially on pictures taken indoors, so it's worth investing in a filter that will get rid of it and produce more natural colour rendition. In this case an FL-D filter was used, and although it hasn't eliminated the green cast completely, it has calmed it down considerably.

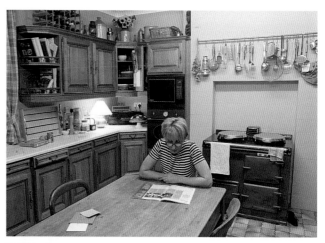

Unfiltered.

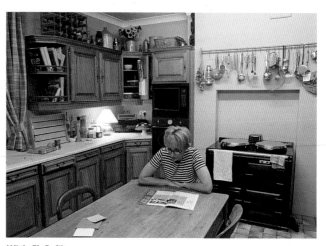

With FL-D filter.

METERING & EXPOSURE

The most difficult aspect of night and low-light photography is not so much dealing with the limited light levels, but making sure you get enough of that light on to the film to produce a correctly exposed picture.

In normal conditions this isn't usually a problem, because as well as being more abundant, the light is also more evenly distributed, so contrast is manageable and accurate metering straightforward. Alas, the same can't be said of most night and low-light subjects, and a more common scenario is to find yourself photographing a scene that contains bright highlights against a sea of dark shadow, or a well-lit subject against a dark background. Whether it's a cityscape at night, Christmas illuminations on a busy high street or a person lit by candlelight, the same ingredients are there, and unless you know how to handle them, there's a high chance that exposure error will result.

That said, things may not be as grim as they might seem. For a start, the same problems tend to crop up time after time, so once you know how to take correctly exposed shots of one low-light subject, you should be able to handle others with the same degree of success. You will also find that many low-light subjects require a similar level of exposure – floodlit buildings, fairground rides, aerial firework displays, landscapes at twilight and outdoor illuminations being good examples – thus making it possible to 'guestimate' with a reasonable degree of accuracy.

UNDERSTAND YOUR METER

The first step in avoiding exposure error is understanding a little about how your camera's metering system works, so that when you use it to take an exposure reading you have a better idea of how it interprets what appears in the viewfinder.

Firstly, all in-camera metering systems measure reflected light – the light bouncing back off a subject or scene – so the reading they give is influenced by how reflective a particular surface is. If you take a meter reading from a landscape scene at twilight, for example, the exposure the camera sets will be very different if that scene is covered in snow, because snow reflects a higher percentage of the light

78

falling on it than green grass does. Similarly, if you photograph a person spotlit on stage at a theatre performance, the exposure your camera sets will be very different if the background is also well lit rather than in deep shadow, because dark colours and shadow areas reflect far less of the light falling on them than lighter colours do.

More importantly, all camera metering systems are designed to correctly expose subjects or scenes that reflect around 18 per cent of the light falling on them. Visually, this can be represented by a mid-grey colour, known as 18 per cent grey.

So, what happens if your subject reflects more than 18 per cent of the light falling on it? Well, give or take reasonable margins, you'll get an incorrect exposure reading because your camera cannot differentiate. So, going back to the above examples, a landscape scene covered in snow will be underexposed because it's much brighter than the typical scene your camera is designed to deal with, while a small spotlit subject against a sea of darkness will be overexposed because the background is much darker than the average scene your camera is designed to deal with. In both cases, your camera sets an exposure that will record the predominant tone as mid-grey, which is why a snow scene is underexposed to make it darker, and a dark background is overexposed to make it lighter.

The thing to remember, also, is that your camera's metering system will base its exposure reading on the most dominant tone. So if you photograph a night scene containing really bright lights, the chances are you'll get an underexposed shot, even if those lights are against a dark background. This is quite a common situation at night,

which is why underexposure is far more common than is overexposure. The exception is when the dark background dominates the scene, and the best example of this is when photographing the moon. Even though the moon is bright, if you take a picture of it sitting in the black night sky, you will get a badly overexposed shot because the dark sky influences the exposure. Try this for yourself by taking a meter reading from the night sky, with a full moon included, using a 100mm or 200mm lens. The exposure suggested will be many seconds in duration, yet a full moon requires an exposure of just 1/250 second at f/5.6 on ISO100 film!

This is obviously an extreme example, but if you think of it when photographing any brightly lit subject that's small in the frame against a dark background, it will hopefully help you to avoid any such exposure error.

When faced by a scene like this, containing extreme levels of brightness and shadow, it's little surprise that many photographers break into a sweat as they try to fathom out how to determine correct exposure. However, after a while you will develop a feel for low-light metering and instinctively know what to do in the most testing conditions. In this case, I used my handheld spot meter to take a reading from the sky to the right of the ornate street light. This gave an exposure of 5 minutes at f/32, but to account for reciprocity failure (see page 88) I opened up the lens 1 stop to f/22, effectively doubling the amount of light reaching the film.

METERING PATTERNS

Modern 35mm SLRs also boast a number of different metering patterns, which are used to measure light levels and determine correct exposure. Some are better than others at doing this, however, so knowing how they work will increase considerably the odds of taking successful photographs.

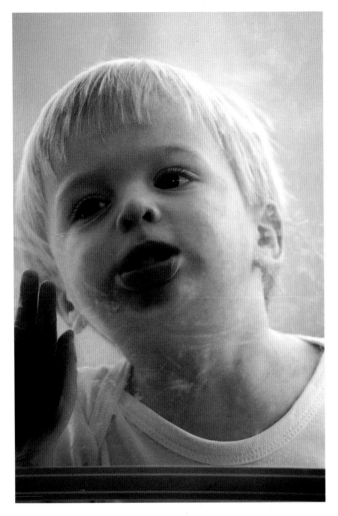

Getting to know how your camera's metering system responds to different lighting conditions, and recognising situations that are likely to cause exposure error, is vital if you want to take successful low-light pictures. In this case, for example, I knew that the bright window behind my subject would cause underexposure, so I increased the metered exposure by 11/2 stops to compensate.

CENTRE-WEIGHTED AVERAGE

This is the most common metering pattern, used as standard in the vast majority of traditional manual-focus SLRs and often offered as an option in more sophisticated autofocus models.

It works by measuring light levels across the whole viewfinder area, but biases the exposure towards the central 60 per cent. As a result, it's particularly susceptible to error in situations where there's a predominance of light or dark tones, such as a small, spotlit subject against the night sky or a person captured against a white wall, and it must be used with care if you are to avoid under- or overexposure on a regular basis when photographing night or low-light subjects.

MULTI-PATTERN METERING

Different makes of SLR have different systems, but all work in a similar way by measuring light levels in different 'zones' of the viewfinder to try to build up a picture of the type of scene being photographed and, hopefully, prevent exposure error. If the zones across the top part of the picture area show light levels to be higher than the bottom part, for example, which is typical when photographing landscapes, the camera will take this into account and try to set an exposure that ensures the bottom part of the shot is correctly exposed.

Despite being clever, however, these systems aren't infallible. If you point your camera at a night scene that contains large areas of darkness, there's still a high risk of overexposure, just as large areas of brightness or intense points of light can cause underexposure.

The key is to try out your own system in different low-light situations and see how it fares. You may get a surprisingly high rate of success, but equally you might not, and the best way to ensure correct exposure at night or in low light is usually by relying on experience and instinct rather than modern technology.

SPOT METERING

There are variations on this pattern, including 'partial' and 'selective', but the basic idea is that it allows you to meter from a very specific part of a scene so that light and dark tones don't influence the exposure reading obtained.

True spot metering is the most versatile of all, as the metering zone usually covers just 1 or 2 degrees, whereas other comparable systems may cover anything from 6 to 15 degrees, depending on the make and model of camera you own; and obviously you can't meter from such a small area.

Any form of spot or selective metering is welcome, however, and in experienced hands can provide the most accurate means of overcoming exposure error there is. If your main subject is surrounded by a large area of darkness, for example, you can meter directly from that subject and ignore everything else.

The main thing to remember is that this type of metering pattern still measures reflected light, so you must meter from a tone that has a similar density to mid-grey and is well lit if you want to get an accurate reading. Meter from something that's lighter than a mid-tone and underexposure will result; meter from something darker and overexposure will result. Overexposure will also result if you meter from a mid-tone that's in shadow, because generally you want to expose the highlights correctly when capturing night and low-light scenes – especially those that contain artificial lighting such as town- and cityscapes, floodlit buildings and so on.

Outdoors there are usually lots of things that equate to a mid-tone – most building materials such as brick, stone, weathered concrete and roof slates; grass and foliage; and so on. If you were photographing a floodlit building such as an old castle or church, therefore, you could take a spot reading from an area that is lit by the artificial illumination – avoiding areas that are too close to the actual light source, as they will be much brighter than the rest of the building and will cause underexposure.

When photographing night scenes that contain a mixture of artificial lighting and ambient (natural) light, blue sky around 30 minutes after sunset will also give an accurate exposure if you take a spot reading from it. This is well worth remembering, as it can provide a quick and easy way of determining correct exposure in situations that may at first appear confusing.

Alternatives

As you can see, spot metering provides the most foolproof way of obtaining accurate exposure readings when shooting in low light. But don't worry if your camera lacks this invaluable facility, as there are two alternatives you can turn to.

Firstly, you could buy a handheld spot meter. There are several models available, and although rather expensive they will soon pay for themselves in film saved if you do a lot of low-light photography. I have a Pentax Digital Spotmeter, and use it more than anything else to determine correct exposure in low-light situations.

Secondly, you could use a telephoto or telezoom lens to meter from a specific part of the scene. Let's say you want to capture a cityscape or a floodlit building on film, and need a 28mm wide-angle lens to get the best shot. After mounting your camera on a tripod and composing the scene through the 28mm lens, just set your camera to manual exposure mode, fit your longest lens – a 200mm or 300mm would be ideal – set it to the same aperture as that at which you'll be taking the final shot, and then take a meter reading from a well-lit mid-tone or the dusk sky, as explained above. All you need to do then is set the required exposure on the camera – or note its length so that you can use the camera's B setting – switch back to the 28mm lens, and fire away. This method isn't as quick and convenient as using a pukka spot meter, but it can be just as accurate.

With other metering patterns, such as centre-weighted average and multi-pattern, you will soon get to know what their strengths and weaknesses are in low-light situations and respond accordingly to avoid exposure error. For this reason, it's a good idea to keep notes of the exposures you use so that you can compare them with the results and try to fathom out what went wrong if your pictures are badly exposed.

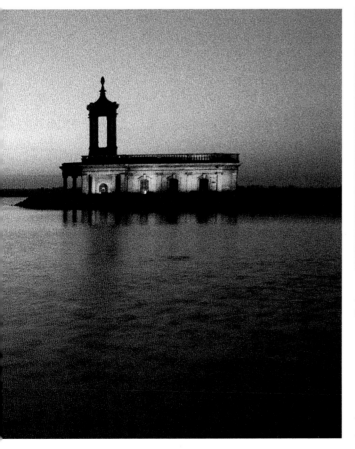

ABOVE **In some low-light situations, your camera's integral metering system can be relied upon to deliver perfectly exposed results with no help from you. This type of scene is a good example, with the exposure being biased towards the sky and sea, so that the castle on the horizon recorded as a silhouette.**

LEFT **Spot metering is ideal for measuring light levels in a very specific part of a low-light scene. Here it was used to take a reading direct from the floodlit church in the distance and ensure that the dark area of water in the foreground didn't cause exposure error.**

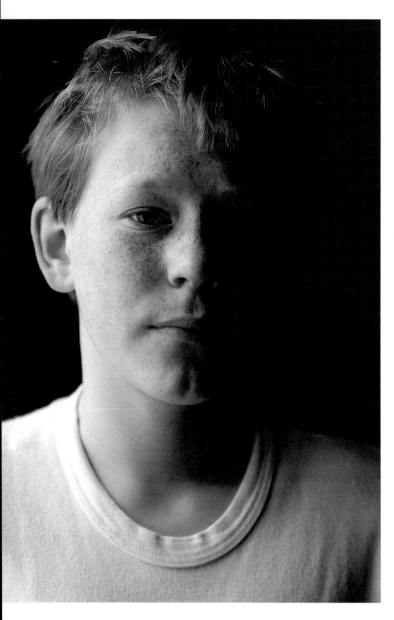

white dome or 'invercone' pointing back towards the camera. With subjects such as portraits and still-lifes you can hold the meter very close to be sure of an accurate reading, whereas with landscapes and other large-scale subjects all you need to do is hold the meter above you, with the metering dome pointing back over your shoulder.

Once light levels have been measured, you will be presented with a range of aperture and shutter speed combinations, any of which can be used to give correct exposure. The one you choose will depend on whether you need a small lens aperture to give extensive depth-of-field and a longer exposure time, or a short exposure and a wider lens aperture. Either way, the aperture and shutter speed are set on your camera in manual exposure mode.

A further benefit of many handheld meters is that they can be fitted with accessories which allow you to take spot readings, as explained earlier, as well as normal reflected light readings; to do this, you simply remove the invercone or slide it to one side so that the metering cell is uncovered. This makes these meters extremely versatile, and capable of giving accurate exposure readings in all low-light situations. They also tend to be more sensitive than a camera's integral metering system, so readings can be taken when light levels are very low – my Minolta handheld meter has a range down to exposures of 30 minutes' duration.

To make the most of a handheld meter, you need to know when to take incident light readings and when not to. Most night scenes containing illuminations are unsuitable, because you are rarely shooting from a position that's in the same light as that actually falling on the scene.

If you were photographing a floodlit building, for instance, the only way an incident reading would work is if you walked right up to the building and held the meter in a pool of light coming from one of the floodlights – which is usually impractical or impossible. Therefore, a reflected reading taken from a well-lit part of the

USING A HANDHELD METER

Many serious photographers prefer to use a handheld meter rather than rely on their camera's integral metering system. This is mainly because traditional handheld meters allow you to measure not only reflected light, like your camera does, but also incident light – the light falling on to a subject or scene.

The main benefit of measuring incident light is that the exposure reading you get isn't influenced by how light or dark the tones are in a scene, so there's less chance of exposure error occurring. If you photograph a person lit by candlelight against a dark, shady background, for example, your camera's metering system is likely to cause overexposure because it is measuring reflected light and will therefore be influenced by the dark background, which has low reflectance and fools the camera into giving more exposure than you in fact need. By measuring the light from the candle flame that is actually falling on to your subject, however, the reading you get won't be affected by the dark background, so the exposure should be very accurate.

To take an incident light reading, all you have to do is hold the meter in the same light that's falling on to your subject, with the

Handheld lightmeters are particularly well suited to subjects such as portraiture and still-life, as you can move in close with the meter and ensure an accurate reading is obtained.

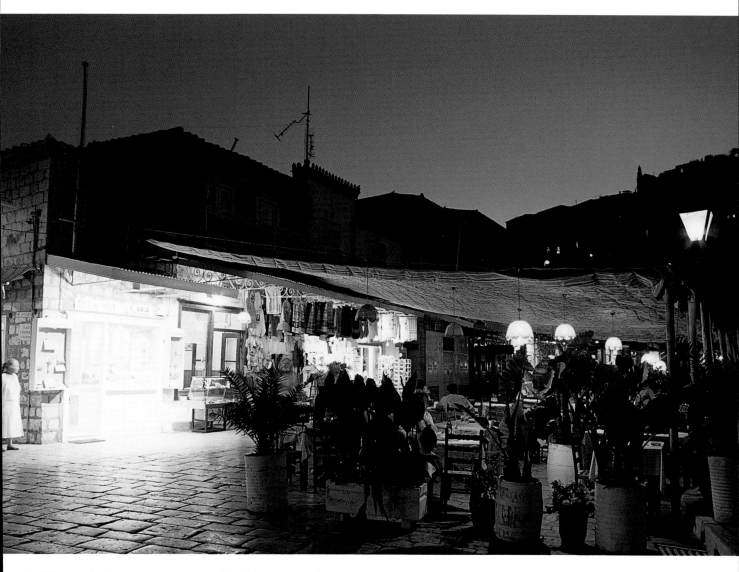

building would be more accurate – especially if it's a spot reading.

Similarly, if you are photographing illuminated signs or a cityscape full of buildings lit by artificial means, you don't actually want to measure the light falling on to them, but the light reflecting back – because it's the reflected light (the artificial light) that gives the scene its colour and impact.

The type of situations where incident light readings come into their own are where it's the light falling on to your subject, rather than the light reflecting back, that is the most important. This includes portraits, still-lifes, nude studies, building interiors, building exteriors, low-light landscapes and so on.

BRACKETING

No matter how bad things get, or how confused a particular lighting situation leaves you, there's always bracketing to fall back on.

This handy technique involves taking a series of photographs of the same subject or scene at exposures over and under the one deemed to be 'correct', thus providing a safety net and ensuring that at least one shot from the set will be acceptable.

The easiest way to bracket is by using your camera's exposure compensation facility. As explained back on page 12, this control allows you to increase or reduce the exposure set by your camera, usually in 1/3 or 1/2 stop increments and by anything from ± 2

In some low-light situations, the brightness range is so high that photographic film simply can't cope and you have to decide which area is the most important. In this shot of a Greek taverna, for example, correctly exposing the bright doorway would have underexposed the rest of the scene, so I metered for the covered seating area and let the doorway burn out.

to 5 stops, depending on the type of camera you have. All you have to do is take your first shot at the metered exposure, then further shots with the exposure compensation facility at the required settings. If you are working in aperture priority mode, the shutter speed will be adjusted when you use the exposure compensation facility, and the aperture you have set the lens to will remain unchanged. Similarly, in shutter priority mode the lens aperture setting will be adjusted when you dial in exposure compensation, and the shutter speed will remain constant.

Alternatively, if you are using a camera in manual exposure mode, you can bracket by adjusting either the aperture or the shutter speed – or a combination of both. With most cameras this method is less versatile, however, as the smallest steps of adjustment are usually 1/2 stops for lens apertures and full stops for shutter speeds. The exception is with modern 35mm SLRs, many of which

offer 1/2 or 1/3 stop adjustment of both apertures and shutter speeds. If you have a more traditional camera and your lenses don't have 1/2 stop click settings on the aperture, simply set the aperture ring so it is halfway between two f/numbers to achieve 1/2 stop adjustment. Don't try this with the shutter speed dial, however, as it could damage the shutter mechanism.

The extent to which you need to bracket depends firstly on the type of film you're using. Colour slide (transparency) film needs to be exposed with great accuracy, so bracketing in 1/2 or, even better, 1/3 stop increments is advised. However, colour and black and white negative film is more tolerant of exposure error, so bracketing in full-stop steps will be fine.

The next consideration is the situation you are in. If you are confident of your metering technique and have taken pictures successfully in similar situations before, then you may only need to bracket one shot over and one shot under the metered exposure. But where you're not completely sure, it's worth bracketing more widely just to be on the safe side. When shooting night scenes, for example, I tend to bracket at least 1 stop over the initial exposure, sometimes two stops, in 1/3 or 1/2 stop increments. If a meter

Timing is crucial when you are photographing scenes that are lit both naturally and artificially. Get it right, and producing well-exposed pictures is made much easier, because contrast is at a manageable level and the difference in brightness between the natural and the artificial lighting is minimal. To determine correct exposure for this scene, a meter reading was taken from the sky.

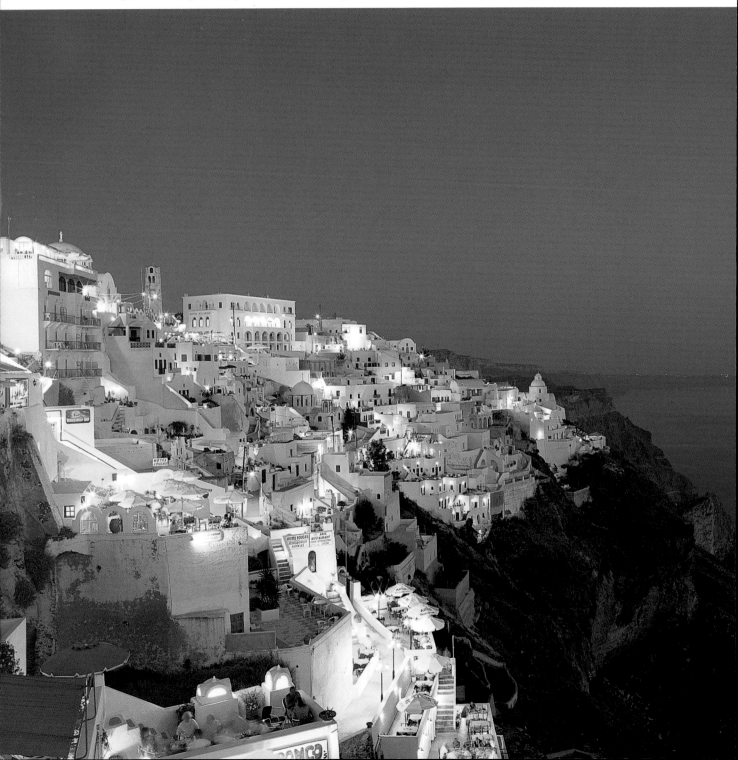

reading indicated an exposure of 10 seconds at f/16, for example, I would shoot one frame at that exposure, then a series of others at 15, 20, 30 and 40 seconds. The risk of underexposure is far greater than the risk of overexposure when shooting night subjects, so I rarely bother to bracket under the metered exposure.

The key is to bracket by just enough to ensure a successful result. Initially this may mean wasting quite a lot of film, but as your experience grows you will be able to reduce the number of frames you shoot and still get perfectly exposed shots.

HANDY EXPOSURE TRICKS

If you find yourself in a situation where light levels are so low that your camera's metering system appears unable to register a reading, there are various tricks you can employ:

• First of all, try setting your lens to its widest aperture to give the meter more light-gathering power. If this gives an exposure reading, you can then backtrack to the aperture you want to use, doubling the exposure each time you move to the next smallest f/number.

For example, let's say you get a reading of 20 seconds at f/4, but you want to take a picture at f/16. The exposure you need at f/16 is 5 minutes 20 seconds – 20 seconds at f/4, 40 seconds at f/5.6, 80 seconds at f/8, 160 seconds at f/11, 320 seconds at f/16.

• An alternative is to try increasing the film speed setting instead of the aperture – your camera may not give a reading at ISO100, but chances are that it will at ISO3200.

The same technique of backtracking is then applied, with the exposure being doubled each time you halve the film speed. So, if your camera meter gives an exposure reading of 15 seconds at f/4 on ISO3200 film, at ISO100 the correct exposure will be 8 minutes at f/4 (15 seconds at ISO3200, 30 seconds at ISO1600, 60 seconds at ISO800, 120 seconds at ISO400, 240 seconds at ISO200, and 480 seconds at ISO100).

• Less extreme is to meter from a white surface and then increase the exposure by 2 stops. Alternatively, meter direct from the brightest light source and increase the exposure by 5 stops. Be sensible about this, of course – you don't want to damage your eyes.

For this colourful picture the photographer took a spot reading from the floodlit church.

If you are in any doubt about which exposure will give the best result when photographing a night or low-light scene, bracket a series of frames over a range of different exposures to be on the safe side. In this example, the first frame was exposed for 45 seconds at f/16, the second for 30 seconds at f/16 and the third for 20 seconds at f/16. Of the three, the first and second frames are both acceptable, while the third is clearly underexposed.

In low-light situations where you can't decide how to determine correct exposure, try the following:

• Hold a grey card in the same light as that falling on your subject and meter from it. Grey cards are available from most good photographic dealers and represent the 18 per cent reflectance for which camera meters are calibrated.

• Meter from a black surface or deep shadow and reduce the exposure by 2 stops.

• If you are shooting low-light portraits or nude studies, move in close to your subject and meter direct from their skin. For Caucasian skin, increase the exposure you get by 1–1 1/2 stops; for dark skin reduce it by 1–1 1/2 stops.

• If there is just one dominant light source in the frame cover it up by placing your finger in front of the lens and then take a meter reading.

NIGHT AND LOW-LIGHT EXPOSURE GUIDE

Below is a chart listing popular night and low-light subjects, with guide exposures for different film speeds. Each low-light situation differs, so the exposures should only be used as a guide, but they will at least tell you if your metering technique is along the right lines. If you use these exposures as a starting point, bracketing at least 1 stop over and under them is advised.

FILM SPEED	SUGGESTED EXPOSURE AT F/16			
	ISO50	ISO100	ISO400	ISO1600
SUBJECT				
Cityscape at night	4 mins	2 mins	30 min	8 secs
Cityscape just after sunset	½ sec	¼ sec	¹⁄15 sec	¹⁄60 sec
Traffic trails on busy road	60 sec	30 secs	8 secs	2 secs
Aerial firework display	60 secs	30 secs	8 secs	2 secs
Floodlit building	30 sec	15 secs	4 secs	1 sec
Neon sign	2 secs	1 sec	¼ sec	¹⁄15 sec
Outdoor illuminations	30 secs	15 secs	4 secs	1 sec
Illuminated shop window	2 secs	1 sec	¼ sec	¹⁄15 sec
Bonfire flames	4 secs	2 secs	½ sec	⅛ sec
Fairground rides	30 secs	15 secs	4 secs	1 sec
Landscape lit by moonlight	60 mins	30 mins	8 mins	2 mins
Landscape at twilight	60 secs	30 secs	8 secs	2 secs
Domestic interior (tungsten)	16 secs	8 secs	2 sec	½ sec
SUGGESTED EXPOSURE AT F/5.6				
Person lit by bonfire flames	4 secs	2 secs	½ sec	⅛ sec
Person lit by candlelight	2 secs	1 sec	¼ sec	¹⁄15 sec
Person lit by bare 100watt lightbulb (tungsten)	1 sec	½ sec	⅛ sec	¹⁄30 sec
Spotlit stage subjects at theatre or circus	⅛ sec	¹⁄15 sec	¹⁄60 sec	¹⁄250 sec
Stage-lit school play	2 secs	1 sec	¼ sec	¹⁄15 sec
Full moon	¹⁄125 sec	¹⁄250 sec	¹⁄1000 sec	¹⁄4000 sec
Crescent moon	¹⁄30 sec	¹⁄60 sec	¹⁄250 sec	¹⁄1000 sec
Museum or gallery	2 secs	1 sec	¼ sec	¹⁄15 sec

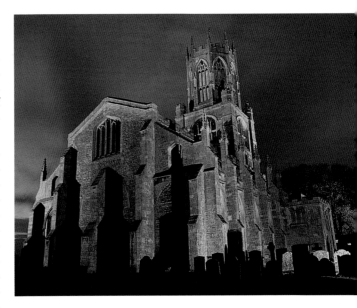

Although the exposure chart at left is intended to provide only a rough guide, after a while you will find that most night scenes require a similar level of exposure. At f/16 with ISO100 film, for example, 15 seconds is usually about right for a floodlit building, and if you shoot further frames at 10, 20, 30 and 45 seconds, you can pretty much guarantee at least one perfect shot without even taking a meter reading.

Obviously, you need to consider the effect you're trying to achieve when interpreting this information. Some subjects, such as traffic trails on a busy road and aerial firework displays, are reliant on a long exposure to produce a successful result, so you should use slow rather than fast film.

Equally, in situations where you need to freeze a moving subject, such as indoor sports or photographing people in candlelight, a faster shutter speed is generally better. Fast film will therefore prove more convenient, and setting your lens to its widest aperture will give the fastest possible shutter speed.

For example, you can see that for a person lit by bonfire flames the suggested exposure is 1/8 second at f/5.6 on ISO1600 film. However, setting your lens a stop wider at f/4 would allow a shutter speed of 1/15 second, and opening up a further stop to f/2.8, a shutter speed of 1/30 second.

EXPOSURE WITH FLASH

The details of various useful flash techniques, such as slow-sync and multiple flash, will be discussed later in the book, but in order to get you thinking along the right lines, they are worth a small mention at this stage too.

The main thing you need to remember when using electronic

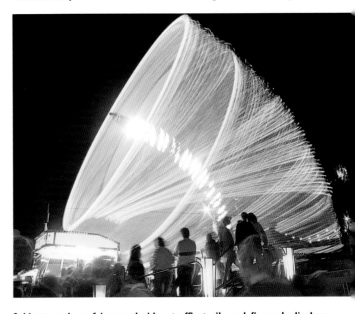

Subjects such as fairground rides, traffic trails and firework displays offer a certain degree of exposure latitude because you are photographing moving elements, so you don't have to be too accurate with the meter reading – 30 seconds at f/16 with ISO100 film is a good starting point.

flash is that it's the lens aperture setting that governs correct flash exposure, not the actual duration of the exposure. It doesn't matter whether you are using an exposure time of 1 second, 10 minutes or 5 hours, if flash is being used to provide illumination, it's the lens aperture that you need to consider. The only limitation here is your camera's flash synchronisation speed, which has already been explained back on page 57. You must not set a shutter speed faster

than the correct flash sync speed, but you can set any shutter speed that's slower than the flash sync speed.

For most low-light flash techniques, especially those involving long exposures, it's best to use a manual flashgun, or to set an auto or dedicated gun to manual mode. That way, it will fire on full power every time, so you know exactly what is happening. In automatic or dedicated mode, the camera and flashgun work together to give correct exposure, but in low-light situations they aren't always very accurate, and you need to take full control.

Calculating the correct lens aperture when using manual flash is very easy – all you do is divide the flashgun's guide number (GN) into the flash-to-subject distance to find the correct aperture, or alternatively, divide the GN into the lens aperture you want to use to find the maximum flash-to-subject distance you can work at. These figures will be correct for ISO100 film, so if you're using slower or faster film, the lens aperture must be opened up or stopped down accordingly.

For example, let's imagine you've got a flashgun with a guide number of 32(m/ISO100), and you want to light a subject – it could be a person, a car, a wall, anything – that's 2m away. The lens aperture required to give correct flash exposure is 32/2=f/16. This is correct for ISO100 film. If you're using ISO50 film, the aperture must be opened up a stop to f/11; but if you're using ISO200 film it must be stopped down 1 stop to f/22.

The alternative approach is to say, OK, I've got a flashgun with a guide number of 45 and I need to use an aperture of f/22 with ISO100 film. What's the maximum flash-to-subject distance I can get away with? The answer is 45/22=2.04m, or 2m.

If your subject is further away than the maximum distance calculated, you can do one of two things. The first is to move closer, in which case the flash might not cover a wide enough area so you will need to move around, firing the flash several times during exposure to light the whole of your subject gradually (see page 176). The second is to stay where you are, and again fire the flash several times to build up the light levels and achieve correct exposure.

With the second option, the number of times you need to fire the flash will depend on how far away you are from your subject. If the maximum flash-to-subject distance you can use for one flash is 2m, as in the above example, you will need to fire the flash twice if you are 3m away, four times if you are 4m away, six times if you are 5m away, eight times if you are 6m away and 16 times if you are 8m away. This works according to the Inverse Square Law, which states that if you double the distance between a subject and light source, the light covers an area four times bigger but at only a quarter of the power, so you need to quadruple the amount of light with each doubling of distance to maintain correct exposure.

You can also calculate the number of flashes required for ISO100 film using the following formula:

No of flashes needed = (GN required/GN of flash) 2

To calculate the GN required, you multiply the actual flash-to-subject distance by the lens aperture being used. So, if you are using a flashgun with a GN of 32 with your lens set to f/16, and your subject is 5m away, the figures are as follows:

GN required = 16x5 = 80
N° flashes needed = $(80/32)^2$
 = 2.5^2
 = 6.25, or 6 when rounded down

Consideration must also be given to any filters that are being used. If you have a filter on the lens that cuts the light by 1 stop, then to maintain correct flash exposure you must double the number of flashes or open up the lens aperture by 1 stop. The same applies if you place a filter over the flashgun.

For a more hands-on explanation of using multiple flash bursts, see pages 176–177.

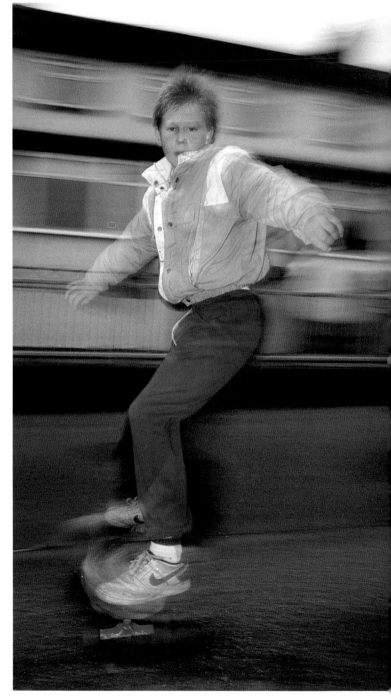

For most low-light pictures taken with flash, getting the exposure correct is easy, even if the end result looks more complicated. For this slow-sync flash picture, for example, the ambient exposure was left to the camera's integral metering system and the flashgun was simply set to an auto aperture 1 stop wider than the aperture on the lens.

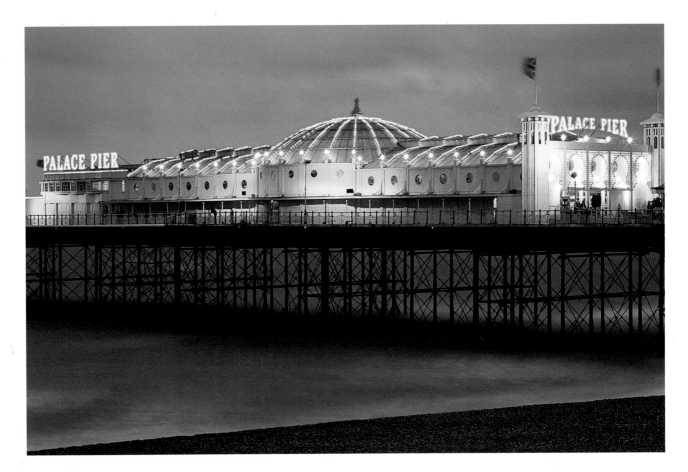

RECIPROCITY LAW FAILURE

Something else you need to consider when taking photographs in low light is a phenomenon known as reciprocity law failure.

Reciprocity is the relationship between shutter speeds and apertures, which allows you to control the amount of light reaching the film in your camera to ensure correct exposure. In other words, in any given situation you can achieve exactly the same exposure using different combinations of aperture and shutter speed: 1/60 second at f/2.8 gives the same exposure as 1/30 second at f/4, 1/15 second at f/5.6, 1/8 second at f/8, 1/4 second at f/11 and so on.

Unfortunately, once you start using exposures briefer than 1/1000 second or longer than 1 second, this relationship begins to break down and reciprocity law failure occurs.

The main outcome of this is that the film becomes less sensitive to light, so you may need to increase the exposure over and above what your lightmeter says is correct.

The precise amount of exposure increase required varies from film to film, though thankfully, film manufacturers publish this information, so if you tend to use long exposures on a regular basis you can correct it quite easily – see the panel on page 90 for the reciprocity characteristics of popular colour transparency films.

Alternatively, you could use a simple rule-of-thumb method, which is what many photographers do: if your lightmeter suggests an exposure of 1 second, increase it by 1/2 stop, if it suggests 10 seconds increase it by 1 stop, and if it suggests 40 seconds increase it by 2 stops. It's also a good idea to bracket a stop either side of this initial exposure with colour transparency film, in 1/3 or 1/2 stop increments, to ensure you get a perfect result.

When compensating the exposure to overcome reciprocity failure you should ideally set your lens to a wider aperture, so that the

Light levels outdoors at dawn and dusk are many times lower than during the middle of the day, so long exposures are inevitable and reciprocity failure must be given careful consideration. For this photograph of Brighton's Palace Pier, a spot reading indicated an exposure of 30 seconds at f/16 on ISO50 film. To compensate for reciprocity failure, however, the lens aperture was opened up 1/2 stop to f/11.5.

duration of the exposure remains the same. Using a longer exposure time to compensate merely increases the effects of reciprocity failure and reduces the chance of you getting the exposure correct.

Also, if you're taking pictures outdoors at dusk, it's surprising how much light levels can drop in the space of a minute or two, so if you're using exposures of that length you will not only need to compensate for reciprocity failure, but falling light levels as well. Again, using a wider aperture to compensate for reciprocity failure will help to prevent this by keeping the exposure as short as possible.

The only time this becomes impractical is when you need maximum depth-of-field to record the whole scene in sharp focus and a small lens aperture such as f/16 or f/22 is essential.

If the metered exposure is 30 seconds or less, increasing its duration to account for reciprocity failure shouldn't cause any great problems, though it's advisable to bracket exposures beyond the one you start with if time permits – outdoors in fading light you may only be able to expose two or three frames of film before the light has gone.

For example, if your lightmeter gives a reading of 25 seconds at f/16 and the film you're using requires a 1-stop increase in exposure to account for reciprocity failure, your initial exposure should be 50 seconds. To overcome the increased effects of reciprocity failure on

such a long exposure, take a series of photographs with exposures of 60, 80, 100 and 120 seconds at f/16.

Another option is to load your camera with a faster film. ISO100 film is a stop faster than ISO50, so using this instead would allow you to work at shorter exposures. You don't want to take this too far, otherwise the drop in image quality you get as film speed increases will create problems of its own, but going from ISO25 to ISO50 or ISO50 to ISO100 should yield acceptable results.

Or why not select a brand of film that requires little exposure increase? The latest colour transparency films from Kodak – Elite Chrome 100, 200 and 400 or Ektachrome E100S and E100SW – require just a 1/3 stop increase for exposures of 100 seconds, while Fujichrome Astia requires just a 1/2 stop increase for exposures up to 120 seconds.

Alternatively, instead of using an increase in exposure to compensate for reciprocity failure, you could have the film push-processed. Pushing film 1 stop has the same effect as doubling the exposure, while pushing 2 stops is equivalent to quadrupling the exposure. So, instead of increasing the exposure by a stop to account for reciprocity, simply use the metered exposure and then have the film push-processed by a stop.

This technique isn't so practical with 35mm film, as it's unlikely you'll use a whole roll of 24 or 36 shots in the same way – which means you'll have to sacrifice the unused film. But medium-format camera users don't have so many shots to play with – just ten for 6x7cm on 120 rollfilm, 12 for 6x6cm and 15 for 6x4.5cm. And for large-format users who work with individual sheets of film pushing is a doddle. Push-processing film makes the pictures grainier and increases contrast, but these side effects are preferable to no picture at all – or one that is badly exposed.

Another side effect of reciprocity failure is that some films suffer from colour casts. These can be corrected with compensating filters – again, film manufacturers will supply the necessary data on request. However, the only time such precise correction is required is when you're photographing subjects such as food or building interiors which require an accurate colour match; for general low-light photography the colour casts created tend to be rather subtle and can actually improve the shot rather than spoil it.

Finally, looking at the table of reciprocity characteristics on page 90 you'll see the letters 'NR' cropping up. This stands for 'Not Recommended', and indicates that the manufacturer suggests you avoid using a particular film at exposures of that duration. If you do, a problem known as crossed characteristic curves may arise, where the highlight and shadows take on strange colour casts. But there's no guarantee this will happen, and there's no law that says you mustn't go into the NR territory, so try it and see what happens. Who knows, you may discover something special.

ABOVE **When you're taking pictures indoors in available light, exposure times are often very long and there's a danger of reciprocity failure causing underexposure. This still-life was taken in the photographer's kitchen using only the light coming in through a door to the left as illumination. Even though the image looks very bright, it required an exposure of 8 seconds at f/8 to produce a correct exposure on ISO50 film.**

BELOW **This sequence of photographs shows the effects of reciprocity failure. All were taken at technically the same exposure, so they should all look exactly the same, but as the duration of the exposure increases, the images become progressively darker due to breakdown of the reciprocal relationship between aperture and shutter speed.**

4 seconds at f/5.6 8 seconds at f/8 15 seconds at f/11 30 seconds at f/16. 60 seconds at f/22.

RECIPROCITY CHARACTERISTICS

Below are the recommended exposure increases to account for reciprocity law failure with a variety of colour films at different metered exposures.

FILM TYPE	METERED EXPOSURE (SECONDS)		
	1	10	100
	EXPOSURE INCREASE IN STOPS (AND FILTRATION)		
Kodachrome 64	+1 (10R)	NR	NR
Ektachrome 64	+½ (5R)	NR	NR
Ektachrome 100	+½ (5R)	NR	NR
Kodak Elite Chrome 100/200/400	None	None	+⅓ (75Y)
Kodak Ektachrome E100S/E100SW	None	None	+⅓ (75Y)
Fujichrome Velvia	None	+⅔ (10 Mag)	NR
Fujichrome Sensia II 100	None	None	+1 (2.5R)
Fujichrome Provia 100	None	None	+1 (2.5R)
Fujichrome Astia	None	None	+½
Agfa RSX 50	None	+⅔ 5B	+1 (10B)
Agfachrome RSX 100	None	+½ (5B)	+1 (10B)

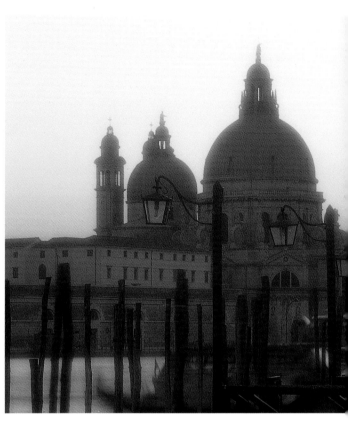

As your experience grows, so will your confidence, allowing you to employ creative metering techniques and think more clearly about how you want a picture to record. Here I used a controlled amount of overexposure to increase the mood and atmosphere of the Venetian scene. No camera on earth can make a decision like that – only the person using it.

The longer the metered exposure is, the more effect reciprocity failure will have. For this low-light landscape, a meter reading from the foreground suggested an exposure of 4 minutes at f/16, but I increased this by 1/2 stop to 6 minutes. The resulting image is acceptable, but another minute or two of exposure wouldn't have gone amiss.

USING EXPOSURE CREATIVELY

If reading through this chapter has filled you with dread, don't worry – things aren't as grim as they seem. There's no denying that taking perfectly exposed pictures at night or in low light is trickier than in bright sunlight, but it's surprising how quickly you will learn to recognise situations that are likely to cause exposure error, and take steps to overcome them. Knowing that you have taken a perfectly exposed shot of a subject or scene that would leave many photographers scratching their heads with confusion is also incredibly satisfying.

The key is to be liberal in your interpretation of the word 'correct'. Exposure is highly subjective, and what's correct technically may not necessarily be the best creative solution to a particular situation. Many night and low-light subjects can also tolerate quite a variation of exposures, so don't be afraid to experiment – better to shoot a whole roll of film and come away with a handful of cracking shots, that only expose half a roll and end up throwing them all in the bin.

The biggest mistake newcomers to night and low-light photography tend to make is not giving their pictures enough exposure. It seems amazing that a scene may need to be exposed for 30 seconds or a minute when you're used to working in hundredths of seconds, but then, long exposures are part and parcel of night and low-light photography – and often a scene will need much more exposure than you think it does to record a wide range of detail.

Finally, remember that when dealing with exposures of many seconds, you don't have to be too accurate with your timing. Exposing the same scene for 25 seconds instead of 20 seconds will have hardly any effect – there's just a 1/4 stop difference in this example. So, if you are using your camera's B setting, counting the exposure in your head is usually accurate enough. Try 'One elephant, two elephants…', or 'One thousand, two thousand…'.

Confidence is the key. The more confident you are, the more risks you take and the better your photography will become.

SUBJECTS & TECHNIQUES

TOWNS & CITIES

Of all the places you can go to take night and low-light pictures, towns and cities provide by far the greatest number of subjects and photo opportunities. As the daylight hours draw to a close in the evening and ambient light levels begin to fade, every street is brought to life under the colour glow of artificial illumination. Floodlit buildings stand out against the ever-darkening sky, traffic rushes along busy roads and neon signs flash their welcome message to passers-by. Dazzling lights reflect in the gleaming bodywork of parked cars or create colourful patterns in puddles and wet tarmac, while the warm glow from shop windows beckons shoppers inside.

Because such things are part and parcel of urban life in the twentieth century, most people take them for granted as they dash to catch their bus home or sit impatiently in queues of rush-hour traffic. But for photographers, towns and cities at night are like an Aladdin's cave – the further you go, the more exciting it gets.

PREPARING TO GO

Before heading for the heart of the city in search of great low-light pictures, a little forward planning is advisable so that your visit goes as smoothly as possible.

THE RIGHT GEAR

First off, spare a thought for the equipment you might need. It's tempting to pack everything bar the kitchen sink, but remember that you have to carry it, and there's nothing worse than dragging a heavy gadget bag around busy streets.

A 35mm SLR is generally the best type of camera to use, as it provides all the features you will need while being compact and highly portable (see page 16). If you intend using two different types of film, be it colour and black and white or fast and slow, it is a good idea to pack two bodies.

In terms of lenses, a range covering focal lengths from 24mm or 28mm wide-angle to 200mm or 300mm telephoto will be ideal. This can be done quite comfortably by a pair of zooms, such as a 28–80mm and 80–200mm or 75–300mm.

Essential accessories include a tripod and cable release, a flashgun perhaps, plus a selection of filters – take starburst and soft focus for creative effects, and colour-balancing filters if you deem them necessary (see pages 44–45).

All these items, with the exception of the tripod, should pack neatly into a relatively small gadget bag and provide a lightweight yet manageable outfit for low-light photography in towns and cities, allowing you to take successful pictures of the full range of different subjects discussed and featured in this chapter.

The Eiffel Tower in Paris is one of the most photographed monuments in the world, and when you see it shimmering like gold against the twilight sky, you can understand why. This shot was taken using a 20mm ultra wide-angle lens on a tripod-mounted Nikon F90x SLR, roughly 40 minutes after sunset. The camera was set to aperture priority mode and exposures were bracketed a stop over and under the metered exposure in 1/3 stop increments. This frame received an exposure of 20 seconds at f/16.

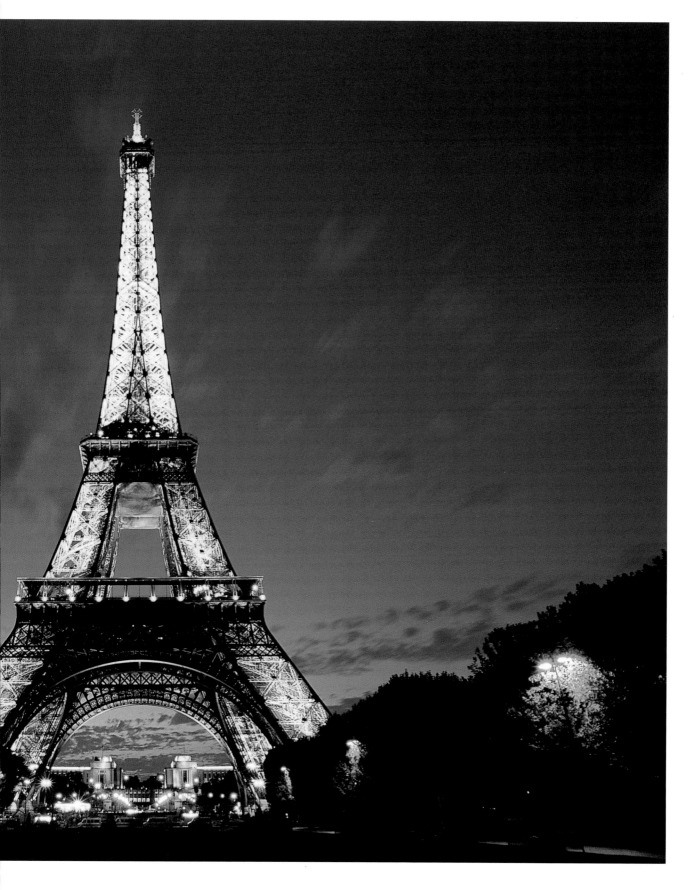

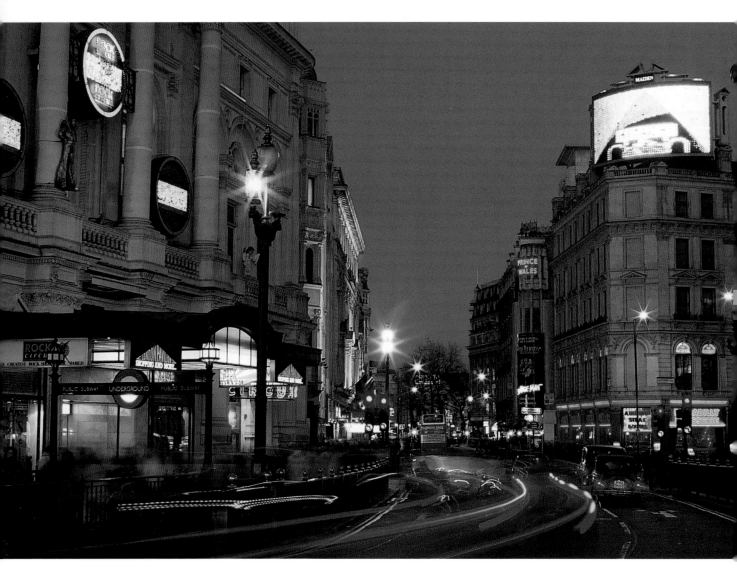

FILM CHOICE

The vibrant colours in low-light urban scenes are best captured using slow-speed film – ISO50-100 – because this gives high-quality, fine-grained images, so make this your priority. Ultra-fast film (ISO1000+) can also be used to take handheld shots in low light, while its coarse grain can provide creative benefits. Pack a few rolls of black and white if you intend shooting in mono as well as colour, and perhaps a roll of tungsten-balanced film to cool down tungsten lighting and add a blue cast to scenes lit by daylight.

Towns and cities at night are full of interesting subjects, so take plenty of film – double what you think you will need. Tricky lighting means you will often be bracketing exposures, and it's surprising how quickly you can eat through a roll of film just on a single scene.

STREET SCENES

Busy streets full of traffic, people and buildings are packed with colourful low-light photo opportunities, and although big cities undoubtedly offer the greatest variety of subjects, even the smallest town can be a source of successful pictures – especially on Fridays and Saturdays, when the shops stay open later and there is so much more activity going on. Seaside towns and resorts are also ideal locations for low-light photography, particularly during the busy summer season when the streets are always packed with people, and

Big cities never seem to slow down, so you can take great night shots on any day of the week. This is London's Shaftsbury Avenue captured late on a Sunday evening. I took the picture from Piccadilly Circus, using a 135mm lens to fill the frame and an exposure of 30 seconds at f/16 to record the colour and action in the street.

the restaurants, cafés and bars add colour to the lively scenes.

As with all urban low-light subjects, dusk is the ideal time to be exploring the streets with your camera, though an earlier recce is advised if you're unfamiliar with the location. This won't be necessary in your home town or city, but if you're on holiday or visiting somewhere purely to photograph it, the more you can familiarise yourself with the location during the day, the better equipped you'll be to photograph it when light levels begin to fade.

Busy shopping streets and squares tend to be where you'll find the greatest concentration of colour and action, especially if traffic has access as well – pedestrianised areas don't have the same impact, and remember that moving objects won't record during a long exposure so you may find that what appeared busy to the naked eye comes out empty and lifeless on film.

Street-level viewpoints can produce excellent shots, especially if you can find a spot to work from such as an island in the middle of

the road where you have a clear view. Busy pavements are less useful, as there's a high risk of your camera being knocked as people try to pass you, and your view will be restricted by heads and bodies.

Wherever you shoot from, put safety first. Avoid standing on the edge of a busy road, or setting your tripod up so that it's half on and half off the road, otherwise you could end up being the victim of a road traffic accident – or causing one because you are obstructing the view of motorists.

Higher viewpoints get round all these problems, so look for cafés and bars with balconies overlooking busy streets, a multi-storey carpark, or a convenient office window – if you ask politely, you may be given permission to shoot from it. Getting on to the rooftop of a building is another option. It's unlikely this will be allowed in the UK, where health and safety regulations are strict, but overseas you may find authority less forbidding. I took some excellent shots in Morocco, for example, from the roof of a hotel overlooking the Djemma el Fna in Marrakech.

If you have an unrestricted view, telephoto lenses between 135mm and 300mm produce the most dramatic shots of street scenes, compressing perspective so that the main elements – people, traffic, buildings – are crowded together in a single composition. Wide-angle lenses are less dramatic because they stretch perspective, so that everything seems more spaced out. This isn't such a problem if there are interesting elements in the scene at close range, such as a floodlit building or parked cars reflecting the colourful lights in their bodywork, but unless you can fill the foreground, or you're working in a confined space where everything is close together, you may well be disappointed with the results.

Whichever lens you use to photograph street scenes, avoid including bright lights in the shot if they are causing flare or ghosting, otherwise your pictures will be ruined. Bright lights just out of shot can also cause flare. This won't be evident when you look through the camera's viewfinder, but you'll see it clearly when the pictures come back from the processing lab.

Exposure-wise, there are no magic formulas here, because every street scene differs depending on what's in it, how much lighting there is and so on. I tend to use one of two approaches. More often than not, I set my camera to aperture priority mode, select quite a small aperture such as f/11 or f/16, and then leave the camera to determine the exposure time required. As most street scenes are reasonably well lit at dusk, this metering method is usually accurate. Where the lighting is more tricky, then a spot reading is taken from a floodlit building in the scene, or the sky.

Either way, exposures are always bracketed at least a stop over and under the metered exposure – a technique you would be foolish to ignore when taking night and low-light shots. It's better to waste a few frames of film but come away with a handful of perfectly exposed pictures than be frugal with your film and end up with nothing worth keeping.

This street scene was photographed on the Greek island of Crete in the main town of Chania. Instead of looking along it, however, I chose a more distant viewpoint across the harbour so that I could make a better feature of the rustic old restaurants and hostels along the waterfront. A 200mm telephoto lens was used to isolate the most interesting part of the scene, and an exposure of 30 seconds at f/11 was required to record the low light levels on ISO50 film.

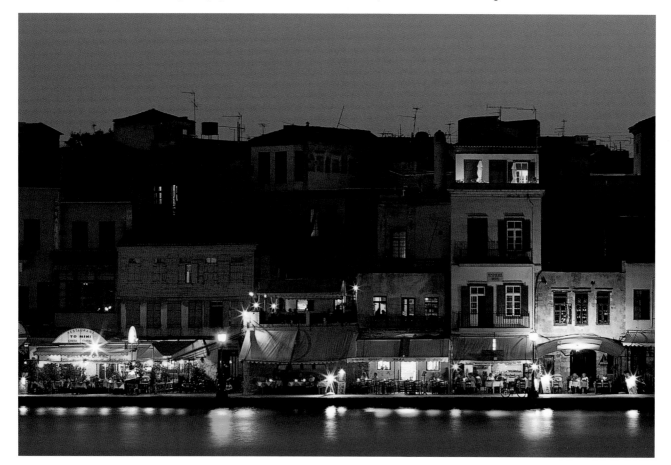

TOWN- AND CITYSCAPES

There are few sights more impressive than a town or city at night shimmering under the colourful glow of artificial illumination, or towering office blocks reflecting the vibrant colours of the dusk sky.

Cities in the USA are particularly impressive in this respect, with places such as Manhattan, Boston, New York and Los Angeles being renowned for their magnificent urban scenes. Hong Kong is another city famed for its incredible skyline. Inhabitants of European cities are less fortunate, mainly because few are on such an enormous scale, but in most big towns and cities it is possible to capture dramatic low-light vistas, even if they're not quite as exotic.

Getting high enough so that you have a clear view is often the main problem, but if you look around and ask, you may find a solution. Office blocks in big cities tend to provide breathtaking views, but bridges and towers are worth checking out too, and in most big cities there's usually some vantage point to which visitors have access. There are many buildings along the banks of the River Thames in London, for example, that offer amazing views, and this includes restaurants with public viewing galleries. Apartments with balconies overlooking towns and cities are also worth seeking out – if you can find one that's for sale, a friendly estate agent may give you access to the balcony for an evening if you ask nicely, perhaps in return for a couple of photographs that can be used to show the view from the property.

If you're forced to work more or less from ground level, the other option is to get well away from the location so that you can view it from a distance. Towns and cities on the coast, by a lake or on the banks of a river tend to suit this approach, as you can usually get an uninterrupted view from over the water. Again, photographers in the USA and Australia are at a great advantage here compared to fellow enthusiasts in Europe – though the view across London from above the Thames takes some beating.

High-rise town- and cityscapes are best photographed around sunset, when the glass façades of office blocks reflect the fiery colour in the sky, contrasting beautifully with the blue sky behind. Using the golden sky as a backdrop to floodlit buildings just after sunset can also produce breathtaking results. The 'afterlight' period, when light levels are low but there's still colour in the sky, is again a good time to shoot town- and cityscapes, though once the sky has faded to black you will find that the scene loses its appeal, with brightly lit areas swimming in a sea of darkness. This is your cue to pack up and head home until the next evening.

When shooting from a high viewpoint, use a wide-angle lens to capture sweeping vistas, with roads and buildings stretching as far as the eye can see, then perhaps switch to a telephoto or telezoom lens to isolate interesting parts of the scene. Telephoto lenses are also invaluable for photographing distant cityscapes where buildings are lined up on the horizon – depending on how far away you are, you will need anything from a 200mm to a 600mm lens in order to achieve frame-filling shots.

Here's another classic low-light shot, of London's Big Ben towering over the River Thames. This picture was taken with a 50mm standard lens on a 35mm SLR from across the river. You can see from Big Ben's clock that the time was around 9pm, just after sunset on a summer's evening. To enhance the rich glow in the sky I used a sunset filter (see page 48), and waited until ambient light levels were low enough for the floodlighting on Big Ben to be clearly visible. The exposure was around 10 seconds at f/16.

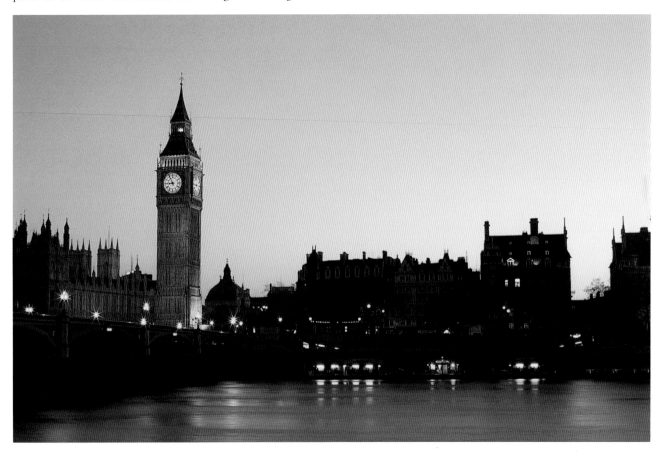

SAFETY

It's a rather sad indication of the way society is progressing, that towns and cities at night can be dangerous places for the innocent and uninitiated, so keep your wits about you – a photographer who is touting expensive cameras and lenses would make an attractive target for some people. Never stray into areas you're unfamiliar with, especially in big cities, and stick to locations where there are other people around so that you are clearly visible.

Late autumn through to early spring is the best time for urban low-light photography, because dusk comes early and the streets are still busy. During midsummer, however, you will need to stay out until 9.30–10pm, by which time the vast majority of people have made their way home.

WHEN TO SHOOT

If you're unfamiliar with the location, it's well worth doing a recce earlier in the day to discover potential subjects and establish view-points. In big cities, check the postcards stands to find out which buildings or monuments are floodlit at night, and which scenes tend to look the best, so that you have a better idea where to head for when you return later.

The best time to take night pictures in towns and cities isn't actually at night at all, but when daylight has faded to a point where the ambient and artificial lighting in a scene is at a similar level, so that both require an equal amount of exposure – often referred to as 'cross-over' lighting. This point is usually reached around 30–40 minutes after sunset, depending on the time of year.

The beautiful hilltop village of Casares, not far from Spain's Costa Del Sol, makes a perfect night-time scene, its small whitewashed buildings glowing green against the night sky. This photograph was taken about 30 minutes after sunset, from a hill overlooking the village, using a 55mm wide-angle lens on a Pentax 67 medium-format camera. The exposure – 45 seconds at f/16 – was determined by taking a spot reading from the blue sky towards the top of the photograph.

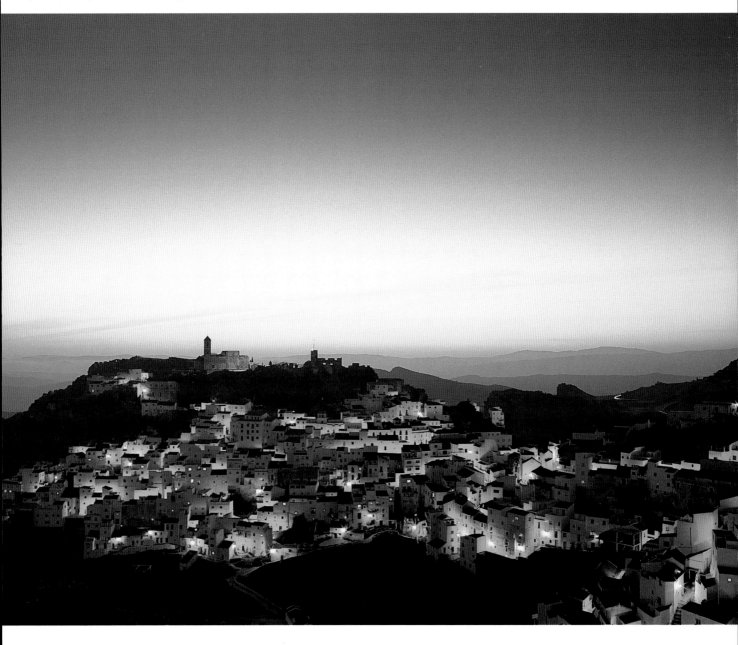

FLOODLIT BUILDINGS

The majority of towns and cities contain a variety of floodlit buildings, from churches, cathedrals and castles, to town halls, museums and art galleries. All make effective low-light subjects, and all can be approached in exactly the same way.

The main factor which makes one floodlit building different from another tends to be the light source that is used to provide the illumination, as it dictates what colour the building will record as on daylight-balanced film. Buildings lit by tungsten or sodium vapour come out yellow/orange, for example, while mercury vapour lighting creates a blue/green cast. In some cases, filters can be used to balance or certainly tone down the colour cast (see pages 76–77), but more often than not this isn't possible. Also, these strange colour casts can look incredibly effective, so few photographers try to get rid of them – none of the pictures in this section were filtered to balance colour casts.

The main factor you need to consider, then, is getting the exposure right. Fortunately, this is easy. Building materials such as brick, stone and slate are close to the mid-tone that reflected light meters are calibrated to expose correctly, so all you have to do to determine correct exposure is take a meter reading direct from an area that's lit by the floodlighting.

If your camera has a spot or partial metering facility you can use that to take the exposure reading. If not, fix a telephoto or telezoom lens to your camera so that a floodlit area of the building fills the frame, and meter from that. The correct exposure can then be set on your camera in manual mode – expect around 15–20 seconds at f/16 on ISO50 film. Alternatively, if you're shooting at dusk when there's still colour in the sky, take a meter reading from the blue sky as this will be correct for both ambient and artificial lighting.

As a final safety measure, it's also a good idea to bracket exposures over the initial reading. If your first picture is taken at an exposure of 20 seconds at f/16, for example, take others at exposures of 30, 40 and 60 seconds. Doing this not only helps to overcome any metering error you may have introduced, but also allows for reciprocity failure which makes the film less sensitive to light (see pages 88–90).

Avoid including in the shot bright lights that are pointing towards the camera, as they will create flare. Thankfully, most floodlighting is well concealed behind bushes or walls, so you can photograph the building from various angles without trying to avoid it. If you are shooting from across the street and traffic occasionally passes in front of the camera, it's a good idea to shield your lens as it does so, to prevent light trails from the head and tail light recording.

Finally, don't worry if people are walking in and out of your shot. Moving objects won't record on film when using such long exposures, so the worst that's likely to happen is that you get faint ghost-like images on some shots where people have stood still for a few seconds before walking on – but this can improve rather than spoil a good night shot.

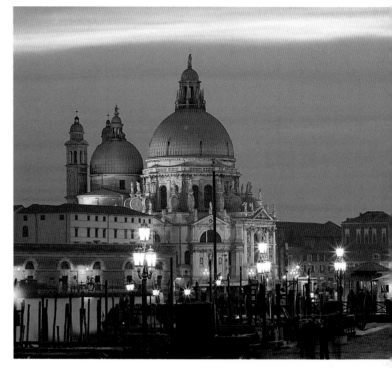

The blue/green cast on this floodlit building – the church of Santa Maria Della Salute in Venice – was probably caused by mercury vapour floodlighting used to illuminate the vast exterior. Trying to balance this with filters is pretty much impossible, and would merely add the colour of the filter to the areas of the scene lit by daylight. However, the colour casts caused by artificial lighting usually add interest to a picture rather than spoiling it, so don't be too fussy about perfect colour balance.

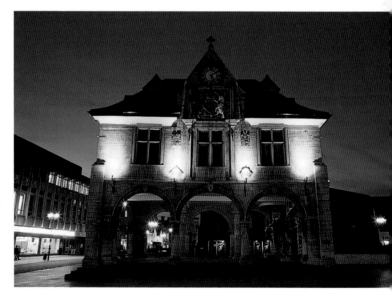

LEFT **Floodlit buildings look their best if you photograph them while there's still colour in the sky to provide a contrasting backdrop to the artificial illumination. This picture of the Giralda Tower in Seville, Spain, was taken 40 minutes or so after sunset, when the sky and tower required the same exposure. Shooting from a low viewpoint allowed me to include an ornate street lamp in the picture and improve the composition – the tower alone would have looked rather boring.**

You needn't travel to exotic locations such as Venice, Paris or London to find interesting floodlit buildings. This shot was taken in my home town, and shows an old building in the square opposite the cathedral. The clock isn't wrong – it really was just 5.10pm. The days are short during winter, although this can be an advantage to the low-light photographer. A 28mm wide-angle lens was used to record the scene, and an exposure of 16 seconds at f/11.

ILLUMINATED SIGNS

The colourful illuminated signs outside nightclubs, wine bars, hotels, restaurants and other urban venues make great low-light subjects, and photographing them couldn't be easier.

If you're visiting a location for the first time, keep an eye out for interesting signs earlier in the day – they won't be lit, of course, but you should still be able to determine if they are likely to make a good night shot.

If you are photographing the sign against the sky, return at dusk while there's still an attractive blue colour visible in the sky. If not, you can take successful pictures of illuminated signs later on, so make better use of this afterlight period for other subjects.

Again, a tripod and cable release will be required to keep your camera steady and avoid shaky results. When you've composed the shot, stop your lens down to f/11 or f/16, set the camera to aperture priority mode and start shooting. Most integral camera meters will give correct exposure for illuminated signs, providing the sign fills most of the picture area, though it's always worth bracketing a stop over and under the metered exposure in 1/2 stop increments.

The main thing to remember is that all illuminated signs flicker, so you need to use an exposure of a second or more so as to record several flickers. Different areas may also flash on and off, so you need to use an exposure that's long enough to ensure the camera's shutter is open to capture all of these areas while they're on.

To add interest to your pictures, experiment with filters – soft focus, starburst and multiple image are ideal. Illuminated signs are also ideal subjects for 'zoomed' shots. To create this eye-catching effect, all you have to do is set your zoom lens to one end of its focal length range, and compose and focus the shot you want; then, as you trip the camera's shutter release, you slowly and smoothly zoom the lens through its focal length range so that the colourful lights in the sign record as streaks.

Before taking any pictures, conduct a couple of trial runs to determine which end of the focal length range you should start at, and how long the exposure is, so that you can zoom the lens at a suitable pace. Starting with the lens at its shortest focal length and then zooming to the longest tends to give the best effect, and a slow, even zooming action will produce smooth streaks of light. You could also leave the zoom on its initial setting for part of the exposure so that the sign records clearly, then zoom through the focal length range for the rest of it to create those characteristic streaks.

RIGHT **Illuminated signs outside bars and clubs make great low-light shots and can be photographed successfully with the simplest camera. This shot was taken while I was waiting to pick up my wife from work – I had seen the sign many times, and eventually decided to take a camera along to photograph it, using a 135mm telephoto lens. What makes the image so interesting is the red glow of the neon sign that contrasts with the pool of light on the window below it coming from a tungsten spotlamp.**

BELOW **Here's another example of an illuminated sign, this time outside a bingo hall. The difference is that while the camera's shutter was open to expose the picture, I zoomed my lens through its focal length range to create a series of colourful streaks radiating out from the sign. This simple technique can turn an ordinary subject into an interesting image, and is well worth trying.**

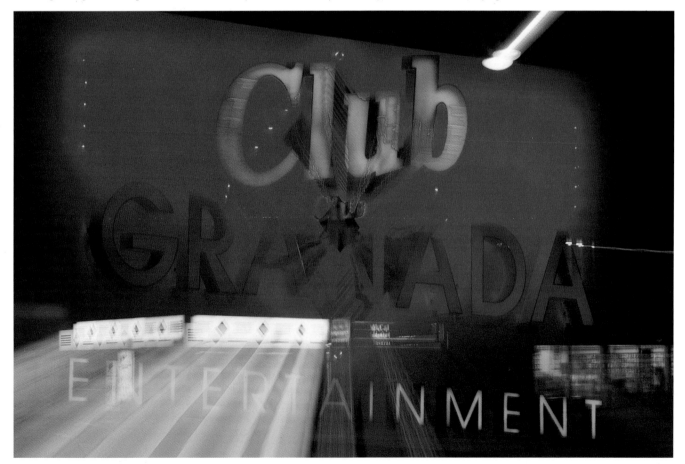

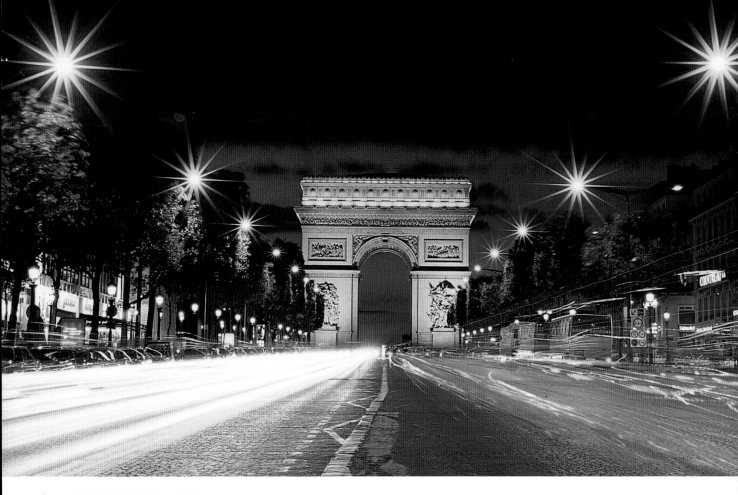

TRAFFIC TRAILS

Traffic trails are created by using an exposure of 30 seconds or more to photograph traffic moving along a busy road at night-time – the vehicles themselves don't actually record on film because they're moving, but their head and tail lights do, creating colourful trails stretching off into the distance.

The best time of year to shoot traffic trails is from late autumn through to early spring, as rush-hour coincides with dusk so that the roads are at their busiest during the optimum period for night and low-light photography, when there's still colour in the sky and shadows are partially filled in by daylight. That said, if you live in a big city such as London, the roads tend to be busy even late at night, so you can shoot traffic trails all year round.

To make the most of traffic trails, an elevated viewpoint over a busy road, roundabout or motorway is usually required. Bridges, flyovers and multi-storey carparks are ideal for this, and although it's possible to take great shots of an average two-lane road or dual carriageway, big motorways or intersections with a number of lanes and lots of traffic merging from slip roads will provide more traffic and therefore more light trails.

To capture the traffic trails on film, mount your camera on your tripod, and set the lens aperture to f/16 or f/22 and the shutter to B. All you have to do then is wait until the light levels have fallen sufficiently for the lights on passing traffic to stand out, and start shooting. Do this by tripping your camera's shutter with the cable release and holding it open for 30–60 seconds so that plenty of passing traffic will record. If there's a lull in the traffic flow, hold your

hand or a piece of card in front of the lens so as to interrupt the exposure, wait for more traffic to appear, then uncover the lens. Repeat this as often as necessary until the scene has been exposed for the required length of time.

If buildings are included in your picture, such as office blocks that are still lit inside, or floodlit buildings lit from the outside, you need to use an exposure that's correct for them. Taking a spot reading from one of the buildings will give you an accurate indication of exposure, though in most situations you won't go far wrong by exposing the scene for 30 seconds at f/22 on ISO100 film. It's also a good idea to bracket exposures – shooting one frame at 30 seconds, another at 45 and a third at 60 seconds, say.

ABOVE **The Champs-Elysées in Paris, one of France's busiest and certainly most famous roads, is the perfect location for traffic trail shots. Islands in the centre provide a safe haven, allowing you to record the light trails of cars passing on either side and include the floodlit Arc de Triomphe as a focal point. For this shot I used a 50mm standard lens and exposed the scene for 30 seconds at f/22.**

RIGHT **You rarely need to venture far to take interesting traffic trail pictures – both these shots were taken just a couple of miles from my home, during mid-November so dusk coincided with the rush-hour and there was plenty of traffic on the roads. The scenes were photographed with a 28mm lens, using an exposure of 90 seconds at f/22 to record the colourful light trails of traffic passing beneath me.**

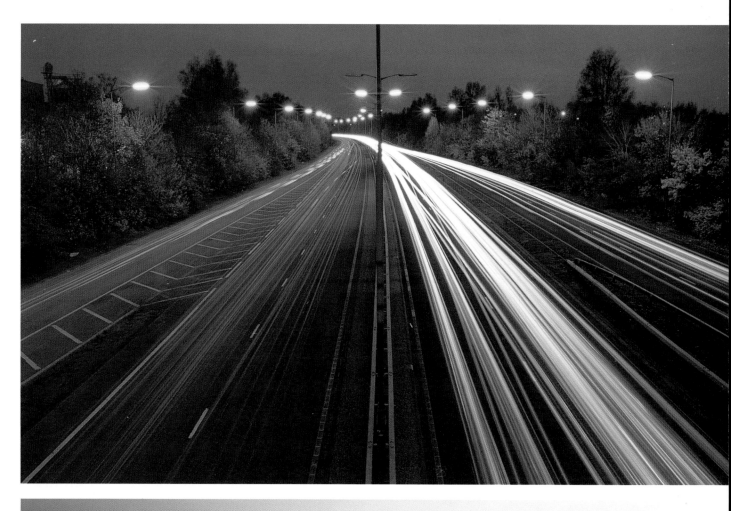

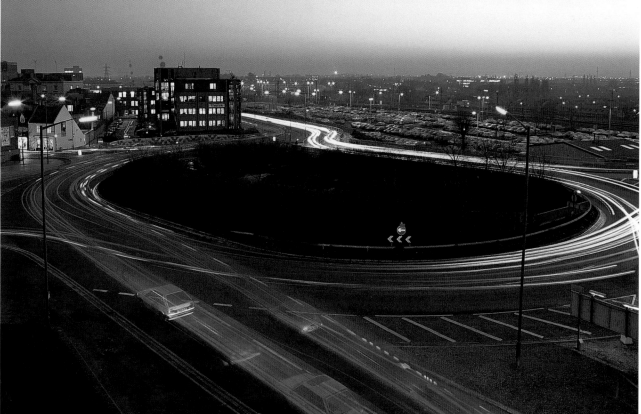

SUNRISE & SUNSET

Sunrise and sunset provide some of the most breathtaking conditions for outdoor low-light photography. The sun's golden orb sitting on the horizon is always a memorable sight, while the beautiful warm light it generates casts a spell over anything it touches and allows you to take dramatic photographs in literally any location.

Technically, there's little difference between sunrise and sunset, though in reality you can often distinguish pictures taken at the start of the day from those taken at the end. At dawn the sun rises over a cold earth and into an atmosphere that has been cleansed during the night, so in clear weather the clarity at sunrise can be incredible, with visibility stretching for miles. Mist can often be found veiling woodland and valley bottoms or floating gracefully over lakes, while the landscape is coated with dew and a cool dampness often pervades.

Come sunset, however, things will have changed dramatically. The atmosphere is no longer clean, but clogged by heat haze or pollution. Light from the sun is scattered and much of the blue wavelengths are filtered out, so the light is much warmer than it was at sunrise, while the sun's orb may appear much bigger as it sets. Think of those classic African sunsets where the sun, enlarged by haze, appears huge as it sinks towards the horizon.

Weather conditions also determine how powerful or subdued sunrise and sunset are. In cloudy weather you may not see the sun at all between dawn and dusk, though when the weather is poor, there's usually a greater chance of seeing the sun at dawn than at dusk – if only for a minute or so.

Some parts of the world are more reliable than others for producing brilliant sunrises and sunsets because the weather is fairly predictable on a day-to-day basis – usually the further south you travel, the better it gets. One summer day in Australia or the southern USA is pretty much like any other, for example, but in western Europe and the UK, the weather can change dramatically in the space of a few hours, and one good sunrise or sunset is no indication of another one the following day.

Making the most of sunrise and sunset is therefore down to patience and perseverance. You need to make the effort to get out there and hope everything will go according to plan – and if it doesn't, be prepared to do exactly the same thing the next day until you get what you want.

Fortunately, when everything does come good, the pictures you take will be so wonderful that it makes all the waiting and hoping worthwhile.

Looking at this photograph, it's hard to decide whether what you are seeing is a sunrise or sunset. Actually, it shows the sun rising behind Bamburgh Castle on England's north Northumberland coast at the start of a beautiful autumnal day. Correct exposure was determined by taking a general TTL meter reading, then bracketing exposures up to 2 stops over the initial exposure in 1/2 stop increments.

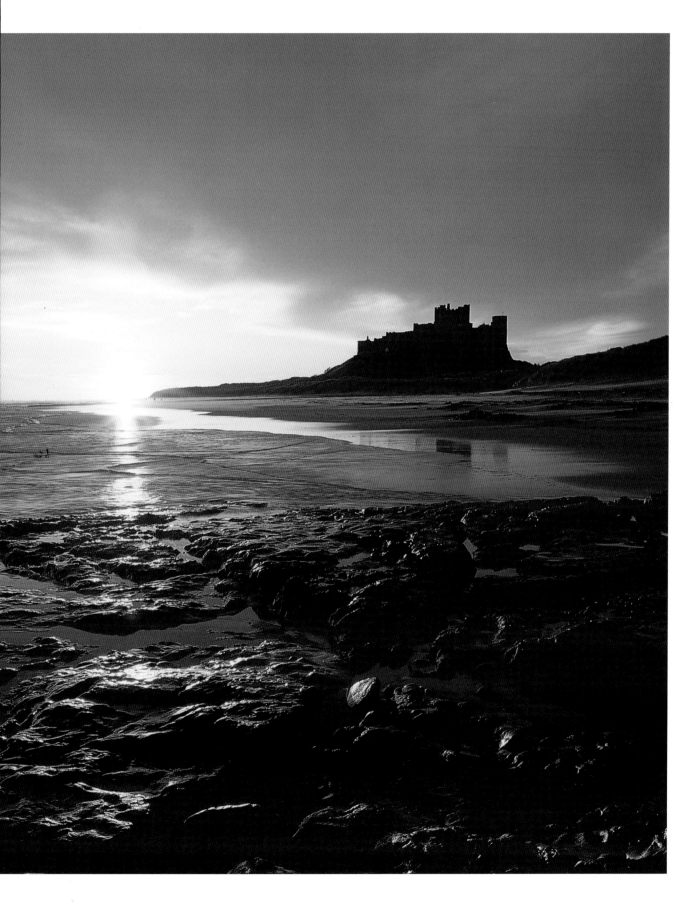

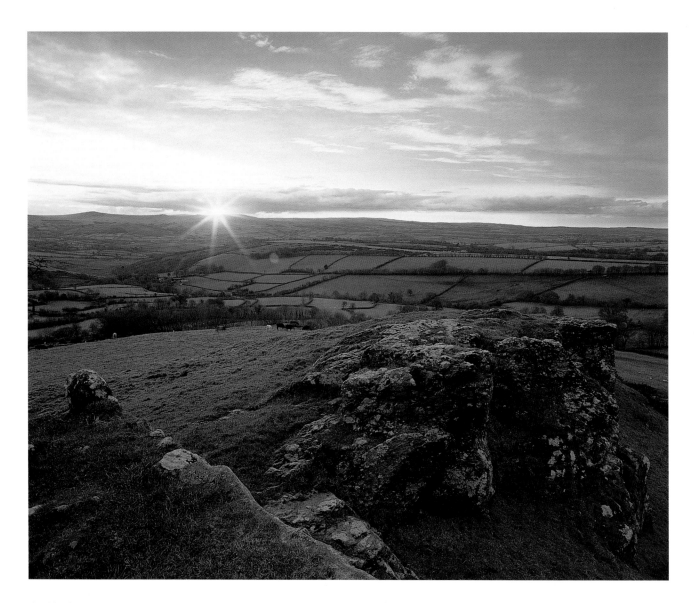

In this photograph, taken from Brentor on Dartmoor, the late autumn sun is just beginning to rise and already its golden light is raking across the landscape. To ensure detail was recorded in the foreground, a spotmeter reading was taken from the grassy bank and set on the camera in manual exposure mode. A 0.9 neutral density graduate filter was then placed on the lens to darken the sky by 3 stops so that it required the same exposure as the landscape.

EQUIPMENT

Exposure error is usually the thing that spoils most sunrise and sunset pictures, so begin by making sure you have a camera that gives a reasonable degree of control over exposure and metering – a 35mm SLR will be ideal.

In terms of lenses, the focal length you use will depend on what you are photographing. The main thing to remember is that the longer the lens is, the bigger the sun's orb will be. So if you want to make a feature of it, use the longest lens you can lay your hands on – anything from 300mm up will do a great job. Wide-angle lenses make the sun appear smaller than it does to the naked eye due to the way they exaggerate perspective, but don't let that put you off – for scenic pictures a 28mm or 24mm lens will be perfect.

Filters can be used to enhance a sunrise or sunset – the 81-series warm-ups are ideal because the effect they have is quite subtle, though if the light appears warm to the naked eye you shouldn't need to use filters at all. Remember, the light at sunrise and sunset has a colour temperature which can be as low as 2000K (see page 74), so your pictures are going to come out much warmer than you expected anyway.

Far more useful are neutral density (grey) graduates, to tone down the brightness of the sky and sun so that you can record detail in the foreground without the sky being overexposed. You will need quite strong ND grads at sunrise and sunset – usually a 0.9 (3 stop) but sometimes even a 1–2 (4stop).

Film choice is down to personal preference. Slow-speed film (ISO50-100) is the best choice for general use if you want to record the stunning colours in all their glory, but ultra-fast film (ISO1000+) can also be used to produce beautiful painterly images at sunrise or sunset, especially when used with a soft focus filter.

EXPOSURE ACCURACY

The way you photograph a sunrise or sunset will depend on the type of effect you are trying to achieve, and the prevailing weather conditions. You may want to shoot into the sun in order to create a

powerful silhouette, or to capture detail in the foreground of a scene without losing the drama of the sky. Then again, you may decide to turn your back to the sun and photograph scenery bathed in its golden light. Each approach can work well, but the metering technique you use can make or break a great shot, so you need to think carefully about what you're doing.

Let's begin with creating silhouettes, as this is the simplest technique to master. Silhouettes are essentially black shapes, devoid of detail but identifiable by their distinct outline, and were made popular by the French politician Etienne du Silhouette in the last century. He created black profiles of people on white backgrounds as a form of portraiture – hence the name.

Photographically, the same effect is achieved by capturing any solid feature, be it a building, tree or person, against a bright background or light source. By exposing for the brightest parts of the scene, that feature is underexposed by several stops so that it records as a solid black mass – a silhouette. Sunrise and sunset provide ideal

BELOW **This beautiful photograph was taken just after sunset on a summer's evening and shows the view across Budle Bay in Northumberland, England. I waited until the sun had set, because its orb was too bright to include in shot without causing flare. An exposure of 20 seconds at f/16 recorded the gentle motion of the sea as a delicate mist washing over rocks in the foreground.**

ABOVE **At sunrise and sunset even the ugliest scene can be transformed into an image of beauty. In this case, it's a sugar factory in my home town, belching out foul-smelling smoke into the winter sky. A straight TTL meter reading gave a perfect exposure, recording buildings and a passing cyclist as silhouettes and emphasising the drama of the rising smoke.**

opportunities to do this, with the bright sky and sun's orb making a perfect backdrop to whatever feature you decide to photograph.

Metering for silhouettes is simple, too. My usual approach is to set my camera to aperture priority mode, select a suitable aperture to provide sufficient depth-of-field, and then leave the camera to select automatically the shutter speed required to give 'correct' exposure. If there is an area of excessive brightness in a scene, it tends to influence the exposure a camera's integral metering system sets, usually resulting in underexposure of the main subject matter. Under normal circumstances this is the opposite to what you want, but with silhouettes it gives perfect results – a solid black shape against a golden sky.

The main thing you need to be aware of is that if the sky or sun's orb is excessively bright, your camera may underexpose by too much, so the sky comes out too dark and the silhouette is hard to make out. Avoid this by taking a meter reading from an area of bright sky without including the sun's orb – adjusting the camera position slightly or fitting a longer lens to your camera will normally do the trick. Alternatively, begin with a general exposure reading, then fire off several frames, increasing the exposure by 1/3 or 1/2 stop for each one until you're 2 or 3 stops over the metered exposure. This will give you a sequence of images that become progressively lighter, and three or four should be acceptable.

The biggest mistake that photographers make when shooting silhouettes at sunrise or sunset is making the composition too cluttered, so that when all the features in a scene are reduced to black shapes, they end up as a confusing muddle. Avoid this by sticking to one or two key features, such as a lone tree on the horizon or maybe a person gazing towards the setting sun. Keep the foreground to a minimum too, otherwise you will end up with a solid black mass at the bottom of your shot – it is better to tilt the camera up to emphasise the sky rather than down. To get a better idea of how a scene will look when solid features in it are reduced to silhouettes, try screwing up your eyes.

The opposite approach to shooting silhouettes at sunrise or sunset is recording a scene as it appears to the naked eye, with a full range of detail in the sky and foreground. This is trickier because while our eyes can cope with an extreme brightness range, film cannot and either records the brightest areas but underexposes the darkest, or it records detail in the darkest area and then overexposes the brightest. Your camera's metering system will almost always take the former route if left to its own devices as it's the easiest.

To prevent this from happening, you need to tone down the brightest part of the scene – in this case, the sky and sun – so that it requires the same exposure as the mid-tone areas and a full range of detail can be recorded. This is where neutral density (grey) graduate filters come in. They are available in a range of densities so that you can reduce the brightness of the sky by anything from 1/2 to 4 stops, or more if two grads are combined.

At sunrise or sunset, when the difference in brightness between the sky and ground is at its greatest, you will generally need one of the darker grads – anything from a 0.6 density to give a 2-stop reduction, to a 0.9 which gives a 3-stop reduction, or even a 1.2 density grad for a 4-stop reduction in brightness. Experience will tell you which density you need simply by looking at a scene, though if in doubt go for a darker grad, as a photograph will look better if the sky is slightly darker than it appeared to the naked eye, rather than lighter. Better still, photograph the same scene with two or three different grads – that way you can't really fail.

SUNRISE AND SUNSET TIMES

The times sunrise and sunset occur depend mainly on the season and the location you are in. Local newspapers usually print these times on a daily basis, and weather bulletins on TV and radio often mention them, so it's worth checking this out if possible. As a guide, here are the average times for western Europe and the northern USA. To be sure of not missing either sunrise or sunset, be on location at least 60 minutes prior to these times.

SEASON	SUNRISE TIME	SUNSET TIME
Spring	6am	6pm
Summer	4am	9pm
Autumn	6am	6pm
Winter	7.30am	3.45pm

You can see from this that the sun rises more than 3 hours earlier in summer than it does in winter, and sets 5 hours later. In practice, this means rising very early and staying out late to photograph the summer sunrise and sunset, whereas in winter the sun is rising as most people head for work and has set before they make the return journey home.

Once you have decided which ND grad filter to use, all that remains is to determine correct exposure. Do this by taking a meter reading from a mid-tone in the foreground. Bracketing exposures a stop or so over and under the metered exposure is also advisable, especially if you're shooting colour slide film.

GOLDEN SHOTS

Of course, there's no law saying you must shoot into the sun at sunrise or sunset, and while doing so can undoubtedly produce stunning photographs, remember that the golden light from the rising or setting sun could be doing magical things literally behind your back – so don't forget to peer over your shoulder every now and then.

Golden sunlight has the ability to transform even the most mundane scene, and never more so than when the sun is almost sitting on the horizon, casting long shadows and blessing everything it strikes with a wonderful warm glow.

In normal conditions, scenes that are frontally lit tend to look rather flat because shadows fall away from the camera and out of view. But when that scene is lit by golden light the effect is far more dramatic, and because shadows cast by the low sun are so long, you can usually include some in the foreground to add a feeling of depth – though with wide-angle shots you will struggle to avoid including your own shadow, and may need to change viewpoint or switch to a longer lens. Alternatively, emphasise the long shadows by shooting with the sun at an angle to the camera with it positioned rather than, directly behind it.

Determining correct exposure in situations like this is easy because the lighting is relatively even, with no areas of excessive brightness or darkness to worry about. I usually use a handheld spotmeter to take a reading from a small, well-lit area, but a general TTL meter reading taken with your camera will give an accurate exposure – and you can always bracket a stop over and under the metered exposure just to be sure.

PINPOINTING SUNRISE AND SUNSET

The position at which the sun rises and sets varies widely throughout the year and depends on the latitude of the location you are photographing. The chart below shows the position of sunrise and sunset every month of the year for a number of locations world wide. In each case, the figure stated is for the middle of that month and represents the number of degrees north or south of east and west that sunrise and sunset take place.

To use the information, find true north with a compass and then apply the figure for your location. For example, in London in mid-April, the sun rises 15 degrees north of east and sets 15 degrees north of west.

Location	Jan	Feb	Mar	Apr	May	June	July	Aug	Sept	Oct	Nov	Dec
Edinburgh	38S	24S	8S	17N	34N	40N	39N	24N	8N	15S	36S	39S
London	33S	20S	6S	15N	31N	36N	35N	21N	6N	13S	30S	35S
New York	27S	17S	5S	13N	25N	31N	28N	18N	4N	12S	24S	31S
Los Angeles	25S	15S	4S	12N	22N	27N	25N	16N	3N	11S	22S	27S
Hong Kong	22S	14S	3S	11N	20N	25N	22N	15N	2N	10S	19S	25S
Copenhagen	38S	24S	8S	17N	34N	40N	39N	24N	8N	15S	36S	39S
Nairobi	20S	12S	3S	10N	18N	23N	20N	13N	3N	8S	18S	23S
Vancouver	33S	20S	6S	15N	31N	36N	35N	21N	6N	13S	30S	35S
Athens	27S	17S	5S	13N	25N	31N	28N	18N	4N	12S	24S	31S
Madrid	25S	15S	4S	12N	22N	27N	25N	16N	3N	11S	22S	27S
Bombay	22S	14S	3S	11N	20N	25N	22N	15N	2N	10S	19S	25S
Singapore	20S	12S	3S	10N	18N	23N	20N	13N	3N	8S	18S	23S

At dawn or dusk many photographers spend so much time capturing the sun as it rises or sets that they forget to turn around and see what's going on behind their back, but the scene could be even more stunning than the one you're photographing.

LANDSCAPES

Although the vast majority of landscape pictures are taken in bright, sunny weather, the most dramatic conditions tend to be encountered in bad weather, at dawn and dusk, or even at night. Light levels are inevitably much lower, but the quality of light can be truly magical. It's for this reason that professional landscape photographers are at their most active at the beginning and end of the day, and reserve the middle hours, when the light is less attractive, as travelling time, or to explore new locations.

The importance of light, and the factors that control it, has already been discussed back on pages 65–73, while sunrise and sunset has been dealt with on pages 102–107. The aim of this section, therefore, is to look at some of the other low-light situations where stunning landscape pictures can be taken, and offer advice on how to make the most of them.

BAD WEATHER

'Bad weather' is a term used by the general public, who tend to prefer warm sun on their backs to freezing wind or driving rain, but photographically there's no such thing, only 'weather', and the more extreme it gets, the more exciting the light tends to be.

Different types of extreme weather bring their own unique

It took several hours of watching and waiting before this stunning picture was taken. Sensing that a break in the weather would eventually occur, I set up my 6x17cm panoramic camera and 90mm lens, composed the view of Berwick-upon-Tweed, and then waited patiently for the clouds to part and golden light from the setting sun to bathe the town. When this finally did happen, I was ready to capture the scene on film using an exposure of 4 seconds at f/22 on ISO50 film.

blend of characteristics to the landscape, allowing you to produce a wide range of different pictures in a single location. What they all have in common, however, is the ability to reduce light levels considerably, to the point that exposures of many seconds may be required even in the middle of the day. This makes a careful and considered approach essential, especially when it comes to keeping your camera steady to avoid shaky pictures (see pages 58–62).

MIST AND FOG

Mist and fog reduce the landscape to a series of simple two-dimensional shapes and monochromatic colour. Fine detail is obscured, and all sense of depth is lost other than the lightening of tone with dis-

tance – a phenomenon that is known as aerial perspective.

Both mist and fog are created when warm, moist air hits the cold ground or clashes with pockets of cold air and condenses. That's why mist is common in the morning and can often be seen floating serenely above rivers and lakes, or enveloping lowland areas and valley bottoms.

The best time of day to photograph mist is during early morning, before the air and ground temperature have a chance to rise and melt away the delicate veil, while the best times of year tend to be spring and autumn. If you reach your location before sunrise, you may be lucky enough to witness the first rays of sunlight melting through the mist and washing the landscape in warm pastel hues, or exploding through trees in woodland, thus creating an incredibly dramatic sight.

Fog is far less subtle, reducing visibility to just a few metres at times and transforming the landscape into a monochromatic grey blanket where only the boldest features, such as trees and church spires, can be seen rising from the gloom. But don't let this put you off – the graphic simplicity of thick fog can make a refreshing change to the clarity and crispness of clear conditions and produce highly evocative images.

The effects of mist and fog can be enhanced using ultra-fast film to produce evocative images with coarse grain and pastel colours. For this winter view of Clare Bridge and the River Cam in Cambridge, I also breathed on the lens to make the mist even denser.

The key to success when photographing mist and fog is playing on its strengths and weaknesses. If you want to emphasise the receding effect created by aerial perspective, use a telephoto lens to photograph things like roads or rivers heading off into the distance, becoming less and less visible the further they are from the camera until everything appears simply to disappear. Long lenses exaggerate this by compressing perspective so that the fall-off in tone seems to happen very rapidly.

Wide-angle lenses do the opposite, because they allow you to include elements in a composition that are close to the camera, where the effects of any mist and fog are minimal and everything appears pretty normal to the naked eye. Alternatively, when taking pictures in thick fog, try to include a splash of bright colour in your pictures to provide a focal point – such as a person wearing a red coat, or a red postbox.

Both mist and fog can cause exposure error because the moisture particles in the atmosphere bounce the light around. To prevent this, it's a good idea to increase the exposure your camera meter sets by 1/2-1 stop. An 81B warm-up filter will also balance the slight blueness in the light you often get in foggy weather – or you could do the opposite and use a blue filter to give your pictures a cool colour cast that will heighten the mysterious, eerie feel of the light.

Film choice is up to you. Slow-speed film can be used to produce sharp, grain-free pictures, but the coarse grain of ultra-fast film can work well too, and allow you to take handheld pictures without fear of camera shake. And don't forget black and white film, which will emphasise the monochromatic nature of mist and fog and allow you to produce stark, simple images – fast, grainy black and white film is particularly effective.

Similar conditions were encountered when taking this dramatic photo of Bamburgh Castle on the Northumberland coast as for the panoramic shot on pages 110–111. The weather had been cloudy and rainy all day, but minutes before the sun was due to set, the clouds parted and sunlight burst through to illuminate the distant castle. To ensure correct exposure, a spot reading was taken from the sunlit castle. I also used a 0.6 density grey grad filter to darken the sky.

STORMY LIGHT

Stormy weather creates the most dramatic conditions for landscape photography, with shafts of sunlight illuminating small parts of a scene against the dark, threatening sky. Such conditions are usually difficult to predict, so you may have to spend time waiting at a location and hoping a break in the storm will occur, but it's worth the effort because when the clouds begin to part and the sun breaks through, the lighting will be truly magnificent.

Days when the sky is a mass of dark, wind-blown clouds tend to be the most promising because the weather is constantly changing and gaps appear regularly in the sky – you just have to hope that one of those gaps eventually passes over the sun.

If it does, the light may only break for a few seconds so you need to be prepared, with your camera already set up, and the scene composed so that you can start shooting immediately. A handheld meter comes in useful here, because you can stop your lens down to the desired aperture, set focus, then as the light breaks, quickly take a meter reading and set the correct shutter speed on the camera without having to move it.

A spotmeter is ideal in stormy weather, because it allows you to meter from a small, sunlit part of the scene and to ignore everything else. If you use your camera's integral metering system, you need to be aware that the areas of the scene that aren't lit will influence the exposure reading obtained, and this will cause the sunlit areas to be overexposed.

If you are lucky, the break in the storm will last long enough for you to bracket exposures and overcome any error, but there's no guarantee that this will happen, so really you need to try to get it right first time.

To enhance the effects of stormy light, use a neutral density (grey) graduated filter to darken the sky so that the sunlit areas of the scene stand out prominently. In most situations a 0.6 density grad will be adequate, darkening the sky by 2 stops. An 81-series filter can also be used to warm up the light on stormy days. This can be particularly effective if you are shooting during late afternoon and the light breaks when the sun is low in the sky.

ABOVE RIGHT **Black and white film is well suited to stormy weather, allowing you to produce stark, dramatic images. For this shot, the negative was printed on grade IV paper to increase contrast, and the sky was burned in to make the clouds even darker. As a final touch, the print was then sepia toned to add the warm colouring.**

RIGHT **The dullest of dull days may not fill you with much inspiration, but the soft, misty light and muted colours can still produce successful images. When taking pictures in rain, as here, protect your camera and lens with a polythene bag and use a warm-up filter to improve the light.**

RAINBOWS

Rainbows are created when sun shines through falling rain and the light rays are refracted by the water droplets to form a band of light containing all the colours of the spectrum. To locate a rainbow in such conditions, simply turn your back to the sun and you should be able to see it arching across the sky.

To emphasise the colours of the bow, try to juxtapose it against a dark background – stormy sky is ideal, along with hills and mountains. Underexposing the shot by around 1/2 stop will also increase colour saturation and make the bow more prominent.

In terms of lens choice, use a wide-angle or 24mm or 28mm if you want to capture the whole bow as part of a broad view, or use a telephoto lens to pick out just part of it, when you would focus on the bow itself.

LIGHTNING

Electric storms are undoubtedly the most dramatic example of 'bad' weather, and can produce amazing images if you are fortunate enough to capture them on film.

The ease of doing this depends very much on which part of the world you live in. In the UK, lightning tends to be very brief and unpredictable, with no warning of its arrival. Photographers have been known to take successful shots here, but it tends to be a result of luck rather than judgement because the lightning flashes are often over before you even realise what has happened, and there may be a delay of several minutes before the next one appears – usually in a completely different part of the sky.

In more tropical regions, including much of Australia and also certain parts of the USA, however, electrical storms usually occur on a much bigger scale, are easier to predict, and last for much longer, making it much easier to capture them on film.

The technique you use to do this is the same as if you were photographing an aerial firework display. Mount your camera on a tripod, note where the lightning bolts are striking, then aim your camera in that direction and lock the shutter open on bulb (B) at an aperture of f/11 or f/16. Lightning is more common at night, and this makes it easier to photograph because you can leave the shutter locked open for a minute or two without having to worry about overexposure.

If there's a lengthy delay between strikes, hold a piece of card in front of the lens to halt the exposure, then take it away when you expect the next strike. By repeating this process several times, you can capture lots of lightning strikes on the same frame of film to produce really dramatic pictures.

RIVERS AND WATERFALLS

Moving water is an ideal low-light subject, as a long exposure will record it as a graceful blur, capturing its energy and motion far better than a fast shutter speed ever could.

How long does the exposure need to be? Well, that really depends on how much water there is and how fast it is flowing. A 1-second exposure makes a useful starting point; anything faster than that is unlikely to give a strong effect. But don't be afraid to go much slower – 5, 10, 30 seconds, even longer.

LEFT **Rainbows add a welcome splash of colour to a dull landscape, but you often need to act fast to catch them. This picture was taken handheld from the roadside using a 200mm telephoto lens and an exposure of 1/60 second at f/5.6.**

RIGHT **Thornton Force in the Yorkshire Dales makes an irresistible sight no matter how dull the weather. In fact, the duller the better, because it means longer exposures can be used to record the graceful motion of the waterfall. Here a 0.6 neutral density filter was used to increase the metered exposure of 2 seconds at f/32 to 8 seconds at f/32.**

Much will depend on the location your are working in and how low the light levels are. If you are in woodland or a shaded valley, then exposures of a second or longer will be easy to obtain even in bright weather – stopping your lens down to f/11 or f/22 and using slow film will be enough. But if you are taking pictures in dull, cloudy conditions, or early or late in the day, much longer exposures can be expected.

Should you find yourself in a situation where the longest exposure you can obtain is too brief, even with your lens stopped right down to its smallest aperture, the easiest solution is to use a filter to reduce light levels and force an exposure increase. Neutral density filters are designed for this very job (see page 45), and cause a light loss without changing the colour balance of the picture. Failing that, why not use your trusty polarising filter? It, too, will cut the light by 2 stops, allowing you to quadruple the exposure time.

For the best results, try to include static elements in the scene to emphasise the movement of the water. Rocks or boulders midstream are ideal, as the water will naturally flow around them and create interesting patterns. With waterfalls, take a step back or use a wider lens to include the immediate surroundings.

WOODLAND

Light levels are almost always low in woodland, simply because the leafy canopy overhead acts as an effective screen to the sun, and even in bright, sunny conditions you will probably find that exposures of a second or more are required when using slow-speed film and small lens apertures.

Autumn is the premium time to photograph woodland, when the leaves on the trees are beginning to turn from lush green to a palette of warm and rustic colours. Beech, sycamore, oak, maple: every type of deciduous tree responds differently to the ending of the summer, but all can produce beautiful results – especially where different species appear in the same scene, providing a rich contrast of colour and tone. Carpets of fallen leaves on the ground also form fascinating patterns and are well worth photographing in close-up.

Overcast weather reveals woodland at its best, as the soft light keeps contrast low but enriches leaf colour – in sunny weather, pools of light filtering through the branches can take contrast well beyond the capabilities of your film, creating stark highlights against deep shadows. To make the most of these conditions, use a polarising

filter to cut through glare on the foliage and increase colour saturation. An 81B or 81C warm-up filter is also worth using, to balance any slight coolness in the light caused by taking pictures in the shade beneath a cloudy sky.

AFTER DARK

Beyond twilight, light levels fade to a point where the landscape appears monochromatic and the sky goes from blue to black, but in reality, the sky is still blue and the landscape full of colour, it's just that our eyes aren't sensitive enough to see it. Photographic film can, however, and when exposed for long enough will record the landscape in a way in which you will never see it with the naked eye, producing surreal images that are lit by the faint glow of skylight.

The time it takes to do this will depend on prevailing weather conditions. On a clear night, light levels will be higher than in cloudy conditions, just like they would be in the middle of the day, and if the full moon is out there will be even more light in the same way there is if the sun is shining. In fact, the only major difference between night and day is light intensity, and if you give a picture taken in the middle of the night enough exposure, you might well struggle to tell it from one taken 12 hours earlier – the only clues

Another panoramic, this time of autumnal woodland on the banks of Grasmere in the Lake District. I took cover in the woods when rain began to fall and realised that the scene before me would make a great shot in its own right. A 6x17cm panoramic camera and 90mm lens was used to capture a broad sweep of woodland, plus a polarising filter to cut through glare on the foliage and increase colour saturation. Polarisers also lose two 2 stops of light, so the exposure required was a lengthy 20 seconds at f/32 on ISO50 film.

being movement in things like trees, and the appearance of faint star trails in the sky due to the long exposure.

Getting the exposure right is fairly hit and miss, because it's unlikely your lightmeter will be able to register any reading at all, even when set to the fastest film speed and widest f/number. Fortunately, there is a certain degree of exposure latitude here, especially towards underexposure, because you wouldn't expect pictures taken at night to look like they were shot at midday.

You could try setting your camera to aperture priority and then leaving the rest to its integral metering system – SLRs can often produce correctly exposed pictures way beyond the longest specified exposure time they are supposed to be capable of. Alternatively, work in manual mode using the camera's bulb setting, and try an exposure of 60 minutes at f/8 on ISO100 film. If the full moon is out, light levels will be a stop or two higher, so try 60 minutes at f/11 or f/16. These times are merely guides, however, so don't expect perfect results on the very first attempt, and be prepared to try more than once – or stay out all night so that you can bracket exposures. If you do bracket, adjust the lens aperture rather than exposure time, so that more pictures can be taken and the effects of reciprocity failure aren't increased.

Any type of landscape can be photographed by night, though scenes containing water are ideal as the long exposure will record lots of movement. Trees or grass swaying in the breeze can also add an extra element to low-light landscapes.

For the best results, arrive at the location while there's still enough daylight present for you to see what you're doing. That way, you can compose the shot accurately, making sure the camera is square, and can set the focus to ensure that everything will come out sharp. It's a good idea to carry a small torch for use later, when you need to check the camera controls - and to find your way back to wherever you came from.

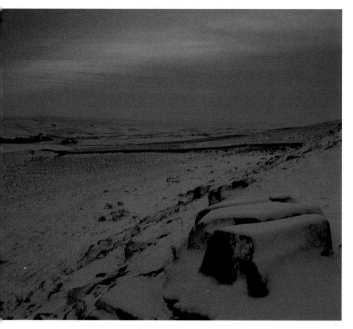

ABOVE **Taken so long after sunset that I could barely see the scene through my camera's viewfinder, this snow-covered landscape required an exposure of 5 minutes at f/16 to record.**

RIGHT **And just to prove that it never really does get dark, here's a pair of pictures of my house, one taken in the middle of the night (above right) using an exposure of 2 hours at f/8, and the other in the middle of the day (right) using an exposure of 1/60 second at f/8. The only thing that gives the night shot away are the star trails in the sky, but other than that it could have been taken in bright sunlight.**

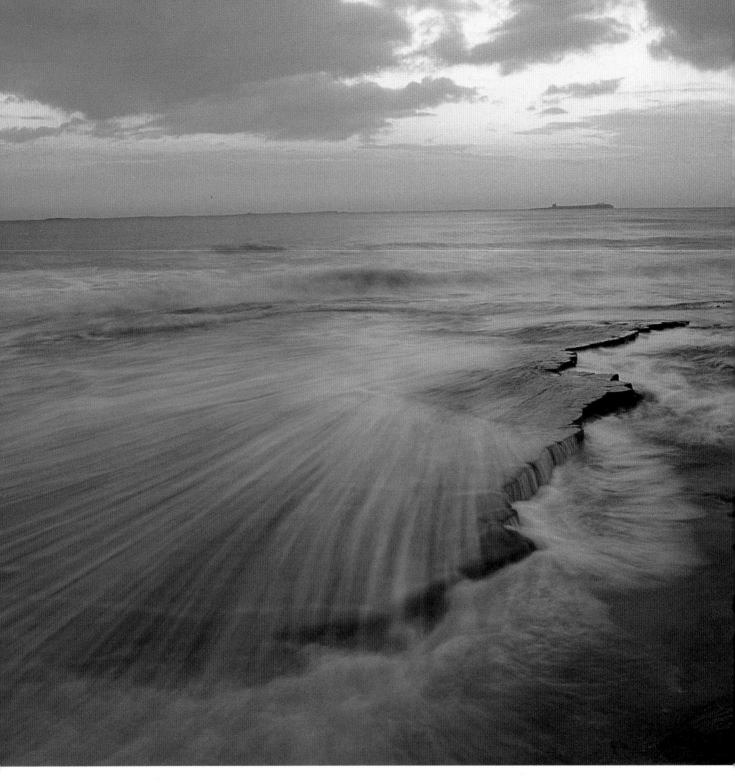

COASTLINE

Coastal views tend to look their best at the beginning and end of the day, for a number of reasons.

Firstly, the mood of the sea is influenced to a great extent by the prevailing weather conditions and the quality of the light, and the light tends to be at its most attractive during these periods. In the cool, blue light of pre-dawn the sea takes on the colour of gun-metal, whereas in the glow of a fine sunset it can appear like liquid gold, turning the reflection of the sun's orb into a shimmering high-light on its ever-changing surface.

Secondly, the coastline, like the landscape, is revealed at its best at dawn or dusk, when golden light from the low sun rakes across it, revealing texture and form and thereby giving your pictures a strong sense of depth.

Thirdly, light levels are low early and late in the day, so you can use long exposures to record the motion of the sea as it crashes against the rocky coastline or washes over rocky shelves and up deserted beaches. The longer the exposure, the more blur you will get, to the point where the sea can appear more like mist than water. Anything from 1 second up will produce a good effect, but don't be

topography of the coastline could mean that you're facing due west on the east coast and due east on the west coast. Equally, you could be facing north or south on either coast. To avoid this, it's well worth checking a detailed map of the area before visiting, so that you can pinpoint the location you want to photograph and determine which way it faces.

When you do reach the location, think carefully about the composition. Views from the coastline looking straight out to sea can easily appear boring unless there's a stunning sunrise or sunset to liven up the picture. So look for vantage points where both land and sea can be included in your compositions, and where there's good foreground interest to lead the eye through the scene. Alternatively, find a viewpoint above a gorge or inlet, so that you can look down and capture the sea crashing against the rocks below.

Long, empty beaches are best photographed when the sun is low, so that light rakes over the sand, revealing the delicate ripples created by the wind and tide – these ripples make ideal foreground interest for wide-angle pictures, acting as lines that lead the eye through the scene. Pieces of driftwood can also be used as foreground interest if you move in close with a wide-angle lens.

Another way to photograph beaches is at sunset, when the sand is wet and reflects the fiery colours in the sky. Look for shallow pools left by the retreating tide that can be included in the foreground, or capture rocks on the beach that stand in silhouette against the sky and reflective sands.

LEFT **Here's a classic low-light seascape, captured at twilight on the Northumberland coast using a 28mm wide-angle lens on a 35mm SLR and an exposure of 2 seconds at f/16. The exposure was left to the camera's integral metering system and I fired off a series of frames as waves washed over the rocky shelf in the foreground. You can see how a long exposure records the rushing motion of the waves.**

BELOW **Spain's Costa Del Sol may be renowned for its concrete holiday resorts, but beautiful coastal scenery still exists if you take the time to look. This photograph was taken a few miles from Nerja in the last hour before sunset. A polarising filter was used to improve clarity and colour saturation, plus an 81B warm-up to enhance the warm light.**

afraid to experiment with exposures that are much longer than this – several minutes if necessary.

The time of day you photograph a coastal location will depend to a large extent on the direction it's facing. The east coast is best visited at dawn because you will then be able to capture the sun's orb rising over the sea and the coastline bathed in sunlight, while the west coast will be lit by the evening sun and will give you good views of itsetting over the sea.

That said, don't automatically assume that by going to the east coast you will see the sunrise, or the sunset on the west coast. The

CHRISTMAS LIGHTS

The festive season is always an exciting time for low-light photography. Not only does it present a great many opportunities to photograph people having fun at parties and at family celebrations, but more importantly, the decorative illuminations that appear everywhere literally overnight can also be a source of great pictures.

Take a walk through any shopping street in the weeks leading up to Christmas and you'll be inundated with eye-catching subjects, from elaborate garlands of lights stretching overhead, to festive signs hanging from buildings, and towering trees just covered in twinkling bulbs. Many people put a lot of effort into decorating the exterior of their home with festive illuminations too, and with a little imagination even the modest lights that you use on your own Christmas tree can produce interesting pictures.

Although the illuminations in this scene aren't particularly exciting, their bright colours against the sky and the inclusion of lots of tree branches still make an interesting picture. It was taken with an 80–200mm zoom lens set to 135mm, and the exposure was left to the camera's integral metering system.

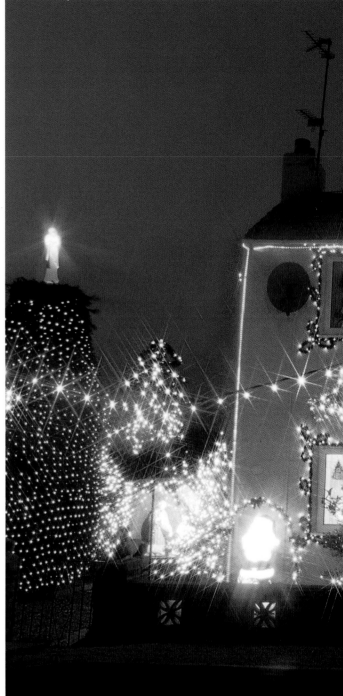

OUTDOOR ILLUMINATIONS

As with all outdoor scenes lit by artificial illumination, the best time to photograph festive light in towns and cities is at dusk, when the daylight has faded sufficiently to make the lights stand out, but there's still colour in the sky. In the UK, the sun sets around 4pm during the Christmas period, so conditions should be ideal between 4.30pm and 5pm. It's worth arriving an hour or so before this time, however, so that you can have a wander around and establish the possibilities,

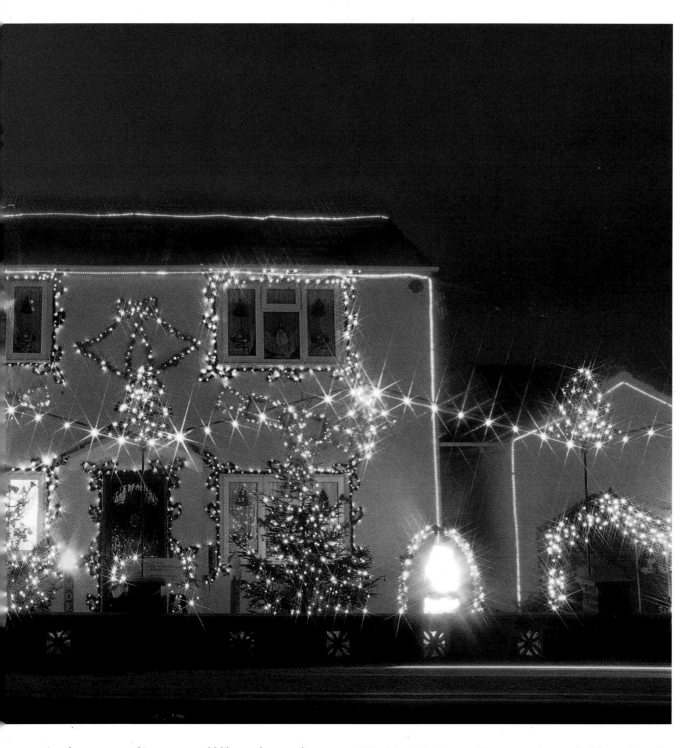

noting the scenes or subjects you would like to photograph.

Big cities tend to offer the greatest variety and the most elaborate displays. London is the premier UK spot, especially Oxford Street, Regent Street and Trafalgar Square. However, it's possible to take successful shots in any town, and one great benefit of remaining close to home is that you can easily return several times until you have exhausted all the picture possibilities, having any exposed films processed between visits to check your progress.

This elaborately decorated house was photographed just a few miles from my home. Well known in the area for its festive illuminations, it is visited each Christmas by hundreds of local people who gaze in admiration at the owners' efforts. To record the house in its glory, a 50mm standard lens was used with a starburst filter to add a twinkle to the lights. The shot was taken around 30 minutes after sunset, and a meter reading was taken from the blue sky above the house to determine correct exposure – 60 seconds at f/16 on ISO50 film.

Take a selection of lenses with you, covering focal lengths from, say, 28mm to 200mm, so that you can take a range of shots. A moderate wide-angle or standard lens will be ideal for street scenes, while a telephoto or telezoom will allow you to home in on interesting displays of lights high up on buildings strung across the street overhead. You could take a general view of a street decorated with lights, for example, then switch to a longer lens and pick out individual details from the same position. Zoom lenses are particularly handy for this, and can also be used to take 'zoomed' shots of festive signs on buildings (see page 100).

Exposures will be long, so be sure to take a sturdy tripod and cable release with you. It is possible to take handheld shots of festive lights if you load your camera with ultra-fast film and shoot at a wide lens aperture, but there's really no point in doing this, and slow-speed film will produce far more impressive results full of sharp detail and vibrant colours.

Special effects filters can also be put to good use when photographing festive illuminations, adding interest to scenes that aren't particularly exciting and helping to take attention away from unwanted details such as parked cars or litter bins that often get in the way. Starburst and soft focus filters are the most effective as they create eye-catching effects without being too garish, but the odd shot taken with a diffraction or multiple image filter won't go amiss.

This festive scene was enhanced using starburst and soft focus filters. The picture was taken using a 50mm standard lens on a 35mm SLR, and I visited the location on a Sunday evening, when there were fewer people walking the streets.

The techniques for determining correct exposure are exactly the same in this instance as when dealing with other night subjects such as neon signs and floodlit buildings, so refer back to the relevant sections for more information.

For street scenes, I tend to take a meter reading from the sky and use the recommended exposure as a starting point, before bracketing several frames over and under it. Where the lights are prominent in the frame – when using a telephoto lens, say – you could also leave the exposure to your camera's metering system, bracketing again as a safety net.

As a guide, expect exposures in the region of 15–20 seconds at f/16 on ISO100 film for general street scenes, and of 10–15 seconds at f/16 for telephoto shots of festive signs and displays.

CHRISTMAS TREES

Part of the Christmas ritual every year for millions of people around the world is buying a fresh pine tree to put in their home, then spending a family evening covering it with colourful decorations, twinkling lights, tinsel and garlands, before the grand switch-on. The same ritual applies in many towns and cities, with local authorities placing a huge tree in a prominent location for local inhabitants to enjoy throughout the festive season.

Indoors or out, Christmas trees offer lots of picture-taking potential, and provide the ideal subject matter on which to try out a range of different techniques. You can experiment with different filters, capture the whole tree or concentrate on small details such as an attractive decoration surrounded by lights, and so on.

Dusk is again the best time to photograph outdoor trees, while any time from dusk onwards will be suitable for indoor trees. If you

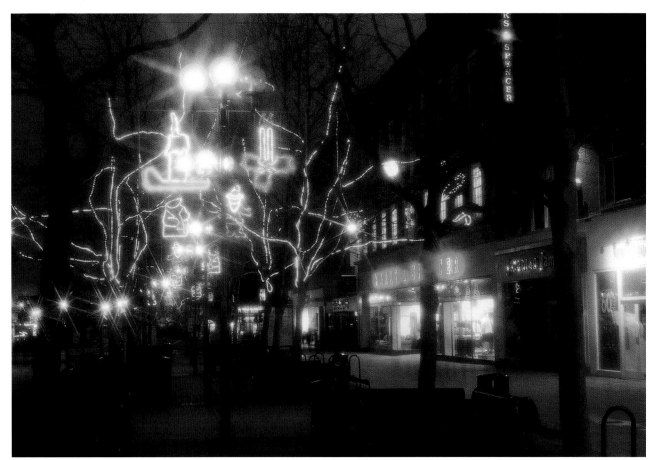

Use a telephoto lens to fill the frame with interesting festive signs, like this one on the front of my local town hall, taken with an 80–200mm zoom at 200mm. A starburst filter was also used so as to add interest.

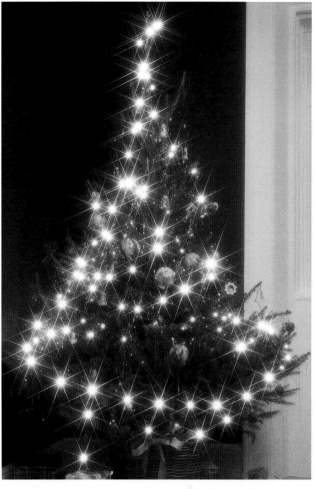

are taking pictures indoors, see what the tree looks like with only the decorative lights switched on and all other lighting extinguished. You may find that these lights don't provide enough illumination, in which case a weak supplementary form of light will be required. Room lights with a dimmer switch are ideal for this, as you can adjust the level until it's just right – not too bright to overpower the tree lights, but not so dark that its effect is hard to see.

Outdoors you will probably need a moderate wide-angle lens to capture the whole tree, due to its size, while indoors a standard 50mm lens should be ideal. Again, mount your camera on a tripod and load it with slow-speed film for the best results.

To ensure perfectly exposed results when photographing outdoor trees, meter as you would for Christmas lights. Indoors, your best bet is simply to switch your SLR to aperture priority mode, set the lens to f/8 or f/11, and then leave the integral metering system to determine the exposure time.

By doing this, there's a high risk of underexposure because the bright lights on the tree will fool your camera's meter, so bracket exposures at least 2 stops over the initial reading, in 1/2 or 1/3 stop increments, using the exposure compensation facility. This will give you a sequence of pictures that become progressively lighter, and you should find that at least half are acceptable. The same technique can also be used if you then move in closer to the tree and capture a smaller area as shown in the picture on the right.

ABOVE RIGHT **This Christmas tree was photographed in my home using a 50mm standard lens fitted with starburst and soft focus filters. The picture was taken at night, with the room lights dimmed to provide a little extra illumination on the tree, and I let my camera's integral metering system determine correct exposure, dialling in +1 1/2 stops of exposure compensation to avoid error.**

RIGHT **This close-up shot shows just a small detail of the tree in the picture above. A 50mm standard lens was again used, but this time it was fitted with a diffraction filter to create colourful stars around the small lights on the tree.**

STREET LIFE

The bustling streets of all our towns and cities are full of interesting photo opportunities for any eagle-eyed photographer willing to explore them.

Night-time, in particular, can be a source of rewarding images, the coming of darkness creating an almost theatrical environment, where the streets are transformed into a colourful stage set and the people on them become actors.

Young men and women dress up and hit the town for a night of fun and frivolity. Drunks stagger wearily from pub to pub in search of their next drink. Loving couples walk arm in arm along rain-washed pavements, sharing tender moments in shady corners or relaxing on park benches and enjoying the tranquillity of their nocturnal sojourn.

Some places are better than others for capturing street life. Big cities always offer a wider range of subject matter, however, simply because they never sleep, and on Friday and Saturday evenings, when most people are enjoying their well-earned weekend break from work, the streets are buzzing with activity from dusk till dawn.

CHOOSE YOUR SUBJECT

The type of pictures that you take and where you take them will obviously depend on how much 'bottle' you have and what your motives are. Some photographers have no qualms about walking up to complete strangers in the street and sticking a flashgun in their face to produce highly confrontational pictures; others frequent seedy bars, fetish clubs and strip joints in search of subjects on the fringes of everyday society.

The thing you have to remember is that city streets at night can be hostile places, and not all the people you encounter on them will appreciate having their photograph taken. Foolish photographers learn about this fact the hard way; sensible ones think carefully about what they're doing, weigh up the risks, and only reach for a camera when they feel 90 per cent sure it will be well received.

An obvious way to reduce the risk of confrontation is to make yourself known to potential subjects first and become a familiar face on the scene so that you're not seen as a threat. So, if you know of a local street café where bikers tend to gather in the evenings, go along without a camera and try to strike up a conversation with some of the people there, returning to take pictures when you feel that you have been accepted. Many extreme social groups may appear closed to outsiders and hostile to strangers, but often they are quite the opposite, and the sight of a camera will be welcomed, not resented. It's all about timing.

Of course, you don't have to put yourself or your equipment at any risk whatsoever, because there will always be plenty of other opportunities to capture street life on film, and under much safer circumstances. Carnivals and processions parading through the streets at night are good examples. Undoubtedly the people involved won't mind being photographed at all; they wouldn't be there if they did. Street entertainers also make great subjects, and providing you leave a little something in their cap, won't have a problem if you point a camera in their direction. Some may even 'ham it up' for the camera, thoroughly embarrassing the photographer as he or she becomes the centre of attention, but providing excellent photo opportunities at the same time.

Alternatively, you could simply walk the streets, keeping an eye out for interesting candid moments – lovers in fond embrace, an old

RIGHT **These street entertainers were captured in London's Covent Garden. Noticing me, they stopped mid-act and posed for the camera. Taken completely by surprise, I had time to fire off just one shot before the act resumed, using a 135mm lens on an Olympus SLR. Light levels were low due to poor weather, so to provide a fast enough shutter speed, ISO400 film was uprated to ISO1600 and push-processed by 2 stops. The exposure was 1/250 second at f/5.6.**

LEFT **Fast food bars are a common sight on city streets at night; they make interesting subjects in their own right, and are frequented by people who provide useful candid shots. This one was photographed using a 50mm lens and exposure of 1/30 second at f/5.6.**

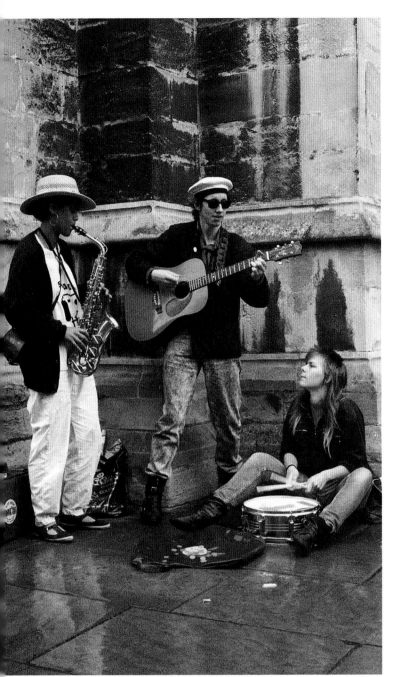

Buskers on a street corner in Bath, England, seemed oblivious to the wet weather, and were so wrapped up in their music-making that they didn't even notice me taking their picture as I passed by.

man asleep on a park bench, people chatting. If you maintain a low profile and don't do anything that announces to the world you're a photographer, pictures can be grabbed in a second and no one will be any the wiser.

Distance can be estimated and your lens focused before you even raise the camera to your eye – though autofocusing will probably be a quicker and more accurate ally. It's also fairly easy to find viewpoints where you can partially conceal yourself, even if it's just a lamp post or the corner of a building.

Another great way of taking candid pictures is to use a wide-angle lens – a 24mm or 28mm will be wide enough – and shoot from close range. This may seem to be the perfect way to get yourself noticed, but because the lens's field-of-view is so wide, you can include someone in a picture who is fully aware of your presence, but unaware they are being photographed because the camera isn't pointing directly at them.

EQUIPMENT

Street-life photography is best approached using the minimum of equipment, so that you can respond quickly to situations as and when they arise and cover lots of ground without being weighed down by heavy equipment. A bulging gadget bag swinging from your shoulder is also a clear sign to all around that a photographer is on the loose, so leave it at home and travel light.

Flash can be used to provide illumination when taking pictures on the streets at night. For this shot of onlookers at a carnival a burst of flash was combined with a 1/4 second shutter speed and the camera was moved during exposure to blur lights in the background.

A 35mm SLR body and one lens is all you need, and if you intend taking a certain type of picture, or know you will be shooting in a particular environment, that lens can be chosen accordingly. A moderate wide-angle or standard lens is ideal for close-range work in low light, because its small size and low weight makes handholding at slow shutter speeds easy. For candid shots taken at a distance, use a telephoto lens instead. A 135mm or 200mm will be powerful enough, and if you use a prime lens instead of a zoom it will not only be lighter, but the maximum aperture will probably be wider, enabling you to use faster shutter speeds.

If you aren't really sure what type of pictures you will be taking, or there isn't going to be a problem with people knowing you are a photographer, carry two or three lenses covering focal lengths from wide-angle through to telephoto. That way, you can respond to anything the streets throw at you.

Flash is useless in situations where you want to go unnoticed, because the blinding light will clearly be an instant give-away. But if you don't mind people knowing you are taking their picture, it will solve numerous problems, providing valuable light, freezing movement and allowing you to use slow-speed film for pictures with high image quality. You don't need a powerful or sophisticated flashgun to

capture street life – any model with a guide number of 30 or more (m/ISO100) and an automatic mode will be suitable (see page 53).

FILM

The type of film that you use to record street life will depend on the situation that you are shooting in, and also whether or not flash is being used. If you are using flash, low ambient light levels become almost irrelevant because the flashgun will provide all the light you need, so you can stick to slow-speed film around ISO100–200.

Where pictures are being taken in available light, however, it's highly unlikely slow film will allow you to work at shutter speeds fast enough to freeze both camera shake or subject movement, so you will need to look further up the ISO scale.

In dull weather or around dusk, you may find that ISO400 film is fast enough for your needs, but it's worth carrying something faster as well so that you can continue shooting when light levels fall even further.

On the streets at night, ISO1000–1600 film will be required, especially if you are shooting with a telephoto lens which demands a faster shutter speed than a wide-angle or standard due to its increased size and weight. If you don't have such fast film with you, slower film can be uprated and push-processed (see page 37).

ISO400 film can be rated at ISO1600 and pushed 2 stops without a significant loss of image quality, and if you're really stretched, it can be uprated 3 stops to ISO3200 – though ISO1600 film rated at 3200 will be easier to process because it requires only a 1-stop push, and carrying a roll or two of ISO3200 film is even better, as you should then be covered for all eventualities.

The choice between black and white or colour is up to you. There's no denying the impact of a good low-light colour photograph, but the gritty nature of black and white can be equally effective for low-light street photography, giving your pictures a raw, reportage feel. Black and white film will also overcome the problems of colour casts when shooting in artificial lighting, and responds better to push-processing so that you can uprate to extreme levels – Ilford Delta 3200 and Kodak T-Max 3200 can be rated at ISO6400 as a matter of routine and up to ISO25000 in extreme cases, whereas with colour film the limit is ISO3200.

Street life goes on no matter how bad the weather is, albeit it at a less enthusiastic pace. This couple were captured as they walked along a deserted seaside promenade on a dull, rainy day – I simply waited in position until someone came along, then tripped the shutter.

FIREWORKS & BONFIRES

November 5 is a special date in the diary of every British photographer because it's the night we remember when, in 1605, Guy Fawkes and his band of subversives tried to blow up King James I with their infamous gunpowder plot.

This event is celebrated with firework displays, enormous fires and also the burning of the 'Guy', an effigy of Fawkes himself, so it naturally provides lots of exciting low-light photo opportunities.

Grand firework displays are also used to mark all kinds of special occasions, including music festivals, regattas and carnivals, so you should have the chance to photograph them throughout the year, as well as on 'Bonfire Night'.

FIREWORKS

Whatever the venue or occasion, the technique used to photograph firework displays is pretty much the same. For a start, your best bet is to ignore the small-scale ground displays, which tend to produce disappointing photographs, and concentrate your energies instead on the much more impressive aerial displays, where powerful rockets explode and fill the sky with a myriad of spectacular colours. Communal firework displays are ideal, because for a nominal fee – and often there's no charge at all – you get to photograph firework displays that cost a fortune and are organised by experts.

Where possible, arrive at the venue nice and early, before the crowds, and establish where the fireworks will be launched from so that you can select a suitable viewpoint. Resist getting too close, otherwise you'll end up being surrounded by people; instead move well back so you have a clear view away from the crowds. A slightly elevated viewpoint can be handy, though it's by no means essential.

In windy weather, the rockets will drift once they're launched and may not explode where you expect them to. If in doubt, have a word with one of the marshals at the event and ask their opinion, explaining that you need to know because you want to photograph the display. Failing that, wait for the first couple of fireworks to be launched and watch where they explode. This should give you a pretty accurate indication of where the action will be taking place.

Once you've established this and found a viewpoint, erect your tripod and get your camera ready. For shots of the whole display you'll need a moderate wide-angle lens such as a 28mm or 35mm, or perhaps a 50mm standard if you're quite a distance from the action. Alternatively, use a telephoto or telezoom lens – anything from 100mm to 300mm will be ideal – and home in on the 'eye' of the display so that you fill the camera's viewfinder with exploding fireworks. Whichever lens you use, stop the aperture down to f/11 or f/16.

As with many night and low-light subjects, firework photography requires you to use your camera's B (bulb) setting so that you can hold the shutter open manually for as long as you like. This makes a cable release essential, to allow you to hold the shutter open without touching the camera. In windy weather it's also a good idea to hang your gadget bag over the tripod to increase its stability – and so that you can see where it is while you're taking pictures.

If you're attending a firework display during the summer months, when the days are long, you may find that there's still some colour in the sky when the display begins – usually it's a beautiful velvety blue which makes a perfect backdrop to the colourful fireworks. In autumn and winter, however, the days are much shorter, so by the time the firework display begins the sky will be completely black. This needn't be a problem, though it's a good idea to try to fill the frame as much as possible so that you don't have lots of empty black sky in your pictures.

Once you're ready to shoot, all you have to do is wait for the first few fireworks to be launched so that you can see where they explode, adjust the position of your camera accordingly, and prepare to take your first photograph.

To do this, watch for the tell-tale light trail shooting into the sky which indicates that a firework has been launched, then trip your camera's shutter and hold it open with the cable release so that the explosion is recorded.

With really lavish displays you may find that fireworks are launched almost continuously, in which case all you need to do is keep the shutter locked open for 30 seconds or so while four or five explosions record. More commonly, however, there's a short delay between fireworks during which nothing happens.

If this is the case, keep the camera's shutter locked open but hold a piece of black card over the front of the lens – taking care not to touch the lens itself – so you're effectively halting the exposure by preventing further light reaching the film. All you have to do then is wait for more fireworks to be launched and move the card away, so that more explosions record on the same frame of film. By doing this several times, you'll gradually build up the number of fireworks on the same shot to create spectacular results.

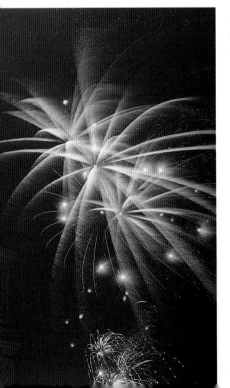

LEFT **Once you've shot some wide-angle lens pictures, switch to a telephoto. This shot used a 135mm lens and an exposure of 30 seconds at f/16.**

RIGHT **This photograph is a classic example of the type of results you can expect. The camera – a Pentax 67 – was fitted with a 55mm wide-angle lens and the shutter locked open on B at an aperture of f/16 for about a minute. Between fireworks I shielded the lens with my hand and gradually built up several colourful explosions on a single frame of film to produce an impressive shot.**

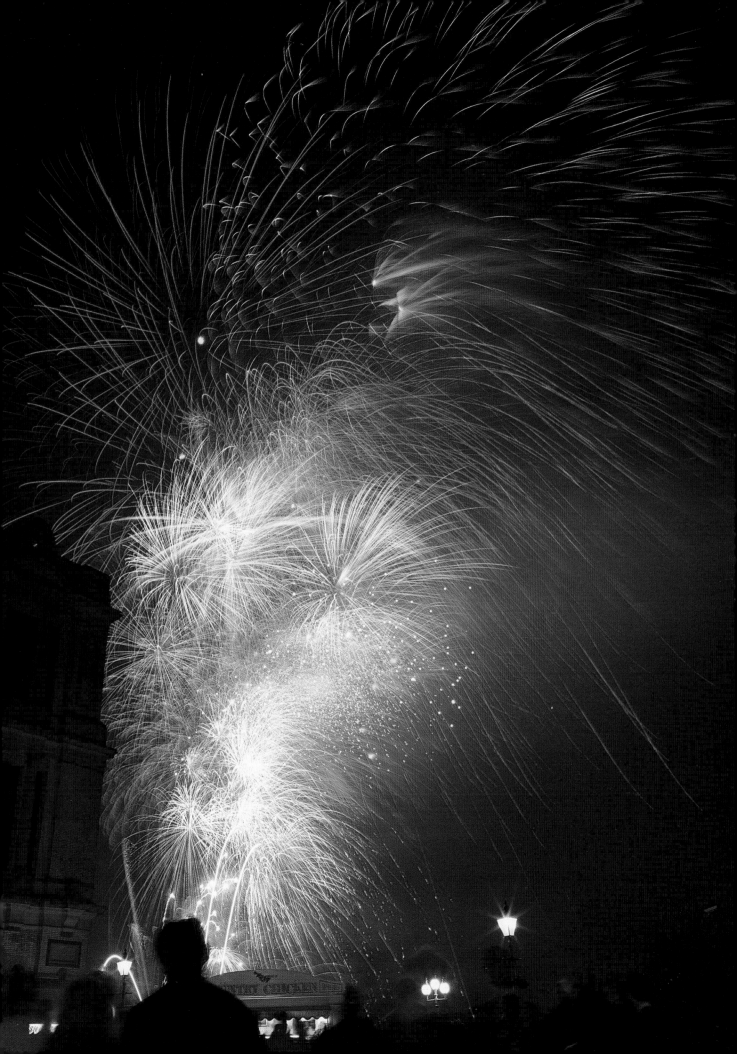

FIRELIGHT

The flickering orange flames of a roaring bonfire can also be used as the basis for some great low-light shots. The people standing around the fire to keep warm will be bathed in golden light, providing ideal opportunities to take candid or posed portraits.

Light levels will be low, even though the fire appears bright to the naked eye, so use fast film to provide a reasonable shutter speed. Expect something in the region of 1/30 second at f/2.8 on ISO1600 film with your subject standing a couple of metres away from the flames. Bigger fires provide more light, but they also generate more heat, so your subject will end up having to move further away and the benefit is lost.

Use a standard 50mm lens if you are handholding, or a fast telephoto or zoom lens around 200mm for more distant shots. As well as cropping tight on your subject's face, it's also worth taking a few full-length shots. If you doubt your ability to handhold at shutter speeds as slow as 1/30 second, mount your camera on a tripod so as to avoid shaky shots. Bracketing the exposures a stop or two over the metered exposure is also advisable, to be quite sure of getting one perfect picture.

Bonfire flames can also be used as the background for silhouette pictures of people – all you need to do is pose your subject so that they are between the camera and the fire. To produce a silhouette, you need to expose for the bright flames so that your main subject is underexposed. Fortunately this is easy, because being the brightest part of the scene, your camera's integral metering system will automatically set an exposure that's correct for the flames, so you can concentrate on the composition of the shot and leave everything else to your camera.

Use a telezoom or telephoto lens around 135–200mm for this type of shot, so that you can compress perspective and give the impression the fire is closer to your subject than it really is, as well as making the flames appear bigger so that they fill more of the background. Shooting at a wide aperture such as f/4 or f/5.6 will also throw the flames out of focus so that your subject, in silhouette, stands out sharply against the golden background. For this type of shot you don't need to use such fast film, because your camera will be pointing directly at the fire where light levels are quite high, so it would be as well to stick to something slow – around ISO100 – for optimum image quality.

Finally, why not take some shots of the fire itself? The burning of the guy on November 5 will provide a great opportunity to do this. As the flames begin to die down, the glowing embers also make interesting subject matter, with flames of different colours licking around the logs and coals.

Again, a telephoto or telezoom lens should be used so that you can fill the frame without having to get too close, and with your camera mounted on a tripod. The brightness of the flames may fool your camera's metering system into underexposure, so use the exposure compensation facility and bracket a stop or two over the metered exposure (not under), in 1/3 or 1/2 stop increments for colour slide film and full-stop increments for colour negative film.

Any pictures taken using firelight as the main source of illumination will come out much warmer than you expect. That's because the colour temperature of firelight is very low compared to daylight, so it has a greater content of red which your eye doesn't see but which film records (see page 74).

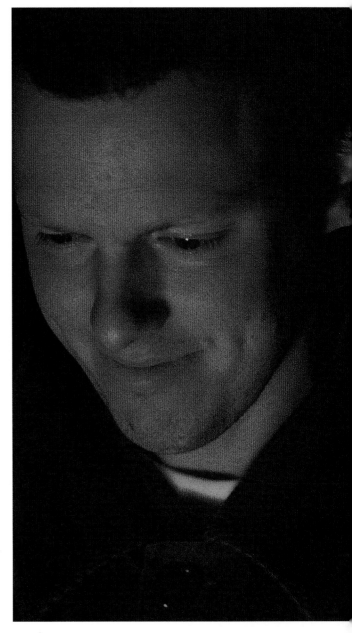

ABOVE **Here the subject is looking down at a roaring fire so that his face was bathed in its golden light. An 80–200mm zoom set to 200mm was used to fill the frame, and I used ISO1600 film to cope with the low light levels – an exposure of 1/15 second at f/2.8 was still required. To determine correct exposure, a handheld lightmeter was used to take an incident reading of light falling on the subject's face.**

ABOVE RIGHT **Using the roaring flames of a bonfire as a background is ideal for silhouettes. Here I used a 200mm telephoto lens so as to fill the frame and ISO100 film. The exposure was left to the camera's integral metering system, and the picture taken in aperture priority mode at an exposure of 1/60 second at f/5.6.**

RIGHT **A 105mm lens was used to capture this detail, the embers glowing orange. An exposure of 2 seconds at f/11 recorded the movement of the flames as they licked around the burning wood.**

SPARKLER FUN

In every box of fireworks you will find a pack or two of sparklers, which can be used for eye-catching 'painting with light' shots where a person writes their name in the air with a lit sparkler or draws a circle in front of their face.

The technique used to capture this on film involves locking your camera's shutter open on B while the sparkler is alight and being moved around, then adding a burst of flash towards the end of the exposure to illuminate your subject. Here's how it's done.

❶ Mount your camera on a tripod, attach a cable release and fit a standard or short telephoto lens: 85–135mm will be ideal. Then set the camera to manual exposure mode and the shutter speed setting to B (bulb).

❷ Position the tripod and camera in a dark, open space at night, well away from brightly lit areas. Avoid locations where there are lights in the background, such as a window – the middle of your garden would be ideal.

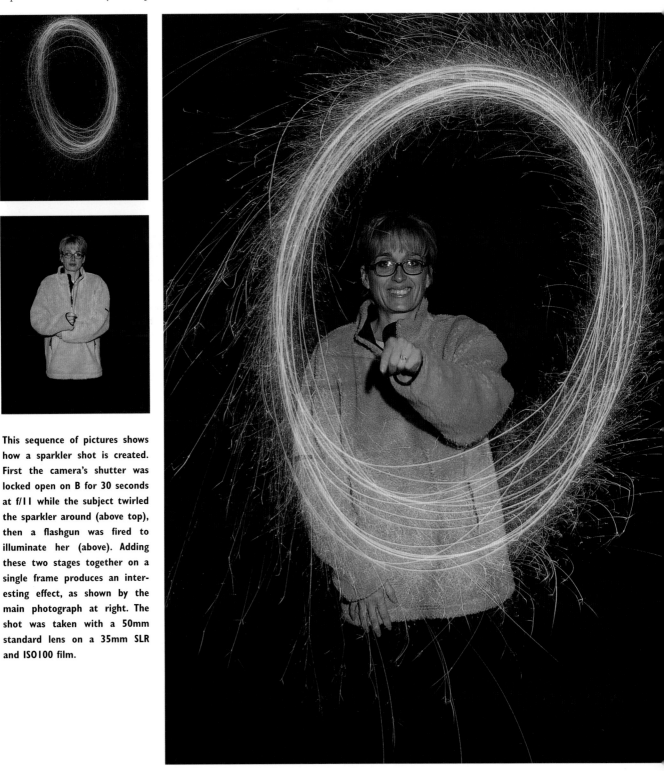

This sequence of pictures shows how a sparkler shot is created. First the camera's shutter was locked open on B for 30 seconds at f/11 while the subject twirled the sparkler around (above top), then a flashgun was fired to illuminate her (above). Adding these two stages together on a single frame produces an interesting effect, as shown by the main photograph at right. The shot was taken with a 50mm standard lens on a 35mm SLR and ISO100 film.

3 Position your subject – a person holding the unlit sparkler – between the camera and the background so their head, shoulders and body fill the frame for a tight, upright composition.

4 Take an electronic flashgun and set it to manual mode. Now check the scale on the gun to see which lens aperture should be set for the flash-to-subject distance at which you are working.

Alternatively, divide the flashgun's guide number (GN) into this distance in metres to find the correct aperture for ISO100 film. If the gun has a GN of 32, for example, because your subject is 2m away the correct aperture will be 32/2=f/16 for ISO100 film. Switch on the flashgun and pop it into your coat pocket.

5 Before taking any pictures, conduct a test to check that the composition is OK by lighting the sparkler and asking your subject to spin it around in front of their body so a circle of light is created around them. While they are doing this, peer through the camera's viewfinder and make sure you are including the sparkler in the shot. If the movement is too wide, ask your subject to make smaller circles, or move the camera further back.

6 Once everything is fine, ask your subject to light a second sparkler. As soon as it is lit, lock your camera's shutter open on B and instruct him/her to start twirling the sparkler in front of them as

before. Keep the shutter open for about 30 seconds, or as long as it takes for the sparkler almost to burn out.

7 Before the sparkler burns out completely, point the electronic flashgun towards your subject and press the test button so that it fires. Make sure your subject's arm is in a downward position before firing the flash, otherwise their face will be obscured. The flashgun doesn't have to be attached to the camera; you can simply hold it in your hand. Once the flash has fired, end the exposure by closing the camera's shutter.

When you have mastered the basic technique, experiment with different variations. Ask your subject to write their name in the air with the sparkler, for example, or get someone else to trace a love heart around a couple in embrace. You could get someone to trace the sparkler around the body of your subject, or use sparklers to trace the outline of other objects such as a bicycle or car.

Of course, you don't have to use flash to illuminate your subject when photographing sparklers – the light from the sparkler itself can be enough. For this grab shot of my young son looking rather mesmerised by his first sparkler, ISO400 film uprated to ISO1600 was used to give an exposure of 1/20 second with a 50mm lens used wide open at f/1.8.

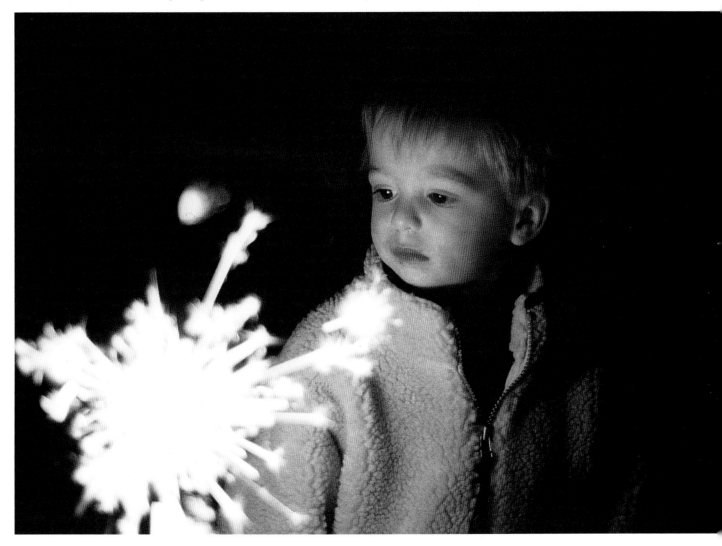

LOW-LIGHT ACTION

Photographing moving subjects in low light presents a set of problems different to other subjects, in that as well as coping with the lack of light, you also have to consider the movement itself and how you can best capture it on film. In normal conditions this isn't a problem, because abundant light allows you to pick and choose shutter speeds to match the rate at which your subject is moving, but in low light much of that control is taken away and you will often find you are struggling to set a moderately fast shutter speed, even with your lens at its widest aperture.

The aim of this chapter is to look at how these problems can be overcome, and discuss techniques that can be used both to freeze and emphasise movement in a variety of low-light situations.

FREEZING MOVEMENT

The two main factors that you must consider above all else when resolving how to freeze a moving subject in low light are firstly, just how low the light is, and secondly, how fast your subject is moving. Obviously, the lower the light and the faster the movement, the more difficult the job becomes, because it will push the capabilities of your equipment, film and skills as a photographer to the limit.

IN AVAILABLE LIGHT

Working in available light is perhaps the most difficult approach to low-light action photography, because you have no choice but to accept the conditions you are presented with, and to make the most of them. That said, by giving some thought to those conditions before you encounter them, steps can be taken to ensure that you take successful pictures. Forewarned is forearmed, as they say.

Conditions are less predictable outdoors because light levels can change significantly in a short space of time. If the weather takes a turn for the worse and cloud cover obscures the sun, you will suddenly lose several stops of light, and that can make all the difference

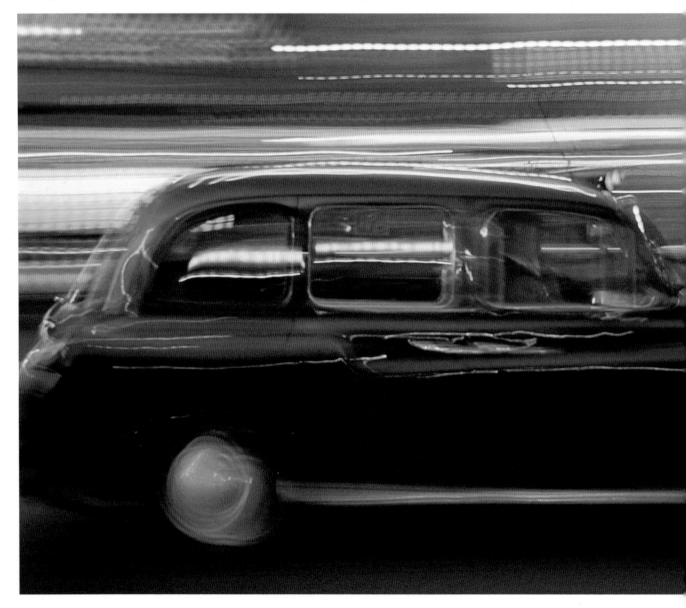

between being able to freeze the action with a suitably fast shutter speed and having to pack up and head for home. Similarly, if you are taking pictures outdoors at dusk, light levels will be far lower than they were earlier in the day so exposures will be longer.

The easiest way to overcome this is by making sure you have a good range of film speeds available. In bright, sunny weather, you can work at shutter speeds of 1/1000 second with film as slow as ISO100, but on a dull day you will struggle to manage 1/125 second, and that won't freeze anything more than a person jogging. So carry a few rolls of ISO400 film as well, to push up the shutter speed should you need it. And if conditions get even worse, be prepared to uprate that film to ISO800 or ISO1600 so that you have even more control (see page 37). To give you an idea of the difference this can make, if you were limited to a shutter speed of 1/125 second with ISO100 film and your lens set to its widest aperture, with ISO200 film you could shoot at 1/250 second, with ISO400 film 1/500 second, with ISO800 film 1/1000 seconds, and with ISO1600 film 1/2000 second.

When taking action pictures indoors, things become even more tricky. Even in a well-lit sports stadium or hall, which is illuminated

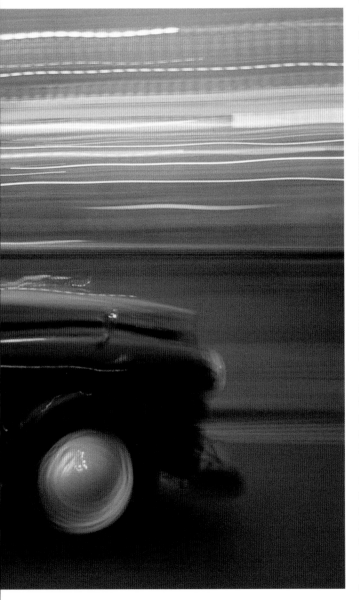

by powerful spot- or floodlights, light levels are going to be much lower than they are outdoors in bad weather, so the need to use fast film from the word go is unavoidable.

How fast you have to go will again depend on the type of action you are photographing, because this will dictate what shutter speed you need to use, but ISO400 will be an absolute minimum, and in most situations ISO1600 will be required. This is where having fast lenses comes in handy, because a wider maximum aperture means you can use faster shutter speeds.

You also need to consider the type of lighting used. At some of the bigger indoor sporting venues that are frequented by TV crews, mixed vapour lighting tends to be used. This has a similar colour balance to daylight or flash, so you can take pictures on normal daylight-balanced film without having to worry about colour casts. Often, however, you will encounter mercury vapour lighting in large stadiums or tungsten in smaller venues, both of which will give your pictures a colour cast – green with mercury vapour and yellow/orange with tungsten (see page 74).

There isn't a great deal you can do about mercury vapour, but tungsten lighting can be controlled using tungsten-balanced film. The fastest version available at present is Kodak Ektachrome 320T, an ISO320 colour transparency film which could easily be uprated to ISO1280 then push-processed by 2 stops. Alternatively, use fast colour negative film and ask the lab to balance the warm cast during printing. This won't be an option if you have standard machine enprints made, but it will be possible if you have your favourite shots enlarged using a hand-printing service, where more time is spent producing a high-quality result.

ABOVE **Light levels in bad weather can be surprisingly low, making it difficult to maintain fast shutter speeds. For this candid shot, taken on a dismal day at a motorcycle rally, I had to uprate ISO400 film 2 stops to ISO1600 so that a shutter speed of 1/125 second could be set to freeze the people trudging through the mud and rain.**

LEFT **Freezing fast-moving subjects outdoors at night is virtually impossible, even with the fastest film and fastest lenses, but that needn't stop you producing dramatic action pictures. For this shot, taken at London's Piccadilly Circus, the fastest shutter speed available was 1/2 second with the lens set to its widest aperture, so the only way I could maintain a reasonable degree of sharpness in the taxi was by panning the camera. Doing so recorded lights in the background as colourful streaks, adding a potent feeling of urgency and speed to the image.**

FOCUSING TECHNIQUE

Once you have overcome the difficulties imposed by low light, the next obstacle is actually taking a sharply focused picture. There are two main techniques at your disposal here: these are pre-focusing and follow-focusing.

Pre-focusing involves focusing your lens on a predetermined spot which you know your subject will pass, and then waiting for the right moment to shoot. This makes it ideal for sporting events which follow a recognised course, such as athletics, car and motorcycle racing, cycling and so on.

The key is to find a good viewpoint where you can get as close as possible to the action, then simply wait for it to come to you. At a motorcycle race you could position yourself close to a bend in the track, then focus the lens on the bend and wait for the riders to

approach; or at a horse race, get near one of the jumps and focus on the top of it, so that you're ready when the jockeys and their mounts become airborne.

The mistake most photographers make when pre-focusing is to trip the camera's shutter release when they see through the viewfinder that their subject has reached the predetermined point and appears sharply focused. However, if you do this there's a strong chance that you'll end up with an out-of-focus picture, because in the short time it takes for your brain to tell your finger to press the shutter button and the shutter actually to open, your subject will have passed beyond the point on which you focused the lens. To avoid this, the shutter must be fired just before your subject snaps into focus. It takes experience to gauge this accurately, but practice makes perfect and the more you try it, the more your hit-rate is bound to improve.

Another common misconception is to think that by keeping your finger pressed down on the shutter button, so that the camera's motordrive fires off several frames in quick succession, a great shot is guaranteed. Unfortunately this isn't always the case, and accurate timing is still required – especially with fast-moving action. So keep your motordrive set to single-shot mode and resist the temptation to use it like a machine-gun.

Where the action is more erratic and pre-focusing becomes unreliable, you need to use follow-focusing instead. As you might gather from its title, this involves tracking your subject with the camera while looking though the viewfinder and continually adjusting focus to keep it sharp, so that you can take a picture when the action reaches its peak.

If this sounds difficult that's probably because it is, but then so was learning to drive the first time you sat behind the wheel of a car, and now look at you. In other words, anything is possible if you are determined enough, so don't lose heart. Follow your kids around the garden as they have fun, or focus on cars driving along a busy road – practise on any moving subject and in a short space of time you will surprise even yourself.

Autofocusing may seem to be a convenient alternative, and in some cases it is. Modern AF systems are surprisingly fast and also accurate, even in the lowest of light, and with subjects moving at moderate speed they will cope admirably – especially if you use a mode such as 'servo' or 'predictive' AF which constantly adjusts focus to keep a moving subject sharp.

Unfortunately, it's when you really need them that autofocus SLRs tend to show their weaknesses, and even the most sophisticated AF system will struggle to keep up with a fast-moving subject.

LEFT **Capturing fast-moving action in bad weather will push your skills to the limit, but nothing is impossible if you're determined enough. In this case, the photographer zoomed his 80–200mm lens while taking the picture, to create an explosion effect that adds a strong feeling of action.**

RIGHT **Indoor sports photography requires fast film to provide action-stopping shutter speeds in the low light. Here ISO160 tungsten-balanced film was used to give natural-looking pictures in the floodlit sports stadium, and the photographer uprated it 2 stops to ISO640 so that he could use a shutter speed fast enough to freeze the action.**

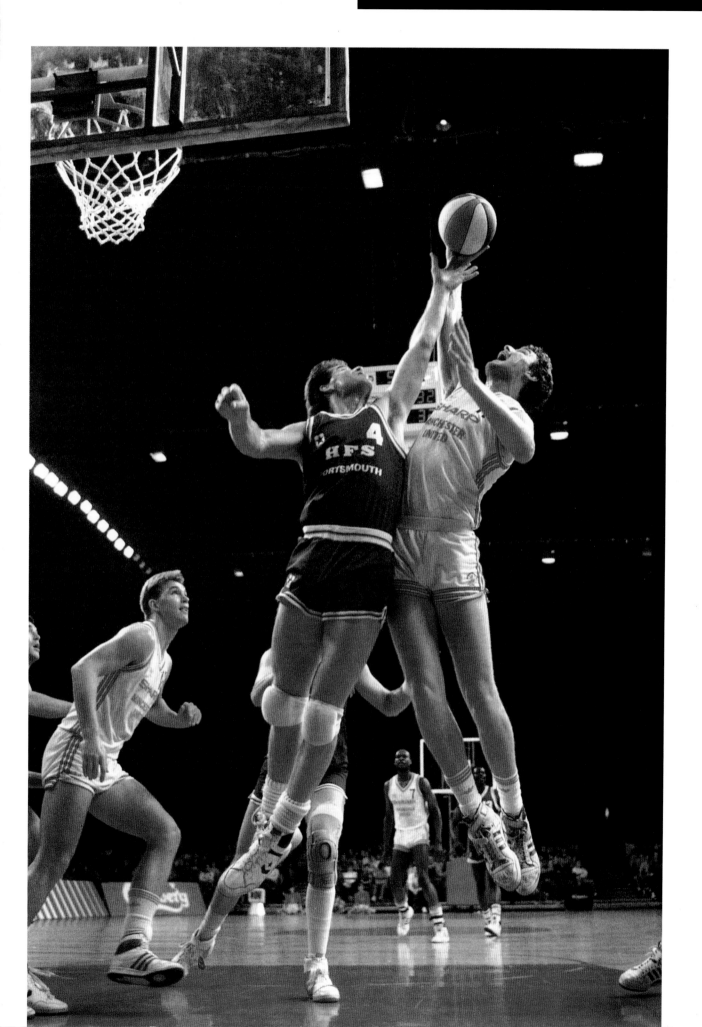

WHICH SHUTTER SPEED?

The minimum shutter speed you need to freeze a moving subject depends on how fast the movement is, which direction your subject is moving in relation to the camera, and how big it is in the frame. Here are some examples for common subjects:

Subject	Across path: full frame	Across path: half frame	Head-on
Person walking	$^1/_{125}$ sec	$^1/_{60}$ sec	$^1/_{60}$ sec
Jogger	$^1/_{250}$ sec	$^1/_{125}$ sec	$^1/_{60}$ sec
Sprinter	$^1/_{500}$ sec	$^1/_{250}$ sec	$^1/_{125}$ sec
Cyclist	$^1/_{500}$ sec	$^1/_{250}$ sec	$^1/_{125}$ sec
Trotting horse	$^1/_{250}$ sec	$^1/_{125}$ sec	$^1/_{60}$ sec
Galloping horse	$^1/_{1000}$ sec	$^1/_{500}$ sec	$^1/_{250}$ sec
Diver	$^1/_{1000}$ sec	$^1/_{500}$ sec	$^1/_{250}$ sec
Tennis serve	$^1/_{1000}$ sec	$^1/_{500}$ sec	$^1/_{250}$ sec
Car at 65kmph	$^1/_{500}$ sec	$^1/_{250}$ sec	$^1/_{125}$ sec
Car at 110kmph	$^1/_{1000}$ sec	$^1/_{500}$ sec	$^1/_{250}$ sec
Formula 1 car	$^1/_{2000}$ sec	$^1/_{1000}$ sec	$^1/_{500}$ sec
Train	$^1/_{2000}$ sec	$^1/_{1000}$ sec	$^1/_{500}$ sec

USING FLASH

If you find it impossible to use shutter speeds fast enough to freeze your subject in available light, a simple solution in some situations is to use flash. Although you may never have realised it, the brief pulse of light from even a basic gun lasts for only a tiny fraction of a second – 1/20,000 second, often even less – so it can freeze movement better than the most sophisticated SLR with the highest shutter speeds. Because this is achieved using light rather than the camera's shutter, it also means that you can photograph subjects moving at high speed in the poorest of lighting conditions, without the need for expensive equipment or complicated techniques.

The only limitation when using flash in this way is that your subject must be within range. This rules out sporting events such as football in a floodlit sports stadium, because the action takes place too far away from the camera; but for close-range subjects such as moto-cross, car rallying, cycling and some athletics events, it's ideal.

Flash can also be used in more everyday situations to freeze movement, such as when photographing people outdoors at night; thus paparazzi photographers almost always have a flashgun mounted on their camera's hotshoe when they are hoping to capture celebrity subjects on film outside nightclubs and restaurants, simply because it makes life so much easier.

Producing well-exposed results is easy, too. Dedicated flashguns should be able to do it with no help from you – just switch your camera to program mode and fire away. The same applies with automatic flashguns, which use a sensor to measure light reflecting back from your subject in order to gauge when sufficient light has been delivered. The only time this may not be the case is if you are taking pictures outdoors at night, as the predominance of darkness in the scene may fool your flashgun into giving too much light, causing overexposure. If in doubt, try it.

Alternatively, switch the gun to manual mode and calculate the required lens aperture by dividing its guide number (GN) into the flash-to-subject distance. If your flash has a GN of 32, for example, and your subject is 2m away, you need to use a lens aperture of 32/2=f/16 with ISO100 film.

Another consideration is which shutter speed to use. Dedicated flashguns tend automatically to set your camera to its recognised flash synchronisation speed, which is usually around 1/125 second, depending on the camera. You can also do this if you so wish, but if you do, remember that in most low-light situations it will be too brief to record any ambient lighting, so there would be a real danger of everything but your main subject coming out black because it's underexposed.

In some situations this can improve the shot by focusing all attention on your subject. Also, if you set up a shot where your subject is photographed against a dark background – such as a martial arts expert caught in mid-air doing a side-kick – you wouldn't want it any other way. But if you do want to record detail in the background, then it is important that you ensure that the exposure time used is long enough.

The easiest way to do this is to set your camera to aperture priority mode, so that you select the lens aperture required to give correct flash exposure, while the camera automatically sets a shutter speed to record the ambient lighting. Check just how long the exposure is going to be – a shutter speed of 1/4 or 1/2 second will be fine, but there's little point in using flash to freeze a moving subject if the camera's shutter then remains open for several seconds.

LEFT **Electronic flash is able to stop a moving subject in its tracks no matter how low the light is. In this picture, taken outdoors at dusk, the only sign of movement is in shadowy streaks left by the woman's arms as she leapt into the air. It was taken handheld using a 50mm standard lens and an exposure of 1/4 second at f/8 on ISO100 film.**

BELOW **Flashguns with a fast recycling time are ideal for capturing rapid action sequences in low light. These paparazzi-style shots were taken to test the capabilities of a flashgun when used with a motordriven Nikon SLR. I started shooting as my subject emerged from the car, then simply kept my finger on the shutter release button while at the same time stepping back so that the camera and flash kept firing.**

Multiple flash

This technique is very similar to open flash (see page 176), in that a flashgun is fired several times during a single exposure. Instead of doing this to provide enough light to illuminate a static subject, such as a building at night, however, you use the flash bursts to capture several images of a moving subject on a single frame of film.

The way you do this will depend on the type of flashgun you own and the rate at which your subject is moving, though in all cases you need a dark environment and your subject should be against a dark background. Indoors, a darkened room will be ideal, while outdoors, night is the best time to experiment with multiple flash.

If you have a normal flashgun which can only fire one burst at a time, you will need to set up a planned situation and fire the flash several times to imply fast movement, even if it takes many seconds to complete the shot.

Outdoors at night, for example, you could photograph a person walking in front of the camera and fire the flash each time they take a step so that you record a series of overlapping images, or do the same with them walking towards the camera. Indoors, in darkness, you could photograph a person in different parts of the room, or ask them to change position slightly between each flash burst – looking to one side, then towards the camera, then to the other side, perhaps.

This effect is achieved by locking your camera's shutter open on the B setting, then firing the flashgun by pressing the exposure test button each time your subject changes position. To ensure correct exposure, switch your flashgun to manual mode and calculate the required lens aperture using the method outlined above. This same lens aperture can be used for each flash burst, providing your subject doesn't move much closer to, or further away from, the camera when they change position.

The best way to use multiple flash to capture a moving subject on film, however, is with a flashgun that has a strobe mode, so that it can fire several times in quick succession. This will enable you to capture fast-moving action as it really happens, such as a basketball player jumping to shoot a basket, a dancer performing a graceful manoeuvre or even things like a hammer striking a nail.

Some modern flashguns can be programmed to fire a set number of flashes, from one to up to 50, over a set period of time – ten flashes in 1 second, five flashes in 2 seconds, eight flashes in 1/4 second and so on – so you have complete control over the effect that will be obtained, and also know exactly how many images of your subject will record.

Achieving correct exposure when using a flashgun of this type is straightforward. Most models will tell you which lens aperture to set once you have programmed in the required number of flashes and the exposure time, and the only other thing that you need to ensure is that your subject is against a black background. This is necessary because the background will be flashed several times, and

This multiple flash shot of a hammer striking a nail was taken in a darkened room against a black velvet backdrop. The flashgun – a Metz 50 MZ-5 – was set to stroboscopic mode and programmed to deliver seven flashes at a rate of ten flashes per second. As the assistant started to bring the hammer down, I tripped the shutter release and the flash performed its magic.

the cumulative effect of the light will result in overexposure. The same applies with any other static objects that are included in the shot. Moving objects aren't overexposed, because each time the flash fires they have changed position.

Multiple flash can be quite tricky to master, but once you have tried it a few times the technique will become second nature and you can use it to produce amazing action shots in low light.

EMPHASISING MOVEMENT

Of course, there's no rule which says you must freeze all traces of action when photographing a moving subject in low light, and in some cases doing so can actually reduce the impact of a picture by losing all sense of motion – which somehow defeats the object of shooting it in the first place.

The solution is to use a controlled amount of blur, so that your subject looks as though it's moving rather than being glued to the spot, and there are several ways in which you can do this.

USING A SLOW SHUTTER SPEED

As well as controlling how long the light entering your camera lens is allowed to reach the film to ensure correct exposure, the shutter also serves another important role – it governs how subject move-ment is recorded. If you photograph a moving subject with a fast shutter speed, all movement will be frozen; on the other hand, if you set a slow shutter speed your subject will blur.

The amount of blur recorded depends on two factors – how fast

Using a slow shutter speed to emphasise movement can produce dramatic results, adding a strong sense of motion and creating a pleasing abstract effect. For this shot of a sportscar the shutter speed used was 1/15 second and the picture was taken from close range with a 28mm wide-angle lens as the car passed by.

your subject is moving, and which shutter speed you use. Therefore, the key to emphasising movement is matching the right shutter speed to the right subject to create a convincing effect without the end result looking like a mistake. If you photograph a Formula 1 car at 1/125 second, for example, the car will come out blurred because it's moving so fast, especially on a straight track. But if you use that same shutter speed to photograph a person walking past the camera, the chances are that they will be stopped dead and all traces of movement frozen.

Here are some suggested shutter speeds for different subjects:

Subject	SHUTTER SPEED (SECONDS)	
	Moderate blur	Extensive blur
Person walking	1/30 sec	1/4 sec
Person sprinting	1/60 sec	1/15 sec
Horse trotting	1/30 sec	1/8 sec
Horse galloping	1/125 sec	1/30 sec
Car travelling at 50kmph	1/125 sec	1/30 sec
Car travelling at 110kmph	1/250 sec	1/60 sec

These shutter speeds assume the subject is travelling towards the camera. For subjects moving across your path, more blur will record, so consider using a slightly faster shutter speed – 1/60 second instead of 1/30 second, for example.

At the same time, there are no hard-and-fast rules as to which shutter speed you must use, and it's possible to produce stunning images by intentionally using really slow speeds to produce abstract shots, where emphasis is placed on the fluidity of movement rather than what the subject is – try photographing people walking using a 1 second exposure, or a car on 1/4 second.

Another useful trick is to include something static in the picture so that the movement is emphasised even more. If you are photographing people on a dance floor in a disco, for example, ask one person to stand still and look at the camera, so that they come out sharp while everyone around is blurred. This can also work well when photographing people walking along the street or on a busy station platform at rush-hour – all you have to do is take someone along to stand in the crowd and provide a natural foil to the hustle and bustle going on in the rest of the scene.

PANNING

A more effective way of emphasising movement is to use a technique known as panning. To do this, the lens is focused on a predetermined point, but instead of keeping the camera still and waiting for your subject to approach, you follow your subject with the camera towards the point on which the lens is focused and trip the shutter as it reaches that point while still moving the camera. The result should be that your subject comes out relatively sharp but the background is reduced to a series of blurred streaks.

The key to success is in the smoothness of the pan. If you follow your subject at an even pace, then it will come out sharp against the background because its position in the viewfinder remains the same, but if the pan is uneven then you will get blur in your subject as well as the background. Both outcomes can produce superb results, but smooth panning takes time to master.

Shutter speed choice can also make a big difference, because the slower the speed is, the more difficult it is to maintain a smooth pan and keep your subject sharp. With fast-moving subjects such as racing cars, motorbikes and trains, 1/250 second or 1/500 second makes a good starting point, while for slower subjects such as a cyclist or a galloping horse, start at 1/60 second or 1/125 second. These shutter speeds may seem rather fast, but relative to the subject's pace they are slow enough to give a strong panning effect.

As your experience grows and your panning action becomes smoother you can use much slower shutter speeds and still keep your subject sharp while capturing much more blur in the background. Slow speeds can also be used intentionally to introduce subject blur and give a more impressionistic effect. Try taking a panned shot of a fast car on 1/15 second, or photograph a person jogging at 1/4 second or slower.

The ideal stance to maintain a smooth pan is standing upright with your elbows tucked into your sides, your legs slightly apart and your back straight. Panning is then achieved by swinging your upper body from the hips. With long lenses, a monopod (see page 64) can be used to aid panning and will help to keep the camera level as you swing. Panning should also continue after the picture has been taken to give a smooth effect.

TRACKING

An alternative to panning is a technique known as tracking. The effect obtained is very similar, with a relatively sharp subject against a blurred background, but instead of standing still and panning the camera as your subject passes by, you move yourself and the camera with the subject.

Car photographers often use tracking, shooting from an open window or the sunroof of a moving car which is being driven in front of or alongside the one they're photographing. Tracking can also be used to photograph other moving subjects, such as cyclists or marathon runners, by shooting from a car or a motorbike that's following the action.

A benefit of tracking over panning is that it's easier to keep your subject sharply focused, because you're moving at a constant pace in relation to them. You can also see what's going on in the camera's viewfinder more clearly, and can take several pictures in quick

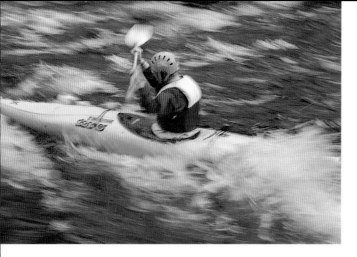

LEFT **When light levels are low, panning is a great technique to use; not only because it will add impact to your action pictures but also because it enables you to use a slow shutter speed to capture moving subjects on film. This picture was taken by chance as I was walking through a wooded river valley. Light levels were so poor that the fastest shutter speed available was 1/15 second – far too slow to freeze the canoeist, but ideal for a panned shot with the subject standing out against the blurred water.**

BELOW **Car rallying is a notoriously difficult sport to photograph, simply because the competitors are travelling at such high speeds, and many events take place along dark, shady forest tracks or at night. One way to overcome this is by shooting on a bend, where the drivers have to slow down, and using flash to freeze the cars. In this case, the photographer panned his camera as well, to blur the background and heighten the sense of motion.**

succession, increasing your chances of success. With panning, especially on fast subjects, things happen very quickly and you often only get the chance to shoot one frame of film before your subject has passed by. This makes it much more difficult to master.

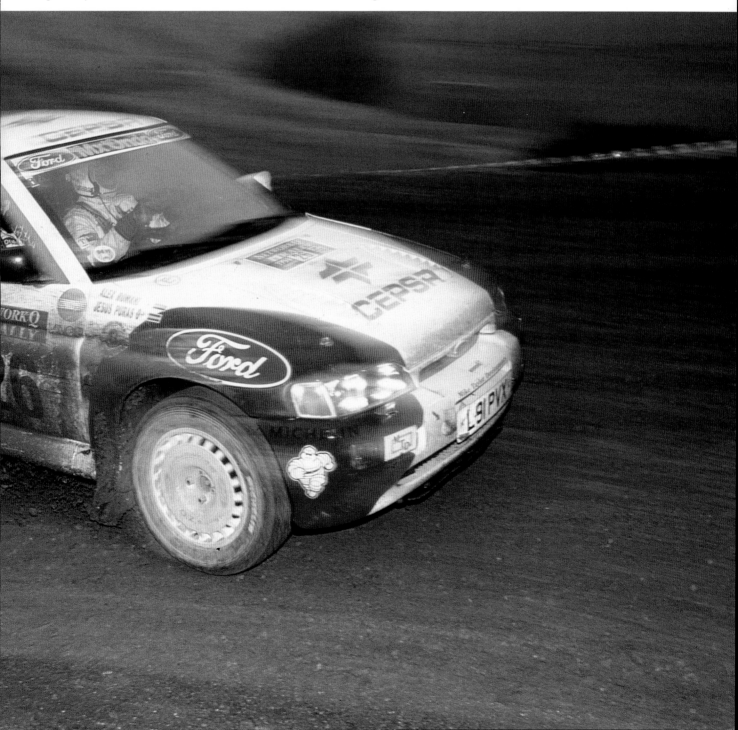

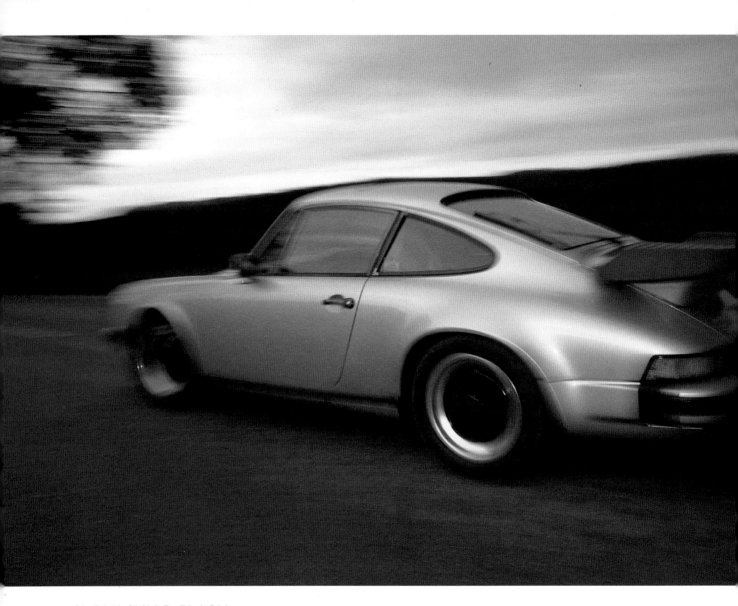

SLOW-SYNC FLASH

So far in this chapter we have discussed using flash to freeze a moving subject in low light and slow shutter speeds to emphasise movement. Now it's time to look at combining those two things so you get the best of both worlds.

Slow-sync flash is the name of the game, and this popular technique can be used to produce dramatic, excitement-filled pictures of all manner of low-light action subjects, from rally cars racing through shady forests at night to people having fun on fairground rides such as the dodgems (see page 151).

Many 35mm SLRs and dedicated flashguns can produce slow-sync flash effects automatically, while modern 35mm compact cameras often have a slow-sync or night mode which does the same job – check your owner's manual for information.

The best way to use slow-sync flash, however, is by switching your flashgun to automatic instead of dedicated mode, and then following these steps:

❶ Switch your camera to aperture priority exposure mode, so that you set the aperture of your choice to contrast the flash exposure and the camera automatically sets the shutter speed required to expose the ambient light correctly.

Slow-sync flash was used to photograph this Porsche sports car speeding down a country lane – the burst of flash helped to freeze the movement of the car, while panning the camera during an 1/8 second exposure has recorded blur in both car and background. The shot was taken with a 50mm standard lens on ISO200 film.

❷ The lens aperture you use will depend on the light levels and how far away your subject is – automatic flashguns have a greater range at wide apertures such as f/2.8 or f/4. Remember that the smaller the aperture is, the slower the shutter speed will be and the more blur you will get. Try something in the region of 1/30-1/4 second, going for faster speeds if your subject is moving at a rapid pace and slower speeds to emphasise the movement of slower subjects.

❸ To achieve a good balance between the flash and ambient lighting, a ratio of 1:2 is normally used. This effectively means that the flash is firing on half power. Some modern flashguns have a variable power output, so you can set them to half power quickly and easily at the press of a button.

If your gun doesn't have this facility, you can achieve the same effect by setting it to an auto aperture that's 1 stop wider than the

aperture set on the lens. So, if you've set f/11 on the lens, set f/8 on the flashgun. Your camera and flashgun are now ready for action.

4 All you have to do now is find a suitable viewpoint where your subject will pass by at close range. When you've done that, focus the lens on the distance away that your subject will be, and then wait for it to approach.

5 Follow your subject by panning the camera, then as it reaches the predetermined point, trip the shutter and continue panning the camera. By doing this, the flash will freeze your subject, but as you pan the camera, the background will blur to give a dramatic feeling of movement.

SECOND CURTAIN FLASH SYNC

Many camera and flashgun combinations operate using a system known as 'first curtain sync', where the flashgun fires at the start of the exposure rather than the end. With second curtain or rear curtain sync, the opposite occurs, and the flash fires at the end of the exposure instead.

In most situations, either can be used and you wouldn't know the difference, but when using slow-sync flash to capture moving subjects in low light, second curtain sync gives a better effect, because you get the blur of your subject caused by the slow shutter speed trailing behind the frozen flash image, instead of the other way round.

Not all cameras and flashguns offer the option of second curtain sync. Some allow it when used with a certain flashgun, while others are capable of first and second curtain sync with any flashgun, so check this out.

1st curtain sync.

2nd curtain sync.

ABOVE **Here's another example of slow-sync flash being used to freeze a moving subject in low light. The young boy was asked to run towards the photographer waving his arms, then once he reached a predetermined point the picture was taken using an exposure of 1/15 second at f/5.6.**

LEFT **This pair of pictures shows how first and second curtain sync produce different results when photographing a moving subject. As you can see, second curtain sync gives an altogether more convincing effect.**

FAIRGROUND FUN

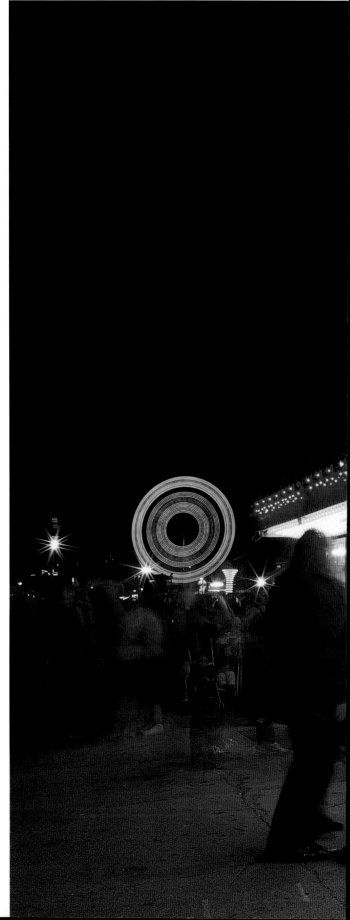

Funfairs and fairgrounds come to life in the evening, when the flashing lights and colourful rides make perfect subjects for low-light photography. Also, as most stay in town for several days, you will have ample opportunity to take lots of pictures – and to correct any mistakes that you make on your first visits.

If you're not familiar with the location, it's well worth having a look around during the day so you can get a feel for the place and what it has to offer. See if you can find a good vantage point that overlooks the whole fairground, as this could produce some great shots, and check out the different rides that are there so that you can start thinking about the type of shots you might take and the techniques you'll need to use – and also how you can make best use of your time each evening.

The best time to arrive at the funfair when you intend to take photographs is at dusk – once daylight levels begins to fade after sunset, the colourful lights of the fairground will light up the sky and create a dazzling spectacle.

This is an ideal time to photograph rides like the big wheel, which look their best when there's still some colour in the sky to provide an interesting background to the spinning lights, or to get a shot of the whole fairground from a high viewpoint. Once the sky begins to darken as nightfall approaches, you can then start taking photographs that don't include the sky.

In terms of equipment, a 35mm SLR with a range of lenses from, say, 28mm wide-angle to 200mm telephoto will allow you to take a range of different shots, though you could manage quite happily with just a single zoom lens such as a 28–80mm. Light levels will be very low, so for many pictures you'll be using exposures of several seconds. This makes a sturdy tripod essential to keep your camera steady and ensure sharp results. A cable release is also handy for tripping the camera's shutter release.

Another essential item is an electronic flashgun. It needn't be particularly powerful, or boast lots of fancy features, but you'll find it invaluable for freezing movement when photographing things like the dodgem cars. For long exposure shots of fairground rides, and for action shots taken with flash, stick to slow-speed film for optimum image quality – ISO50–100 is ideal. It's also worth packing a roll of faster film such as 1600. This will allow you to take some handheld shots, too, of people enjoying the fair.

The main thing to remember is that fairgrounds, like any busy venue or event, often attract some rather unsavoury characters who will be on the lookout for some easy pickings. Photographic equipment always looks expensive so never leave your gadget bag unattended while you're taking a photograph, otherwise it's likely to disappear as you are peering through the camera's viewfinder and concentrating on your shot. Instead, hang it from your tripod so you can see it.

The bright lights of a winter funfair stand out brilliantly against the night sky in this photograph. Because light levels were so low an exposure of 30 seconds at f/16 was used on ISO50. You can see how people moving during the exposure have blurred, while those standing fairly still have come out almost sharp. The colourful circles on the left of the photograph were created by a big wheel in the distance which was spinning throughout the exposure.

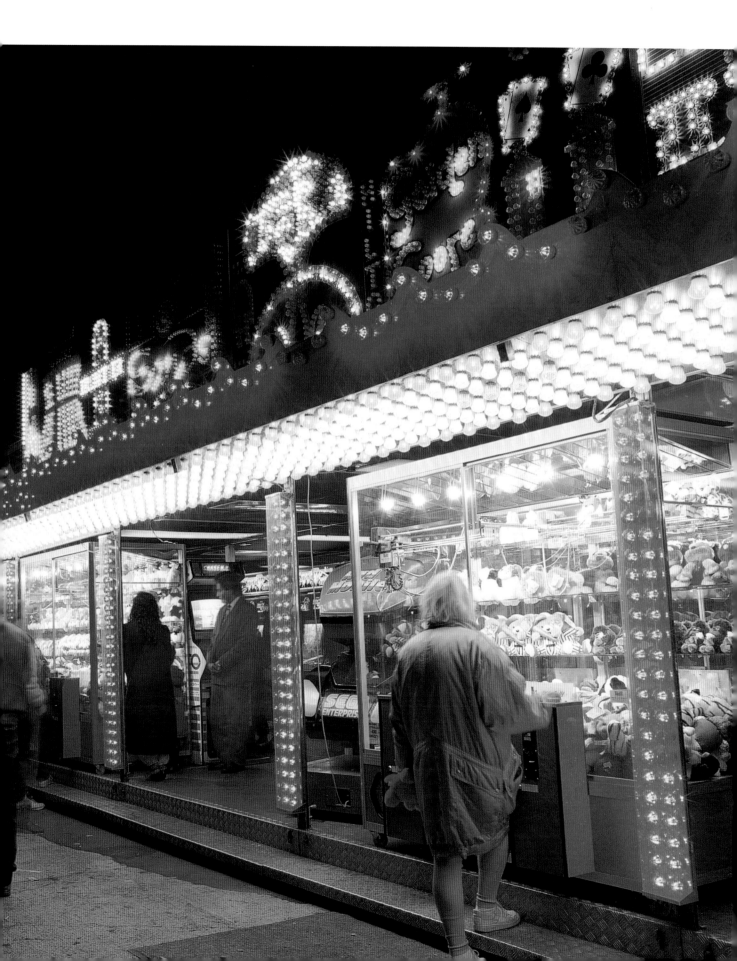

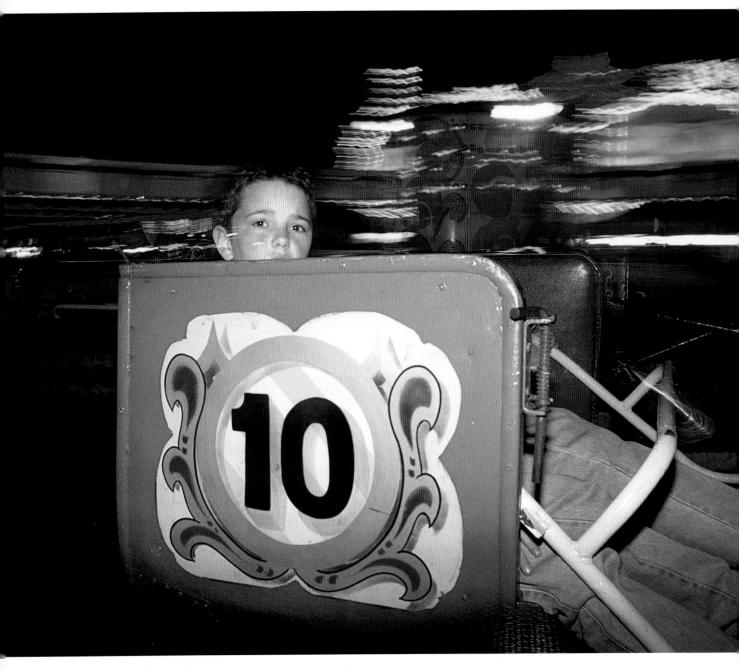

EXPOSURE HEADACHE

The biggest problem you're likely to face when photographing fun-fair rides is getting the exposure right. Bright, flashing lights against ever-darkening sky creates a very high contrast situation that your camera's integral metering system may find difficult to cope with. Modern SLRs with sophisticated multi-pattern metering systems may partly overcome this, as they're designed to recognise tricky lighting situations and deal with them accordingly. However, that's still no guarantee of success.

One option is to take a general TTL meter reading with your camera and then bracket exposures. The risk of underexposure is much higher than that of overexposure, so only bracket over the metered exposure. Do this by setting your camera to aperture priority mode and then overriding the metered exposure using the exposure compensation facility. That way, the lens aperture you select will remain unchanged, so you can control depth-of-field, and the

ABOVE **Don't limit your activities to just the rides – funfairs are also full of stands and stalls where people try to win prizes such as cuddly toys or goldfish by throwing darts into playing cards, hooking plastic ducks from tabletop ponds and trying to get hoops over bottle necks. These make great subjects for handheld shots, and the yellow cast created by the artificial lighting will add a welcoming warm glow to your photographs.**

camera will make any adjustment to exposure by changing the shutter speed (exposure time). A bracket of 2 stops over the metered exposure in 1/2 stop increments should do the trick – this means you will expose five frames: one at the metered exposure, then four more at +1/2 stop, +1 stop, +1 1/2 stops and +2 stops.

If you are using your camera in manual mode, bracket by increasing the exposure. If the metered exposure is 20 seconds at

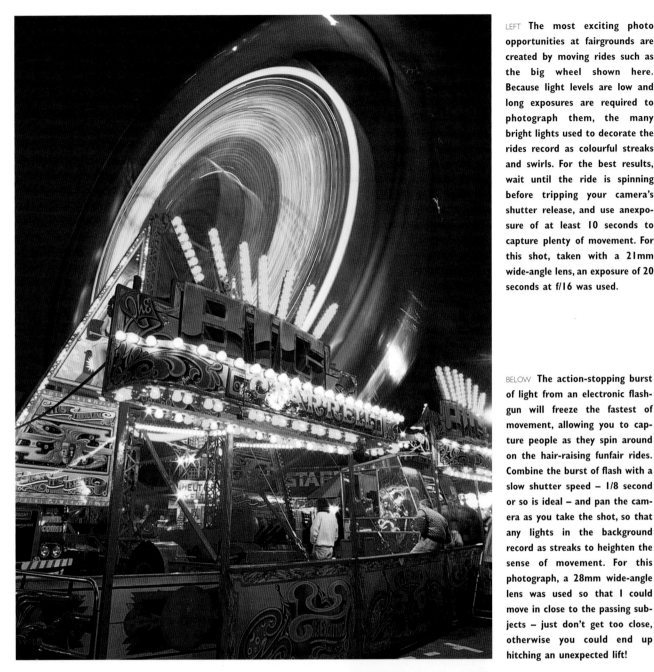

LEFT **The most exciting photo opportunities at fairgrounds are created by moving rides such as the big wheel shown here. Because light levels are low and long exposures are required to photograph them, the many bright lights used to decorate the rides record as colourful streaks and swirls. For the best results, wait until the ride is spinning before tripping your camera's shutter release, and use anexposure of at least 10 seconds to capture plenty of movement. For this shot, taken with a 21mm wide-angle lens, an exposure of 20 seconds at f/16 was used.**

BELOW **The action-stopping burst of light from an electronic flashgun will freeze the fastest of movement, allowing you to capture people as they spin around on the hair-raising funfair rides. Combine the burst of flash with a slow shutter speed – 1/8 second or so is ideal – and pan the camera as you take the shot, so that any lights in the background record as streaks to heighten the sense of movement. For this photograph, a 28mm wide-angle lens was used so that I could move in close to the passing subjects – just don't get too close, otherwise you could end up hitching an unexpected lift!**

f/16, for example, shoot a sequence of frames at 20, 30, 40, 60 and 80 seconds.

A more reliable technique is to meter from the dusk sky. Once the sun has set and light levels begin to fade, the sky will eventually appear blue – usually 20-30 minutes after sunset. At this time the ambient (daylight) and artificial light levels are similar, so if you take a meter reading from the sky, the exposure reading you get will be correct for the whole scene. Use a telephoto or telezoom lens to home in on a patch of dusk sky so that you can meter directly from it, then set the exposure on your camera in manual mode. Expect an exposure of around 20 seconds at f/16 on ISO100 film.

This latter method is particularly reliable, and should enable you to take perfectly exposed shots of any fairground rides – though it's always worth bracketing a stop over the metered exposure to compensate for reciprocity failure and to provide a safety net in case your metering is a little inaccurate.

FAIRGROUND ACTION

The aim of funfairs is to give people a thrill as they spin around at high speed on the various rides, so when you've taken loads of long-exposure pictures of those rides, why not look for some closer-range action opportunities? Rides like the waltzer and dodgem cars are ideal for this because the action is more or less at ground level.

Because light levels are low, action-stopping shutter speeds are out of the question, no matter how fast the film you are using. But this needn't be a problem, because the chances are that you have an accessory in your gadget bag that will allow you to freeze the fastest movement – a portable flashgun. The pulse of light from even the simplest flashgun lasts for only a tiny fraction of a second: this is more than fast enough to freeze a bullet shattering a light bulb, so it won't have any problems coping with fairground rides.

The technique used to photograph fairground action is known as slow-sync flash and involves combining a burst of flash with a slow shutter speed. The idea is that the flash freezes your subject while the slow shutter speed records ambient light and movement, so you get a frozen and blurred image on the same photograph.

The easiest way to achieve the effect is by using a flashgun in automatic mode, and your SLR set to aperture priority, so you select the lens aperture required to give correct exposure for the flash, while your camera automatically sets a shutter speed to expose the background lighting correctly. For a step-by-step guide to this technique, turn to pages 144–145.

The amount of blur you get in the background depends on the shutter speed set by the camera. Initially you will find 1/4 or 1/8 second is more than slow enough, but once your confidence increases, try experimenting with speeds down to a second or more.

LEFT **Taken at a street fair, this pair of pictures shows how using a long exposure to photograph a ride completely transforms its appearance. The shot at the top was taken when the carousel was stationary, while beneath it is the shot taken when it was spinning, using an exposure of 60 seconds at f/16.**

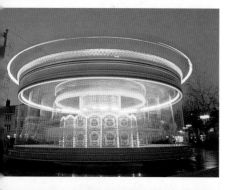

BELOW **If you can find a high viewpoint, it's often possible to take an aerial view of the whole funfair and all the colour and action it contains. This photograph was taken soon after sunset and I waited until the biggest ride was in full swing. Although crowds of people were milling around, many have almost disappeared because they were moving during the 30-second exposure.**

RIGHT **This is the centre of a fairground big wheel, photographed using an 85mm telephoto lens to fill the frame, and an exposure of 30 seconds at f/16 to record the spinning lights as concentric circles.**

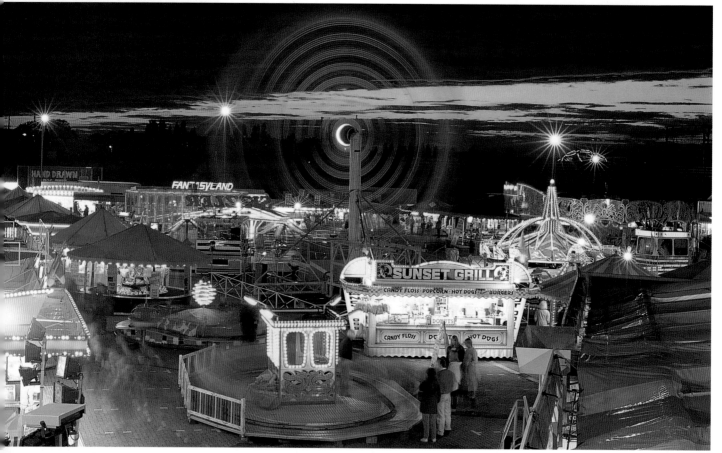

THE SKY AT NIGHT

Although the best time to photograph most night scenes is during the period after sunset when there is still colour in the sky, once that colour has faded to blackness you don't have to pack away your camera and head for home. Why? Because if you take a look overhead you will see a whole new area of low-light photography opening up before you – namely, the moon and stars in the night sky.

Serious astro photographers use complicated tracking devices known as equatorial drives and powerful telescopes to take pictures of the galaxies, but you don't need them to produce interesting images, and the aim of this section is to look at how you can produce breathtaking results using the equipment that you already own.

PHOTOGRAPHING THE MOON

Including the moon in a night scene, or photographing it in isolation, is relatively straightforward providing you are aware of two important facts. Firstly, it's very bright compared to the rest of the scene. Secondly, it moves – a distance equivalent to its own diameter every 2 minutes.

What this means in practice is that if you include the moon in a picture, it's going to be badly overexposed if you correctly expose the rest of the scene, and if you use an exposure longer than a few seconds, it will also record out of shape – the longer the exposure, the more 'sausage-like' it will become.

If you are using a wide-angle lens to record a scene in which the moon is included, this won't necessarily be a problem, because the moon itself will be so small that it won't spoil the shot – even if it does record as a featureless white smudge! However, if you use a telephoto lens for the shot, then you need to keep the exposure as brief as possible to minimise the degree of overexposure and movement recorded. Shooting when the moon first appears and ambient light levels are still quite high will help here, allowing you to use short exposures. Loading up with faster film can be a benefit too, but not if you end up using ISO1600 film which produces a grainy, muddy image.

The alternative is to photograph the moon separately, so that you can ensure it's pin sharp and perfectly exposed, then combine it with the night scene on a single frame of film. This is the technique many photographers use as it produces much better results, and there are various ways you can go about it.

The best time to shoot is on a clear night when the sky is black so that the moon is sharply defined, and also when the moon is quite high in the sky so you have a clear view of it with lots of empty sky around. The moon also looks its most impressive when it's full, so check your diary for the full moon dates. A few days either side of this will also produce good results.

To get a perfect shot of a full moon surrounded by blackness you need to be using an exposure of 1/250 second at f/8 with ISO100 film; 1/125 second or 1/60 second for a crescent moon. There is a little leeway in this, but if you are photographing the moon in clear conditions against the black night sky, these exposures will give a good result.

In terms of lenses, for every 100mm increase in focal length, the diameter of the moon will increase by 1mm on a 35mm film

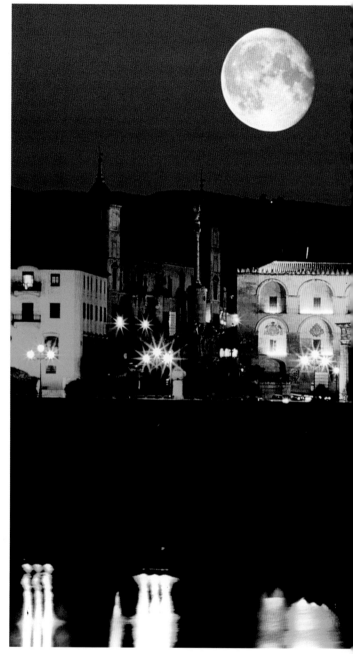

This stunning night scene was created using a double exposure. A roll of film had previously been exposed to the moon using a 400mm lens. During a visit to the Spanish city of Cordoba, I decided to reload the film and use it to photograph the floodlit old mosque, knowing the moon already on the film would fall nicely in the sky.

frame – 0.5mm with a 50mm standard lens; 1mm with a 100mm; 2mm with a 200mm; 4mm with a 400mm; 6mm with a 600mm and so on. Anything from 300mm will give you a good shot, but which ever lens you use, it's a good idea to mount your camera on a tripod to keep it perfectly still, and trip the shutter with a cable release.

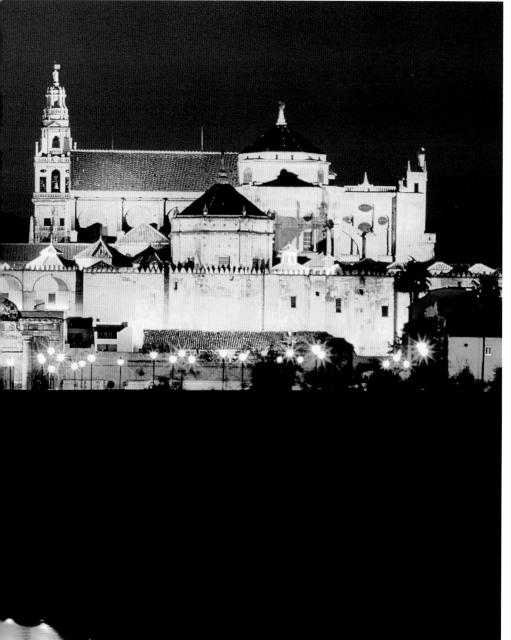

100mm.

300mm.

600mm.

ABOVE **This set of pictures shows the size of the moon on a 35mm film frame when photographed with different lenses. As you can see, the longer the lens you use, the more dramatic the moon looks.**

When you then photograph a night scene to combine with the moon, do so while there's still some colour in the sky but the sky itself is quite dark, otherwise the moon won't stand out too well.

Now to adding the moon to your night scene...

USING A MULTIPLE EXPOSURE FACILITY

If your camera has a multiple exposure facility, you can photograph the main night scene and then use a longer lens to add the moon to the same shot a little later.

It really is that simple, though you need to wait until the sky has darkened before photographing the moon; you should also make sure that you don't include anything but black sky around it,

otherwise you'll end up with elements in the scene overlapping with the main night shot.

It's also important to note where key features in the night scene are so that you don't position the moon in the wrong place – in front of a church tower or something silly like that. Sketching the scene will remind of you any danger areas, and leaving plenty of sky on one side of the shot will reduce the risk of disappointment.

A reasonable number of 35mm SLRs have a multiple exposure facility. Cameras with a shutter in the lens rather than in the camera body are also suitable, as you can keep re-cocking the shutter without having to advance the film. Many medium-format cameras and all large-format ones fall into this category.

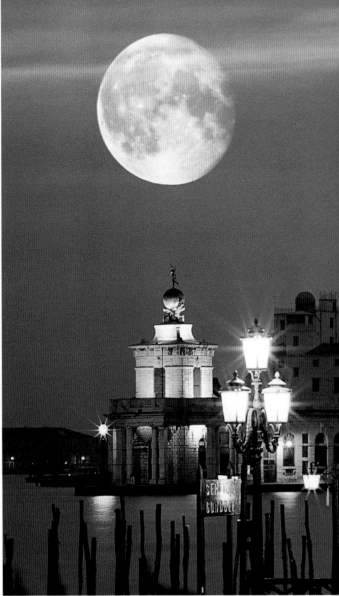

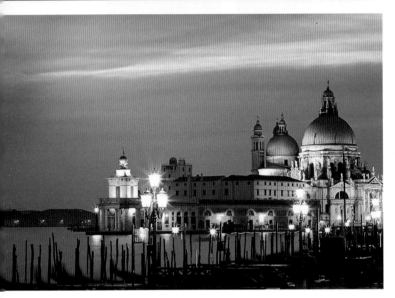

RELOADING THE SAME FILM

If your camera doesn't have a multiple exposure facility, the easiest way to re-expose the same frame of film is by rewinding it, then reloading it into the camera and winding onto the same frame again. Here's a step-by-step guide to doing that.

❶ Load a fresh roll of film, then just before closing the camera back, put a mark on the film leader (the bit you can see) against a reference point in the camera back using a Chinagraph pencil. This will help to ensure you get the film correctly aligned when you reload it because you can line up the mark on the film with the point inside the camera.

❷ Once the film has been advanced to the first frame take a picture of the moon, placing it towards the top of the picture area in one of the corners or in the middle. Repeat this for the whole roll of film, varying the position of the moon and perhaps using different lenses to vary its size. Keep notes about the position of the moon, such as: 'Frames 1–9 top left; 10–20 middle; 21–36 top right.' Now rewind the film and write on the leader 'moon shots'.

❸ On the same evening or at a later date, reload the roll of film that has been exposed to the moon, using the reference point and mark

on the leader to aid perfect alignment, and then photograph your chosen night scene. Travel photographers often do this, exposing several rolls of film to the moon so that when they visit interesting locations, such as the Eiffel Tower or Pyramids in Egypt, they can take night shots of them with the moon already in place on the film to create stunning effects.

❹ Once you have re-exposed the whole roll of film, take it to be processed so you can admire your work.

Cameras with a manual film advance lever work better for this technique because they make it much easier to get the film perfectly aligned when you reload it. Unfortunately, cameras with integral motordrives don't work as well because they leave uneven gaps between film frames as you shoot off the film. This means that no matter how carefully you reload the film, the chance of getting the alignment right is slim, especially from the middle of the roll onwards.

I have first-hand experience of this, and wasted several rolls of film trying to use the technique with my SLR. I found that when the films were processed the moon was in a completely different place to where I expected it to be, usually rendering the pictures useless as the composition was incorrect.

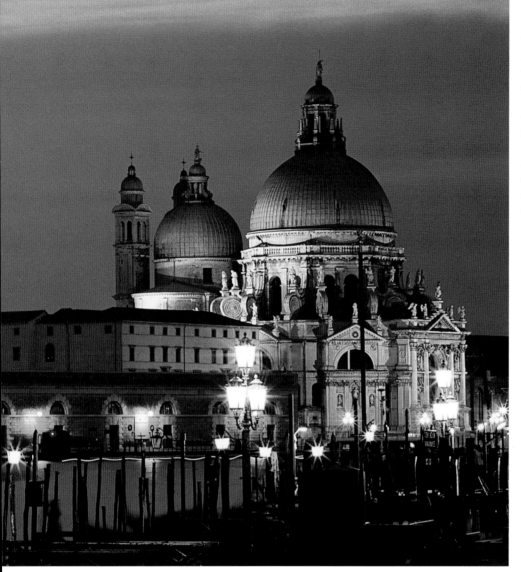

This night shot was created by copying two separate medium-format transparencies on to a single frame of 35mm film using a 105mm 1:1 macro lens on a Nikon f5 SLR and a lightbox to provide illumination. The moon was originally photographed with a 300mm lens and the Venetian scene with a 165mm lens, both using a Pentax 67 medium-format camera and Fuji Velvia slide film.

USING A MACRO LENS AND LIGHTBOX

To overcome this problem, I prefer to use a 1:1 macro lens – extension tubes or bellows could also be used – to copy medium-format transparencies of both night scenes and the moon on to 35mm film using my Nikon F5's multiple exposure facility.

It's important to use a film format bigger than 35mm for the night scenes and moon as this gives more compositional options. If 35mm originals were copied on to 35mm film, a 1:1 macro lens would only just get the original in, and you could have problems with the film rebate on the originals being included. Working with 6x4.5cm, 6x6cm or 6x7cm transparencies eliminates this problem – my Pentax 67 produces 6x7cm images.

The slide-viewing lightbox is a convenient source because it's daylight-balanced, so pictures copied on to daylight film don't have a colour cast. It's also constant, so you can control the exposure.

Again, it's worth doing some test shots prior to working on the final double exposures, so that you know which exposure setting to use. Some night scenes will copy perfectly if you leave the exposure to your camera's integral metering system, but with others you will need to increase or reduce the exposure your camera sets, using the exposure compensation facility.

This can be established by doing test shots of all the night scenes you want to work with and bracketing exposures for each –

remembering to take notes so that you know how much adjustment is required for the final copies. You may need to set the exposure compensation facility to +1 stop for one shot, -2/3 stop for another and +1/3 stop for another, for example.

The same applies with the exposure you use for the moon. If you leave the exposure to your camera's integral metering system when copying the moon transparency, the expanse of blackness around the moon will fool it into giving too much exposure and the moon will be badly overexposed. So take some test shots, bracketing exposures under, not over, what your camera sets – I found that dialling in -4 1/3 stops with the exposure compensation facility gave perfectly exposed copies of my moon transparency.

Armed with this information, producing the final double exposure image is simple. Mount your camera on a tripod, set it up over the lightbox in a darkened room, then focus and compose the first night scene, making sure the camera is square to the transparency. Next, activate the multiple exposure facility and copy the night scene. The shutter will re-cock automatically if your camera has an integral motordrive, but the film won't advance. Replace the night scene with the transparency of the moon, make sure the moon is in the right position and sharply focused, and make the second exposure.

You can now advance the film to the next frame and repeat the process again with a different night scene.

Superimposing the moon on to this dark, cold landscape via a double exposure has increased its drama by adding a splash of brightness to break up the deep blue colour cast.

USING A SLIDE DUPLICATOR

Another option is to expose a roll of film to the moon, then reload it as explained earlier and use a slide duplicator to copy some of your favourite night shots on to the same roll. This is a more versatile approach, because it allows you to pick and choose which night scenes you use, and if you already have a good collection of them you can create lots of stunning new pictures in a short space of time.

Various forms of illumination can be used to backlight the duplicator, including windowlight, a tungsten lamp, a slide-viewing lightbox and electronic flash. Flash is by far the most reliable and consistent, especially if you use a dedicated flashgun connected to your camera via a dedicated sync lead, because perfect exposure will be calculated automatically – all you have to do is fire away.

Before taking any 'live' shots, conduct some tests so that you get

the set-up just right. Your camera should be mounted on a tripod, and the flashgun positioned about 1m behind the slide duplicator, pointing back towards the camera. Accessories are available which allow you to fix your flashgun to a second tripod or lighting stand.

Once you've got it right, make a note of the exact set-up and camera setting so that you can repeat it again and be confident of perfect results.

DO IT DIGITALLY

If you have access to a computer system with image-manipulation software such as Adobe Photoshop, adding the moon to a night scene is even easier.

First of all, scan both transparencies to the resolution required, then call up the image of the moon on your computer, cut it out from the black background and paste it to a new layer. Next, place this layer over the scan of the night scene and adjust the position, size and opacity of the moon until you're happy with the effect. Finally, resize the composite image as desired – and you're finished.

CAPTURING STAR TRAILS

If you look up at the night sky in clear conditions, you will see that it's packed with thousands of tiny stars twinkling overhead. To the naked eye, these stars appear as small, fixed points of light, but if you photograph them using a longer exposure something surprising happens – those stars record as white light trails streaking across the sky.

This effect is produced because the earth is rotating on its axis, and if you keep your camera's shutter locked open for long enough this rotation will be recorded in the night sky. All you have to do to try the effect yourself is, literally, mount your camera on a tripod, point it up to the sky, and leave the shutter locked open on B for a while. However, to get the best results you should follow a few simple guidelines:

❶ Wait for a clear night when there's no cloud obscuring the sky, and the stars are clearly visible. Cold, clear nights are ideal.

❷ Choose a location out in the countryside where there is no light pollution from street lighting or buildings to spoil the effect. You may not be aware of the light pollution yourself, but prolonged exposure will record it. High-altitude locations are the best of all because the air is clearer the higher you get, but any rural spot well away from built-up areas will work.

❸ Try to include a feature in the picture such as a hill, electricity pylon or tower to provide a sense of scale and add interest. Sky alone doesn't work as well.

The sun is often used as a light source to create silhouettes, so why not the moon? It may be much dimmer and require much longer exposure, but the effect is the same – as you can see from this shot. A 300mm lens was used to increase the apparent size of the moon behind the tree branches, and the exposure was left to the camera's integral metering system.

❹ Lens choice is down to you. Wide-angle lenses work well because they allow you to capture lots of stars, but any focal length can be used successfully.

❺ Although you can capture star trails in any part of the sky, the area around the Polar Star (Polaris) is the best because the star trails will form a series of circles around this star, which doesn't appear to move when photographed with a wide-angle or standard lens. To locate the Polar Star, refer to a stargazer map of the night sky.

❻ There is some degree of leeway when it comes to determining 'correct' exposure. Try exposing ISO100 film for 15, 30, 45 and 60 minutes with your lens set to f/2.8, reducing these times according to whether you use faster film. Once you have had the film processed, check the results and adjust the exposure for future shots if necessary. A few minutes either way won't make too much difference, so don't worry about pinpoint accuracy. If you don't want to spend long periods sitting by your camera, electronic cable releases are available from some camera manufacturers which can be programmed to give a specific exposure up to 100 hours or more, then automatically close the camera's shutter.

❼ Cameras with a mechanical B setting are the best for star trail photography as they don't rely on battery power. On a cold night, you may find that the batteries of an electronic camera drain when your camera has been outdoors for half an hour or more, and this may cause the shutter to close, ending the exposure prematurely. Keep spare sets of batteries to hand so that you can put in a fresh set for each shot and avoid this happening. Once back indoors, the batteries will warm up and regain their power.

❽ When you return to your camera, avoid breathing over it while you prepare the next shot, as the warmth of your breath will cause the lens to mist over and it could take quite a while to clear.

This star trail shot was taken from my garden looking towards my house. An 18mm ultra wide-angle lens was used to capture a large area of sky and the exposure on ISO100 film was 30 minutes at f/4. Despite the location being several kilometres from the nearest town, with only one other property nearby, light pollution has tainted the natural blue colour of the sky, while the glancing headlights of the occasional passing vehicle have lit up the front of the house.

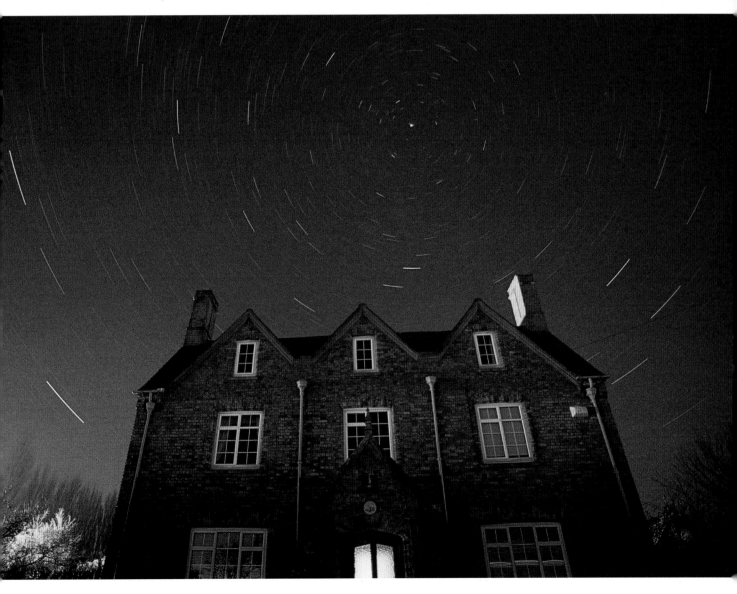

PEOPLE INDOORS

There are more pictures taken of people than of every other subject put together, but that's hardly surprising when you consider the significance that these pictures have in our lives, and the number of occasions when we are inspired to pick up a camera and capture those around us on film.

Pictures of people are special because they remind us of specific times in our lives – holidays with family and friends, parties and celebrations, the arrival of a baby, or just ordinary moments that capture the happiness and laughter of everyday life. People also provide keen photographers with an endless supply of ideas and inspiration, which is why portraiture ranks as one of the most popular subjects among enthusiasts.

Whether they are mere snapshots or considered, creative photographs, however, these pictures tend to be taken indoors, so certain restrictions are immediately imposed, mainly by the lack of light. No matter how well lit a location may be, the level of lighting indoors is almost always lower than outdoors in natural daylight, and in some cases it is almost non-existent. Indoors, the lighting also tends to be provided by artificial means, so that colour casts must be considered if you are using colour film.

Many photographers overcome both these problems by reaching for their flashgun – camera manufacturers promote such an approach by building them into so many modern cameras. But while doing this is the best option in some situations, often you can produce far more evocative images by capturing the ambience of the available light.

The aim of this section is to look at how you can do just that, and give your people pictures a touch of magic.

IN WINDOWLIGHT

Of all the different forms of illumination you can use to take photographs indoors, windowlight is considered by many to be the most effective. This is mainly because it's so versatile – the prevailing weather conditions, the time of day, the direction the window faces and its size, all influence the quality of light passing through. You can also control this further by reducing the size of the window opening, using reflectors to bounce it around or by placing translucent materials over the window to diffuse the light. Consequently, it's possible to achieve a wide range of different lighting effects in your own home, completely free of charge.

The main drawback with windowlight is that it tends to be of relatively low intensity compared to daylight outdoors, and the level of that intensity falls off rapidly with distance so that the area lit by the window is limited. There are exceptions to this, such as modern buildings that incorporate huge windows to make full use of natural daylight, or in structures such as conservatories and summerhouses that contain lots of windows; but in the average house, windows are of modest size, so your subject needs to be close to them in order to be well lit and to keep exposures as brief as possible.

Bright overcast weather tends to produce the most flattering window illumination, because with the sun obscured by cloud the light is very soft, and if your subject is close to the window, shadows will be relatively weak. This is ideal for portraiture and classic nude studies. As the weather becomes progressively duller, so the light becomes softer and the shadows weaker – you can take beautiful

window-lit photographs on grey, rainy days – but light levels fall, too, so longer exposures are required. The lighting effect you get by shooting in windowlight on an overcast day is very similar to that achieved by fitting a large softbox to a studio flash unit.

In sunny weather, windowlight is much harsher, especially with windows that admit direct sunlight, and you may find that the light is just too intense at close quarters.

One solution is to move your subject a bit further away from the window so that they are in a pool of light spilling on the floor or opposite wall. This effect is seen in older buildings such as public houses, barns and warehouses, where sunlight shining through small windows creates an almost spotlit effect. This play of light and shade can produce incredibly atmospheric pictures.

Another option is to wait until later in the day, when warm light rakes through the window from a lower angle, casting long shadows

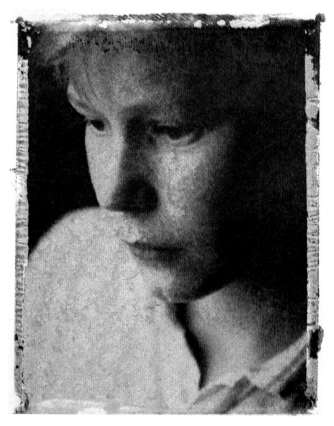

ABOVE **This windowlit portrait is a Polaroid image transfer of the original, which was taken handheld on ISO1000 colour transparency film with the subject looking towards the window, so that his face was bathed in the soft light.**

RIGHT **Here's a classic example of windowlight being used for portraiture. The photograph was taken on a bright but overcast day with the subject sitting at 90 degrees to an average-sized room window, so that one half of his face was lit and the other half thrown into deep shadow. The grainy effect was achieved by shooting on ISO1600 film, and the image was printed on a hard grade of paper – grade IV – to emphasise the bold side-lighting.**

and a golden glow on anything it strikes. This type of light is ideal for portraiture as it makes skin tones more attractive.

Alternatively, find a window in your home that isn't admitting direct sunlight. North-facing windows (in the northern hemisphere) come in handy in sunny weather, because even though the light is intense outdoors, they only admit reflected light, so the quality of illumination is much softer.

Direct windowlight can also be controlled by covering the window with a translucent material such as tracing paper, or a white cotton sheet or white muslin material. Even net curtains can work well. The effect of doing this is similar to placing a softbox or brolly over a studio flash unit – the light is softened and spread over a wider area while shadows are weakened.

SIZE MATTERS

The next factor to consider is the size of the window because this, too, influences the quality of light – the bigger the window, the more light you get and the greater the area it covers, while smaller windows admit less light and cover a smaller area.

For head-and-shoulders' portraits, a modest-sized window that measures a metre or so square makes a good starting point; bigger windows and patio doors are ideal for half- or full-length shots. If the window you're using proves to be too small you can always move your subject further away from it so that the light is spreading over a wider area. The thing you must remember when doing this is that light levels will be lower and you'll need to work at longer exposures – not a problem if your camera is mounted on a tripod and your subject is stationary, but a potential obstacle if

This is my son taking an afternoon nap. He was lying on a sofa with a window behind, so the light was glancing across one cheek while the rest of his face faded into shadow. The picture was taken using a Pentax 67 medium-format camera and 135mm macro lens. To cope with the low light levels, ISO400 film was uprated to ISO1600 and push-processed 2 stops, though an exposure of 1 second at f/11 was still required. A soft focus filter was used on the lens to add a gentle diffusion.

RIGHT **The soft light of an overcast day is perfect for attractive window-lit portraits. Here the subject was posed next to a room window on her right and asked to gaze through it so that her face was well lit. ISO400 black and white film was fast enough to allow handholding at an exposure of 1/60 second at f/4 with an 85mm lens – a good focal length for portraiture as it flatters facial features.**

either camera or subject moves during exposure. If you prefer or need to take pictures handheld, use film with a rating of ISO400 or more so that you can set faster shutter speeds to prevent camera shake. On the odd occasion when the window you are using is too big, its size can be reduced easily by masking it down with pieces of black card.

Once you're happy with the window set-up, think about where your subject will be positioned in relation to it. The classic approach is to pose your subject with the window on one side, so that one half of their face and body is lit while the other half fades into shadow. Depending on the size of the window and the harshness of the light, this approach can produce anything from bold side-lighting, where shadows are black, to a gentle fall-off in illumination.

Either way, if you want more even illumination, place a large reflector opposite the window so that it bounces some of the light into the shadow areas. White is the traditional colour for reflectors, but if you're shooting colour film you could use a gold one instead, to warm up the light it reflects and give more flattering results. Make your reflectors from sheets of white card or board painted white, and glue gold foil over one side so that you have a dual-colour reflector.

Another lighting option is to ask your subject to look at or through the window, so that their face and body is flooded with light and any shadows fall away from them. For tight head shots your subject could be close to the window and gazing out of it, while for half- or full-length shots, ask them to stand a couple of metres away from the window so that you can stand next to it and look into the room towards them.

For side- or front-lit portraits, determine correct exposure by measuring light levels on your subject's face. This is easy to do with a handheld meter – just hold the meter in front of their face with its measuring dome pointing back towards the camera and take an incident reading of the light falling on their face. With your camera's integral metering system, move up close so that your subject's face fills the viewfinder, take a reading and then adjust it accordingly using the exposure compensation facility. Dial in +1-1/5 stops for Caucasian skin, and -1-11/2 stops for dark skin. This will account for the high or low reflectancy of your subject's skin tone.

The third option is to use the window as a background, so that the side of your subject facing the camera is in deep shadow. You can then either record them as a silhouette by exposing for the window, or record detail in the shadow areas so that the window burns out. If you go for a silhouette, your camera's integral metering system will do this automatically if you take a general reading. To record detail in the shadows, move up close to your subject and take a reading with the window excluded from the viewfinder.

Bright sunlight produces a bolder form of illumination but it's still effective when used on the right subject. This picture was taken on the spur of the moment when I noticed late afternoon sunlight bathing my colleague's face. Interest is added by the shadow patterns on the background wall and the catchlights in the subject's eyes.

PORTRAITS IN ARTIFICIAL LIGHT

Although windowlight is an ideal source of illumination for people pictures, you will often find yourself in situations where you have to work with artificial lighting – pubs, clubs and restaurants being good examples. This needn't be a problem – artificial lighting can produce incredibly atmospheric results, in fact – but in order to avoid disappointment, you need to be aware of the limitations it imposes and how you can overcome them.

Firstly, you will have little or no control over the lighting, so you will simply have to make the best of what you're given. Secondly, light levels will be lower than windowlight, making exposures longer and the risk of camera shake higher. Thirdly, the light source or sources will produce a colour cast on daylight-balanced colour film.

Overcoming low light levels is easy – just use faster film. If you're taking candid pictures indoors in available light you will need at least ISO400 film, probably ISO1000 or ISO1600 if you're handholding with a heavy telephoto or zoom lens.

Colour casts are less easy. Most interiors where you are likely to

BELOW **Compact cameras or 35mm SLRs with integral flashguns are ideal for party pictures that capture people having a great time. This shot was actually taken en route to the party, inside a coach travelling along the motorway, but the revelry had already begun so I couldn't resist grabbing my camera and firing away.**

ABOVE **This picture was taken in a room lit by tungsten lamps, so to prevent the subject being affected by its warm cast, flash was used to light him, while a slow shutter speed ensured that detail was recorded in the background.**

take people pictures are illuminated by either tungsten or fluorescent light, so you know that on daylight-balanced colour film you will get a yellow/orange cast with tungsten film and a green cast with fluorescent. However, unless you are taking pictures at night or in a windowless room, there will almost certainly be daylight mixed with the artificial source. That just adds to the problem, because if you try to filter out the colour cast caused by the artificial lighting (see page 74), the areas lit by daylight will take on the colour of the filter – blue with tungsten lighting and magenta with fluorescent.

The easiest way out of this one is to ignore it. Mixed lighting rarely looks too horrid anyway, and you do rather expect it when taking pictures indoors so no one will think there's something wrong with your pictures. Shooting in black and white is another option, of course, as it means there will be no colour cast at all for you to worry about.

In situations where you are working with a single type of lighting, you should also think carefully about how much it's corrected. The green cast of fluorescent lighting makes people look pretty terrible so you should do what you can to banish it, but the warm

your subject will produce a bold half light/half shade effect, while a second light or a large white card reflector on the opposite side will fill in those shadows.

The light output from domestic tungsten bulbs is low, so expect very slow shutter speeds – especially when shooting at anything but your lens's widest aperture. This won't be a problem if your camera is mounted on a tripod, so you can use slow-speed film. But if you want to handhold the camera, fast film of at least ISO1000 will be required. Don't be put off by this, though – the coarse grain and muted colours of ultra-fast film will enhance the warmth of tungsten lighting no end. Try shooting through a soft focus filter as well, to heighten the mood even more.

Working in the light of a simple desk lamp, this young boy was photographed using ISO640 tungsten-balanced film to eliminate the orange colour cast which would otherwise have recorded. To determine correct exposure, a meter reading was taken of the light falling on his face. The picture was taken with an 85mm lens using an exposure of 1/30 second at f/5.6.

glow of tungsten lighting can be very evocative and atmospheric when used creatively, so don't be so eager to get rid of it completely. Uncorrected tungsten lighting can be a little over the top, but fully corrected it can equally be rather bland and lifeless. A compromise is therefore to use a blue 80B or 80C instead of a blue 80A filter, so that you lose some of the excessive warmth but not all of it.

TAKE CONTROL

Tungsten lighting can also be used as a more controllable source for portraiture and nude studies. Take the humble desk lamp: it may not look much, but when used creatively it can be highly versatile. The same applies to spotlights, table lamps and any other contraption that holds a light bulb and which you can move around – you could even rig up your own.

The light from a bare tungsten bulb is quite harsh and unflattering, so it's a good idea to diffuse it to produce a gentler form of illumination. Bouncing the light off sheets of white card is one way, although you'll lose much of the light in doing this and exposure will be long. Shining the light through a diffusion screen made from tracing paper or white muslin is a better bet, though if you do this, remember that tungsten lamps generate a lot of heat so should be kept well away from things that could scorch or catch fire. Portrait subjects will also find the heat uncomfortable after a few minutes if the lamps are positioned too close.

For portraits or figure studies, one diffused lamp to the side of

PARTIES AND SPECIAL EVENTS

Birthdays, weddings, Christmas gatherings, anniversaries, the annual office bash – life is full of celebrations and for many people rarely a month goes by without at least one opportunity to let their hair down and enjoy a party.

For the party-goers themselves fun is the name of the game, and for photographers this invariably means just one thing – the chance to take great pictures. Most adults become shy and embarrassed when a camera is aimed straight at them, but combine high spirits with alcohol and all that changes, as inhibitions are thrown to the wind in favour of a good time.

The best way to capture this on film is by adopting a sophisticated snapshot approach. In other words, you take pictures quickly and instinctively, so the moment isn't lost, but use your creative and technical skills as a photographer to produce something a little more interesting than would the average compact-toting party-goer. This may mean taking a back seat from the antics yourself – at least for a little while – so you can concentrate on what's happening around you, but if great pictures are your goal, it's a necessary evil.

Most parties take place indoors and usually at night, so light levels are low and are nearly always provided by artificial means. The easiest way around this is by using flash, for several reasons: it will allow you to use slow-speed film for high-quality pictures; you can set a decent lens aperture to provide sufficient depth-of-field; and you can work at a fast enough shutter speed to freeze both subject movement and camera shake.

In terms of film speed, ISO100 will be fine with portable flashguns that have a decent guide number of 25 or more, while ISO200 would be better if you're using a camera with a low-powered integral flash, as the added film speed will extend the working range of the flashgun, allowing you to shoot from a greater distance without having to set your lens to a really wide aperture.

Flash is so convenient at parties and special occasions because you can just wander around, looking for interesting expressions, and take a picture instantly. The lighting isn't particularly flattering, but it makes colours look vibrant and will allow you to take bright, crisp shots in the poorest of lighting.

The main thing you need to watch out for when using flash is red-eye, which is caused by light from the flashgun reflecting off the retina in your subject's eyes and causing them to glow bright red. The risk of red-eye is increased in low-light situations because our pupils dilate to take in more light. Alcohol also causes our pupils to dilate, so at parties you have the worst possible combination.

Many flashguns today have a red-eye reduction mode, which fires a series of pre-flashes or shines a light in your subject's eyes before the main flash is fired, to make the pupils constrict. Few are effective though, particularly in low light, and with some the strobe-like pre-flash sequence can be positively offputting for your poor subject. Fortunately, there are other ways in which you can reduce or eliminate the problem.

A common cause of red-eye is the flash being too close to the lens axis. So, if you take the flashgun off your camera's hotshoe and fit it to a bracket on the side of the camera, you may see a big improvement. Hammerhead flashguns are ideal in this respect.

Another option is to bounce the flash from a wall or ceiling – this not only gets rid of red-eye, but also improves the quality of light immensely.

Bouncing causes a light loss which dedicated and automatic guns take into account. If you're using a manual flashgun, however,

ABOVE **When people have had a few drinks it's amazing how uninhibited they become. Here the subject was captured on the dance floor in a disco doing his John Travolta impersonation – very badly, as it happened, but good enough for another embarrassing photograph. A 35mm SLR with hotshoe-mounted flashgun was used to take it.**

LEFT **When your child throws a tantrum, picking up a camera is likely to make things worse rather than better, but I did exactly that for this amusing picture of my little boy. Flash was used to overpower the green colour cast of fluorescent lighting, though you can still see it clearly in the background. A slow shutter speed was also used, and the camera moved during a 1-second exposure to create the blurred effect which suits the subject's expression perfectly.**

you should set the lens to an aperture that is 2 stops wider than the recommended aperture. Pressing the test button and checking to see if the exposure confirmation light comes on is also advisable with any flashgun that you're using to bounce.

In many party situations, bouncing the flash may not be either convenient or possible, so instead consider investing in a flash diffuser (see page 59). There are many different types available, but all are intended to do the same job – improve the quality of light from your flashgun. Try a few different models before making a decision.

If you're using a camera with a built-in flashgun, be it a 35mm compact or SLR, your options are far more limited because the position of the flashgun can't be changed. What you could try, however, is asking your subject to move to a brighter part of the room or to look at a light for a few seconds so that their pupils constrict. This isn't ideal, because it loses the spontaneity of the moment, but it's better than nothing.

And remember, of course, that red-eye is only caused when your subject looks directly at the camera, so if you are photographing people candidly, the chances are they won't be, therefore red-eye will not be a problem.

Slow-sync flash is also a handy technique worth trying at parties and special occasions, because it will help you to capture the fun and frolics of the event. This is achieved by using a slow shutter speed with a burst of flash, so that you get a frozen and blurred image on the same shot. At parties this usually results in a sharp, flash-lit subject against a blurred background, because either people have moved or the camera has moved during exposure. See pages 144–145 for more details.

If you're feeling a little more ambitious, you could even take some black and white infrared pictures. Flash is again used, but instead of placing a red or infrared filter over your lens, you use it to cover the flash tube. By doing so, the pulse of light from the flashgun will be hardly noticeable to the naked-eye – if you use an opaque infrared filter it won't be visible at all – but the film will still record it. This means you can photograph people using flash without them even knowing it, which is ideal if you fancy taking some candid shots in night clubs and discotheques.

Getting the exposure right with this technique is a little hit and miss because the effective ISO rating of infrared film depends on how much infrared radiation there is in and around the things that you're planning on photographing. Fortunately, it is quite a forgiving film at the printing stage, so you can usually rescue a decent shot from a negative that has been under- or overexposed by a couple of stops or so.

The best approach is to go completely manual, setting your camera and flashgun to manual mode so that you can control what both are doing. As a guide, if you're using Kodak 2481 High Speed Mono Infrared film, which has a nominal rating of ISO400, set your flashgun to ISO50 so that it takes into account the 3-stop light loss caused by the red filter placed over the tube. By checking the scale on the gun, you can then determine the correct lens aperture for the flash-to-subject distance you'll be working at – 2m, say.

The key to success with photographing people at parties and special events is always to be on the lookout for interesting moments – a couple having a 'domestic' in a quiet corner, lovers in fond embrace, people living it up on the dance floor and generally having a great time. But this shouldn't be very difficult, because if you put a group of people in a room, play some music and hand them a glass of wine, anything could happen. Just make sure you are there to capture it all on film.

LEFT **This is the type of effect you can expect when using infrared film with flash – pale skin tones and an overall ghostly feel. The shot was taken in a dimly lit room using Kodak High Speed Mono infrared film, with a deep red filter held over the flash tube with sticky tape.**

RIGHT **Although flash is convenient, it tends to kill the ambience of available lighting indoors, so when you can, try to avoid using it. This candid shot was taken at a wedding reception in a mixture of window-light and artificial room lighting, but the slightly unusual colours don't detract from the subject at all. A 75–300mm zoom was used at 300mm to fill the frame, and an exposure of 1/30 second at f/4 was necessary on ISO200 film. To prevent camera shake, I rested my elbows on a tabletop to provide support.**

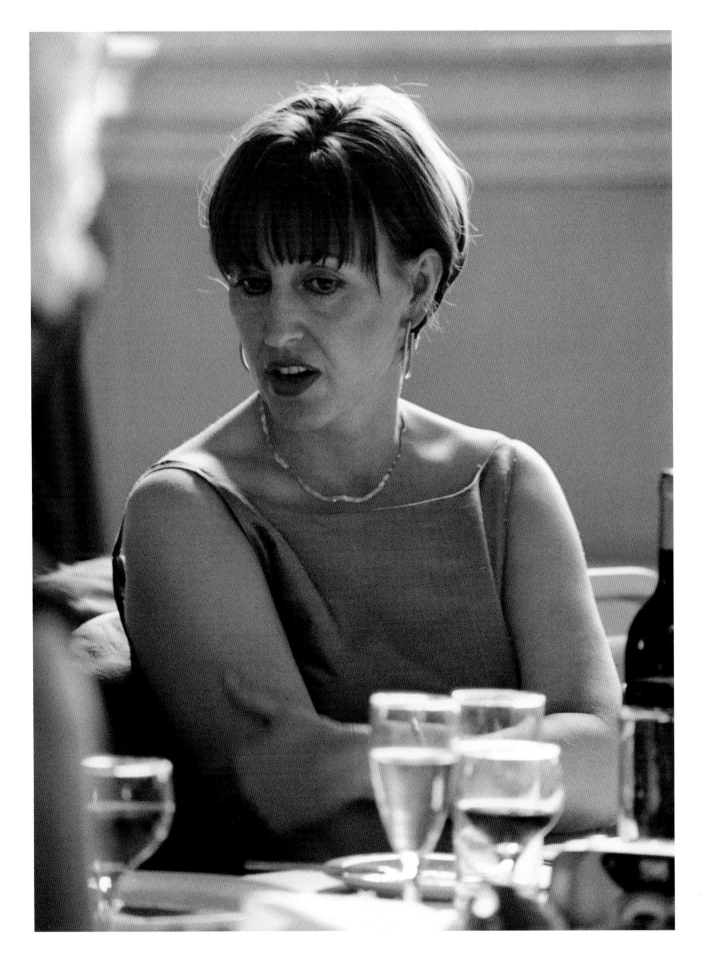

location is lit by tungsten or fluorescent lighting, for example, you need to be aware of the colour casts they will produce on daylight-balanced film and act accordingly, either by shooting black and white film, using tungsten-balanced film, or using filters with daylight film to balance the colour casts (see page 74).

Alternatively, you could simply make a mental note of the light source and then ignore it, as the addition of a colour cast may improve rather than spoil the picture. Think of a steelworker's face lit up by the orange glow from the furnace he's tending: would you want to lose the wonderful glow that is so characteristic of his occupation and environment?

The way the subject is lit should also be considered, irrespective of the light source, as this will have a strong influence on the mood of the pictures you take. Brightly lit locations are the easiest to deal with, but tend to produce the least interesting pictures because they appear rather sterile. At the other extreme, environments that are poorly lit, such as old workshops, are trickier to photograph but the lighting is far more evocative, so you have to weigh up convenience with creativity.

In some situations you may also be able to employ your own lighting, in the form of electronic flash, to provide illumination or for creative effect. If your subject has a job that involves a lot of running around, slow-sync flash will help to capture the energy and activity of that occupation, as well as to overcome the problems of low lighting which limit your choice of shutter speed.

Film choice will depend on the environment and the type of pictures you wish to take. As always, stick to the slowest film you can get away with, for optimum image quality, while still being able to use a suitable aperture and shutter speed combination. If you can mount your camera on a tripod and use a slow shutter speed, ISO100 film will probably be fast enough, but if you need to hand-hold the camera or work with faster shutter speeds, don't be afraid to load up with ISO1600, even ISO3200 film, or uprate the film you're using to a higher ISO. The coarse grain of ultra-fast film can also add a gritty, stark feel to your pictures of people at work, so it can be used specifically for this effect, even in situations where you don't need a high ISO.

The lens you use will also depend on the situation. In confined spaces, a 28mm or 35mm wide-angle lens will be invaluable for including your subject and at least some of their surroundings. This tends to produce more interesting results than capturing your subject alone, as much of the picture's appeal will come from the clues offered by the environment. Where space isn't limited then you obviously have more choice, using a 50mm standard lens, perhaps, or a short telephoto. Whichever lens you are using, always remember to focus on your subject.

Fast lenses (with wide maximum apertures) are ideal for taking handheld shots in low light, or capturing moving subjects, as they allow you to work with faster shutter speeds. However, if you can get away with mounting your camera on a tripod and using slower shutter speeds (with smaller lens apertures) do so, as it will increase the level of control you have over the situation.

Some occupations require slow shutter speeds to bring out the drama of the work being done. Welding, grinding and steelworking are good examples of this – a slow shutter speed will allow you to capture lots of sparks and flames, just like you would use a long exposure to record a firework display or a sparkler on bonfire night.

When it comes to determining correct exposure, the key is to meter for your subject and for the light they are in. So, if you are

PEOPLE AT WORK

Photographing people in their place of work is both challenging and rewarding, as every occupation brings with it a different environment and a different approach. However, all can produce fascinating pictures that say far more about the subject than a traditional portrait taken in a formal situation. People also tend to relax far more in their place of work, as they're in familiar surroundings where you are the naive layman, instead of them.

Manual occupations tend to be the most interesting, simply because they take place in more photogenic locations and feature characterful people. Think of a farmer milking his cow in the light of a single light bulb hanging from the barn rafters, or a blacksmith hammering white-hot steel in his dimly lit forge. The more low-tech the profession and primitive the setting, the better it is from the photographic point of view.

To get the best possible results when photographing people at work you need to spend a little time analysing the environment, the lighting and how you might overcome any technical problems. If the

ABOVE & LEFT **Both of these photographs were taken in the confines of a small workshop using a 28mm wide-angle lens and ISO100 film. The welder was captured in the wonderful blue light created as he welded steel plates together, while the steelworker was photographed from a low angle so the warm light from the sparks could be seen illuminating his face. In both cases an exposure of around 1/2 second at f/4 was used.**

RIGHT **Slow-sync flash has added an amusing touch to this picture of an office 'trolley' lady making her daily visit with snacks and drinks for the workers.**

photographing a mechanic under a car, take a meter reading from his face, which will be illuminated by the spotlight he's using to see into the dark recesses of the car's chassis. Once you have done this, other readings can be taken from different parts of the scene in order to establish the brightness range, but it's by no means essential.

The key to success when photographing people at work lies in judging each situation on its merits and responding accordingly. So, begin with an open mind and just follow your instincts, using the techniques and ideas covered in this book to take extraordinary photographs of ordinary occupations.

INTERIORS OF BUILDINGS

Interiors differ enormously in terms of their size, style and the quality and type of lighting used to provide illumination. A twee thatched cottage full of dark, shady corners will present a different set of problems to the interior of a modern glass and steel office block. Similarly, the cavernous interior of a cathedral will require a different approach to a bustling shopping centre.

What all interiors have in common, however, is great photographic potential, and when treated in a considered, sympathetic way, they can be a source of superb low-light pictures.

EQUIPMENT

The type of lens you use to photograph an interior will be governed by two main factors: how much space you have to work in, and how much of the interior you want to record in a single shot.

For general interior shots you will find yourself reaching for a wide-angle lens more than any other, and usually a moderate 28mm or 24mm will satisfy your requirements. The only time you will need anything wider is if you are trying to photograph a small interior where space is restricted, or a big interior where obstacles prevent you moving back sufficiently to get what you want in the frame. In these situations, a lens with a focal length between 17mm and 21mm should do the trick. Ultra wide-angle lenses are also ideal for shots of interiors that have particularly high ceilings – by turning your camera on its side, you will be able to include everything from the floor up. And if you want to produce more unusual interior shots, nothing beats a full-frame fisheye lens.

Interior photography isn't just about the big picture, however, and in most buildings you will find other small details that can make interesting pictures – stained glass windows, ornate architectural features, the play of shadows on a wall to name but three. So pack

at least a 50mm standard lens so that you can exploit these things, and ideally a telephoto or telezoom as well so that you can fill the frame with more distant details.

Another essential piece of kit is a sturdy tripod. Light levels in interiors are generally quite low, so exposures of several seconds will be necessary when using small lens apertures for increased depth-of-field and slow-speed film. Add a cable release too, so that you can trip the shutter without touching the camera, plus a small spirit level for the hotshoe so you can check that the camera is perfectly square.

WHICH FILM?

Architectural photographers swear by slow-speed film for its high image quality – the slower the better. For black and white shots, films such as Agfapan APX25 (ISO25) and Ilford Pan F Plus (ISO50) are favoured, because they can resolve detail and produce amazingly crisp, grain-free images even when enlarged to 16x20in or more. For colour work, slow-speed transparency films such as Kodachrome 25 and Fujichrome Velvia (ISO50) can't be beaten.

Slow film inevitably means longer exposures. But as with other low-light subjects, quality should always be given priority over convenience, and if your camera is mounted on a sturdy tripod, exposure times become irrelevant. So why compromise image quality for an extra stop or two of film speed, when it won't make any difference whatsoever to your working methods?

The only time faster film becomes necessary is if you need to take pictures handheld, in which case anything from ISO400 up will save the day, depending on light levels. It can also be used creatively to produce grainy images, although this approach tends to work better on architectural details rather than whole interiors, as coarse grain reduces a film's resolving power so that fine detail is lost.

COMPOSITION

Composition needs to be given special thought when using wide-angle lenses to photograph interiors, as they stretch perspective and make everything appear further away from the camera than it really is. On the one hand, this is a benefit, allowing you to capture a broad area in a single frame, but at the same time it can result in rather empty, boring compositions, with the foreground filled with acres of empty floor space and the more interesting parts of the interior condemned to the background.

To overcome this, look for features in the interior that can be

ABOVE **The extensive windows in the roof of this building meant that light levels inside were high and relatively even, making it possible to take a handheld picture at an exposure of 1/30 second at f/11. A 17mm ultra wide-angle lens was used to include as much of the interior as possible in a single shot.**

RIGHT **Here's a classic interior shot, of a small village church lit by both natural daylight and tungsten, hence the warm colour cast on parts of the stonework. The picture was taken with a tripod-mounted 35mm SLR and 28mm wide-angle lens on ISO50 film for optimum image quality. To determine correct exposure, I used a handheld meter to take incident light readings in various parts of the interior. I then used an average exposure as my starting point and bracketed a stop over and under. This frame was exposed for 2 seconds at f/16.**

used to add interest and depth to the composition. The bold lines created by rows of pews or seats in churches and cathedrals are ideal. Ornate patterns on the floor can also be used, as well as statues or other architectural details to fill the foreground.

If you do include foreground interest, a small lens aperture such as f/16 or f/22 will be required in order to provide sufficient depth-of-field so that everything is recorded in sharp focus. This will make exposure times longer, which is why a tripod is an essential piece of equipment for interior photography.

Converging verticals must also be considered. They are created if you tilt the camera back when photographing an interior, and cause any vertical lines in the picture to lean in towards the top of the frame. If you exaggerate this effect by using a wide-angle lens and really tilting the camera it can work in your favour, adding a dynamic feel to the composition, but moderate convergence tends to look odd and should be avoided.

Professional architectural photographers manage to overcome converging verticals by using a large-format camera which has movements, so that the lens can be raised to capture the higher levels of the interior whole whilst keeping the camera perfectly square (see page 18). Perspective control or shift lenses for 35mm SLRs and medium-format cameras do the same thing.

If you have access to neither, just make sure the camera back is kept parallel to the verticals in the interior – a small spirit level slipped on to the hotshoe can help here. If this means that you end up including too much of the floor and not enough of the ceiling, shoot from a higher viewpoint by raising your tripod to its highest level and then standing on a box or case so that you can peer through the viewfinder.

LIGHTING

The type and quality of lighting used to illuminate interiors varies enormously. Some are lit solely by natural daylight flooding in through windows, others by artificial means, and more still by mixed lighting, be it artificial and natural, or different types of artificial lighting such as tungsten and fluorescent.

Older buildings are often poorly lit because the windows were intentionally kept small to minimise heat loss, whereas modern buildings are designed with quality of light in mind, so big windows are installed to make the best use of daylight, and much thought is given to the use of artificial lighting to create a suitable environment – be it domestic or commercial, for work or pleasure.

Establishing exactly what you've got to work with is therefore of paramount importance before you start taking pictures, because it will govern your approach more than any other single factor.

The easiest interiors to photograph are those lit by one type of lighting, be it natural daylight or tungsten, because a uniform source is easy to deal with. Natural daylight can be supplemented by electronic flash to produce more even illumination without colour casts being created, while filters or tungsten-balanced film can be used to deal with artificial lighting if you so wish (see pages 44–45 and 74).

With mixed lighting the situation becomes more complicated because by dealing with one source you then create problems with another. Tungsten-balanced film can be used to produce natural colour rendition in tungsten lighting, but if that interior is also lit by windowlight, the windows and areas affected by the light coming in will take on a blue cast. Similarly, if you use a magenta filter to balance the green cast caused by fluorescent lighting, any areas lit by daylight in the same interior will take on a magenta cast.

One solution is to wait until night so that the interior is lit by artificial means only, but you'll get black windows which look odd. Another is to compose the shot so that no windows are included, but this isn't always possible. Shooting in black and white film will obviously take colour casts out of the equation altogether, so it's worth considering, or you could simply shoot in colour and ignore the colour casts.

USING FLASH

Another option is to use electronic flash as your main source of illumination, so that colour casts can be avoided and you have complete control over the quality of lighting. Professional architectural and interior photographers often do this as a matter of course, setting up their lights to mimic the effects of windowlight and in sympathy with any artificial lighting.

This is a highly skilled practice that takes years to perfect and involves lots of planning. It may take several hours to set up the lights for a single shot, with test pictures being taken along the way to gauge the effect of each light and small adjustments being made to the output of each flash unit to achieve the perfect balance between the flash and other existing light sources.

This type of photography is out of the reach of most enthusiasts, not only for financial reasons – you need a number of powerful studio flash units to do the job properly – but also because without

RIGHT **Sometimes, any picture is better than no picture when you encounter a memorable interior that you are unlikely to visit again. That sentiment was put into play when I took this shot of the old mosque in Cordoba, Spain. Refused entry with a tripod, I had no choice but to handhold the camera and hope for the best. At shutter speeds of 1/8 second with the lens at maximum aperture that's asking a lot, but this picture does manage to capture the wonderful atmosphere of the old Moorish interior – even if it isn't 100 per cent sharp.**

BELOW **Large interiors are usually well lit, though mixed lighting makes it impossible to produce perfect colour balance. Fortunately, the weak green cast in this shopping mall, caused by fluorescent lighting, has been overwhelmed by daylight flooding in through the roof. It was taken from a balcony on the first floor using a 20mm lens and ISO100 film, after seeking permission from the management – something you should always do when taking pictures on private property, if only to smooth the way for other photographers who come after you.**

BOTTOM RIGHT **Stained glass windows in churches and cathedrals make irresistible subjects – and great pictures. They're best photographed on overcast days, or when the sun isn't shining directly on them, and your camera's integral metering system should then be able to produce perfectly exposed results when left to its own devices.**

For this photograph of the living room in my former home, flash was bounced off the white ceiling to supplement the light coming in through windows on two walls. The lamp in the corner was left on merely for effect, but made little or no difference to the light levels or the exposure.

full co-operation from the building's owner or manager you won't be able to set up the shots. A more accessible alternative is to use your portable flashgun to provide illumination. This may seem like a David and Goliath kind of partnership given the size of most interiors, but an average flashgun can be surprisingly effective.

For small interiors the size of a typical domestic living room, you can supplement available light by bouncing flash off the ceiling (see picture above). Doing this will not only increase the coverage of the flash so that a wider area is lit, but will also reduce the harshness of the light and provide softer shadows than if you fired the flash straight into the interior.

Many flashguns have a bounce head which can be adjusted to a suitable angle, so that the flash can be directed towards a ceiling while the gun is mounted on the camera's hotshoe, though you don't actually need this facility because the gun can always be taken off the camera and physically pointed in the right direction.

White ceilings are more suited to bounced flash because as well as reflecting more light than other colours, they also produce neutral illumination. If you bounce the flash off a coloured ceiling, on the other hand, the reflected light will take on that colour and add an unwanted cast to your pictures – unless you're shooting in black and white, that is.

The only downside with bouncing flash is that it causes a light loss. If you use a dedicated flashgun, this will be accounted for automatically, so no adjustment is required. The same applies with an automatic flashgun, though it's a good idea to fire a test flash and check to see if the exposure confirmation light comes on to indicate that the flash can deliver sufficient light at the auto setting chosen. If this isn't the case, set the auto aperture on the flash to the next setting – f/8 instead of f/11, say – so that the auto exposure range is extended, and try again. When using an automatic flash, you also need to make sure that the sensor on the front of the gun is pointing in the same direction as the lens, so that it measures the light reflecting off the interior. If you don't do this, exposure error may result.

For bigger interiors, a single burst of flash will be insufficient, so you will need to use multiple flash bursts to light different areas and gradually build up the light levels. This technique, known as 'open flash', involves locking your camera's shutter open on B (bulb); then, during an exposure of many seconds you walk around the interior, firing the flash at different areas to fill in shadows and emphasise interesting features.

Open flash is easier if you can take a friend along to help out – perhaps using a second flashgun to light other areas so that you can complete the task in less time, or ask them to stand at the camera and cover the lens with a piece of card between flash bursts, while you wait for the gun to recycle and move to the next position. That way, you can spend several minutes building up the flash levels but need only expose the film for a fraction of that time, because when the lens is covered no light can get to the film.

For more advice on this and open flash generally, see page 176.

EXPOSURE

Light levels and contrast can differ enormously from one interior to the next, so there are no magic formulas for getting the exposure right – you just have to use your knowledge and experience to assess each situation.

The main factor that will cause exposure error is high contrast, which tends to be more common in old buildings than in new ones because the windows are smaller and the lighting less even. If you point your camera towards an interior like this, where light levels are high around the windows or in areas lit by spot lamps, but are dark and shady everywhere else, its metering system will almost certainly be confused and give a false reading – usually influenced by the brighter areas, resulting in underexposure.

Where the lighting is more even and the contrast is lower, the risk of exposure error is reduced. That said, your camera's metering system may still not be reliable. Back on pages 78–79 you may recall an explanation of how camera meters are designed to expose mid-tones correctly. The trouble is that building interiors often have a tonal value far higher than this. Think of churches painted white to reflect the light, or offices and domestic interiors painted bright, cheery shades. Pale-coloured walls have a reflectance higher than the 18 per cent grey your camera recognises, so if you aren't careful, underexposure will again result.

To prevent this happening, and ensure perfectly exposed results in all interiors, big or small, bright or dark, you need to meter for a mid-tone that is evenly lit. To do this, picture in your mind a mid-grey colour and then set about looking for something that has a similar tonality. It could be a patch of stone wall, the carpet on the floor, timbers in the ceiling, a coat thrown over the back of a chair. Providing that it's well lit and in a part of the interior which you want to expose correctly, anything with the right tonality will do.

Once you have located something suitable, take a meter reading either by using your camera's spot or partial metering facility, or by moving close to the object so that it fills the frame. If you use the

latter method, set the exposure on your camera in manual mode so that it doesn't change when you move back to the shooting position – or hold it by activating the exposure memory lock.

After taking a picture at this exposure, bracket over and under it in 1/3, 1/2 or full stops, depending on the type of film you are using. If contrast is high, bracket 2 stops over and 2 stops under so that you have plenty of different shots from which to choose, each with a different level of highlight and shadow detail recorded.

Alternatively, if you have a handheld meter you can take an incident light reading of light falling on the most important part of the interior. This will give you an accurate exposure no matter what is going on elsewhere, though it's also a good idea to measure light levels in the brighter and darker parts of the interior so that you can assess the overall brightness range and establish whether the highlights are likely to burn out or the shadows to block up when you expose for a mid-tone.

ABOVE RIGHT **Watch your metering when taking pictures of interiors that have a high tonal value. The off-white colour of this building would have caused underexposure if the camera's metering system had been relied upon, but realising this, I increased the metered exposure by 1 1/2 stops in order to compensate for the scene's high reflectancy.**

RIGHT **In crowded interiors like this Turkish bazaar a tripod will probably get in the way and attract unwanted attention, so load your camera with faster film and take pictures handheld. In this case, ISO400 film proved fast enough in the dimly lit passageways of the market.**

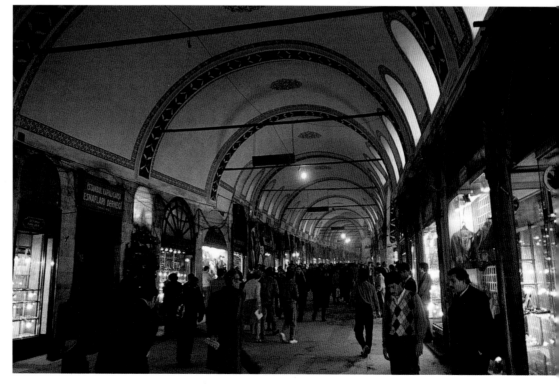

PAINTING WITH LIGHT

Although the majority of night and low-light scenes are photographed in available light, there's nothing to stop you adding your own light. This may be necessary to provide illumination in situations where little exists, to supplement the lighting already present, or to create unusual lighting effects.

A variety of different light sources can be used to do this, from a flashgun to a torch. This section is devoted to looking at how to make the most of these things, both indoors and out, and the type of results you can expect.

OPEN FLASH

This technique involves using an electronic flashgun in conjunction with a long exposure. In essence, it's just like slow-sync flash, but instead of using a shutter speed of 1/8 or 1/4 second, the camera's shutter is locked open on B for anything from a few seconds to several minutes, depending on the situation. And instead of the flash firing when you trip the camera's shutter release, it's taken off the camera and fired manually using the test button. This way, you have complete control over when the flash is fired, where it's fired from, which part of the scene you light, and how many times it's fired.

On a small scale you could use a single burst of flash to illuminate a feature in the foreground of a low-light scene, such as a cross in a churchyard with a floodlit church behind it, or a swan on the edge of a lake at twilight. On a bigger scale, the flash can be fired many times during an exposure of several minutes to illuminate the front of a building, a ruined castle, cliffs on the coastline, or perhaps to light the interior of a building that has poor natural lighting.

Filters can also be used to colour the light for more interesting results. You could place an orange or blue filter over the flashgun and use the coloured light to illuminate a whole building, or you could use different filters to light different areas, so that you get several colours on a single shot. Bold colours work well on flashlit objects in the foreground of low-light scenes.

Whatever the subject or scale of the picture, a manual flashgun, or an automatic or dedicated gun set to manual mode, is the easiest to use, as it always fires on full power unless set to something else and delivers a consistent amount of light with each burst. You should also use the most powerful flashgun you can lay your hands on, as more power means you can either work at greater flash-to-subject distances or use a smaller lens aperture.

To determine which lens aperture you need to use to give correct flash exposure, divide the flashgun's guide number (GN) into the lens aperture you're using to find out how far away the flash needs to be from the area you're going to light with it. For example, if you have a flashgun with a GN of 32 and are using an aperture of f/16, the correct flash-to-subject distance is 32/16 = 2m. This is correct for ISO100 film. If you are using ISO50 film, open up the lens aperture a stop to f/11, or reduce the flash-to-subject distance to 1.5m; if you're using ISO200 film, stop the lens down 1 f/stop – to f/22 in this example – or increase the flash-to-subject distance to 3m. Most flashguns have a dial or a scale which tells you the correct flash-to-

subject distance for a range of film speeds and lens aperture settings, so you shouldn't have to work it out for yourself.

If the area you want to light with the flash is relatively small and accessible, then you should be able to provide sufficient illumination in a single flash burst. Usually you can trip the shutter and lock it open on B with a cable release – the camera must be on a tripod, of course – then walk up to the area you need to light, point the flashgun at it and fire the test button. If this isn't possible, and you have to fire the flash from a distance that's outside its range at the aperture you want to use, there are two options.

One is to set a wider aperture – by opening up the lens 2 stops you can double the flash-to-subject distance. This is the easiest option, but setting a wider lens aperture means you will lose depth-of-field. The other is to stay where you are and fire the flash more than once at the same area while the camera's shutter is open, to build up the light on it. If the maximum flash-to-subject distance you can use for one flash is 2m, for instance, you will need to fire the flash twice if you are 3m away, four times if you are 4m away, six times if you are 5m away, eight times if you are 6m away and 16 times if you are 8m away (see pages 86–87 for a more detailed explanation).

In situations where the area you want to light is too great for a single flash burst due to the flashgun's limited coverage, such as the front of a building or the interior of a dimly lit building, then you have no choice but to use multiple flash bursts. Instead of doing this to build up the light levels in a single area, however, you walk around your subject and fire the flash at different areas so that you can gradually light the whole subject – or the parts of it that need lighting.

Here's a step-by-step explanation of how it's done, using an old church exterior as an example.

❶ Visit the location you want to photograph during daylight hours, so that you can determine where to shoot from and decide how the scene will be composed. Try to include something in the foreground such as a gate, which will add an extra feature for you to light with the flashgun.

❷ Large-scale subjects such as buildings are best photographed with a wide-angle lens so that you can set up the camera at relatively close range – this reduces the distance that you have to walk to get up to the building and light it with the flashgun, and it also reduces the time that it takes you to get back to the camera at the end of the exposure.

❸ Return just before dusk and set up your camera on a tripod in the position you chose on your earlier visit. Then switch the camera to manual exposure mode, set the shutter to B (bulb) and stop the lens down to f/11 or f/16. Attach a cable release.

❹ Get your flashgun ready, making sure it's set to the right film speed and to manual mode. Place a spare set of batteries in your pocket, in case you need to use them halfway through a shot.

Here's a good example of how a flashgun can be used to 'paint' a scene with light. Situated right at the top of a hill, the tiny eleventh-century church at Brentor in East Devon is completely unlit at night, as you can see from the inset picture, so I decided to provide my own form of floodlighting by walking around the exterior, repeatedly firing a flash at different areas. Two Vivitar 283 flashguns were used, and it took about six minutes to complete the shot. After locking the camera's shutter open on B, the wall and the gate in the foreground were flashed three or four times, then I walked up to the church itself and fired 25–30 flashes from a distance of around 2m. I even included myself, accidentally, by standing between the camera and flashgun when the flash was fired.

❺ Wait until light levels have dropped to a point where you need to use an exposure of at least 2 minutes at f/11 or f/16 to record colour in the sky. Such a long exposure is necessary so that you have time to fire sufficient flash bursts to light your subject. Using slow film – ISO50 or 100 – will help. To determine when this point is reached – usually about 30–40 minutes after sunset – take a meter reading from the sky with a telephoto lens or spot meter.

❻ While you are waiting for this to happen, start planning how you are going to light the scene. You should already have worked out the flash-to-subject distance required to light an area with a single burst of flash, but there will be areas that you can't get close enough to, which will require more than one burst, such as a church tower.

❼ Once light levels have dropped sufficiently, check that everything is set up correctly, switch on your flashgun, note the time on a wrist-watch so you can monitor the exposure – or set the required time on a stopwatch – then trip the camera's shutter and lock it open on B with the cable release.

❽ Now quickly head towards the building. When you get up close enough, fire the flash at the first area, wait for the gun to recharge, then light the second area. You will have to repeat this as many times as you think is necessary.

Having two flashguns can be a great help here, as it means that while one is recharging you've always got a second one that's ready to fire, so you can cover a large area in a short space of time. Flashguns that recharge quickly make life easier as well, because this means you don't have to wait around for what seems like ages between flash bursts – a separate power pack is worth considering for this purpose.

❾ Providing you keep moving around while you're working, you won't register your own image on the shot. However, when firing the flash you need to be absolutely sure that you aren't between the gun and the camera, otherwise you'll end up with a nice silhouette of your own body on the picture – not necessarily a bad thing, but not ideal either, especially if you appear several times on the same shot.

Flash doesn't have to be the sole source of illumination when you're painting with light. For this night shot taken in a railway goods yard, a flashgun was fired several times at the side and undercarriage of the train during a 60-second exposure, to brighten up areas that weren't adequately illuminated by the overhead floodlight and to record a more evenly lit image.

❶❶ Once you've lit the entire building, and any other features in the scene that take your fancy, head back towards the camera and release the shutter to end the exposure.

It's difficult to know how many flashes you will need to light an entire building, but it's almost always more than you think, so be extravagant rather than mean with your flashes.

Remember, when working at long exposures – in this case anything from 2 to 5 minutes – reciprocity failure occurs and you need to increase the exposure. For the ambient light, expose for 3 or 4 minutes if your meter reading says expose for 2. The same applies with the flash. On areas that you have calculated to require just one flash burst, give two or three to be on the safe side, and for areas that require two bursts give four or five. Expect to need about 30 flashes to light an average-sized church or house.

If filters are used to colour the flash, you must also take into account the light loss they introduce. A 1-stop light loss can be compensated for by firing the flash twice instead of once; a 2-stop light loss will require four flashes instead of one.

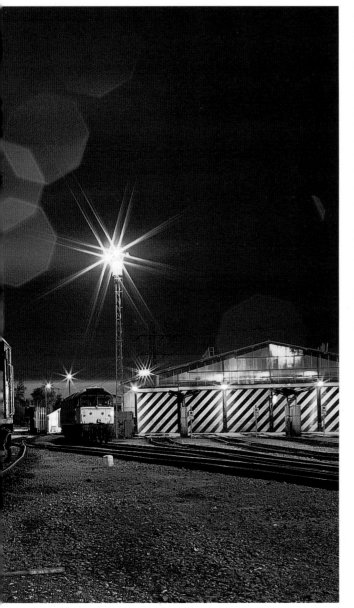

TORCHLIGHT

Invaluable for helping you find your way around in the dark, the humble torch can also produce eye-catching lighting effects.

Indoors, you can use a torch to illuminate still-lifes in a darkened room, selectively highlighting different areas with the narrow beam, and perhaps using coloured gels to introduce different colours to different areas. Outdoors, a powerful torch or lamp can be used to illuminate a feature in the foreground of a scene or a whole structure, in the same way that multiple flash bursts can. The benefit of using a torch on large-scale subjects is that you have a much better idea of where the light is going because it's a continuous source, whereas a burst of flash lasts for just a fraction of a second.

The type of torch you need will depend on the scale of the subject. I use a range of American Maglite torches, which are ideal for use at close range as the beam can be adjusted down to a narrow, concentrated spot so that it only lights a small area. For larger-scale subjects you will need more power, so consider investing in a big security torch with an output of 500,000 candles, or a 100-watt hunting lamp with a rechargeable battery pack.

Determining correct exposure is straightforward as the light from a torch is constant. Just shine it on your subject and take a meter reading from the brightest area. Or, shine it on the metering dome of a handheld meter placed the same distance away as your subject and take an incident reading of the light falling on it.

Once you know that when using a certain torch from a certain distance you will need a certain exposure, you can control the effect it has. If an exposure of 4 seconds at f/22 is required when you keep the narrow beam of your torch aimed at an object 1m away, for example, which is about right for a torch powered by two AA batteries, you can make some areas darker than others by shining the torch for just 1, 2 or 3 seconds. Equally, if you want an area to come out really light, shine the torch on it for 5 or 6 seconds. Areas can also be left unlit so that they record as black or near-black.

If you're using torchlight for still-life photography, set up your props, compose the picture, and then turn all the lights off so that the room is in total darkness. That way, the only light recorded will be coming from the torch, so you can create exactly the effect you choose. Your camera's shutter can also be locked open on B for as long as it takes to build up the lighting on your still-life.

Start off simple, perhaps using the torch like a spotlight so that it picks out one object or area while everything else is plunged into darkness. Once you've seen what the results are like you can then experiment with more ambitious lighting.

Outdoors, the same technique is employed, only on a bigger scale. With your camera's shutter locked open on B, leave the camera in position and move closer to whatever you're lighting so the torch isn't aimed at any one area for too long, and gradually build up the light. Again, correct exposure is determined by shining the torch on the area from the distance at which you expect to be working, and then taking a meter reading from that area.

Don't take this to be the exposure you need to use, however. It merely gives a guide as to how long you must shine the torch on any one area for it to be correctly exposed, but on a large-scale subject such as a ruined building you may need to spend 10–15 minutes gradually lighting the whole thing.

In order to use an exposure of this duration, you will need to wait until ambient light levels are very low and the scene almost in darkness. Taking a meter reading from the sky, as suggested earlier, is a good guide to the exposure you will need to use. Reciprocity

ABOVE & LEFT **This is the type of soft, dreamy lighting you can get from a torch – quite unlike the original set-up, as shown in the inset photograph below. After setting up the shot at night, I turned off the room lights and locked my camera's shutter open on B at f/22. I then began to paint the still-life with torchlight, first aiming the narrow beam at each flower head for 8–10 seconds from a distance of roughly 1m, then shining it on the vase to create a highlight, before aiming it at various parts of the background for a few seconds each to give the dappled effect. A small Maglite torch powered by two AA batteries was used for this, and it took about 3 minutes in total to complete the shot. A soft focus filter was placed on the camera lens, and while the torch was shone on the background a blue 80A filter was held in front of it to add a cool colour cast.**

RIGHT **To create this surreal painting-with-light effect, a small pen torch was used to trace roughly the outline of the boots and laces while the camera's shutter was locked open on B in a darkened room. The image was recorded on ISO100 film using a standard lens, and it took around 40 seconds to complete at an aperture of f/16. Residual light from the torch has also created an attractive glow on the boots, adding to the picture's appeal.**

failure must be considered, so if your lightmeter is saying use an exposure of 5 minutes at f/16 to expose the sky correctly, lock the shutter open for 10 minutes at f/16. It doesn't matter if you give too much exposure – the sky comes out slightly lighter than you remembered it, which isn't necessarily a bad thing.

PHYSIOGRAMS

A torch can also be used to create fascinating images that are known as physiograms. To do this, you need a pen-light torch with a small bulb on the end, a piece of string and somewhere to suspend the torch – a light fitting in the middle of a room is ideal.

Basically, all you do then is tie the torch to one end of the string, then tie the other end to the light fitting so the torch is suspended. Ideally, use a piece of string that is 1m or so in length, and suspend it so that you can set up your camera on a tripod about 1m directly under the torch.

Once you have got your camera in position, mounted on a tripod and with a cable release attached, set the shutter to bulb and stop the lens down to f/5.6 or f/8 with ISO100 film. Now turn the torch on and focus the lens on it while you are looking through the camera's viewfinder.

With all preparations now complete, you are ready to create your first physiogram. To do this, switch the torch on and the room lights off so that you're in darkness, then pull the torch back 40–50cm from its static position over the camera and set it swinging in an arc. Once you've done this, peer through the camera's viewfinder, and at the point where the swing of the torch is small enough to fit in the picture area, trip the shutter and lock it open.

Each swing of the torch will create a sphere on the film, so if you leave the shutter open for 30 seconds or so you will end up with an amazing light pattern traced on the film that can never be repeated – each time you swing the torch, it will create a different pattern.

To add interest to your physiograms, place filters over the lens to colour the light trails – red, green, blue, orange and yellow are ideal. If you hold a piece of card over the lens to stop light from the torch recording on film, you can swap filters in mid-exposure and then take the card away and capture more light trails in a different colour. Repeat this three or four times until the torch has almost come to rest; the effect is stunning.

Alternatively, let the torch swing for 15 seconds or so, then cover the lens with card, stop the torch, set it swinging in a different way and take the card off the lens to record a different pattern over the first one. Do this three or four times, placing a different filter over the lens each time you set the torch swinging again.

Physiograms are incredibly easy to create, but the effects can look amazing, with each image completely different to the last. So the next time you're stuck at home with nothing to do, give it a try.

This physiogram was created in four stages using a 28mm wide-angle lens set to f/8 and a single exposure of a minute or so on ISO100 film. The different colours were created by placing filters over the lens at different stages during the exposure – being careful to hold a card over the lens to block out light from the torch while the filter was changed, then taking it away to resume the exposure with the torch still rotating above the camera.

SPARKLERS

Back on pages 132–133 we looked at how to photograph people having fun with sparklers on bonfire night, but with a little imagination you could come up with something far more interesting, so remember to keep a few packets handy for use later.

Here are a few ideas to get you started:

• Trace around the outline of bold objects with a lit sparkler, then light that object with a burst of flash. Cars, bicycles and statues are ideal. You could also trace around a person's body.

• Draw patterns in the air with a sparkler – circles, squares, love-hearts, or just random squiggles.

• Ask a person to write their name in the air with a sparkler, then light them with a burst of flash.

As with sparkler shots on bonfire night, you need to wait until it's dark outdoors and then take the pictures against a plain, dark background – or work in open space. Your camera should also be mounted on a tripod and the shutter locked open on B for as long as it takes to produce the sparkler effect – you will find that 30–60 seconds is usually sufficient.

Use your flashgun in manual mode and fire it by pressing the test

Sparklers can be used for painting-with-light shots just like a torch can. Here the camera's shutter was locked open on bulb at f/16; I then dashed behind the car, lit a sparkler and started to trace the car's outline. Once that sparkler had burned out, I lit a second and continued, before hopping inside the car and turning on the headlights and hazard warning lights for 20 seconds. All in all, it took around 4 minutes to complete and was shot using a Pentax 67 medium-format camera fitted with a 45mm wide-angle lens.

button towards the end of the exposure. Refer to the section on open flash on page 176 for advice on how to determine which lens aperture you need to set to expose the flash correctly. A smallish aperture such as f/11 will be ideal, allowing you to keep the shutter open for a minute or two without recording any ambient light. With most flashguns, this will give you a working distance of 3–3.5m.

Planning is the key to success, so think about how the shot can be put together. It's also a good idea to recruit the help of another person if you're using sparklers to trace the outline of a large object, as you can each work on a different area and complete the outline in a shorter space of time, often without having to re-light more sparklers. If your subject is a person, make sure they're adopting the right pose and expression before firing the flash, as this can make or break a great shot.

CANDLELIGHT & FIRELIGHT

The light from a candle is perhaps the simplest source of illumination, yet its symbolism is far-reaching. Think of candlelight and you think of love, romance, warmth, religion and remembrance. Loving couples dine by candlelight; people take part in candlelit processions on holy days, or in vigils as a sign of respect for the loss of someone they loved. Firelight has a similar symbolic value, providing warmth and energy as well as light.

Photographically, candlelight and firelight are highly versatile, producing images full of atmosphere and ambience. The light from a flickering candle or roaring log fire is ideal as a source of illumination for portraits, nude studies and still-life pictures, while the flames can be the source of interesting pictures in themselves.

GOLDEN MOMENTS

What makes this type of lighting so attractive is its warmth. The colour temperature of a candle flame or fire is very low – less than 2000K – so pictures taken on daylight-balanced film will come out with a very distinct orange cast (see page 74). Often such a cast is unwelcome – when taking pictures in tungsten lighting, for example. But the whole appeal of candlelight and firelight is the very fact that it adds this cast, which enhances the mood of the pictures you take. The light is also selective, illuminating a very small area while everything else around it is thrown into deep shadow. This means you can use it to pick out specific things like a person's face, the curve of a woman's breast, or interesting props in a still-life composition.

Where pictures are being set up specifically to take in candle- or firelight, you can control the effect obtained. One candle will light very little, for instance, but several candles strategically placed will have much greater covering power. Similarly, the bigger and more energetic a fire is, the more light it will generate. You can also control where your subject is in relation to the light, to vary the effect obtained.

Candlelit portraits often look better if all or part of the flame is included, so that the viewer can immediately see why your subject's face is bathed in a warm glow. You could set up a shot where he or she is seated at a table behind a candleabra, then photograph them with a telephoto lens set to a wide aperture so that the flames are thrown out of focus and help to guide the eye towards their face. Take care with the positioning of the candle or candles, so that they don't cast unflattering shadows across your subject's face.

With nude studies you will need more light, so a roaring fire tends to be more suitable; its flickering flames casting an ever-changing pattern of light and shade across your subject's body.

Here's a classic example of candlelight being used as the sole source of illumination for a picture. The subject is my son, photographed while trying to blow out a candle – you can see from the orange glow on his face just how warm the light is. The picture was taken handheld using a 50mm standard lens wide open at f/1.8, and the exposure on ISO1600 film was 1/30 second. A handheld meter was used to measure the light falling on the little boy's face and ensure correct exposure.

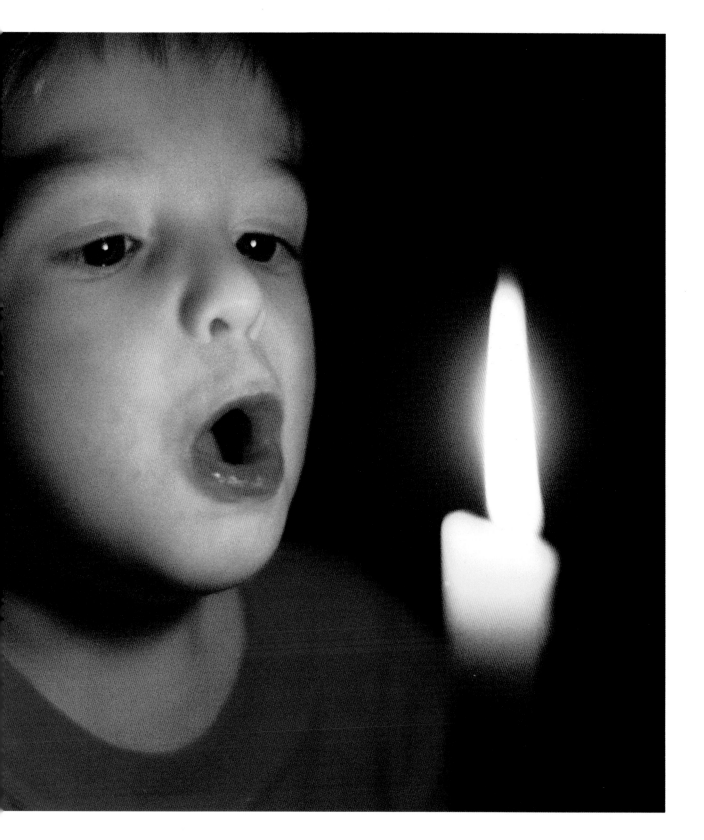

Obviously, the heat from the fire must be taken into account, as it can quickly become uncomfortable but a reclining nude photographed in the light of a fire can produce a highly evocative image.

Firelight also makes an ideal background to still-life shots of translucent objects, providing light as well as enhancing the mood of the shot. Try setting out a bottle of champagne and sparkling glasses on a table in front of a fire, and see how the flames backlight the glass.

Where you are taking pictures in a 'found' situation, such as a display of candles in a church, a person blowing out candles on their birthday cake, or people in a candlelit procession, then you must make the most of what's there, and use you experience to produce the best possible results. Wherever possible, crop in nice and tight and fill your camera's viewfinder with the brightest areas, so that you don't end up with large areas of shadow ruining the effect of the subtle lighting. Lanterns work better than uncovered candles in this respect, because although they reduce light levels, the glow is more even and covers a larger area.

TECHNICAL TIPS

Film choice will depend on the situation. If you are setting up a shot and your subject is static, slow film of ISO100–200 is perfectly acceptable because you can use a tripod so that the risk of camera shake is eliminated. Shooting with your lens at its maximum (widest) aperture will also keep the shutter speed as high as possible. Expect an exposure of around 1/8 second at f/4 on ISO 100 film when shooting candlelit portraits where your subject is 40–50cm away from the candle flame.

The alternative is to load up with fast film of ISO1000 or above, so that you can take pictures handheld. If a tripod isn't an option or your subject is moving, then you won't have a choice in the matter. However, fast film is worth experimenting with because its coarse grain can enhance the mood of your pictures no end – especially when partnered with a soft focus filter to diffuse the image.

If you want to cool down the light from a candle or fire you have

This still-life shot was set up in front of an open fire in my dining room so that the orange flames of the fire backlit the bottle and glass. Two white reflectors were placed on either side of the camera to bounce some of the light from the fire on to the front of the props, and the picture was taken with a 105mm standard lens on a 6x7cm medium-format camera using an exposure of 1 second at f/5.6 on ISO100 film.

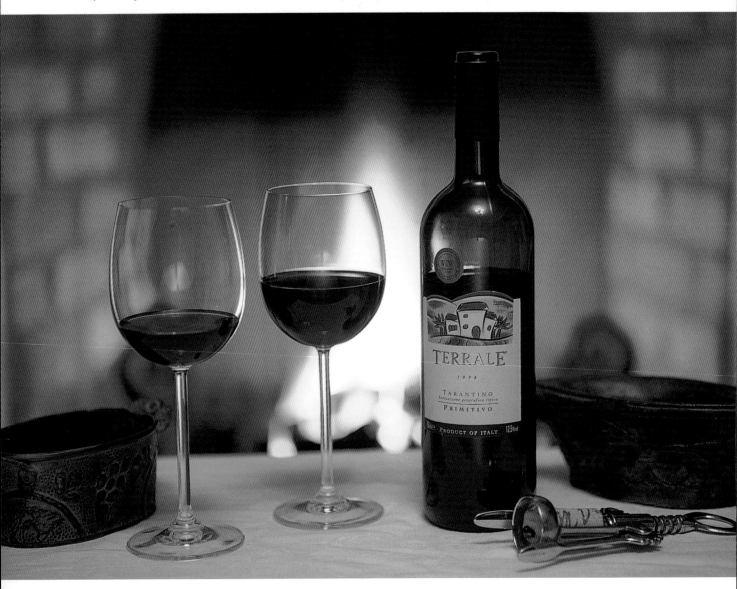

ABOVE **Of course, you don't need lots of fire to provide sufficient illumination for a photograph. In fact, if push comes to shove, a match will do, as you can see from this portrait. Taken in a pitch-dark log store with a 50mm standard lens at f/1.8 – its widest aperture – the exposure on ISO1600 film was 1/15 second.**

RIGHT **A colour diffraction filter was used to add interest to this shot of three candles. The effect is rather clichéd, but don't let that put you off trying it.**

two options – either use tungsten-balanced film such as Kodak Ektachrome 320T (ISO320), or place a blue 80A or 80B filter over your lens when using daylight-balanced film. Both will cool down the light but will not get rid of all the warmth – doing that would produce rather strange results. If you're not sure which effect you prefer, take a few shots unfiltered and then a few with a filter.

Getting the exposure right needn't cause any major headaches providing you think about what you're doing. The key is to meter for an important area that's lit by the candle or fire – your subject's face in the case of a portrait, or part of their body if you are shooting a nude study – and ignore everything else. Do this by moving in close to your subject so that the bright flames and areas of deep shadow are excluded from the camera's viewfinder, or by using your camera's spot-metering facility.

When you do this, remember that if the area you meter from isn't a mid-tone, you will need to adjust the exposure to compensate. Caucasian skin is about 1 1/2 stops lighter than 18 per cent grey, for example, so you should increase the exposure by that amount, or make sure you bracket the exposure wide enough to cover any adjustment required. Similarly, dark skin is around 1 1/2 stops darker than 18 per cent grey, so you need to reduce the exposure by

that amount to prevent overexposure.

Alternatively, if you have a handheld meter, take an incident light reading by holding the meter as closely as possible in front of your subject with the metering dome pointing towards the camera or light source. That way, you can measure the light falling on your subject from the candle or fire and obtain an accurate reading that won't be influenced by bright or dark areas.

For shots of a candle flame or roaring fire, I tend to leave the exposure to my camera's integral metering system, shooting in aperture priority and bracketing a couple of stops over the metered exposure in 1/2 or 1/3 stop increments. When photographing candle flames you can also use filters to add interesting effects – try a starburst or diffractor (sees pages 48–51), perhaps combining it with a soft focus filter as well to create simple but atmospheric images.

CONCERTS & PLAYS

Whether it's a school nativity play or a lavish production in a West End theatre, a band playing in a local pub or a clown making children laugh at a circus, people performing make great photographic subjects.

First impressions are probably that all these subjects – and the many others that haven't been mentioned – require a completely different photographic approach. However, technically they present a similar set of problems, so the same techniques and equipment can be used to overcome them. You will inevitably be shooting in artificial lighting, for example, so light levels will always be low compared to daylight outdoors, and contrast is almost always high due to the way the people and sets are lit.

BE DISCREET

Where differences do occur, it's more in the type of venue where the performance is taking place and the attitude of the people around you. It will be much easier to get close to the stage at an amateur dramatics performance than a major London production, for example, because the venue will be smaller and access more relaxed. So, if you are trying theatre photography for the first time, stick to local venues initially, where you'll have far more freedom and can work on your technique.

Another option is to ask permission to take pictures during rehearsals. This isn't as exciting as doing the real thing, but at least you won't have to worry about getting in the way of the audience, who have paid to watch a play rather than the back of a photographer. Dress rehearsals are the closest you'll get to the real thing, but even without costumes it's still possible for you to take great pictures of the actors and actresses – in particular amusing candids when people break into fits of laughter because someone has fluffed a line, or unguarded moments when the players are relaxing. This sort of opportunity won't be there on the big night.

Rock and pop concerts are a different matter. Photography is banned in the bigger venues unless you have full press accreditation – which is only given to professionals working for music magazines or national newspapers – and many bands only allow photographers to shoot them for the first two or three songs before they are turfed out. As for the paying public, photography isn't allowed and you will usually see signs at the entrance saying this, and also that cameras will be confiscated.

There are two ways around this. The risky one is to attempt to smuggle in a camera, though at big venues you will need to be right up by the stage to get decent shots without long telephoto lenses – and the heads of people in front of you getting in the way. The sensible one is to forget about photographing the Rolling Stones, REM or Pink Floyd at their next gig and concentrate on smaller bands in smaller venues where there are no access restrictions and you can get up close to your subjects.

The same applies to comedy clubs and to other venues where performers show off their talents – stay local. The faces won't be as well known, but the pictures will be just as good.

Cameras are also banned at many circuses, though security isn't as tight as at a rock concert, so you should be able to smuggle one in. Try slipping a 35mm SLR body into your coat pocket, and perhaps ask someone else to carry a telezoom in a handbag, then unite the two once the show begins. When the lights on the audience are turned down and all attention is directed towards the stage, who's going to know what you're doing?

LEFT **School plays are much easier to photograph than bigger theatrical productions because they take place in smaller venues and you can get closer to the action – making it possible to take frame-filling pictures with a moderate zoom lens. Light levels are usually quite reasonable, so if you've got a steady hand you may be able to produce sharp results with film as slow as ISO100 if you shoot at maximum aperture.**

RIGHT **SLRs are often banned from rock and pop concerts, but a small, pocketable compact should go unnoticed. This picture, of the vocalist from a band called the Buttermountain Boys, was taken from close to the stage using a Konica Big Mini compact with fixed 38mm lens. With no control over the exposure set, and knowing the bright stage lights would probably fool the camera's fully automated metering system into causing underexposure, ISO400 black and white film was used at the recommended rating, then push-processed by 2 stops – effectively overexposing the whole film by 2 stops. This made up for any exposure error and produced negatives that printed well on grade II paper.**

In all cases, the key is to be discreet. Cameras are often banned because the organisers assume that everyone will be using flash, and that can be incredibly offputting for both the performers and the audience. So leave your flashgun at home and concentrate on working in available light.

EQUIPMENT

A 35mm SLR is the best type of camera for both stage and theatre photography, being quick to use and easy to handhold in low light. A compact camera is also worth considering if you want to travel light, and if you will be able to get close to your subjects – switch off the flash, load a roll of fast film, and it's surprising just how good the results can be.

Lens choice will depend on what you are photographing and how far away you will be from the stage. For amateur dramatics and local bands, where you can get reasonably close, an 80–200mm telezoom will be more than adequate for head shots or picking out individuals, while a standard or moderate wide-angle lens can be used to capture the whole stage set or band.

Light levels vary from venue to venue, depending on the size of the production, so you need to carry film that will help you deal with all eventualities. There will be much more light on the stage of a large theatre production, for example, than at a rock concert. One solution is to carry a range of film speeds from, say, ISO200 to ISO1600. Alternatively, stick with ISO400 and then uprate it a stop to ISO800, or 2 stops to ISO1600, as and when required (see page 37). You should very rarely need to go faster than ISO1600.

If there is a possibility that you will be uprating film, carry a pack of white sticky labels and a pen, so that you can mark the new film speed on the cassette. That way, when you emerge from the venue you will know how many stops the film needs to be push-processed by, and you will also avoid mixing up films that have been rated differently thus resulting in processing error.

The type of lighting used for stage performances varies. At worst it is going to be unfiltered tungsten spots, which will give pictures taken on daylight-balanced film a strong orange colour cast. You could overcome this by using tungsten-balanced film, or by cooling it down a little with an 80C or 80D filter. The stronger 80A or 80B filters will give more balanced results, but the effect may look odd if you filter out all the warmth. They also lose more light than the weaker filters in the series, and that's the last thing you want.

More often than not, however, coloured gels are used on the lights to create eye-catching effects, especially at rock and pop concerts, so you might as well just use unfiltered daylight-balanced film and let the colours record – and often this will improve your shots.

Finally, if access is relatively free and you won't get in the way of other people, it's worth taking a monopod along so that you can support the camera. This will be very welcome if you are using a telephoto lens for long periods, as the monopod will take the strain of the lens off your arms. You can also shoot at slower shutter speeds without having to worry about camera shake.

AVOIDING EXPOSURE ERROR

The trickiest task facing any photographer taking pictures of stage performances is getting the exposure right. The type of lighting used is the main culprit for this. Powerful spots are often employed to pick out individuals at key moments during the performance, while large areas are left in darkness, creating a high-contrast situation that camera meters find difficult to cope with.

Rock and pop concerts are the most troublesome in this respect. Local gigs aren't too bad, because limited space and facilities often mean that the lighting is kept relatively simple, with just a few spots used to pick out the lead vocalist and other members of the band. But when well-known bands perform live they usually employ a whole team of engineers to put on lavish light shows that change constantly.

Experience counts for a lot when faced by such conditions – as does sound metering technique. Once you have photographed several concerts or theatre productions you will know what to expect, and should be able to guestimate the exposure required with a fair degree of accuracy. Until that time comes, however, you will need to rely on what your meter says.

Spot metering is the most versatile system, as it allows you to take readings from a very specific area – such as a spotlit performer – without other bright or dark areas influencing the reading obtained. But it isn't foolproof, and you must remember to meter from a mid-tone, otherwise exposure error will still result.

If you take a spot reading from a bright item of clothing such as a white shirt, for instance, your pictures will be underexposed by up to 1 1/2 stops, while metering from something dark or black will cause overexposure. The ideal colour from which to meter is mid-grey, as it represents a perfect mid-tone, but mid-brown or mid-blue will also give an accurate exposure reading.

More general metering systems such as centre-weighted average or multi-zone can work well too, but you need to use them with more care. If you are using a telephoto or telezoom lens to take

frame-filling shots, the light levels should be fairly even and a straight meter reading will probably give an accurate exposure. It's when you capture wider views where spotlit subjects are against large areas of shadow that error is more likely, with the darker tones often causing overexposure of your main subject. To prevent this, reduce the exposure your camera sets by a stop or so and bracket – though it's better to keep this to a minimum as you will often find that the best shots are the ones you under- or overexpose.

There are also a couple of other tricks you can employ to reduce the risk of exposure error. One is to use negative film instead of slide film. Colour slide (transparency) film needs to be exposed with great accuracy, but a negative that has been under- or overexposed by up to 2 stops can usually be rescued at the printing stage and still yield

an acceptable print. Black and white film is particularly good in this respect, because you can also pick and choose different paper grades to control image contrast, and even control contrast using specific film developers.

Another option is to have a clip test done of one roll of film. Professional labs usually offer this service, and it involves processing part of a roll of film, or one full roll from a batch, to check the exposures. If the clip test shows that most of the shots are underexposed, the rest of the roll or the other rolls from the same shoot can then be push-processed by the required amount to correct that error (see page 37), or 'pull-processed' if overexposure is a problem. This is no substitute for getting the exposure right in the first place, but it can provide a useful safety net if all else fails.

INDEX